THE ARTS
OF MANKIND

EDITED BY ANDRÉ MALRAUX
AND GEORGES SALLES

SCIENTIFIC CONSULTANT : ANDRÉ PARROT

The Flowering of
The Italian Renaissance

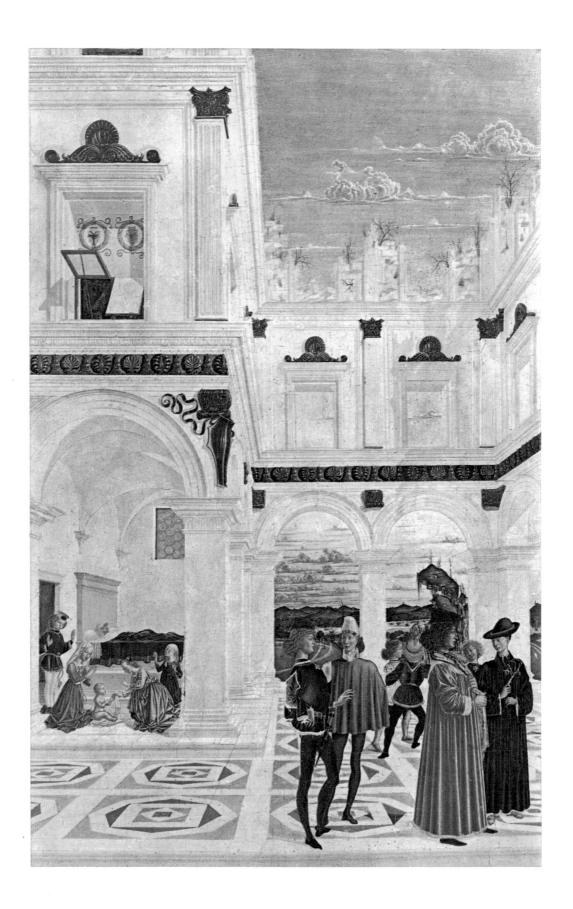

ANDRÉ CHASTEL

The Flowering of the Italian
RENAISSANCE

TRANSLATED BY JONATHAN GRIFFIN

THE ODYSSEY PRESS • NEW YORK

49 547

Library of Congress Catalog Card Number: 65-27309

Printed in France

CONTENTS

To Georges Salles

who has had faith in the historians

in respectful and affectionate homage.

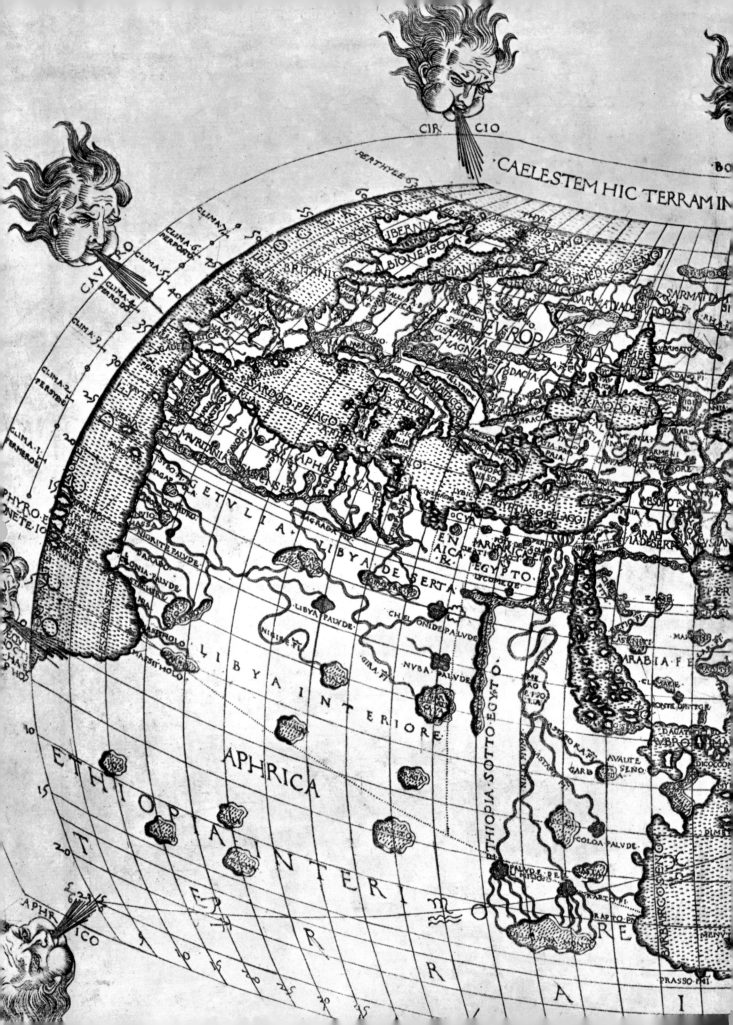

PREFACE

I⊤ is a century since Jakob Burckhardt published his *Kultur der Renaissance in Italien* (1860). This study, though subjected to every conceivable refutation, discussion and reappraisal, still dominates the interpretation of the period by historians. Burckhardt's essay on the civilization of the period was intended as an introduction to a complementary book on Renaissance art, which, however, he left uncompleted. A chapter on architecture was published in 1867; otherwise there are only his notes, which are enough to make us regret his failure to complete the project.

In a sketch written in 1858, Burckhardt explained the approach he intended to use: 'A history of the art of the Renaissance must always submit to the requirement that it should give the story of the artists in chronological order, and I have no thought of establishing mine on any other basis. In trying to arrange it according to the materials they worked in and the genre they practised, my aim is merely to add to the narrative history, which is traditional, a second and systematic part... If some readers regret the absence, here, of the kind of argument that enables other writers to discourse on the individual works of art, I beg them to consider that I too could have furnished that...' Burckhardt in fact was proposing, in contrast with the already common practice of reeling off names and commenting on the works of art, to establish a *structural* history, that is to say, to bring to light the contexts within which names and works would find their places as elements of a whole that helps to define them.

Since then the history of Renaissance art has been a kind of parade-ground for the great theories. We have witnessed an astonishing proliferation of monographs, the heyday of the formalist point of view, the iconologist reaction, and some essays in sociological synthesis. The discipline has lost its freshness, perhaps without gaining any force. The most interesting conclusion that has emerged from the conflict and attrition of the theories is the need for an integral account of Renaissance art, capable of combining the different points of view, balancing them against one another and submitting them to historical standards. I make no pretence to have written here the book which Burckhardt was planning to write, but only to have followed his advice and returned to a classification by genres and

I - F. BERLINGHIERI. MAP OF THE WORLD (DETAIL) — LONDON.

themes, with a fundamental mechanism of facts and dates. That this has been delayed for a century has one advantage: it has been possible to examine the problems involved in the perspective of the present state of our knowledge.

Being unable to present a scientific description of all the sectors of the subject, and not wishing to write a mere textbook, I have thought it useful to bring to the fore certain facts that seem illuminating, such as the polarity of Padua and Urbino, the vogue for marquetry, the innovations in the design of villas and the popularity of the altarpiece. I have tried to show, in each field, what may be taken to be the feature peculiar to a period. Between the initiative of the artists and the logic of the styles, I have systematically introduced that intermediary stage which is defined by genres and themes. It is well worth noting: it encourages us to remember the real conditions in which the craftsmen worked and their dependence on commissions. The artist is always head of a studio or workshop. By considering each work of art in the category of production to which it belongs, one sees more clearly the nature of its means and the range of its effects.

Artistic innovations do not pass like a flash of lightning through the void, but—at least in a country with an ancient cultural heritage like Italy, and above all in the Quattrocento—they are diffused in a space that is already charged. In about 1460 Tuscan innovations finally reached other centres: the consequences of this influence are studied here. Deliberately breaking with the traditional histories, which consider artistic phenomena beyond the context of their own time and relate them to categories that are often too abstract, I have tried here to restore the limited horizon and the conflicts of tendencies proper to each circle of artist and patrons, to each workshop and to the individual artist—that is to say, to dramatize the history, to make the art felt as a human activity, with its struggles and its victories: in short, to recapture the singularity of situations and moments.

And so the activity of the artists is given definition within frameworks, both mental and technical; the measure of the greatness or insufficiency of these contexts is given by the actors in them. It seems to me that the history of the arts contains fewer lifeless elements and artificial connections when presented in this way. The period studied here is especially favourable to such a method; and the choice of this particular narrow band of time is easy to justify. It has, above all, two advantages: it allows us to see the co-existence of the arts, that is to say, the points at which they harmonize or are incompatible, points that never declare themselves over long periods; at the same time it emphasizes such phenomena as the consolidation or weakening of styles, or the rise and decline of an artist or an artistic centre, which are inevitably neglected in wider panoramas. I have tried to throw as much light as possible on to these revealing situations without falsifying the general outline. This, I hope, will excuse various lacunae and the absence of the usual set-pieces.

André Chastel

PART ONE

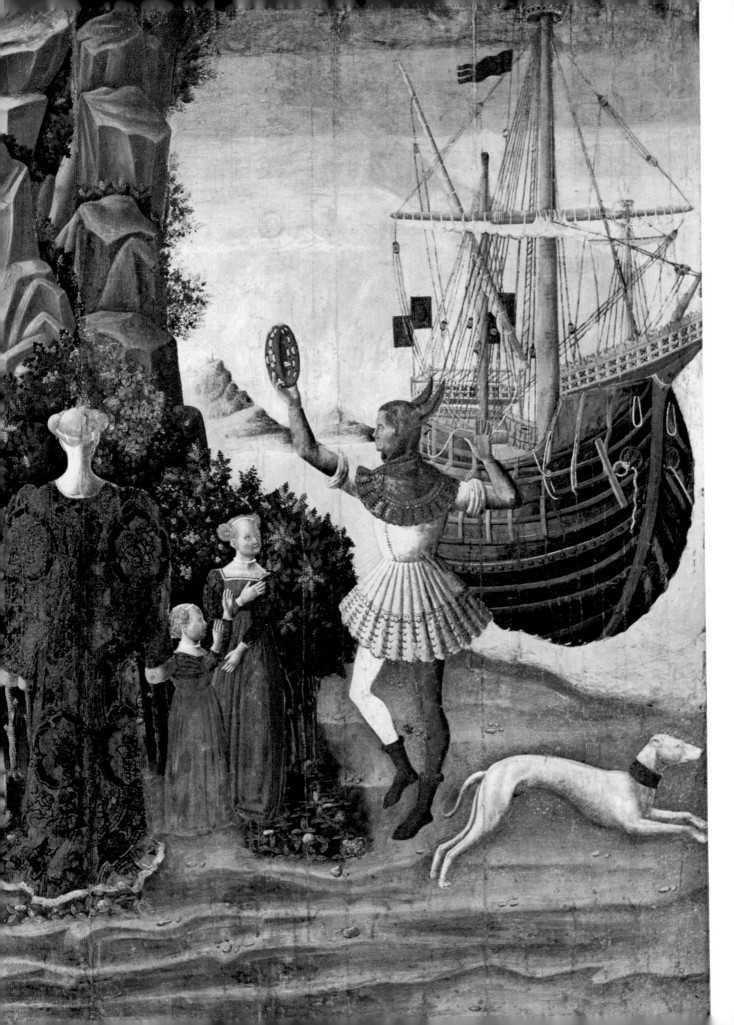

ITALY AND THE WORLD

THE discovery—as yet confused—of a *mundus novus* beyond the Atlantic Ocean was announced early in 1493. After a year of disputes Pope Alexander VI laid down, in the Treaty of Tordesillas, the demarcation between the Spanish and Portuguese jurisdictions—an imaginary meridian passing 370 leagues to the west of the Cape Verde Islands, a line which was difficult to determine at that time. Suddenly the world expanded: there began a vast pivoting of the trade route —prepared for a century by the Portuguese advance towards South Africa—in the direction of the Atlantic, to the advantage of Seville and Antwerp, that is to say at the expense of Genoa and Venice. The Italian peninsula ceased to be the median axis of the *imago mundi*, and the Mediterranean to be the site of world history. Meanwhile Italy had become the eastern and southern frontier of the Christian world: the Ottoman Empire had taken root in the Greek—and then in the Egyptian—part of the Mediterranean; it now occupied, and derived great prestige from, the second capital of the Roman Empire. The death of Pope Pius II at Ancona in 1464 had marked the abandonment of the idea of the Crusade for several generations. Asia had come into Europe and Italy was now on the frontier of defence.

To these two long-term facts there was added the slow evolution which tended to displace the centre of gravity of Europe towards the North, or at least to create a second centre. The fifteenth century—the age of the merchant cities—confirmed the importance of the great Italian centres, but only within a general development in which the wealth and energies of the North

2 - DARIO DA PORDENONE. THE STORY OF HELEN (DETAIL) — BALTIMORE, WALTERS ART GALLERY.

played an increasingly important part. Trade routes shifted towards Flanders, the Rhine and the Baltic. In Spain, in Poland and in Muscovy the Florentine, Venetian and Lombard traders constantly met English or German-speaking colleagues, for whom Italy was now little more than a marginal province. But the Renaissance was the age of conflicting trends: all sorts of forces were tending, so to speak, to 'de-Mediterraneanize' Europe; on the other hand the wars that began with the French invasion, the movements of commerce and the religious struggles were to bring attention back, for sixty years, to the key centres of Italy. And Italy was to impose on the West a 'Mediterraneanization' of culture far more radical and complete than all the earlier waves of Byzantine or Graeco-Roman influence.

ITALY AND THE BARBARIANS

ITALY at the end of the Quattrocento appears as a kind of miniature Europe. The behaviour of its five major States and of its secondary powers, principalities, merchant cities and feudal townships is in the image of the Christian world as a whole, a behaviour interestingly magnified by the southern habit of emphatic discourse and by the cult of this great history rich in examples.

Demographically, Italy was not very impressive: nine to ten million inhabitants, unevenly distributed between the States; Venice and the Holy See each had a population of a million and a half. The towns with more than a 100,000 inhabitants—Venice and Milan— were powerful city-states; Genoa and Florence did not reach this number. The North teemed with small towns and townships. Nearly all of these had their own culture, tradition and customs: Italy was naturally municipal. This diversity comes out clearly if one looks at the powers involved in the Peace of Lodi (1454), a settlement which took the form of a 'balance' between the five major powers—Venice, Milan, Florence, Rome and Naples. All these, between 1460 and 1470, underwent a change of rulers which transformed their general climate. It was the age of grand intrigues rather than of wars. At the same time significant and active principalities, such as Ferrara, Urbino and Mantua, made their appearance in the interstices between the consolidated territories of the five major states.

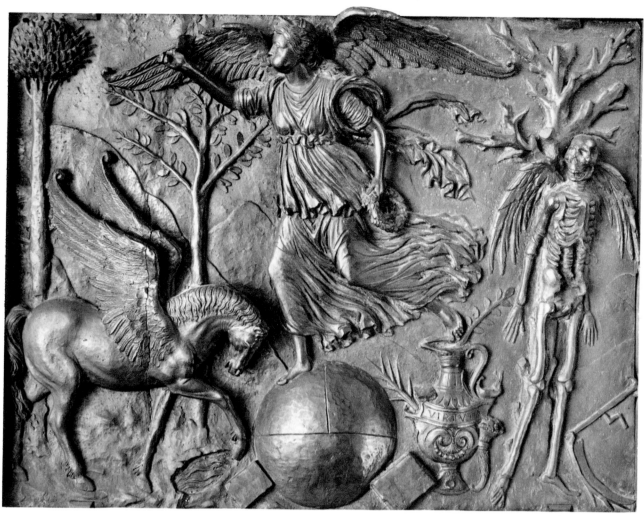

3 - ANDREA RICCIO, HUMANISM OVERCOMES DEATH — PARIS, LOUVRE.

The links between Italy and the West were many and constant, long before the 'descent' of the French armies in 1494. But they did not affect all the centres equally. The activity of the Holy See, lastingly strengthened at Rome by the pontificate of Nicholas V and the Jubilee of 1450, kept a certain internationalism alive throughout Italy. Aeneas Silvius Piccolomini, the future Pius II, was Legate at Basle, knew Prague and Austria well, and returned from them with a personal interest in Gothic art. The Curia, more and more closely concerned with political affairs from the time of Sixtus IV onwards, was the meeting-point for prelates and diplomats of all countries; these sometimes brought painters or craftsmen in their train, and sometimes became interested in modern Italian art. The Aragonese and Valencians who had come in the train of the Borgias exported in due course a number of

3

4 - BOTTICELLI. ALTARPIECE OF ST BARNABAS (DETAIL) — FLORENCE.

altarpieces. And it was, after all, a French prelate, Jean Bilhères de Lagraulas, who in 1497 (having been Cardinal of Santa Sabina since 1493), commissioned the Vatican *Pietà* from the young Michelangelo.

The expansion of commerce produced equally definite contacts between the Italian cities and the markets of the North. A typical example is the trade in alum (indispensable to the wool trade) which was stimulated from 1462 onwards by the success of the mines of La Tolfa in the Papal territory. Tuscan, Genoese and Venetian firms had long since taken root in the main centres of industry and banking in Flanders, France, the Rhine and Spain, and their growth continued steadily during the fifteenth century. This bourgeoisie was an enlightened one. Often these

5 - HUGO VAN DER GOES. PORTINARI ALTARPIECE (DETAIL) — FLORENCE.

merchants and bankers were attracted by the local art: Arnolfini, the Lucca merchant who settled at Bruges, had had his marriage portrait painted by Jan van Eyck in 1434; and shortly before or after 1480 Portinari, the representative of the Medici firm, apparently convinced of the superiority of Flemish art, sent the altarpiece by Hugo van der Goes to Florence, for the church of Sant' Egidio. After 1440-1450 Flemish oil paintings were particularly in demand: an interesting trade in them developed as a sideline to the regular trade in wool, manufactures and spices, which knew no frontier[1].

Account must also be taken of a third 'international set', which counted for a great deal in the spread of the fashions and forms of luxury—that of aristocratic and court

1. See Notes, p. 315.

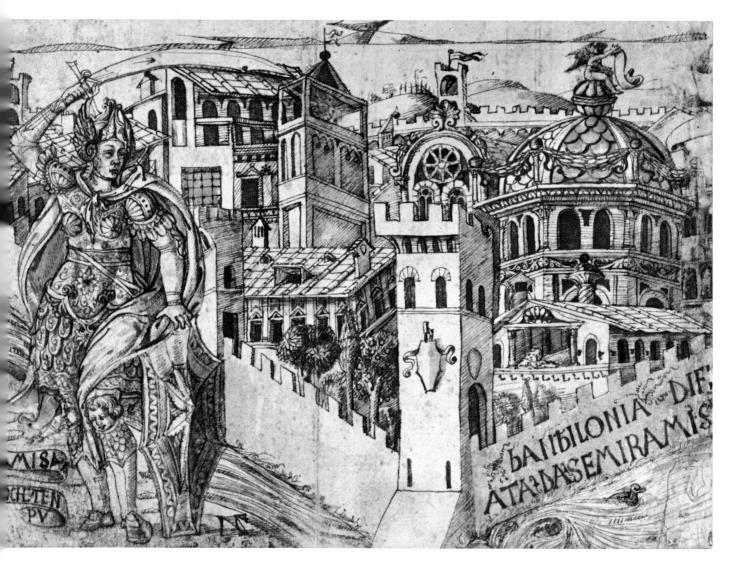

6 - MASO FINIGUERRA. FLORENTINE PICTURE-CHRONICLE. SEMIRAMIS AND THE CITY OF BABYLON — LONDON, BRITISH MUSEUM.

snobbery. The fifteenth century was deeply marked by the influence of Burgundian ostentation and fantasy. Even after the death of Charles the Bold (1477) and the partition of the Duchy (1482), the prestige of Burgundian fashions was lively in the Italian principalities of the feudal type, such as the Lombardy of the Sforzas, the Ferrara of the d'Estes and the Urbino of the Montefeltros, even in the Neapolitan kingdom of Ferdinand of Aragon. It was revealed particularly in the cult of elegant clothes, whose popularity is demonstrated around 1460 in the *Picture-Chronicle* of the Florentine Finiguerra; but it was also apparent in the public festivals, the triumphal entries, and other manifestations of the cult of chivalry.

7 - MASO FINIGUERRA. FLORENTINE PICTURE-CHRONICLE (DETAIL) — A PAGE — LONDON, BRITISH MUSEUM.

PARIS

8 - M. FINIGUERRA. PICTURE-CHRONICLE.

A general revival of courtly literature took place, culminating in the neo-Provençal lyric poetry of Bembo; the taste for the *chansons de geste* and for the *reali di Francia* was reinforced by Boiardo's *Orlando Innamorato* and Ariosto's unforgettable *Orlando Furioso*. These links with civilized centres beyond the Alps did not prevent the Latins from reacting sometimes with pointed malice against the people of the North, finding them rather comic, and growing more and more inclined to flatter themselves with the idea of their intellectual superiority. For another international network was beginning to harden—one in which the Italians were dominant. It was not that of the Curia, nor that of the business community, nor that of chivalry: it was what was soon to be called humanism—the world of sophisticated clerks, whose aspiration was to install at the heart of the Western world a new ruling power, that of culture.

It was in this field that, ever since Petrarch, the idea of an original quality peculiar to the peninsula had been formed—of an *Italianità* distinguishing it from the barbarians. But this idea had no political significance. The small divided world of Italy was fair game for European diplomacy[2]. The intervention of foreign armies in Italy began before 1494: there were the Catalonian battalions of Alfonso V of Aragon, the Swiss militiamen, always ready to descend from the Ticino, the French troops who marched on Genoa several times, not to mention the attempt on Naples by René of Anjou in 1458. The Peace of Lodi limited the obvious foreign interventions, but it amplified the play of political affinities: Alfonso had his connections with Spain, Sicily was Aragonese, Florence looked to France, and Milan was caught between the attraction of those two powers and the proximity of the Empire. It was not till the end of the century, after the shocks of the occupation, that the idea of 'the barbarians'—invaders to be driven out—became definite. But, all things considered, one of the beneficial elements in the Renaissance was, precisely, the division of Italy. Not only did this bring about a fertile competition between the centres of culture, but each of the neighbouring countries found in Italy some province with which it had a natural and close relationship, so that exchanges were always possible in both directions. The encouragement given by foreign powers to the diversity within Italy can, paradoxically, be considered a fortunate contribution of the barbarians to the Renaissance (Denys Hay). It was indispensable to the growth, and then to the triumph, of the new culture.

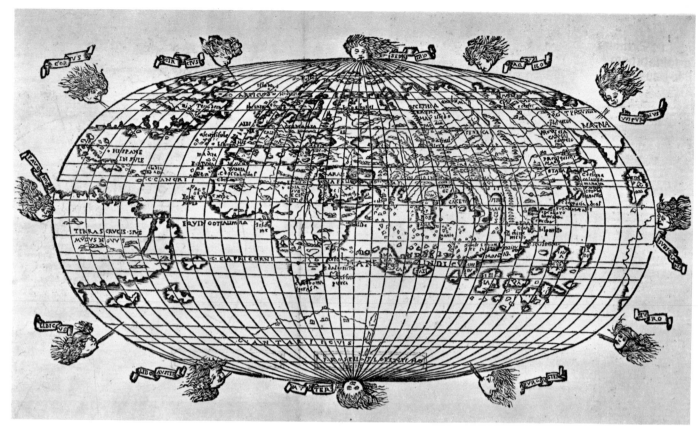

9 - AFTER F. ROSSELLI. PLANISPHERE — PARIS, BIBLIOTHÈQUE NATIONALE.

ITALY AND THE NEW WORLD

THE series of overseas discoveries from 1493 onwards had been prepared by the work of the cartographers and cosmographers, as well as by improved methods of navigation. These discoveries became probable, and the whole adventure became imperative, as soon as man's way of representing the earth suggested regions waiting to be explored and showed these in a framework of measured distances. In the second half of the fifteenth century, throughout Europe but especially in Italy, the image of the *sphaera terrae* stirred men's minds profoundly: princes and notables commissioned painters to produce maps of the world and, very soon, models of the globe. Maps were printed at Bologna from 1474 onwards, and the printed editions of Ptolemy made the *figura terrarum* the order of the day. Among revisions made at the time F. Berlinghieri's *Sette Giornate della Geografia*, with its detailed maps, shows how wide was the scope of geogra-

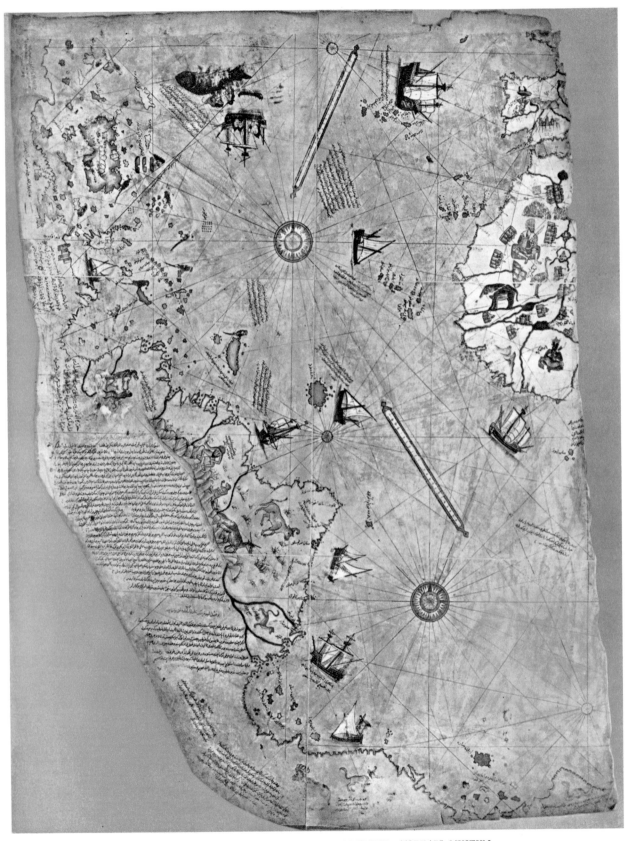

10 - TURKISH MAP OF THE ATLANTIC. COPY BY PIRI REIS — ISTANBUL, TOPKAPI MUSEUM.

10

phical work in Tuscany. Such facts make it easy to understand why, after exploring in 1499-1500 the north coast of Brazil and then in 1501-1502 the coast westwards to the Rio de la Plata, Amerigo Vespucci, the nephew of a canon of Santa Maria dei Fiori, dedicated his letter, *Mundus Novus*, to Lorenzo de' Medici, Duke of Urbino, the son of Piero: he was addressing himself to the quarter where the speculative implications of the discoveries could best be appreciated. It was only within a system of graphic representation that these discoveries took on their meaning: maps and diagrams that had illustrated the texts of Ptolemy had now to be recast in the light of the fresh observations of the voyagers. These were not only navigators, in correspondence with the shipping offices of Genoa or Naples: often they were also traders and diplomats, like Benedetto Dei, the Medicis' agent in Asia and in Africa, or Bartolomeo Marchionni, member of a family that was acknowledged by the rulers of Ethiopia. The exchanges of information on the size of the continents, on the distribution of the islands and seas by longitudes, etc., took place chiefly through Italy, where the need to map the globe with precision was strongly felt[3].

This interest in forming a picture of the world was shown even in popular publications. A certain Giuliano Dati, who specialized in pious pamphlets and in verses composed for the strolling street singers, wrote a *Lettera dell'isole che ha trovato nuovamente il re di Spagna*, which appeared as early as 1493; it used the discoveries of Columbus as the occasion for publishing two *cantari* on '*la gran magnificenza del prete Janni signore dell'India*', in which the mediaeval theme of the magnificence of the Indian monarchs is revived. The discoveries were all the more apt to rekindle the feeling for the marvellous since the explorers themselves were full of it: Columbus, writing from the Bahamas, used terms which had served, in the *Amadis*, to describe the isles of fairyland. In an atlas dating from 1513 Piri Reis, a Turkish cartographer, copied—or at least imitated—a lost map made by Columbus himself in 1498: in it he includes samples of the inhabitants, such as the unicorn, dog-headed men and men with heads growing below their shoulders, lending fresh authority to the monsters of imaginative geography. And indeed, as is well known, the age of the discoveries quickly gave the teratological forms of antiquity and of the Middle Ages a new lease of life in the books on natural history —chiefly, it is true, in France and in Germany. The main problem was considered to be that of the ratio between the waters and the land masses, and men were anxious

11 - TURKISH MAP (DETAIL) : MAN WITH HEAD BELOW HIS SHOULDERS.

12 A AND B - TURKISH MAP (DETAILS). UNICORN AND DOG-HEADED MAN.

to determine whether there was a kind of reservoir of water, the Mediterranean or, perhaps, a hanging sphere of water that fed the seas and rivers and might flood the world. For the discoveries also revived the feeling of uneasiness with regard to Nature and, in particular, the haunting thought of the Deluge.

Thus at the end of the fifteenth century men's consciousness of cosmic reality became keener, especially in Italy. Their image of the earth, modified by astounding news, led them to wider speculations, more or less closely linked with an expansion of the symbolic imagery and the themes of astrologers. In the new representations of the world, the distribution of the land masses over the globe was associated closely with the arrangement of the constellations and with the order of the elements, those key principles of the whole of physical reality. For instance, Goro Dati's short popular treatise, *La Sfera* (first edition, 1478), includes the super-human order and the sublunary order in one continuous account, representing them as a set of interlocking spheres; in all this there is little difference from the well-known models current in the thirteenth and fourteenth centuries.

In the years 1480-1490 cosmological speculation was intensified. There was, for instance, a revival of controversy about the southern hemisphere and the reality of the Antipodes. The inhabitants of these legendary islands are described in Pulci's comic poem, the *Morgante*.

The existence of an austral world was unquestioned by the followers of Dante's cosmography, knowledge of which was by this time widespread among ordinary people as well as among the learned and the artists. Yet there were also many who contested it: for instance, Giovanni Michele Alberto Canaro, in his manuscript *De constitutione mundi* (written before 1483), or again Antonio Ferrari il Galateo, whose *De situ terrarum* (*c.* 1500) connected the newly-discovered islands with the myth of Atlantis.

The revival of belief in the fabulous took place just when the old cosmographical models were being filled out with impressive concrete data, and nobody yet guessed that these were destined to condemn such beliefs for ever. The new awareness of the cosmos demanded a vocabulary of symbols which the growth of knowledge would later transform. In Italy the *imago mundi* was sedulously kept up to date. The unified theory of the cosmos was one of the original contributions of the new culture.

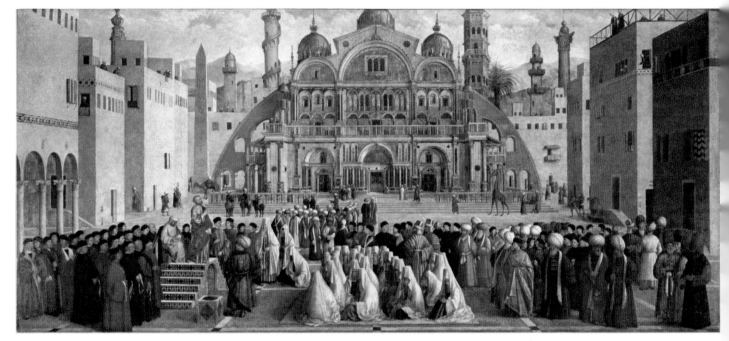

13 - GENTILE AND GIOVANNI BELLINI. ST MARK PREACHING AT ALEXANDRIA — MILAN, BRERA.

ITALY AND THE OTTOMAN EMPIRE

ADVENTURE lay to the west, tragedy to the east. The
Adriatic and Ionian side of the Christian world
was now, and for a long time to come, paralysed by the
Ottoman occupation of the Balkans and by the menace
that weighed heavily upon commerce in the eastern
Mediterranean. Genoa and Venice were evacuating their
outposts, one by one: their slow withdrawal—with the
encouragement it gave to rivalries between Christians
and to local intrigues—was to last for more than a century.
Euboea was abandoned in 1470. In 1489 Catherine Cor-
naro handed over the sovereignty of Cyprus to Venice,
which alone seemed capable of facing up to Turkish
pressure by using in turn negotiation, naval warfare and
trade. As in the time of St Louis and of Sigismond of
Hungary, there seemed to be some hope that a rival
power might take the Infidel in the rear: on one occasion
the Signoria negotiated an alliance with the Persian prince
Uzun Hasan, who presented to Venice a sumptuous cope

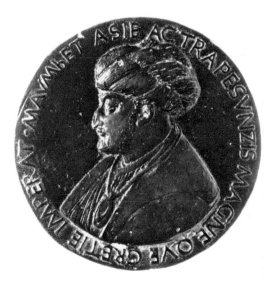

14 - BERTOLDO DI GIOVANNI. MAHOMET II.

(now in the Treasury of St Mark's); but as early as 1473 he was defeated. Under Mahomet II, the Conqueror (1451-1481) and his son Bajazet II (1481-1512), the Ottoman world achieved a long-lasting consolidation in face of a wavering and disunited West. The presence of this massive and apparently impregnable Empire even had the effect of dividing the western powers—first and foremost those of Italy—more than ever: from the end of the fifteenth century onwards, the threat of a pact with the Turk became one of the means of pressure used against a rival city; everyone, even the Holy See, was capable of recourse to it.

This became evident very quickly. The death of the defender of Albania, Giorgio Castriota (known as Scander-Beg) in 1468, the fall of Negropont in 1470, and in 1478 the capture of Scutari by the Turks, led Doge Giovanni Dario to seek through negotiation an ending of the war which had lasted since 1463. Peace was promulgated in Venice on St Mark's Day, 1479. Fifteen months later Ottoman forces landed at Otranto, took the town and massacred thousands of Christians with terrible cruelty: these horrors seem to have a connection with the new obsession of certain schools of painting, such as the Sienese, with the Martyrdom of the Holy Innocents. Not only the Aragonese, who were the victims of this formidable aggression, but other powers also accused Venice of having, with a policy of appeasement, steered the Turks against them. At the same moment Lorenzo de' Medici—being at odds with Rome and Naples after the affair of the Pazzi— was negotiating with the Sultan, and it was in 1480 (or 1481 at the latest) that a medal of glorification was engraved for Mahomet II by Bertoldo, sculptor to the Medici; many were inclined to see in this a somewhat scandalous encouragement of the Sultan's enterprises.

Relations with the Ottoman world—which now included eastern Europe and the eastern Mediterranean— shifted between several different positions. To the idea of the crusade, and to cultural and commercial competition, there was gradually added a feeling of curiosity: a certain exoticism began to emerge. The effect of these relations on men's ways of representing the world and history was too profound for us to pass over. The subjection of the eastern part of the Christian world to the hegemony of the Infidel could be put down, at first, to the obstinate refusal of the Greeks to reach agreement with the Latins; but the fall of Constantinople (1453)—and the profanations that accompanied it—inevitably resounded in the conscience of the West like some new Scourging of Christ.

15 - MATTEO DI GIOVANNI, MASSACRE OF THE INNOCENTS (DETAIL) — SIENA, SANT' AGOSTINO.

IL GRAN TVRCO

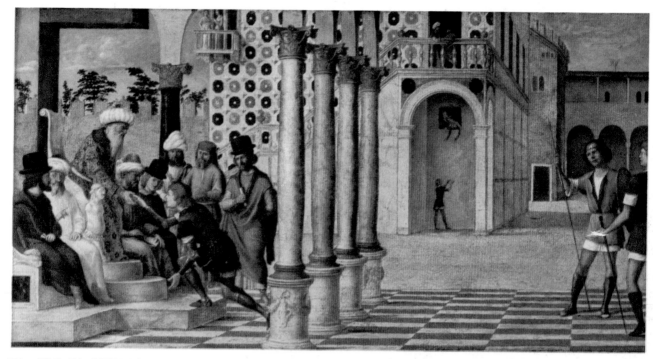

17 - CIMA DA CONEGLIANO. EMBASSY TO THE SULTAN — ZURICH, PRIVATE COLLECTION.

At the time of Pius II, while plans for a crusade were being developed, only to miscarry when the fleet he laboriously gathered was dispersed virtually while he lay on his death bed, the pictures of Christ's Passion took on an increasingly explicit oriental symbolism, and crusade themes were revived in painting. For instance, the old Franciscan legend of the 'wood of the Cross', which culminates in the reconquest of Jerusalem by Heraclius, was glorified in the choir frescoes of the church of San Francesco at Arezzo (completed in 1459); in the frescoes the Emperor Paleologus, with his typical head-dress *alla grecanica*, figures as Constantine.

Many Italians remained under the impression that a profound cleavage separated Greeks from Latins: they had had proof of it in 1438 and 1439, in the councils for the uniting of the Churches, which were held at Ferrara and at Florence and ended in failure. The Byzantines were led not merely by their long-standing and litigious dogmas, but by new developments in their philosophical thinking, especially by the neo-Platonism of the school of Mistra, to look on the thinkers and learned men of Italy with indulgent or ironical disdain. There was a clash, but also an attraction. Pletho was received with special honours at Rimini, and after him Bessarion made an indelible impression in Venice. It was in the image

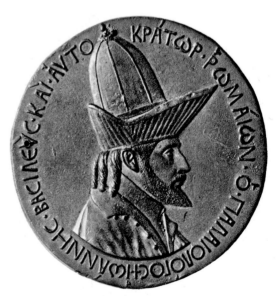

18 - PISANELLO. JOHN VIII PALEOLOGUS — LONDON, BRITISH MUSEUM.

16 - ANTONIO POLLAIUOLO (ATTR.). EL GRAN TURCO — LONDON, BRITISH MUSEUM.

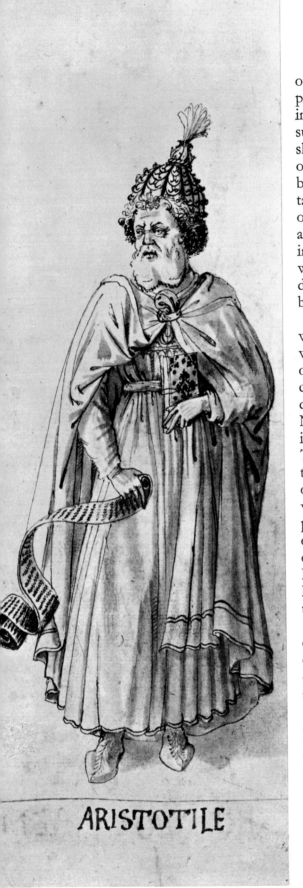

ARISTOTILE

of the great Byzantines that, for some time, Italian artists pictured the sages of antiquity, Aristotle and Plato, and indeed any figure symbolizing knowledge and its dignity; such images are frequent after about 1460. But, by a shift of imagination that is easy to follow, the wearers of turbans and of tall head-dresses and of long robes became gradually jumbled together, so that an orientalist exoticism, transcending the conflicts and dangers of contemporary history, took shape and invaded the art of Northern Italy in about 1490: to Carpaccio, for instance, the Jerusalem of St Stephen is a fabulous city with its streets full of orientals, among whom the distinction between Infidels and orthodox Christians is becoming more and more blurred.

This eastern world, which to Romans or Venetians was taking on a new solidity by the force of events, was distinguished by its fantastic buildings and luxurious ornamentation; in particular, it was the world of fine carpets and of silks. Never had these been so much in demand among the princes and prelates of the West. Never had the Italian painters taken so much interest in these cloths and furnishings. And in this field the Turks, having taken over the palaces and cities of Byzantium, were the more able to benefit from the prestige once possessed by the Greeks, since their own tastes were rather similar. Besides, the marketing of these products was on the whole improved by the powerful organization of the Ottoman Empire, which attracted observers. For example, the Florentine adventurer Benedetto Dei (1418-1492) made, between 1460 and 1470, long journeys as agent for the Signoria; these took him to Timbuktu, and then to the Levant; from Chios, in 1466, he sent a report to Lorenzo de' Medici. This mission of diplomatic and commercial liaison was no isolated case. The Sultans in turn took an interest in the West —at first in its technicians, but then also in its customs and culture. In a *Trattato dei costumi e vita dei Turchi* (1548) a Genoese, who at the beginning of the sixteenth century had spent five years in captivity at the court of Bajazet, reported that the Sultan understood a little Italian and liked Tuscan vivacity. His father, Mahomet II, had taken an interest in painting and had summoned Gentile Bellini to his court. Bajazet, in search of engineers, received a message from Leonardo, shortly after 1500, on the subject of the Ponte da Pera, and addressed a flattering invitation to Michelangelo through the Franciscans. These facts warn us against imagining too radical a separation between the two worlds.

19 - MASO FINIGUERRA. FLORENTINE PICTURE-CHRONICLE. ARISTOTLE — LONDON.

20 - VITTORE CARPACCIO. CONSECRATION OF ST STEPHEN (DETAIL) — BERLIN-DAHLEM, STAATLICHE MUSEEN.

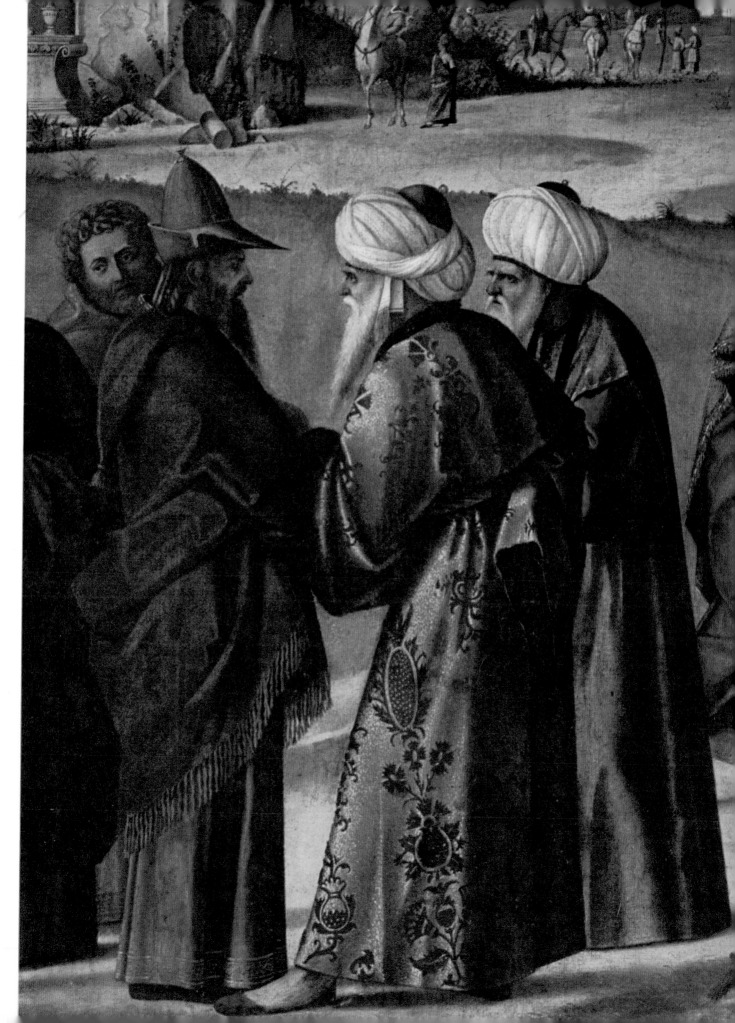

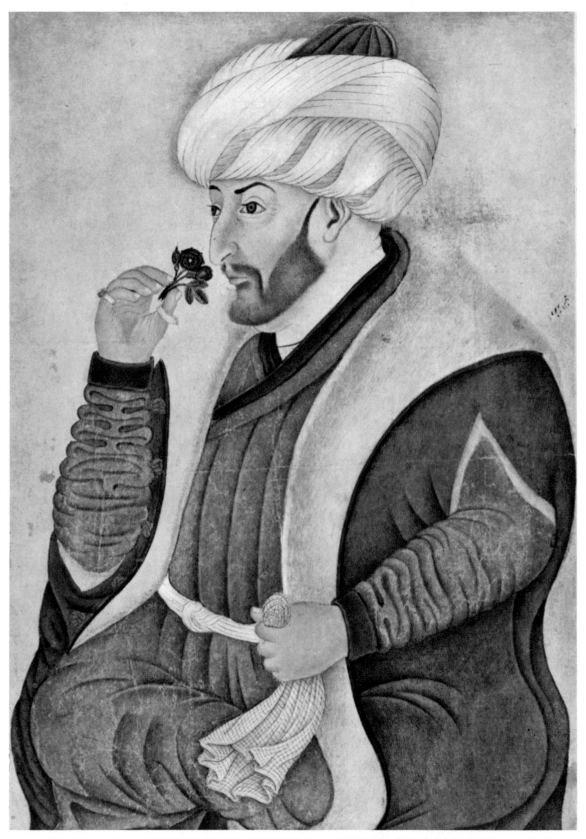

21 - PORTRAIT OF THE VICTORIOUS SULTAN MAHOMET II — ISTANBUL, TOPKAPI MUSEUM.

22 - GENTILE BELLINI. PORTRAIT OF MAHOMET II — BASLE, PRIVATE COLLECTION.

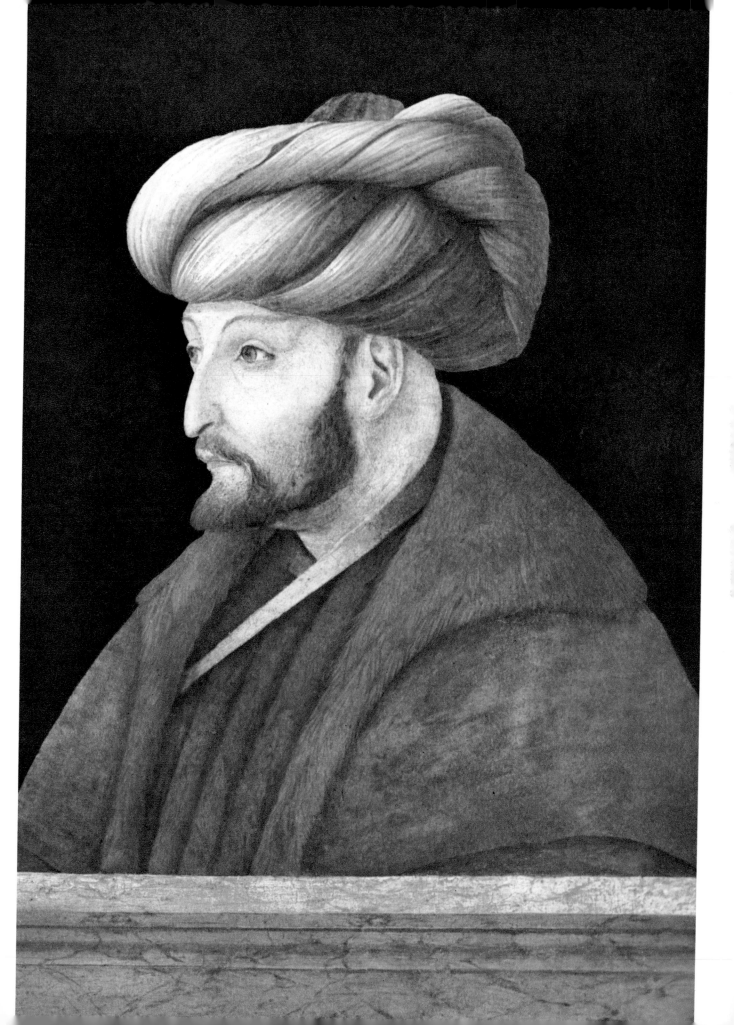

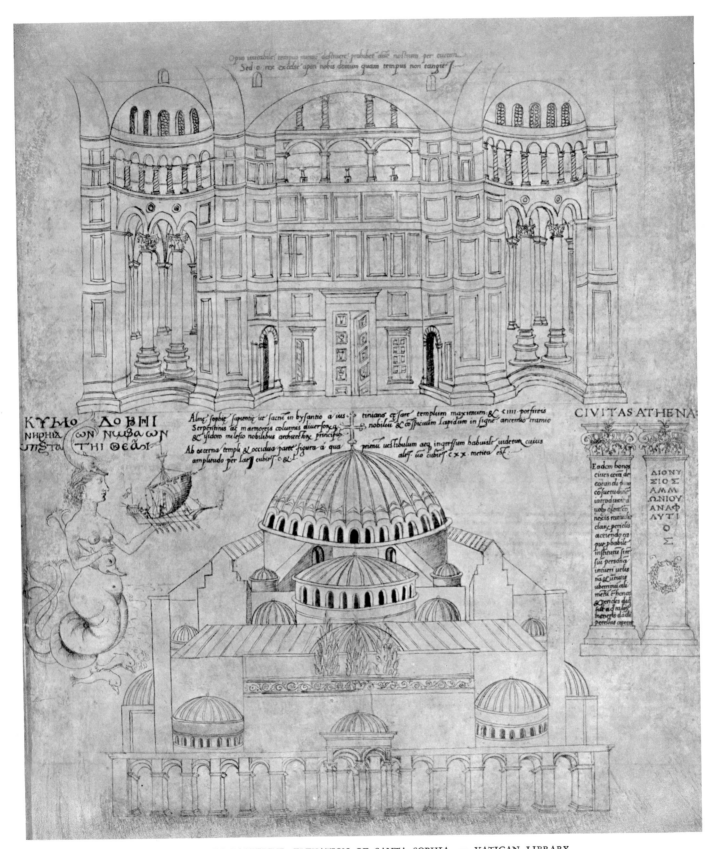

23 - GIULIANO DA SANGALLO. CODEX BARBERINI. ELEVATION OF SANTA SOPHIA — VATICAN LIBRARY.

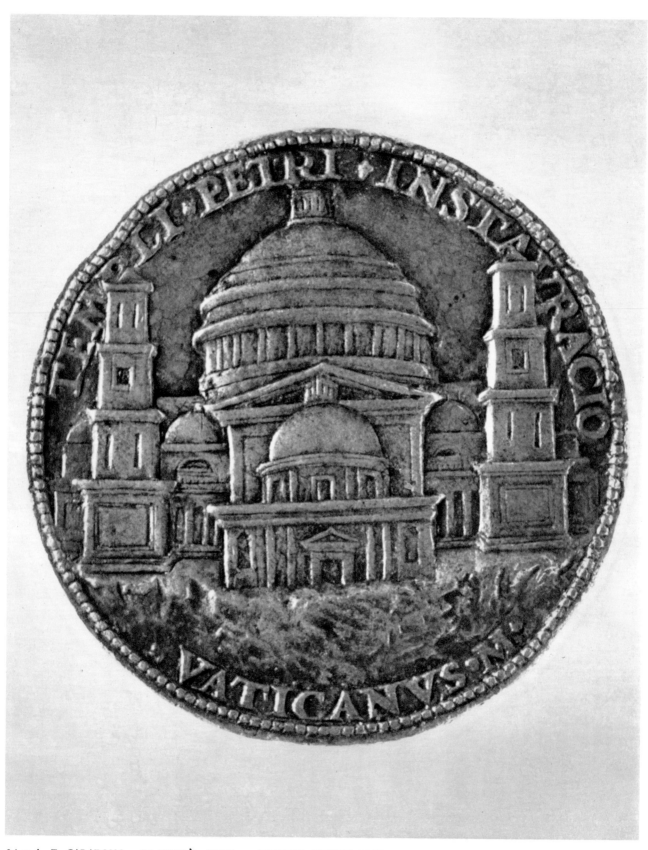

24 - A. F. CARADOSSO. ST PETER'S, ROME — LONDON, BRITISH MUSEUM, DREYFUS COLLECTION.

The embellishments of Byzantium, which had become Istanbul, are exactly contemporary with those of Rome: the mosque of Bayezid was rising at the same time as St Peter's, to bear witness to the unity between a faith and an authority. It may be correct, taking account of possible exchanges of information, to put the monumental development of Istanbul and that of Rome—with their common revival of the central ground-plan—together in one perspective[4].

In any case, never had the problem of the conversion of the Infidels—and of the Jews—been more frequently discussed than it was between 1460 and 1510. Eschatological beliefs tend naturally to revive in situations that are without issue. In 1459, in a letter which, though astonishing, is authentic and in conformity with the ecumenical spirit, Pope Pius II promised to recognize the conquest of eastern Europe by the Ottomans if the Sultan would be converted to Christianity and recognize the authority of the Church; and this was no masterpiece of Machiavellism, but a kind of appeal to the possibility of a miracle, an appeal often repeated by preachers and visionaries. Italy was full of these, from the friends of Ficino to those of Savonarola. Though the Turkish danger did not unite the Christian States, it rendered the division of the human race more evident and increased the desire for a universal coming together, which could be conceived only as a prophetic aspiration or as an episode pointing to the coming of the Apocalypse[5].

In short, geographical expansion was tending to awaken in Italy an awareness of the cosmos, both of its concrete configuration and of its symbolic grandeur; at the same time the shock to the Christian world in the East produced, at the end of the fifteenth century, a new and intense feeling that the times were critical. The loss of their central position through two different sets of causes merely made the Italians more apt to give their way of representing the physical world and contemporary history a quality of universality.

25 - VITTORE CARPACCIO. LEGEND OF ST URSULA (DETAIL) — VENICE, ACCADEMIA.

II

ITALY AND CULTURE

IT is possible to be at the same time cynical and superstitious, a pleasure seeker and a worrier. A banker in the Quattrocento was not content to endow monasteries and churches; he would build his tomb in one of them, being anxious to perpetuate his name on earth as well as to ensure his salvation in heaven. The cities themselves displayed the same mixture of greed and aspiration: glory became an obsession with societies as with individuals, and the idea of 'triumph' was common to both. And indeed, when people like the *Condottieri* (or mercenary captains) became heads of States, they were conditioned by their profession to seek renown and publicity, and gave a new style to politics, literature and art. The outward signs of glory invented in the ancient world were now regarded as both the evidence of greatness and the incentive to it. 'This,' says a letter drafted by Politian and sent by Lorenzo de' Medici to Frederick of Aragon in 1476, 'is why chariots and triumphal arches, marble trophies, sumptuously adorned theatres, statues, palms, crowns, funeral orations and a thousand other admirable distinctions were created.' In Italy ostentation became a passion for the spectacular, and found its way into architecture and ornamentation.

The old merchant cities like Venice or Florence, conscious of their historical significance, had always possessed the art of giving their renown an exalted expression: their monumental centres, constructed with much thought and sedulously kept up, were the public guarantees of their prestige. A number of other cities, following the example of Florence (where Lorenzo caused many commemorative plaques to be set up), began deliberately to uphold the reputation of their great men: Padua put up a statue to Virgil, Ravenna gave attention to the preservation of Dante's tomb, and in

26 - MANTEGNA. ST SEBASTIAN (DETAIL) — VIENNA.

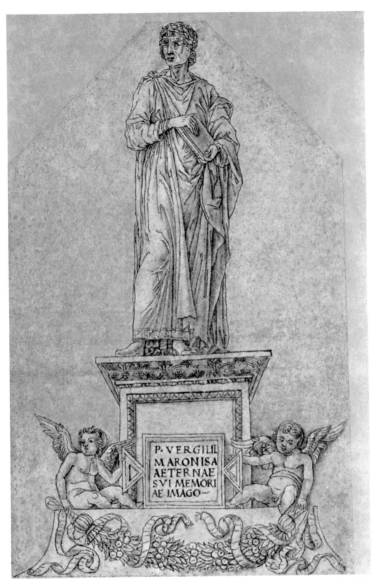

27 - SCHOOL OF MANTEGNA. MONUMENT TO VIRGIL — PARIS, LOUVRE.

Rome, under Sixtus IV, the Capitol was restored. The law of prestige caused an expansion of the public works designed to strike the imagination, in Venice, Milan and in Florence. But the latecomers were prone to indecision. In 1481 the Milanese church authorities began consultations about the *tiburio* of the cathedral, perhaps in the hope of completing the Gothic building with a 'modern' crown; and in 1490 a competition was opened for the design of the façade of the cathedral of Florence, but no decision was reached. In fact taste was changing, yet the completion of Gothic buildings was demanded by the concern for glorification, and this

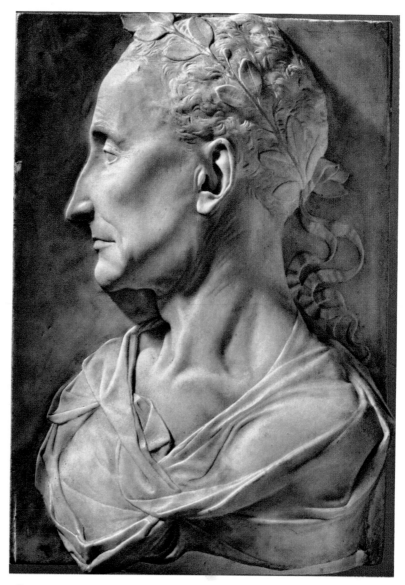

28- DESIDERIO DA SETTIGNANO. JULIUS CAESAR — PARIS, LOUVRE.

accounts for the impression, which the older cities make, of a lack of inspiration. The new ones were impelled to start projects which also, in many cases, were broken off: there was the temple of the Malatestas at Rimini, begun in 1447, interrupted in 1468; and then the palace of the Montefeltros at Urbino, which came to be described as 'a palace in the form of a city' and displays a formidable and uneven mass, full of careful ornamentation *all'antica*. The Ferrara of the d'Estes went further: it extended court dignity to include the city, by means of regular streets lined with remarkable buildings. The urgency of making an effect was felt on all sides.

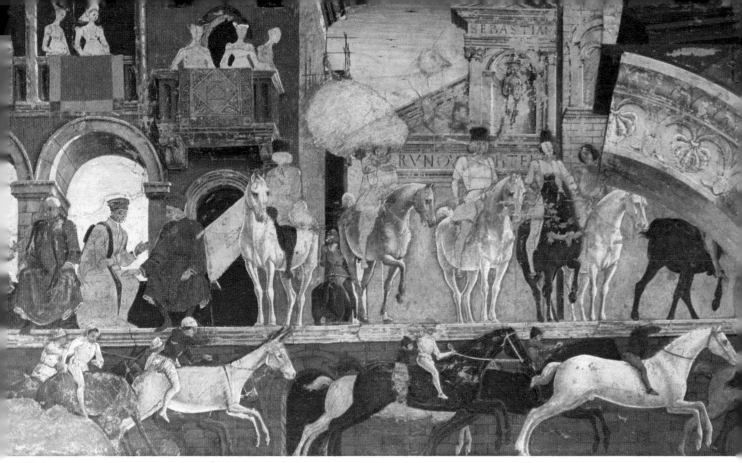

29 - FRANCESCO DEL COSSA. THE MONTH OF APRIL (DETAIL): THE PALIO — FERRARA, SCHIFANOIA PALACE.

Everywhere, as in the North, social life became
more and more dominated by periodical festivals. This
powerful collective ritual had become necessary to conso-
lidate the institutions of the State and to give them life.
Sometimes it was purely political, such as the triumphal
entries of princes and the celebration of princely mar-
riages; sometimes, strictly civic, such as the thanksgivings
and other important anniversaries; or religious, such as
the processions and games attached to the great liturgical
commemorations. In appearance all this was traditional,
but the emphasis was changing and each of these activities
was becoming more of a parade. Their style was modified:
the procession became the introduction to a 'show,'
which might be a tournament, a *rappresentazione*, a
mystery play or a series of tableaux. The transition from
one type of effect to another was smooth: in Florence
the mystery of the Annunciation, given on the 21st of
March (the first day of the year according to the local
calendar), had become, thanks to the *mise en scène*
by Brunelleschi, a spectacle that could be revived; it
was put on, for instance, in 1471 in honour of Galeazzo
Maria Visconti, and again on the 23rd of November 1494
in honour of Charles VIII; Cecca, an engineer-architect,

30 - R. DE MONOPOLI. NICOMACHEAN ETHICS — VIENNA.

was employed to repair and improve the machinery. In
contrast with the period that followed, the theatre still
had no separate existence: it took place in the street and
in the squares, which the spectacle itself transformed.
There was a close and constant connection between
parade, march past, procession with chariots—which
were a theatre on the move, in scenery through which
men moved—and the tournament, tableaux or *rappre-
sentazione*, held on stages or in an enclosure with arran-
gements for spectators. In Rome, plays adapted from
antiquity were sometimes produced in the *cortili* of
palaces; at Milan and Ferrara, in the rooms of the castle;
at Venice, in the precincts of a confraternity or monastery.

The Renaissance was an age of energy and passion,
not of discrimination. Its tensions were due to impatience
and curiosity, not to exclusions. Hence the popularity
of powerful symbolical manifestations, whose confused
character became evident only later. There is no more
typical example of this than the rage for astrology.
This was nothing new, but its popularity was brought
to new heights by books and pamphlets filled with
prognostications, whose success in Italy was not less
great than that of the 'computus' and the 'calendars'

31

31 - E. DEI ROBERTI AND F. DEL COSSA. THE MONTH OF AUGUST (1ST DECADE) — FERRARA, SCHIFANOIA PALACE.

32 - THE MONTH OF AUGUST (2ND DECADE).

33 - E. DEI ROBERTI AND F. DEL COSSA. THE MONTH OF AUGUST (3RD DECADE) — FERRARA.

in Northern Europe. Astrology noticeably gains strength after 1450-1460; the great cycle of the Months in the Schifanoia Palace gives it an unprecedented importance.

Outstanding mediaeval texts on the *Sphera* and on the principles for the reading of the heavens had become generally familiar: in 1478 came G. Dati's publication of his *Sfera volgare*, the 'heavens without tears.' Not only doctors and mathematicians, but humanists specializing in the texts of antiquity and able to translate Manilius or Macrobius, took an interest in astrology. In the work of Marsilio Ficino and his friends the reading of the stars was granted a ritual value and was associated with the most exalted speculations: it brought with it a whole conception of knowledge, based on the intuitive apprehension of mysteries and the decipherment of signs. This tendency seemed to Pico della Mirandola so dangerous that he opposed it and vindicated the scientific study of the heavens in a famous essay, his *Disputationes adversus astrologiam divinatricem* (1493), which Savonarola did not disdain to have published in 1498. Thus a philosophical controversy about the validity of astrology marked the climax of its influence at the end of the fifteenth century.

Astrology made itself felt as a practice, as a body of knowledge and as a system of symbols. The first of these aspects answered to a general need: astrology was involved in all sorts of calculations concerning marriages, wars, business deals, the founding of palaces or churches, etc.; sometimes it brought fear and sometimes consolation in difficult situations. In 1509, for instance, Pellegrino Prisciano advised Isabella d'Este to use a precisely worked-out astrological prayer to obtain the liberation of the Duke from prison. Horoscopes were always taken seriously and in some buildings they were painted on the ceilings; the figures of the planets played an appreciable part in the communal shows and, since they fitted in with the mythological tradition, they contributed to the intermingling of this tradition with the general culture. Astronomy was regarded as the key to universal knowledge, insofar as nature is dominated by mathematical order, but at the same time the figures of the ancient gods, such as Venus, Mars and Jupiter, and of the heroes, such as Hercules and Orpheus, were considered as representing the very forces of nature and so constituted an inexhaustibly rich range of symbolism. This gave them entry everywhere. In the second half of the fifteenth century the invasion by the gods and heroes became general: it was far less accidental than is often thought.

From the 'scientific' description of the world and

34 - AGOSTINO DI DUCCIO (ATTR.) THE GOD MARS — RIMINI, TEMPIO MALATESTIANO.

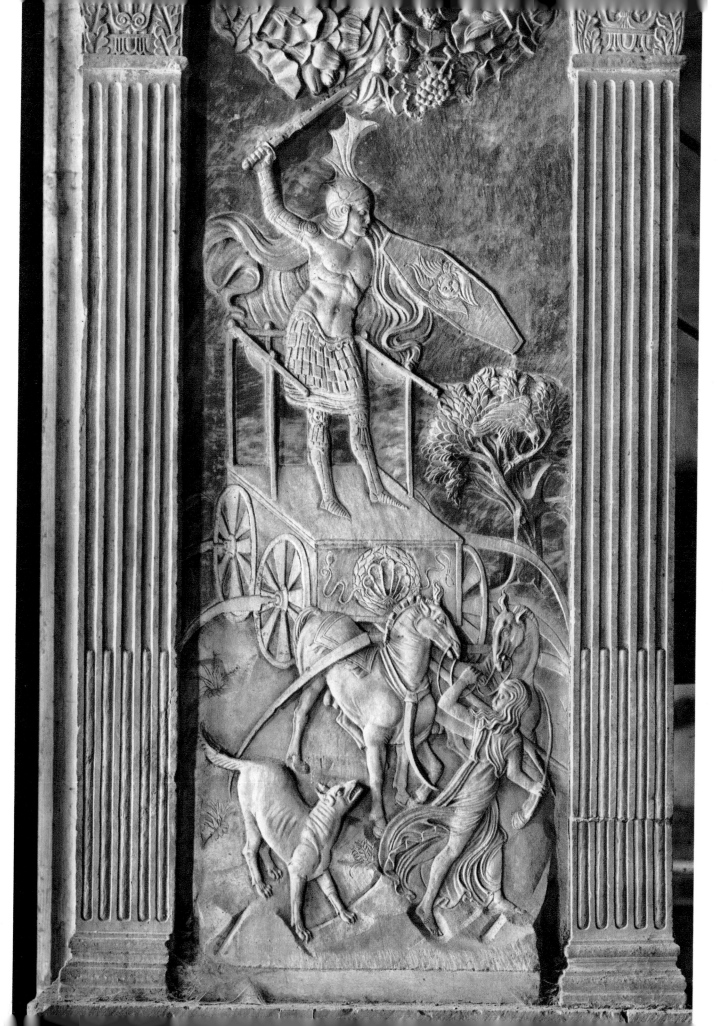

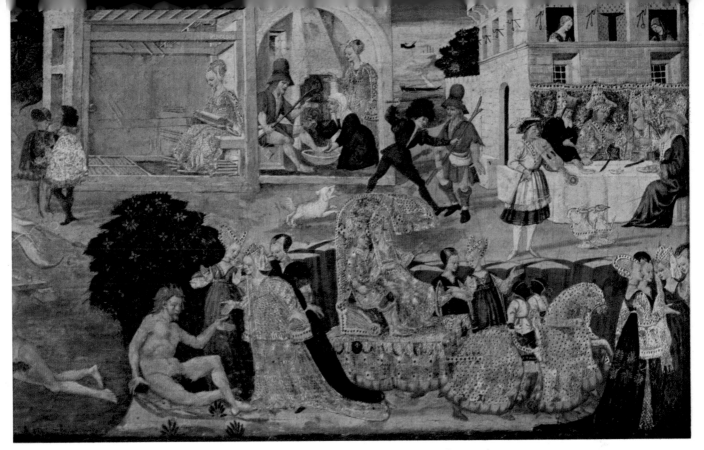

35 - APOLLONIO DI GIOVANNI. CASSONE PANEL. SCENES FROM THE ODYSSEY (DETAIL) — CHICAGO, ART INSTITUTE.

the mathematical 'sphere' the transition was easily made to astrological consultations putting this knowledge into practice; also, the imagery of the ancient world, now being reconstituted with untiring curiosity, came to be regarded as something quite different from a historical spectacle —as a kind of human 'cosmos,' a summation of civilization, the intuitive understanding of which had become, as it were, the guarantee of all that was active in cultural life. It was part of the intellectual equipment of the 'moderns' —that is to say, the humanists—that to sing the praises of the present time should involve glorifying, more or less conventionally, the achievements of art: it became commonplace to stress the parallelism of the arts and letters, as Aeneas Sylvius did in 1451 in his well known epistle, *Dum viguit eloquentia, viguit pictura*. As they were tirelessly repeated, these declarations have been taken as mere rhetoric; but they should be taken seriously, for it is through them that the generations living at the end of the Quattrocento attempted to formulate what they believed in and what they were trying to do. They reflect the need to assert with fresh vigour the universality of human power (avoiding any too sharp distinction between the ancient world and that of the present) and the reality of progress (allowing men to enjoy the advantages of both). So there

38

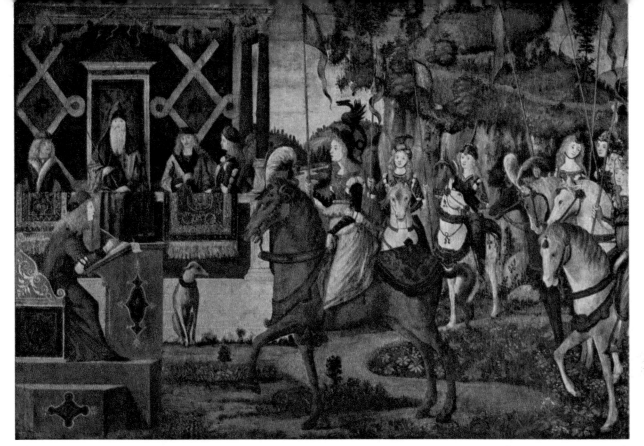

36 - VITTORE CARPACCIO. THE EMBASSY OF THE AMAZONS TO THESEUS — PARIS, MUSÉE JACQUEMART-ANDRÉ.

took shape a new anthropology with a metaphysical basis, and a new articulation of history; the agreement between these seemed to supply the framework for a way of thinking which was the first to associate art closely with its two-fold view of the whole. The result was a great feeling of expectation. The more one explores the second half of the Quattrocento, the more one is struck by the sincerity of the striving towards a transformation of society, including the Church, and this went far beyond immediat problems. The idea of *renovatio* took its place in the series of great fictions of the West. The imaginative vigour that had characterized the epic, mystical and speculative Middle Ages had not disappeared, but its rhythm was changing. 'Visions', fantastic anticipations of the future, and attempts at picturing the globe, were more numerous than ever. And humanism itself more and more took the task of spelling out Reform programmes. Around the middle of the century the expectation of the Golden Age makes its appearance as frequently as the fear of catastrophes, at the end of the century—and, during the sixteenth century, the nostalgia for vanished 'good old times.' Thus the new culture faithfully matched the trends and impulses of collective consciousness; but its imagery had the advantage of a powerful framework supplied by humanism.

39

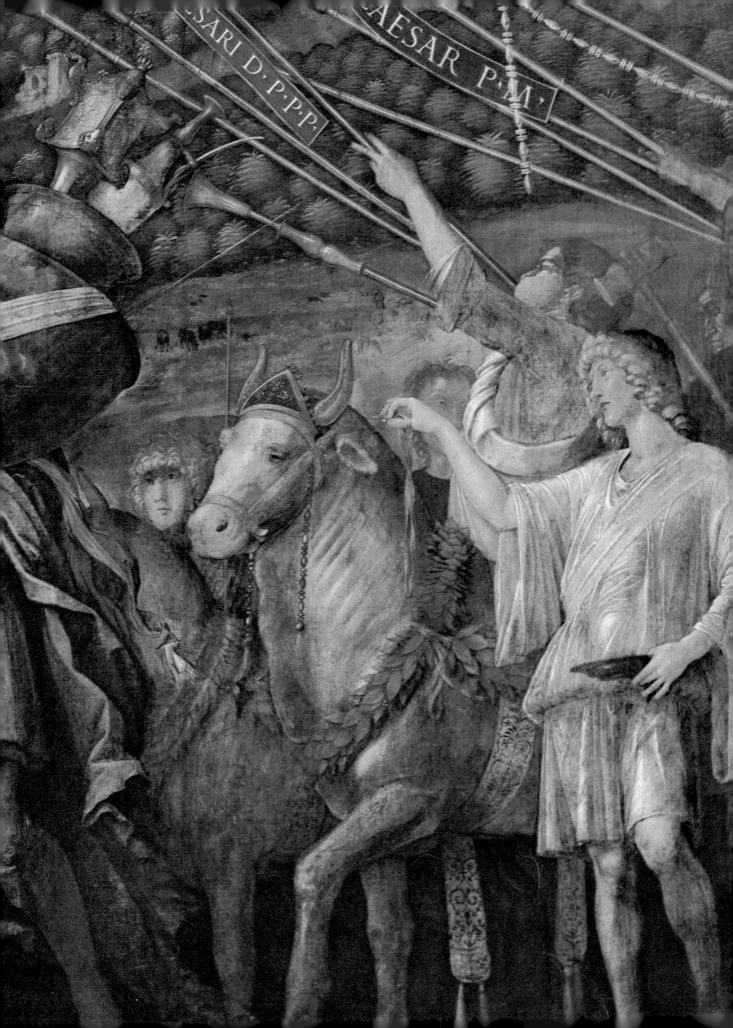

THE THREE HUMANISMS

SEVERAL aspects of the humanist movement need to be distinguished and localized. There was the epigraphical and archaeological humanism, with its principal centre in the North, at Padua; there was the philological and philosophical humanism, which developed in Florence; and the mathematical humanism, most brilliantly represented at Urbino. The last of these was most closely bound up with the arts. The second appeared to keep at the greatest distance from them by virtue of its abstruse speculations and its literary connections, but there nonetheless emerged from it ideas that proved fascinating to the more sophisticated artists, and a kind of climate of aestheticism. But the type of humanism which exercized the greatest influence on the imagination and repertory of artists was the first. It is through these three modalities of humanism that we can come to understand how closely the visual arts shared in the new formulation of culture: no conclusion can be reached without their aid.

There is a strange document—still worth attention—which shows the connection between the visual artists and the 'antiquaries' of Northern Italy. Its title is *Jubilatio*, and it is the account, by the epigraphist and archaeologist Felice Feliciano, of a walk by Lake Garda, in which Marcanova and Mantegna, and Feliciano himself took part, '*sub imperio faceti viri Samuelis de Tridate.*' This little expedition has about it an atmosphere of truancy and dressing-up, of joy and even of deep emotion. The friends took a boat ride on the lake, wore crowns of flowers, sang, gathered inscriptions, invoked the memory of Marcus Aurelius, and visited the Temple of the Blessed Virgin at Garda—where they addressed

37 - A. MANTEGNA. THE TRIUMPH OF CAESAR (DETAIL) — HAMPTON COURT, ROYAL COLLECTION.

41

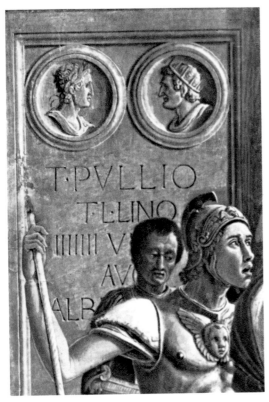

38 - MANTEGNA. JUDGEMENT OF ST JAMES (DETAIL) — PADUA, EREMITANI.

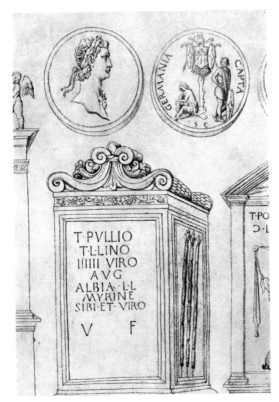

39 - JACOPO BELLINI. ROMAN EPIGRAPH — PARIS, LOUVRE.

prayers and thanksgivings to the 'sovereign Thunderer and His glorious Mother.' This was in October 1464 —if the account is to be taken literally as preserving the memory of an actual excursion, a forerunner of those in which the young members of the Pléiade delighted. Mantegna was then at the height of his glory, in Mantua. His companions were men of learning and talent: Marcanova in particular was well-known for his collections of inscriptions, such as the one that was to be compiled in 1465 and edited by Felice Feliciano himself. In it we find Rome with its great names and monuments, viewed in a somewhat fantastic light and mingled with the remains of ancient Verona, Mantua and Padua, with outlines of statues, notes on marble fragments, epigrams and emblems —antiquity seen from the Patavian point of view. For all this stems from Padua: the book begins by mentioning the epitaph of Gattamelata and makes much of *Patavium regium*, the ideal palace of the author's dreams. We are here at the heart of a strong tradition of archaeological humanism, which derived from Cyriacus of Ancona and leads to the most important of the archaeologist-epigraphists, to Fra Giocondo da Verona, engineer, *pontifex* and architect, the key personality of that region at the end of the century.

The painter drew and emphasized what the archaeologist pointed out to him. The exchange of services is clear. A single example will show how far this went: in the fresco of the *Judgment of St James* (1454) in the Eremitani a conspicuous inscription—T. PVLLIO T.L. LINO—turns out to be a copy of a Roman inscription which Marcanova said he had seen at Monte Buso. Since the same inscription was used, independently of Mantegna, by Jacopo Bellini in one of his architectural drawings, it is clear that the documentation was passed from hand to hand. A slight error in transcription (Mantegna has written III IIII v[iri], *septemviri*, instead of *severi*) shows that these are not altogether archaeological abstracts, but rather 'motifs,' elements that are both significant and plastic. There is a preference for exploiting a fragment or inscription found in the province. This was the source of what became an imposing fashion: Mantegna started it, but it was continued far beyond the Mantua-Venice-Padua triangle.

Venice, towards the end of the century, attracted publications on pure archaeology, such as the *De amplitudine de vastatione et de instauratione urbis Ravennae* by D. Spreti (1489). The name of Jacopo Bellini is worth mentioning in this connection: it is enough to remember those

42

40 - JACOPO BELLINI. STUDY IN PERSPECTIVE — LOUVRE.

extraordinary documents, his great studies of perspective
and architecture, to see the source—as early as 1450-
1460—of that stream which would triumph in the great
Aldine publications, and have its crowning glory in the
Hypnerotomachia Polyphili (1499). The enthusiasm that
fills this laborious and obscure masterpiece derives from the
Jubilatio of Felice Feliciano, yet must be seen also as the
culmination of a certain school of humanism and of a
certain kind of taste which had not, as yet, their equivalent
anywhere.

It is true that Rome, meanwhile, had again become a
centre of study. Flavio Biondo's book, *Roma instaurata*
(finished in 1446), had had an effect; but when, in 1471,
Alberti took Donato Acciaiuoli, Giovanni Rucellai and
Lorenzo the Magnificent round the ruins of Rome, what
they mainly saw was how much would have to be done if

43

41 - HYPNEROTOMACHIA. TRIUMPH — PARIS, BIBLIOTHÈQUE NATIONALE.

so many scattered fragments were to be drawn and interpreted. And it is still a fantastic impression of Rome that the anonymous author of the *Antiquarie prospettiche romane* (a small compilation dating from the end of the century) seems to be trying to create. In the fifteenth century Rome was not yet the great centre of antiquarianism and of the trade in antiques (genuine or imitations); nor was Florence, nor was Milan. It was more in Padua and Venice that—as already in the Trecento—samples of *Kleinkunst* 'in the ancient style' were to be found: they were becoming more and more fashionable, with repercussions both on collecting and on neo-classical imitation. It was from Venice that Cardinal Pietro Barbo, when he became Pope Paul II, brought his famous series of Roman medals. And Boldi, another Venetian, was one of the first to delight in supplying his own medals with learned inscriptions imitated from antiquity. The small plaque, the medal and the statuette were to dominate taste in the north of Italy for a long time: through them, that taste was to leave a pronounced mark on the Renaissance.

The Florentine innovators had proclaimed with assurance, as a profession of faith, that the visual arts

44

42 - HYPNEROTOMACHIA. TRIUMPH — PARIS, BIBLIOTHÈQUE NATIONALE.

must be closely related to the *ordo mathematicus*. The idea made its way slowly—with Alberti, for instance, at the very beginning of his *De pictura* (1435), and with Brunelleschi; it took on its full meaning only when mathematical knowledge itself was set apart as a privileged discipline and began to detach itself from the traditional body of the 'liberal arts'. The translators of Plato, particularly in their commentaries on the *Timaeus*, produced attractive arguments in support of this 'intellectual' conception of art. In his commentary on the *Philebus*, Marsilio Ficino says: 'The sciences that operate manually are called arts; these owe their penetration and perfection chiefly to the mathematical faculty, that is to say to the particularly "mercurial" and rational ability to count, measure and weigh.' This faculty is regarded as rescuing the arts from uncertainty and from the merely approximate, as can be seen clearly in the case of architecture. What makes propositions of this kind interesting is that they show how one type of speculative humanism helped to steer the plastic arts in the direction of an 'absolute' conception, made explicit through mathematics.

In 1482 the Latin edition of Euclid appeared, in 1484 Ficino's Latin translation of Plato, in 1485 Alberti's

C III.

VCOCEDRON · ABSCISVS
VACVVS.

De re aedificatoria (published posthumously), and in 1486 the first edition of Vitruvius by Sulpitius. All this was done in Rome and in Florence. In 1492 the *editio princeps* of Boethius, whose *De musica* was of fundamental importance, appeared in Venice. So there was a fairly general interest in the mathematical classics among learned circles in Italy: the desire to extract from them principles that would prove useful became an obsession, and desperate efforts were made to bring Plato, Vitruvius, and factual evidence into harmony.

In about 1480 a painter who, because of old age, could no longer practise his art, was writing, at the request of Federigo da Montefeltro, a treatise in three books, *De prospettiva pingendi*, 'the optics of painting,' which presents a series of remarkably lucid and abstract geometrical propositions and figures. This was Piero della Francesca, a member of the Urbino circle—where, in about 1465 if not earlier, he had met Alberti. His book gives us a clear idea of the state of theoretical knowledge in this field. A little later he wrote a treatise *De corporibus regularibus*—on the five basic volumes—which was published some time later by Fra Luca Pacioli following Pacioli's own treatise *De divina proportione* (finished in 1497 at Milan and published in 1509 at Venice) without mention of its author: this behaviour provoked, in due course, a violent denunciation from Vasari; but elsewhere Pacioli did render homage to Piero in no uncertain terms as the supreme prince of painting. Pacioli, it seems, came to Urbino only in 1489—after the death of Federigo—to give lectures on mathematics; it must have been then that he received Piero's book. The most important of the mathematicians who visited Urbino was certainly Paul of Middelburg, a Dutch priest who became physician to Guidobaldo; in 1484 he had published at Antwerp his *Pronostica ad viginti annos duratura*, which had made a sensation. Pacioli treated him with reverence, and it was to him that Ficino, in 1492, addressed the famous letter in which he sings the praises of Florence, city of the Golden Age. It has been suggested that Paul of Middelburg was the model for the portrait of the lecturer speaking before the Duke and his court in an architectural setting of a decidedly 'urbinesque' purity

43 - L. DA VINCI. SEMI-REGULAR POLYHEDRON —
MILAN, BIBLIOTECA AMBROSIANA.

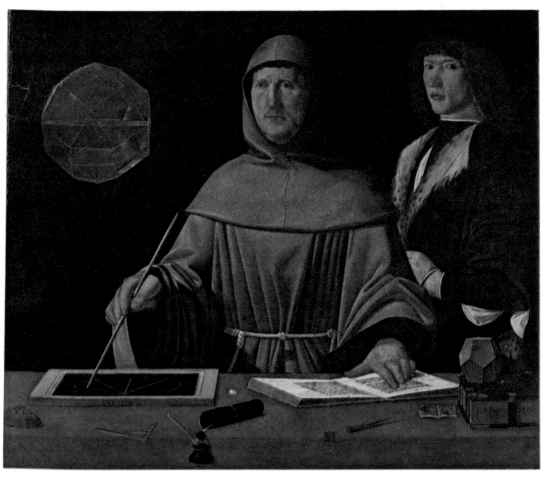

45 - JACO BAR. PORTRAIT OF LUCA PACIOLI — NAPLES, MUSEO E GALLERIE DI CAPODIMONTE.

indeed he is a perfect representative of the situation of thought in the Quattrocento, in which practise and theory jostle without precise mutual adjustment. The tendency of the 'speculatives'—of Alberti or Filarete as well as Pacioli—is to speak by anticipation, so that they create the illusion that the practitioners followed their maxims. But in the studios and workshops these scruples were not all observed: even in the case of perspective, it is reasonable to suppose that Alberti's unitary construction was not followed everywhere.

Pacioli stated, in the letter-preface to his *Summa*, that the greatest artists of his time were dependent on mathematical humanism; this way of relating visual art to general culture seems to reflect perfectly the ideas of the Urbino group. In his list of approved artists we find Bellini, Mantegna, Melozzo, Luca da Cortona, Perugino, Botticelli, Filippino Lippi and Domenico Ghirlandaio, 'who with rule and compass give their works a propor-

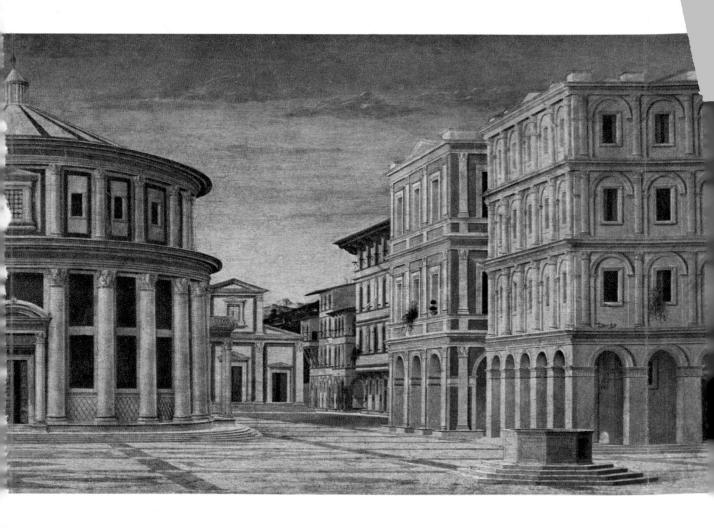

and decorators, the secret of the harmonic forms. On a slightly closer examination, the content of the two treatises turns out to be less surprising and less explicit than Pacioli claims: his facility as a compiler was heightened by a touch of charlatanism. Along with a somewhat confused symbolism of numbers (6, honoured in Genesis, and 5, exalted by Plato, are set up as the keys of the system), the *Summa* contains applications to commerce, to money, to weights and measures and, more vaguely, some reflections on the universal value of proportions. The *Divina proportione* opens, similarly, with a sensational flourish, and goes on to present a rather commonplace programme of mathematical formulae wrapped up in philosophical definitions; it concludes with some maxims for stone masons and decorators. In fact, Pacioli's recourse to the most lofty philosophical references covers no more than a series of practical indications, devoid of deduction or logical sequence. But his case is no isolated one:

48

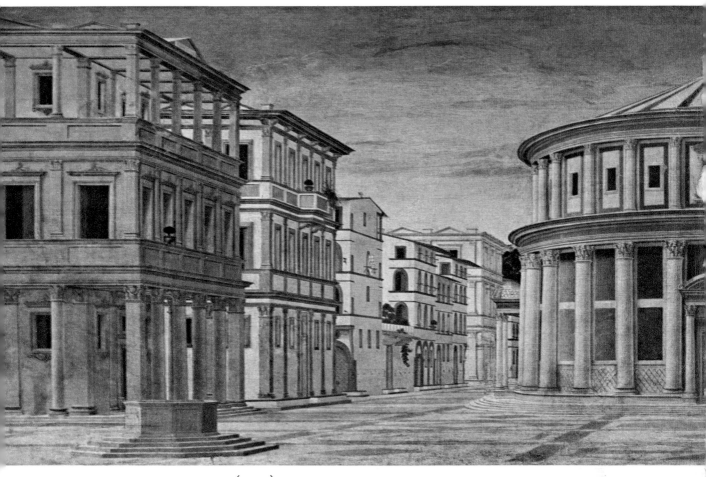

44 - FRANCESCO DI GIORGIO (ATTR.). IDEAL CITY — URBINO, NATIONAL GALLERY OF THE MARCHES.

(the picture is in the Royal Collection, Windsor Castle and dates from about 1480).

Luca Pacioli (1445-1514) is certainly the most famous representative of the new scientific culture. His wandering career took him to Perugia, Urbino, Florence, Venice, Milan and Rome, and acted as a bond between the most active circles; he taught in the monasteries, in the universities and in the courts. A compatriot of Piero della Francesca and clearly in close touch with him, he also attracted the attention of Leonardo in Milan. He showed his interest in the arts and his desire to perfect their mathematical basis in his two principal works, the *Summa de arithmetica, geometria, proportione e proportionalitate* (Venice, 1494) and *De divina proportione* (Venice, 1509). The first of these is a résumé of his lectures, while the second, the *De divina proportione*, was largely the result of the discussions in Milan in 1497 or 1498, in which Leonardo took part; its express aim was to reveal to architects, sculptors

47

tion that endows them with an admirable perfection.' This statement surely goes beyond the simple expression of admiration. A superb picture, contemporary with the *Summa*, represents Pacioli as teacher of geometry, with a young man at his side who is usually identified as Guidobaldo. The picture, which is in the Naples Museum, bears the inscription IACO BAR Vigen/nis 1495 p(inxit); on the basis of this it was at one time attributed to Jacopo da Barbari, but this attribution is now abandoned in favour of a painter from the Marches who was strongly influenced by Piero and Bellini. It is, in any case, the perfect image of the mathematical humanism then practised at Urbino and of its glamour: the Franciscan with his oval face and the folds of his habit seems himself a geometrical volume; his table—that of a scientific conjurer—has a green cloth, on which lies an open book; the teacher's hand, pointing to a passage in it, is not far from another book, closed and held down by a brilliantly painted dodecahedron; this book has, written on the edge of its pages, the letters LI. R. LUC. BUR *(Liber reverendi Lucae Burgensis;* on the slate there is a figure demonstrating how to inscribe an equilateral triangle in a circle; and above it there hangs a crystal icosahexahedron—the volume with twenty-six facets described in chapter 53 of the *De divina proportione)*[6].

Humanism, whether archaeological or mathematical, once more tended to give culture and taste a Mediterranean flavour. The fine lapidary inscriptions now so eagerly reproduced by the frontispieces of the manuscripts, the triumphal arches and the porticoes, with the solemn proportions that had taken hold of men's imaginations —these must live again because they ought never to have died. In this way humanism intervened as a stimulant to creation. It was not retrospective. Its aims were practical. And Alberti defined very well what he expected of an architect: 'In the study of his art I would have him follow the example of those who apply themselves to letters. For no one considers himself sufficiently instructed in any science if he has not read and studied all the others... So by a continuous study of the best creations... he can exercise and sharpen his own invention...' (*De re aedificatoria*, IX, 10). The Florentines wished to have the formidable support of an ancient Italian culture now recovered, in order to face up to the modern tasks of which they had a more precise awareness than anyone. This gave rise to the methodical publications and critical studies carried out within the Accademia at Careggi, which were paralleled by the efforts of Giuliano da Sangallo to

establish a kind of corpus of architecture in his monumental *Libro*; but it also led to the revolutionary application of all these resources to literature in the vulgar tongue—in the shape of the masterpieces of Politian, the *Stanze* and the *Orfeo*, and to philosophy—in the shape of Ficino's *Theologia platonica* (already written in 1474 and published in 1482) and of Pico's *Oratio de hominis dignitate* (1496), to mention only the best known. In a few years the whole tone of literature and culture was modifed. The compositions of Politian bring together in a curious way the *all'antica* style and the courtly tradition—the comparison with Botticelli's *Primavera* is irresistible. Characters borrowing their language from Ovid or Virgil are engaged in adventures unknown to antiquity; and, inversely, the speeches of Orpheus take on the rhythm of a Tuscan lyric.

In philosophy the apparatus of scholasticism was still used for the purpose of demonstration; but it was now invaded by Platonic formulae, references to the ancient gods and quotations from the poets. The ancient world lay beyond history. The literary and philosophical humanism of the Florentines was led to a precocious awareness of the paradoxical quality of the period. In the mind of a Politian the permanent part of the ancient heritage was essentially poetry, in that of a Ficino a philosophical arcanum. 'In the second half of the fifteenth century, Hermes was the fashion' (E. Garin). It was this supra-historical viewpoint—the viewpoint of a universal doctrine and symbolism—that imposed order on that crushing accumulation of texts and ideas to which the humanists proceeded. Poetry, theology and mythology pointed to one and the same end. And no one who was not carried away by a certain enthusiasm could see this at all. The man of superior quality, the ideal man, was a magus, sensitive to the degrees of being. Nature was looked on as a concert, a 'demonic' edifice, tending towards an invisible harmony, and accomplishing itself through the intervention of man, who deciphered and proclaimed it. The success of this doctrine was immense, both in Italy and in the whole of the West. It is all the more necessary to replace it within the horizon of the Quattrocento, since it helps us to understand the mood of veneration in which men considered both the mother-forms, or mathematical principles, and the symbols of religion. It also enables us to gauge the breadth of the ambitions of that period,—the kind of great gulf, or wide intellectual difference, produced by the new knowledge of the ancient world, in which for the first

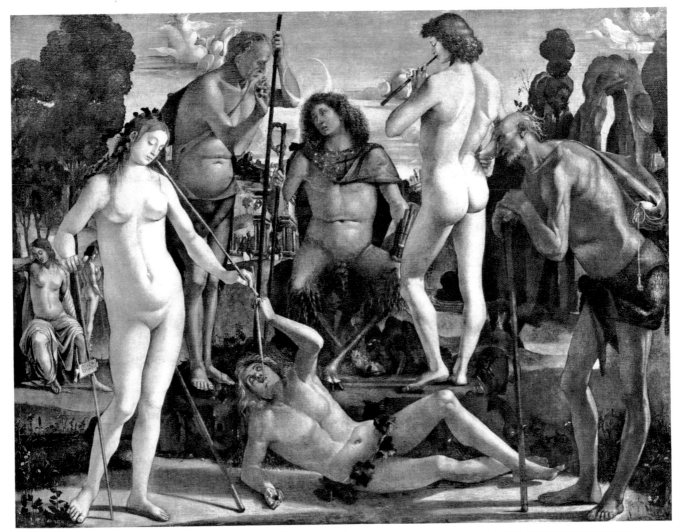

46 - LUCA SIGNORELLI. THE TRIUMPH OF PAN (DESTROYED) — FORMERLY IN BERLIN, KAISER FRIEDRICH MUSEUM.

time symbolical thinking was allowed as great an intensity as the historical vision.

Archaeology, science and doctrine were all present, demanding fresh means of expression. The result was a remarkable development of the preoccupation with symbols. This soon left its mark on architecture, now searching after new forms. At the same time men's image of man and nature was being changed by the rapid progress of naturalism: it became one of the tasks of the studios and workshops to supply a version of the traditional themes that would be modern, articulated, complex and supported by living and convincing details. Artists had acquired such assurance that they soon returned of their own free will to the hieratic themes, disengaging, for instance, the *Holy Face* of the icons from its inert

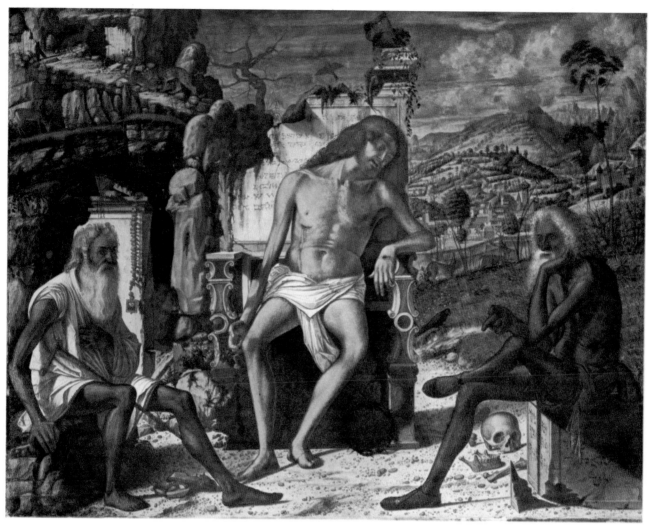

47 - VITTORE CARPACCIO. MEDITATION ON THE DEAD CHRIST — NEW YORK, METROPOLITAN MUSEUM.

form: one may observe, round about 1480-1490, many variations on this devotional theme, to which the Flemish painters also restored all its old interest, and in which the fascination of the frontal image makes itself clearly felt. Similarly, the Entombment was re-interpreted, being either amplified to a great dramatic scheme or concentrated into a formula of presentation (following Donatello, the Paduan artists gave currency to the theme of Christ supported by two angels). The very development of the traditional themes produced, by the multiplication of picturesque details, a phenomenon of hypersymbolism, in other words, a tendency to summon up in some original way motifs taken from nature in order to harmonize them with the theme: thus in Carpaccio's *Meditation on the Dead Christ* everything, even minerals, seems to take

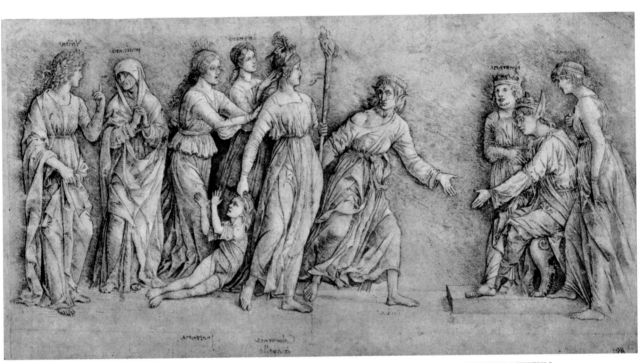

48 - SCHOOL OF MANTEGNA. CALUMNY OF APELLES — LONDON, BRITISH MUSEUM.

on a precise value. The resources of the image were now such that everything seemed representable. The great astrological cycles, like the one in Ferrara, were continued by mythological series, such as those painted for Lorenzo de' Medici in the Villa of Spedaletto, and by allegorical series like the (lost) decorations of the library of Pico da Mirandola. All aspects of human activity and every type of emotion found a form, a symbol giving them authenticity; art offered consciousness the support that would exalt it. It was destined to be the age, *par excellence*, of cross-fertiliz-

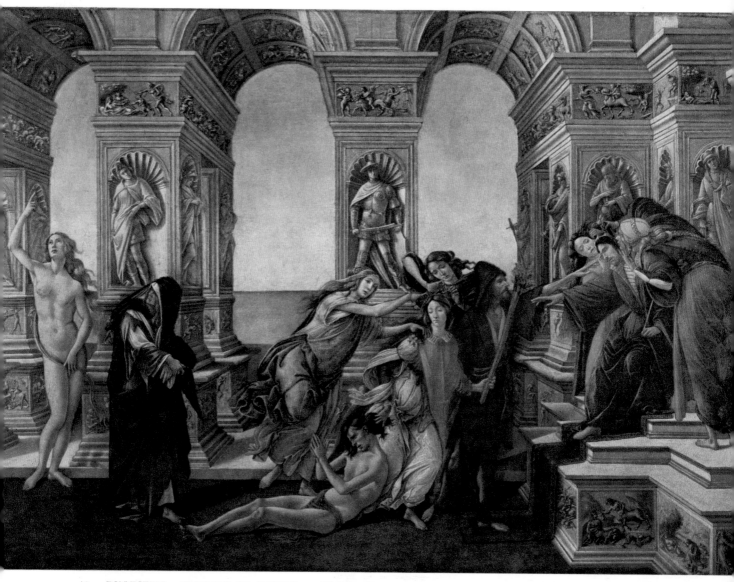

49 - BOTTICELLI. CALUMNY OF APELLES — FLORENCE, UFFIZI.

ing meanings: Signorelli modelled his image of Pan on
the *sacre rappresentazioni*.

By association with the ruin of the Temple—asso-
ciated with the *Templum Pacis*, or with the triumphal
arch, that symbol of antiquity—the Epiphany became
a festival of architecture. Vanished works of art were
reconstructed from the ancient texts about them: Botticelli
arranged the agitated figures of his *Calumny of Apelles*
in an original setting. Even ornamentation became
'speaking'.

THE CENTRES

DIFFICULTIES OF THE OLDER CENTRES

AFTER the great Roman Jubilee of Nicholas V (1450), followed by the end of the wars and the Peace of Lodi, there was a period of general prosperity, confidence and vitality, to which art bore witness. Work was started everywhere : in the choir of Prato (1452-1464) Filippo Lippi set to work on what was to be his masterpiece; in San Francesco at Arezzo (1452-1459) Piero, returning from Ferrara, found for the first time a commission that matched his stature; and in 1454 Mantegna, aged only twenty-three, was on the scaffoldings in the Eremitani at Padua, setting a very definite new course. It was the same with architecture: in 1450 the triumphal arch façade of the Tempio in Rimini was conceived, in 1452 work was begun on the *all'antica* entrance to the Castelnuovo at Naples. And with sculpture: the altar of the Santo at Padua and the third gate of the Baptistry at Florence were unveiled in 1450. The masters pressed their advantage, watched from all sides by youthful forces preparing for action. For fifteen years there was a stream of new enterprises; it went on unchecked. In all, or almost all fields the leadership still belonged to the Florentines: the general enthusiasm was due very largely to the impulse they had given and to the shock caused in every centre by the discovery of the new style of the Tuscans. There was no longer, in all Italy, a city with an up-to-date chapter or municipal council that did not feel obliged to take account of that style. This primacy was not to last; it had provoked reactions so powerful that they could not help transforming the physiognomy of the centres.

50 - BRAMANTE. INTERIOR OF A RUINED CHURCH —
LONDON, BRITISH MUSEUM.

51 - ANDREA MANTEGNA. FRESCOES. PADUA, EREMITANI, OVETARI CHAPEL.

52 - ANDREA MANTEGNA. ASSUMPTION (DETAIL) —
PADUA, EREMITANI, OVETARI CHAPEL.

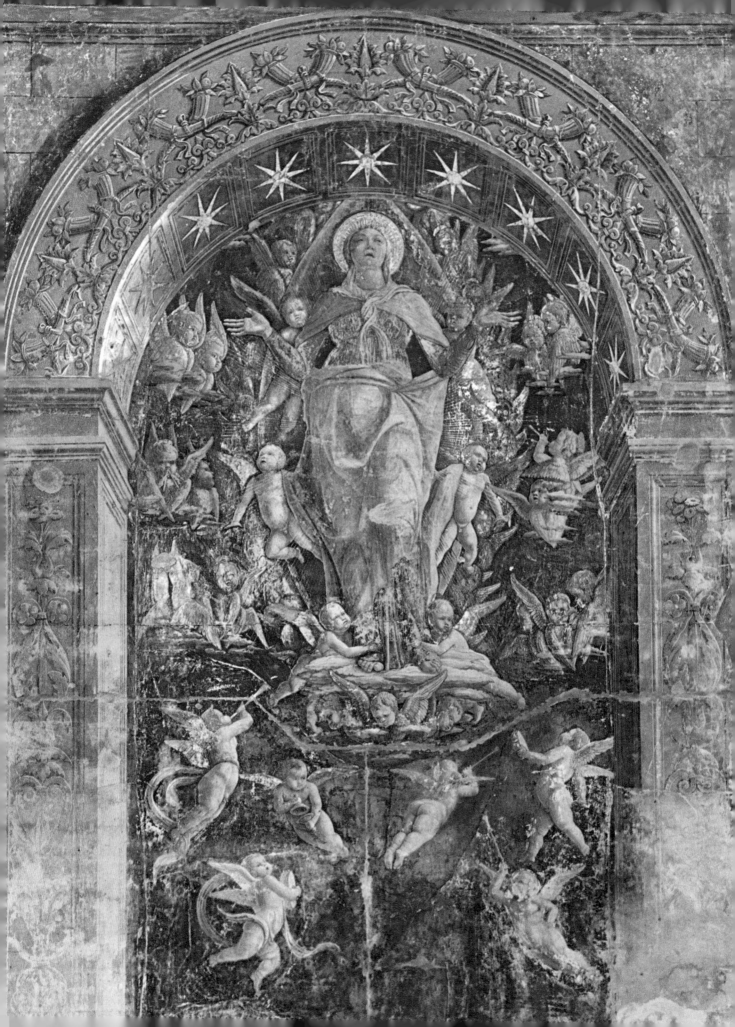

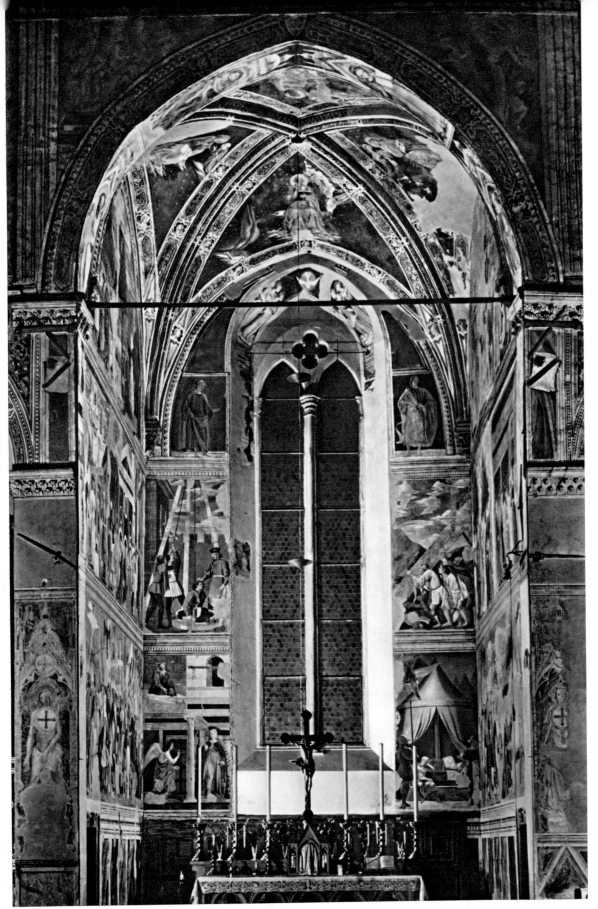

53 - PIERO DELLA FRANCESCA. FRESCOES — AREZZO, SAN FRANCESCO.

54 - PIERO DELLA FRANCESCA. THE STORY OF THE TRUE CROSS
(DETAIL) — AREZZO, SAN FRANCESCO.

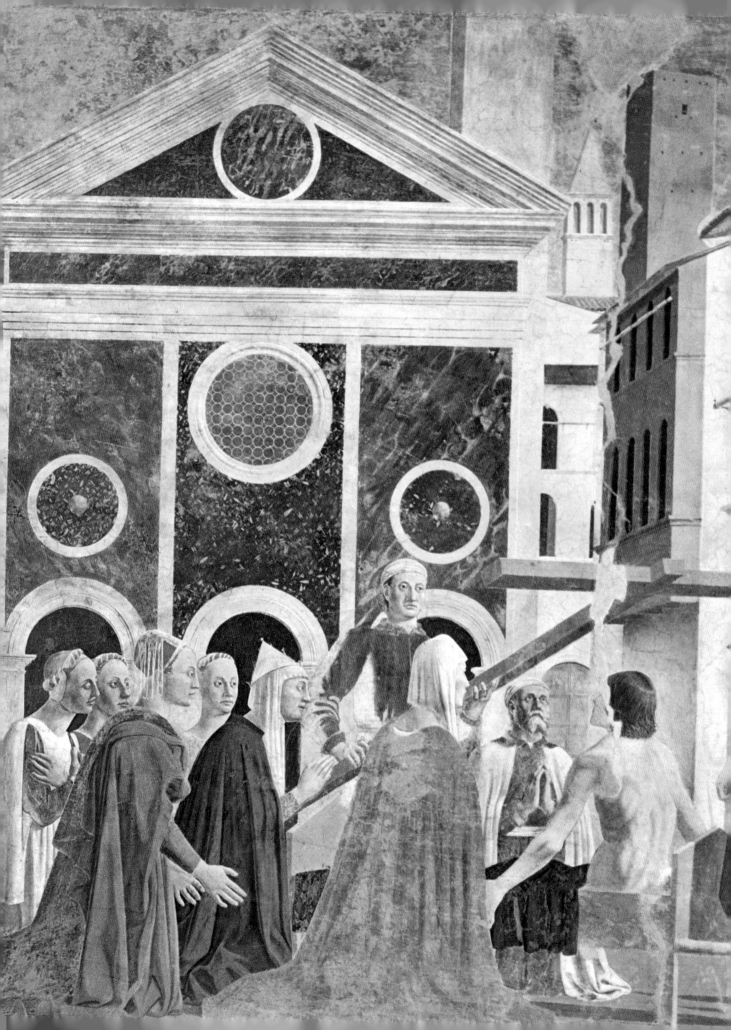

55 - FILIPPO LIPPI. FRESCOES — PRATO CATHEDRAL.

56 - FILIPPO LIPPI. DANCE OF SALOME — PRATO.

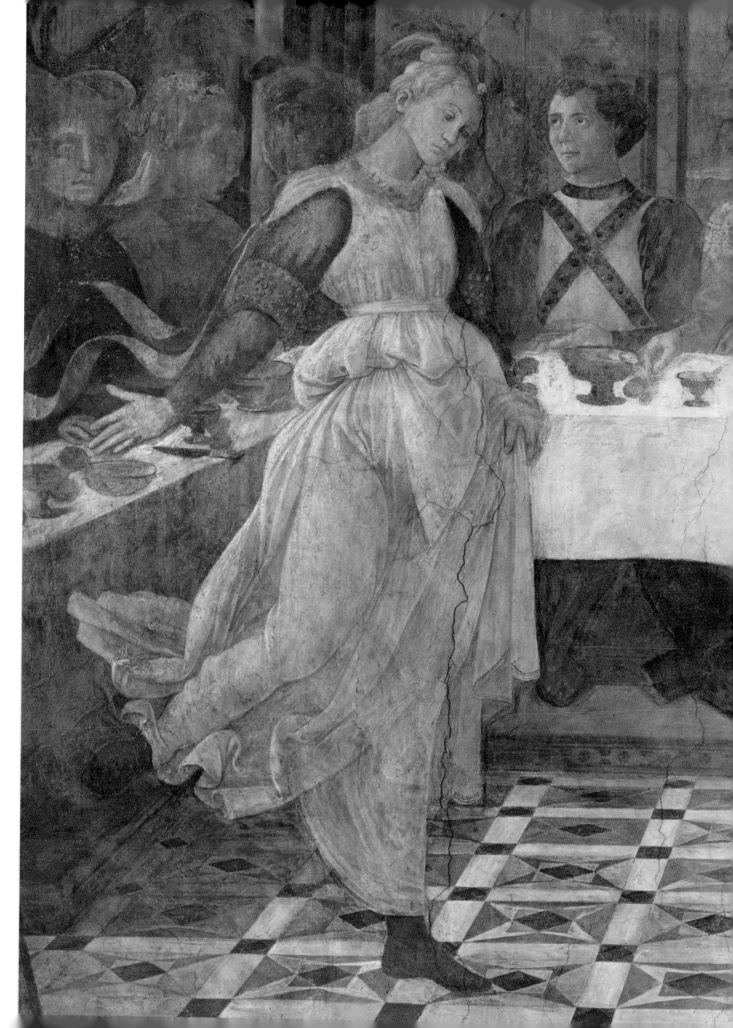

57 - LORENZO GHIBERTI. THE DOORS OF PARADISE (DETAIL) — FLORENCE, BAPTISTRY.

58 - LUCA DELLA ROBBIA. VIRGIN AND CHILD —
FLORENCE, OR SAN MICHELE.

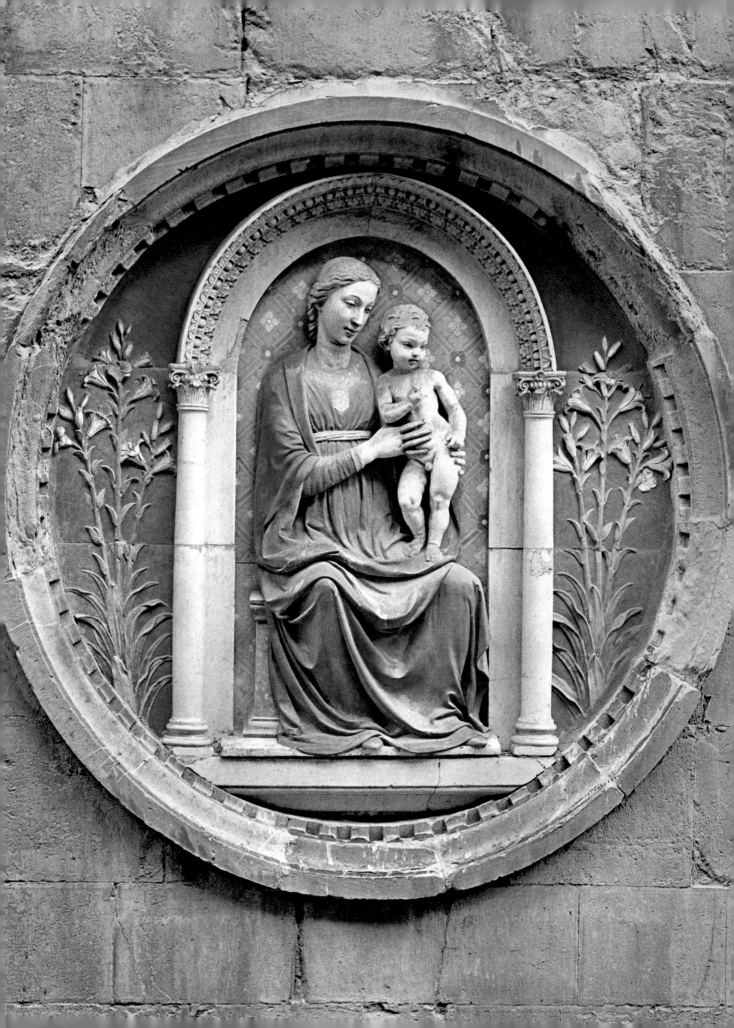

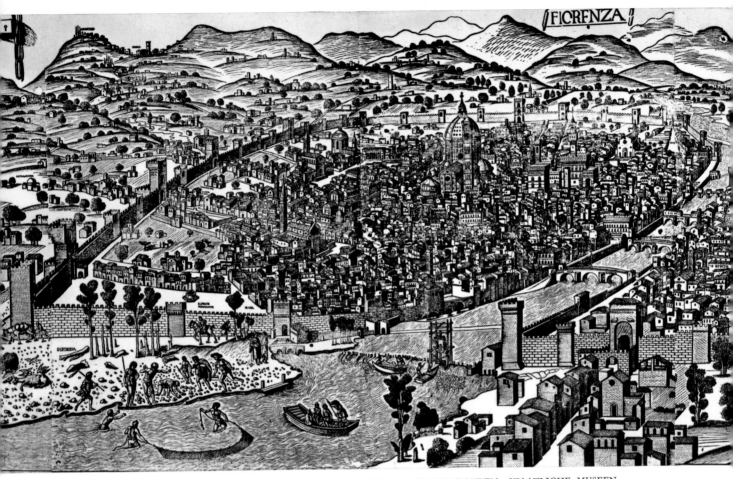

59 - FRANCESCO ROSSELLI. VIEW OF FLORENCE — BERLIN-DAHLEM, STAATLICHE MUSEEN.

FLORENCE

Vasari once wrote a somewhat surprising sentence about Florence. He was trying to explain why Perugino, when still young (in about 1465-1470), had been anxious to go there to complete his education. The originality of Florence, says Vasari, comes from its climate of incessant criticism and intellectual intolerance, from the competition between the artists. This engenders a kind of incurable appetite for greatness and success. But he adds that, through this, 'Florence does to its artists what time does to its creatures—as soon as they are created, it begins to destroy and consume them.' This remark perhaps explains the regular migration which kept the city's artistic influence widening; it is also an indication of the kind of wear and tear by which life in Florence was constantly threatened[7].

Round about 1460 Cosimo, after having relied for a

66

long time on the aid of the Serene Republic, quarrelled with it. There was an exchange of coarse insults, a 'war of epithets,' in which Benedetto Dei (already mentioned as an agent of the Medicis) took a prominent part. His *Lettera a' Veneziani* is merely a long drawn-out invective against those 'puffed up ignoramuses, good for nothing but speaking Turkish,' with no religion but the ducat. Florence, he says, is noble: 'Blood that is Roman, French and Etruscan distinguishes Florence for ever from that mixture of Slavs, Paduans and Molamocco or Chioggia fishermen that is to be found on the lagoon.' In the still largely unpublished 'Chronicles' by the same author, the tone is equally proud, and, though less passionate, it keeps its popular touch. They include a description of the city as it was in 1472. It contained, Dei reports, 108 churches, admirably equipped *('piene di paramenti d'oro e d'argiento e veluti e damaschini')*, 23 palaces for the various administrative bodies, 3,600 *'palazzi fuori della città'* (extramural farms and villas) and, within the circuit of the walls, 50 well laid out squares and 365 *'chasati e parentale'*. The chronicle then gives details of the *botteghe*: there were 270 for *'l'arte della lana'*, 83 for *'l'arte di seta'*, and the list included *'gli botteghe di legniauoli di tarsie e' intagliatori e 54 botteghe di pietre chonci a fattura di marmi e macinghi e mastri di intagliatori e orilievo e 1/2 relievo ...'*

These indications are rather valuable. They throw light on how the spread of Tuscan art took place, based as it was on an output of highly exportable products of crafts: the existence of so many specialized *botteghe*, among which woodwork and the working of marble predominated, would not be intelligible without a solid demand from abroad. The woodworkers were strong in a speciality in which Florence had for more than thirty years achieved distinction—marquetry, or intarsia. Its full importance will be seen later, but at the date now under discussion it was no longer a Florentine monopoly. Pupils of Piero della Francesca developed and encouraged the craft, and there is evidence of their success in Emilia, at Padua and even at Lucca. The fact remains that in Florence there were always great specialists in woodworking; and, remarkably enough, it was these workshops that trained the great sculptors by first making them adept at producing wooden models for architectural projects—for instance Giuliano da Sangallo, to whom we owe the stalls in the Medici Chapel (1459) and Giuliano da Maiano.

As for the art of working marble, it had never been practised more exquisitely or with surer mastery. In

1455 Desiderio da Settignano, still a young man, had carved the tomb of Marsuppini, and before his premature death in 1464 he was to produce that masterpiece of virtuosity, the tabernacle in the church of San Lorenzo (1461). Ghiberti died in 1455, just after completing the second of his Baptistry doors, the work which had involved a large number of pupils and confirmed the strength of the Ghibertian school. This had established itself firmly during the long absence of Donatello; and when, in 1452, he returned from Padua, old but still active, he was forced to recognize the hold obtained by the gentle, chiselled, polished style which almost all the marble-workers by the Arno had made their own, and which Luca della Robbia, in his terracottas with their polychrome glazes, was vulgarizing charmingly for the market he had found in the monasteries and villages.

It was through the express intervention of Cosimo de' Medici that Donatello received one more commission, for the two pulpits in San Lorenzo. He died in 1466, aged eighty. He left behind him, of course, a powerful memory; but his inspiration was not followed up. In Florence his hour had passed: it was in Padua, Siena and even Venice that, around 1460, his style inspired both sculptors and painters. This infidelity is not an isolated case: in Florence, as Vasari later cynically remarked, it was the rule.

Talent must succeed at a distance: within the city it was disputed, contradicted and ignored. The craftsmen were expected to synthesize a formula from the great examples, adapt it and cleverly preserve it (continuity is to be found among the workers in marquetry, specialists in ornament, carvers of frames and shrines, embroiderers, goldsmiths and silversmiths); but that a master should claim to make dominant an erudite style shaped by himself, was not to men's taste. Piero della Francesca, who worked at the church of Sant' Egidio in 1440, left Florence immediately afterwards and never returned; Leonardo da Vinci deliberately exiled himself to Milan; Antonio Pollaiuolo was to create his masterpiece in Rome. Lorenzo the Magnificent in due course showed his cleverness by devising a kind of cultural policy, using for the purpose of propaganda this propensity of the Florentine masters to leave their city: Florence was to radiate abroad in the persons of men like Mino da Fiesole and the Maianos; but within, the increasingly apparent tendency was towards fixation of ideas and superficial facility, characteristics which, interspersed with moments of remorse and recovery, marked the end of the century.

60 DESIDERIO DA SETTIGNANO. TABERNACLE — FLORENCE, SAN LORENZO.

61 - DONATELLO. PULPIT (DETAIL): THE THREE MARYS AT THE SEPULCHRE — FLORENCE, SAN LORENZO.

62 - MASO FINIGUERRA (ATTR.). THE PLANET MERCURY — LONDON, BRITISH MUSEUM.

70

63 - A. POLLAIUOLO (ATTR.). FEMALE PROFILE — BERLIN-DAHLEM, STAATLICHE MUSEEN.

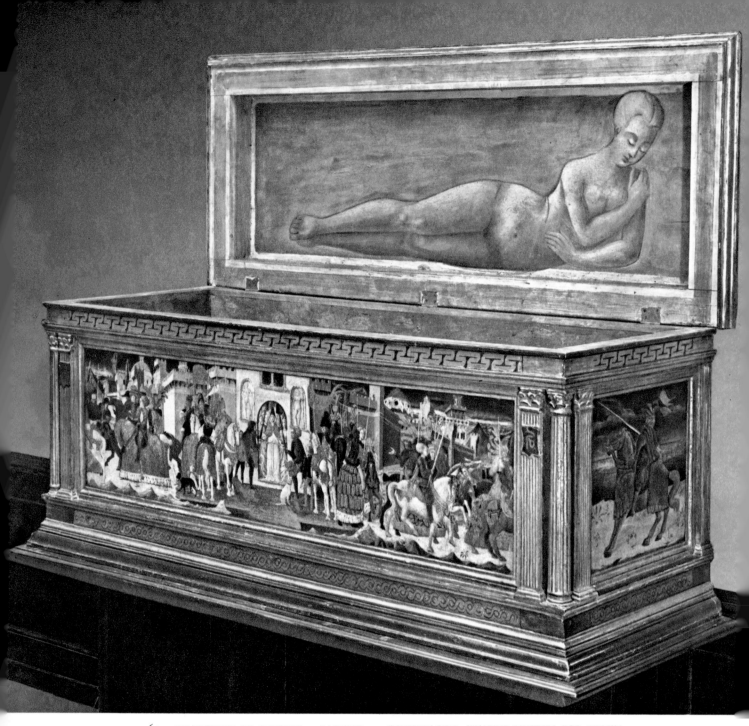

64 - FRANCESCO DI ANTONIO. CASSONE — COPENHAGEN, STATENS MUSEUM FOR KUNST.

The decorators', goldsmiths' and silversmiths' work-shops flourished, and engraving began to establish itself about Maso Finiguerra (who died in 1465).

The output of altar pictures and of *cassoni* (the chests given as wedding-presents) was considerable. The former led to the prosperity and success, nowadays almost incomprehensible, of such mediocre painters as Neri di Bicci; the latter, round about 1460-1470, employed enchanting artists

65 - FRANCESCO PESELLINO. CASSONE PANEL. THE STORY
OF GRISELDA (DETAIL) — BERGAMO, ACCADEMIA CARRARA.

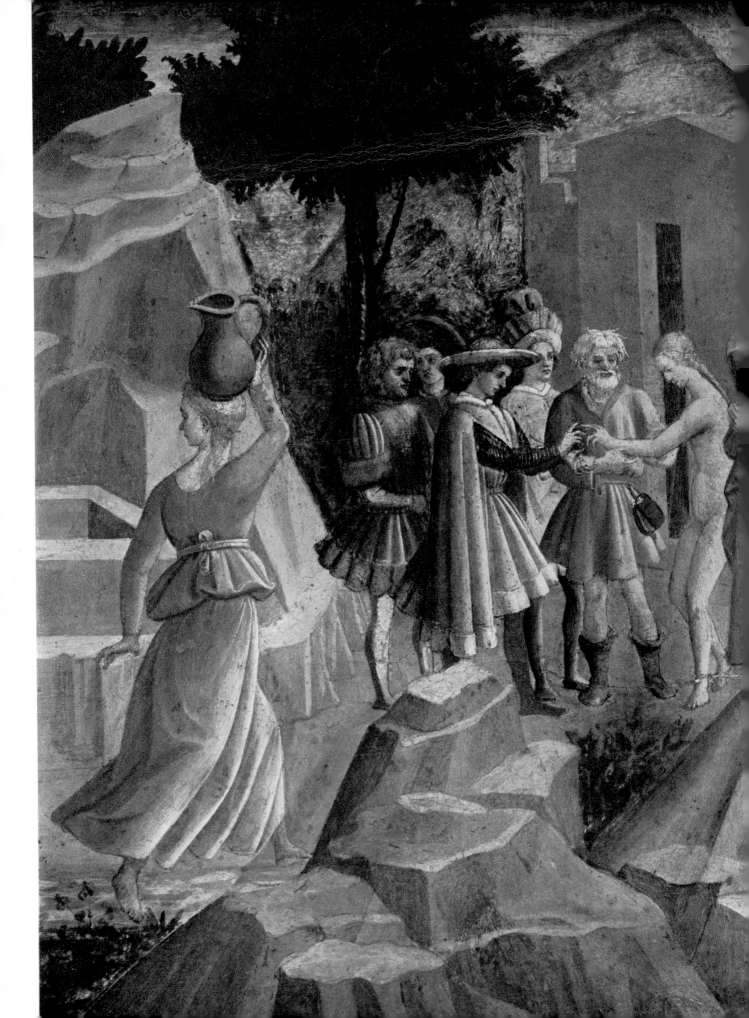

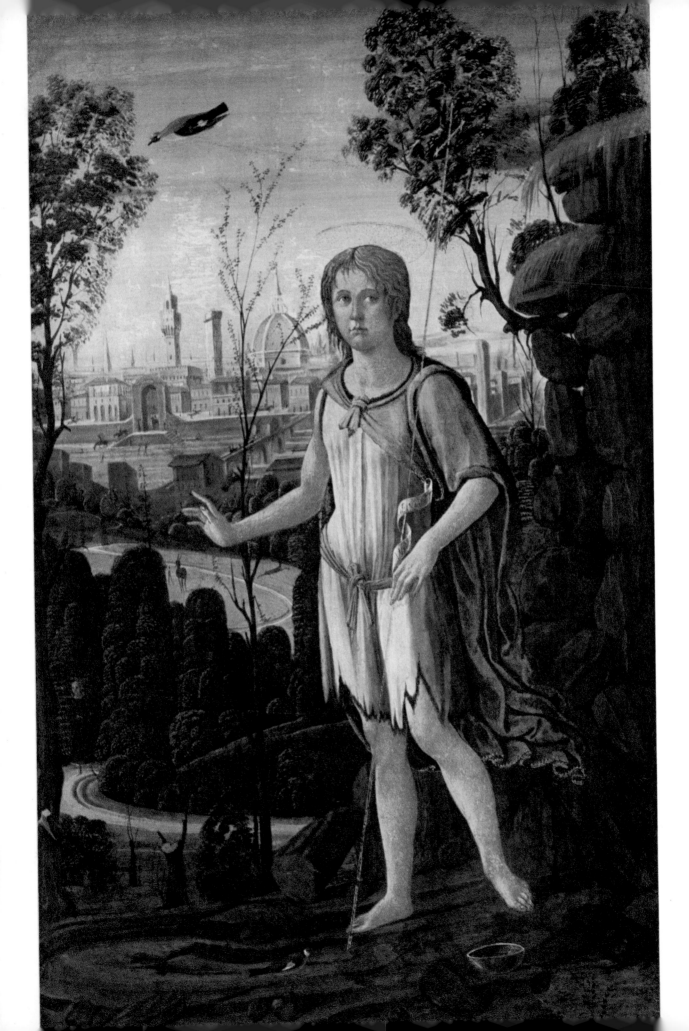

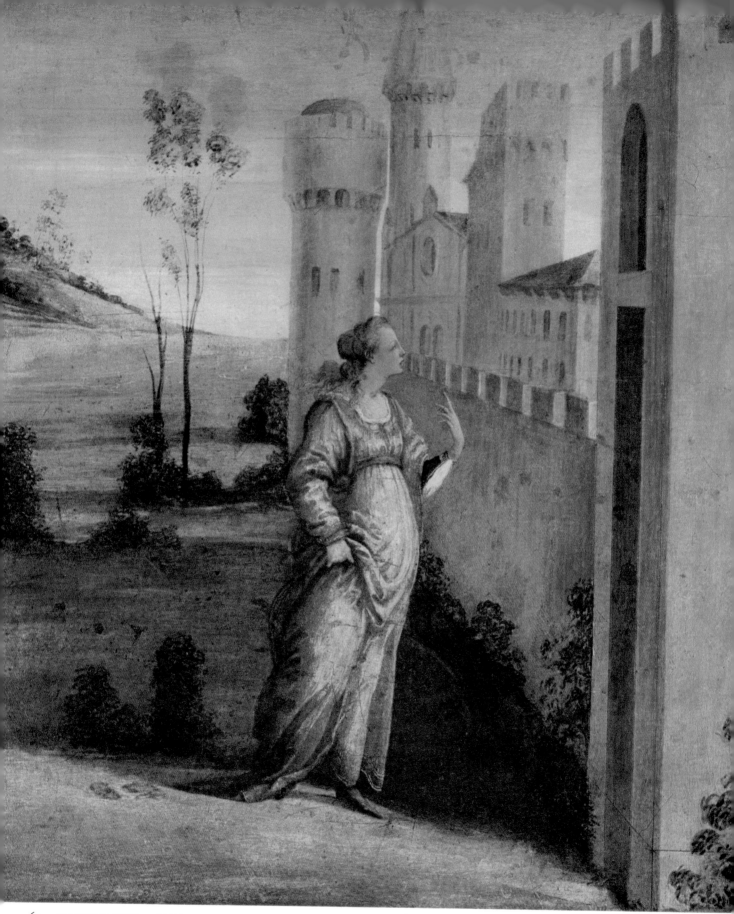

67 - FILIPPINO LIPPI. CASSONE PANEL. ESTHER ARRIVING AT SUSA (DETAIL) — OTTOWA, NATIONAL GALLERY.

66 - JACOPO DEL SELLAIO. ST JOHN THE BAPTIST —
WASHINGTON, NATIONAL GALLERY.

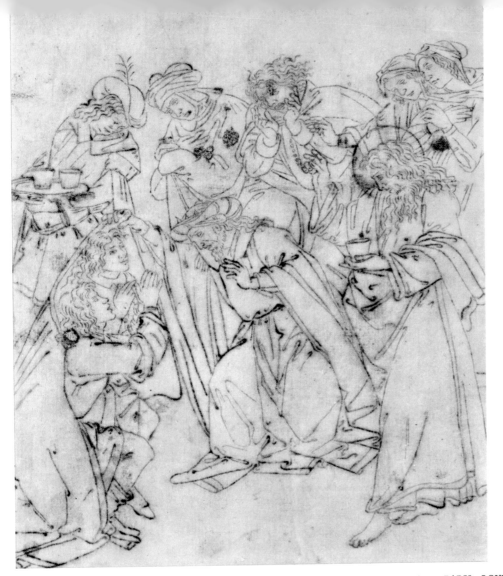

68 - SCHOOL OF BOTTICELLI. THE MIRACLE OF ST JOHN THE EVANGELIST — PARIS, LOUVRE.

like Apollonio di Giovanni, Botticelli and the young Filippino, as well as many craftsmen faithful to the formulae of Pesellino.

Small commissions were more abundant than large ones in a city where, for the last two hundred years, everything had been embellished and scrupulously preserved. Filippino was chosen to complete Masaccio's work in the Carmine (1484), and the big workshops were called upon to finish the silver altar in the Baptistry, which had been begun in the fourteenth century, and to supply designs for embroidery for this altar. It is characteristic that the great *botteghe*, those of the Pollaiuoli brothers and of Verrocchio, were very versatile, supplying painting, sculpture and decoration. Botticelli produced designs for embroidery, and perhaps for marquetry. To illustrate this, we need only note the undertakings of the major workshops in the years 1470-1480; of this the account of sums due from the

69 - GIULIANO AND BENEDETTO DA MAIANO. MARQUETRY. PORTRAIT OF DANTE — FLORENCE, PALAZZO VECCHIO.

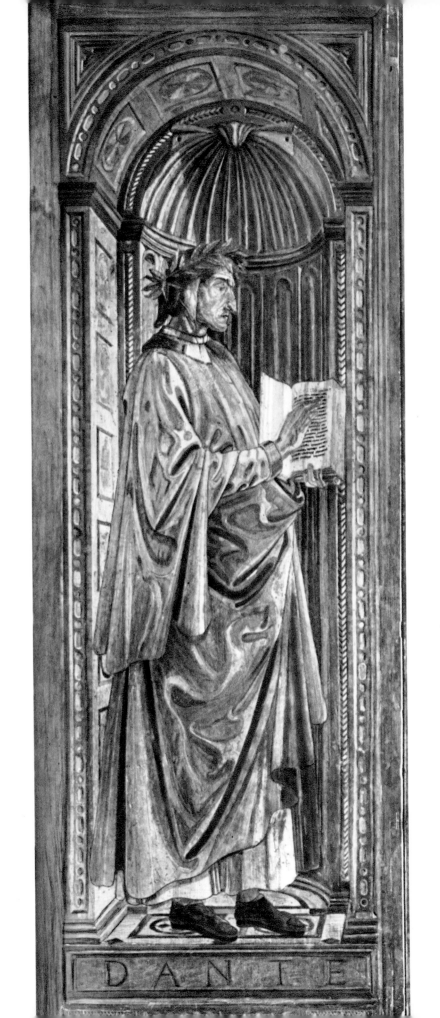

DANTE

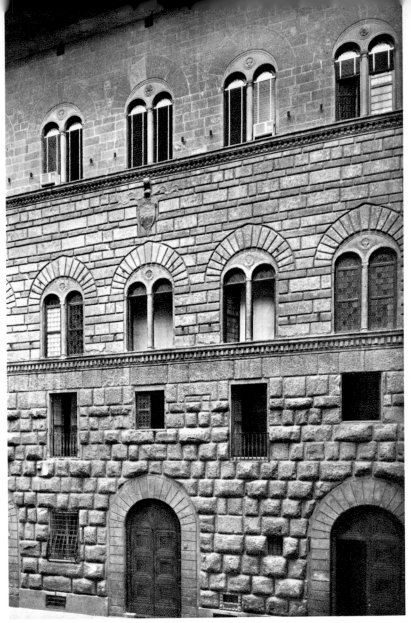

70 - MICHELOZZO. FLORENCE, PALAZZO STROZZI, FAÇADE.

Medicis to Verrocchio's heirs is clear evidence—in fifteen entries one is for a restoration, three are for the organization of festivals, four are for decorative work, and so on.

To what extent Florence was closing in on herself can be seen, above all, in architecture. Dei's pride in the palazzi has been mentioned; in another passage he states that, from 1450 to 1478, '*si murarono in Firenze trenta palazzi*'. Even if we are to understand by this, as an ancient commentator makes it clear, large houses rather than palaces in the full sense, his statement, which is reliable, hardly suggests a crisis in the building trade. Indeed another well-known chronicler, after mentioning the Strozzi and Gondi palaces, notes that in 1489 a great deal of building was going on in the city, '*per modo che*

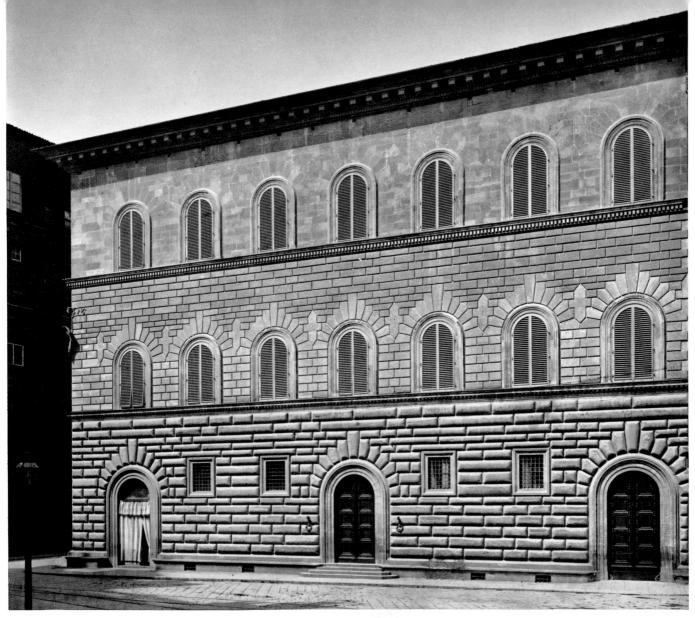

71 - GIULIANO DA SANGALLO. FLORENCE, PALAZZO GONDI, FAÇADE.

c'era carestia di maestri e di materia. Lorenzo seems to have
had plans for building which his sudden death interrupted.
And yet the Rucellai palace, which was finished in 1451
and was the prototype of a new kind of building—with
its façade arranged in bays and therefore *all'antica*, had no
following in Florence. After 1460 there was a 're-
Tuscanization' of architecture: Michelozzo's middle style
in the Medici palace triumphed decisively over the
inventiveness of Brunelleschi and the strictness of Alberti.
The palaces built at the end of the century returned to
the block, to the horizontal bands and to the *bifora*,
even embodying a certain distrust of ostentation already
to be seen in the Palazzo Strozzi. It is safe to say that the
palazzi of the end of the century were modest in appear-

ance and conformed to the traditional norms, with the ground floor built of stone, probably rusticated. As for religious architecture, it did not develop: Brunelleschi's friends tried without success to have his plans for the openings in the façade of Santo Spirito carried out, and the church was not finished until after 1481—a fact highly typical of Florentine infidelity. Brunelleschi was supported by the intellectuals, but they did not invariably win their battles.

The most original and brilliant Florentine building of the 1460s, the funerary chapel of the Cardinal of Portugal in the church of San Miniato al Monte, was due to the accidental death of a young and princely prelate, whom his family wished to honour in an exceptional fashion. This was the occasion for a masterpiece in which the co-operation of the three great arts was realized incomparably; without this almost fortuitous creation a whole aspect of Florentine sensibility would now hardly be traceable. In general, a certain severity constantly tended to gain the upper hand, and the taste for colour in decoration and even in painting steadily weakened: we have only to compare with Filippo Lippi's highly coloured manner the composite, colder style of Ghirlandaio.

One curious fact, however, is the interest in mosaics. Around 1480-1490 there were several attempts to embellish churches with mosaics, indicating a revival of interest in brilliant decoration, an attachment to craftsmanship and perhaps some dream of restoring in Florence—the city which had astonished Italy with its Baptistry—the splendour of palaeo-Christian painting. But apart from this aspiration, spectacular enterprises were more and more sporadic and isolated.

73 - MONTE DI GIOVANNI. ST ZENOBIUS — FLORENCE, OPERA DEL DUOMO.

72 - ANTONIO ROSSELLINO. TOMB OF THE CARDINAL OF PORTUGAL — FLORENCE, SAN MINIATO.

ARS VTINAM MORES
ANIMVM QVE EFFINGERE
POSSES PVLCHRIOR IN TER
RIS NVLLA TABELLA FORET
MCCCCLXXXVIII

75 - DOMENICO GHIRLANDAIO. PORTRAIT OF GIOVANNA DEGLI ALBIZZI (?) — LUGANO, PRIVATE COLL.

74 - FILIPPO LIPPI. THE FEAST OF HEROD (DETAIL)
HERODIAD — PRATO CATHEDRAL.

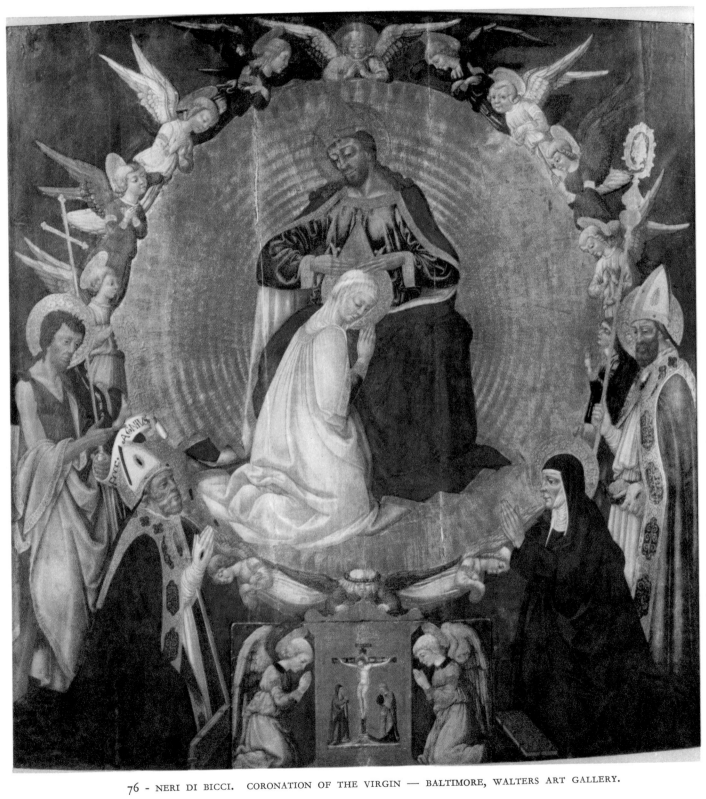

76 - NERI DI BICCI. CORONATION OF THE VIRGIN — BALTIMORE, WALTERS ART GALLERY.

77 - FRANCESCO BOTTICINI. VIRGIN AND CHILD WITH ST MARY THE EGYPTIAN AND ST BERNARD — PARIS, LOUVRE.

78 - LEONARDO DA VINCI. CODEX ATLANTICUS. DRAWING OF THE TOWN OF MILAN (DETAIL) — MILAN, BIBL. AMBROSIANA.

79 - LEONARDO DA VINCI. STUDY FOR DOME OF MILAN CATHEDRAL (DETAIL) — MILAN.

LOMBARDY

At the very moment when Antonio Rossellino, along with Luca della Robbia and their painter friends, was composing the *sacellum* of San Miniato, the Florentine Michelozzo, representing the Medicis, was building in Milan the Portinari chapel in the church of Sant' Eustorgio, on a design derived from the sacristy of San Lorenzo in Florence; however the ornamentation in brick on the outside and the decorative bands of the interior (not to speak of Foppa's frescoes, placed at a height) give it an atmosphere that is not very Florentine.

Lombardy was a traditional region of masons and decorative sculptors in stone, thanks to the Alpine quarries, but it was a slow province: it had come late to Gothic and now came late to the Renaissance. The Viscontis had been needed to give Milan the idea of its ambitious cathedral. Founded in 1386, this giant building was for two centuries to pose endless problems to every generation, including that of Bramante and Leonardo. Clearly it was too late for a cathedral in the French style and too early for a modern one. In any case, those responsible for the unwieldy enterprise were constantly summoning to Lombardy colleagues from the Rhineland

86

or from France, sculptors in particular[8]. The result was a constant impregnation by the styles of Northern Europe, the more serious since Lombardy came gradually to feel a vocation for the fusion of the arts, or for what may be so called. It was a region where the painted altarpiece was rare and sculptured *pale* were common: the Lombard craftsmen were thus practised in rendering the complexities of form in relief and half-relief; they could embellish every part of an architectural scheme, even the medallions, pilasters and parts of the structure, with motifs or with scenes containing figures. Carved ornamentation proliferated: it seemed destined to take the place of painting and to modify architecture. The meeting between the thought-out and four-square structures of Central Italy and this style of overlay and animation—encouraged by flamboyant models—promised to be picturesque: it surpassed all expectation, even acquiring its own theorist in the person of Filarete, a Florentine who entered the service of the Sforzas thirty years before Leonardo. In about 1460 he wrote what was intended as an anti-Gothic manifesto—the astonishing *Trattato* in which he develops a whole programme of fantastic imaginative architecture in the grand style.

Its principle was to make use of the more cubic, horizontally well articulated modern structures as supports for a system of decoration that would gather up and combine all the fashionable motifs, and to annul by the continuous chain of these motifs, the interplay between filled and empty spaces which is the major effect of Tuscan architecture. The Ospedale Maggiore in Milan and the design for the façade of Bergamo cathedral mark the birth of this new taste, which is equally distinct from Gothic—except in its exuberance—and from the Florentine clarity. The appearance of this colourful, lively and complicated art in the Colleoni chapel at Bergamo (1470-1475) was one of the great events of the second half of the century; but its full vogue belongs to the years 1480-1490, with the Incoronata at Lodi and Santa Maria dei Miracoli at Brescia, both of which also contain interesting

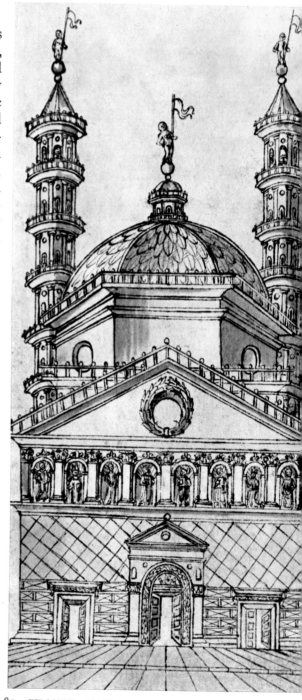

80 - FILARETE. PLAN FOR BERGAMO CATHEDRAL — FLORENCE, BIBLIOTECA NAZIONALE.

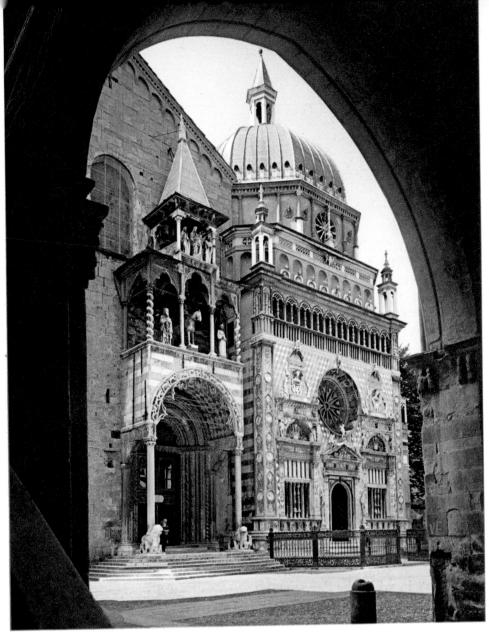

81 - AMADEO. BERGAMO, COLLEONI CHAPEL AND BASILICA OF S. MARIA MAGGIORE.

experiments in the handling of mass and interior space. The façades of the palace at Cremona are other examples, and Amadeo's conception of the façade of the Certosa (1490 onwards) appears as the culmination of an irresistible movement. Throughout the region the success of this formula was complete: the masons and ornamental carvers were the masters of a new style which no one can confuse with that of the Florentines.

Another decisive event was the almost simultaneous arrival of Bramante and of Leonardo in Milan. A useful document is one dated October 1481, in which a certain Magister Bernardus de Prevedaris undertakes to engrave a design containing buildings and figures: the print has

82 - MILAN. SANTA MARIA DELLE GRAZIE.

survived and shows a romantic architectural setting which
is like a comment on the art of Bramante. Wealth of
ornament is dominant—the rays of the *oculus*, for instance,
stand out powerfully; but the amplitude of the enclosed
space is not diminished by this. In the church of Santa
Maria presso San Satiro (after 1482) what dominates is
the astounding variety of the decoration; in Santa Maria
delle Grazie (after 1492) it is a resolute monumentality:
in both cases the fidelity to Lombard forms is striking.
It was by a rather similar process that Lombard painting
assimilated—with Foppa, at an early stage—the solid
principles of lighting and construction whose effect was
attenuated by the lessons of Padua and Verona; these

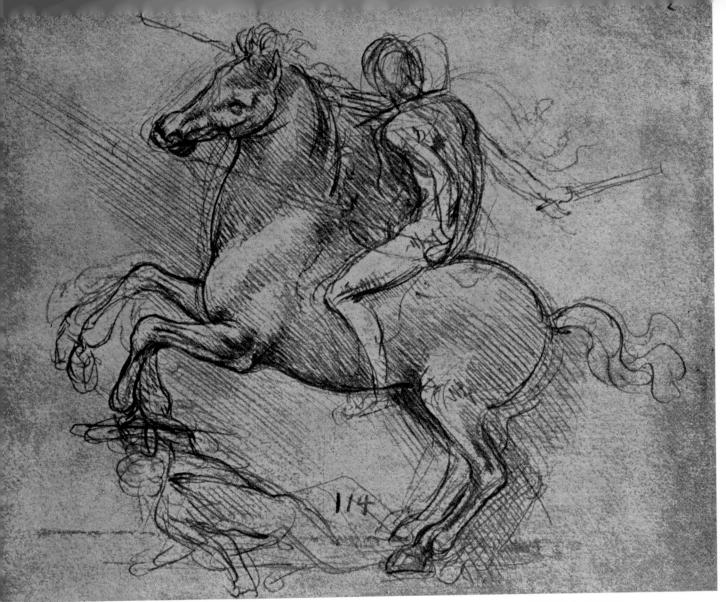

83 - LEONARDO DA VINCI. STUDY FOR EQUESTRIAN MONUMENT TO FRANCESCO SFORZA — WINDSOR CASTLE.

principles were later exploited freely, though somewhat heavily, by Braccesco and the Breas—and again by Spanzotti. The ambitions of Bergognone and of the pupils of Foppa hardly went beyond a certain realism, with stocky forms heavily overloaded but redeemed by a delicacy of light; they were not troubled by the monumental figures of Bramante or the subtleties of Leonardo.

Lodovico il Moro was anxious, among other things, to raise a statue to Francesco Sforza. As is well known, the work on the *Cavallo* (of which the clay version was set up in anticipation of its being cast in bronze) occupied Leonardo for several years. The ambition of Lodovico was to create a magnificent court in the Burgundian manner: the meetings of Milanese humanists aimed at imitating and perhaps outclassing Florence, and efforts

were made to attract the 'stars' with the usual princely offers[9]. Leonardo was engaged as organizer of festivities, maker of seals and coats of arms, military engineer and designer of gardens: this reveals the concrete, practical side of court life in Milan. Here too thought was given to town-planning, as in Ferrara; to fortifications, as in Mantua; to the theatre, as in Urbino. The separation between the interests of the court and the practice of the craftsmen was, it seems, important: two worlds were superimposed without communicating and, while the castle drew to it men like Bramante or Pacioli, the wandering masons and ornamental carvers of the lake region were continuing to spread throughout Italy.

In its own field, that of building and of every kind of ornamentation, Lombardy in the middle of the fifteenth century was a clear and powerful rival to Florence. The emigration of the masons and stone-carvers from the lake region was a constant phenomenon with many consequences: 'The Palazzo Communale at Jesi', says E. Arslan, 'could not have acquired its present appearance unless, in addition to Francesco di Giorgio, the Lombard workmen Michele and Alesse from Milan, had worked on it; the activity of Rossetti at Ferrara is inseparable from that of his collaborator Gabriele Frisoni; Pietro da Milano is, without any doubt, the principal author of the arch of Alfonso in Naples ...' It was not merely a question of workmen, but of *entrepreneurs*, who often played a decisive part. In fact, the Lombards were filling all the gaps left by the Florentines. Often, indeed, the two met—in Rome, for instance, and in Venice—even exchanging tricks of the trade and peculiarities of style, the Lombards being better at adaptation, the Tuscans at clarity of style. In the field of carved decoration and architecture, the last part of the Quattrocento appears as the encounter of Tuscan and Lombard artists and the rivalry between their favourite devices. A revealing case is that of Domenico Gagini. Born in about 1425-1430 at Genoa, he worked in 1456 at the chapel of San Giovanni in the cathedral there. His style was modest, he gave life to the panels by means of scrolls and inserted small niches into the walls. His touch was delicate, and this he was to show in Naples when he arrived there in 1458 in the influx of sculptors brought by Alfonso to work on his Castelnuovo. Gagini either did not wait for the end of this work or was not successful: in 1463 he was at Palermo where he settled. He died in 1492 after having spread widely about Sicily, in innumerable altars, shrines and doorways, a simple Lombard style.

84 - G. A. AMADEO. GROUP OF PUTTI — LONDON, VICTORIA AND ALBERT MUSEUM.

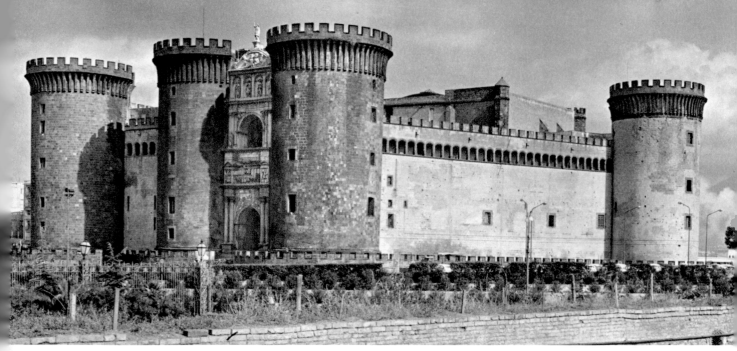

85 - NAPLES. CASTELNUOVO. GENERAL VIEW.

NAPLES: A 'PRO-FLEMISH' CENTRE

The polarity of Tuscany and Lombardy dominated the second half of the fifteenth century. Where they joined forces, things moved fairly quickly, and a new spirit made its appearance with mouldings derived from antiquity, niches, decorated pilasters, candelabra, and so on. But the result was not fruitful and interesting everywhere at the same time. In Venice it was, as we shall see later. But the same forces met in Central and Southern Italy also, in Naples and in Rome. Neither of these two centres played a leading part during this phase. Yet a mere outline of their activity is enough to show their essential contribution to the solution of the problem common to all: one of them made possible and sustained the spread of Flemish influence, the other the appeal of Antiquity.

Naples under Aragon was graced by far fewer important enterprises than it had been while under Anjou. About mid-century the Castelnuovo attracted sculptors of various origins: they included Pietro da Milano, Francesco Laurana—a young Dalmatian artist just beginning his career—and after them Antonio di Chellino, a collaborator of Donatello, now set free from work in Padua, and Domenico Gagini from Genoa. This considerable effort at recruitment did not lead to the birth of an important school: the chief task was to finish the entrance to the fortress, the triumphal arch commissioned by Alfonso from the Catalan workshop of Sagreras; this

86 - F. LAURANA AND PIETRO DA MILANO. NAPLES.
CASTELNUOVO. ARCH OF ALFONSO OF ARAGON.

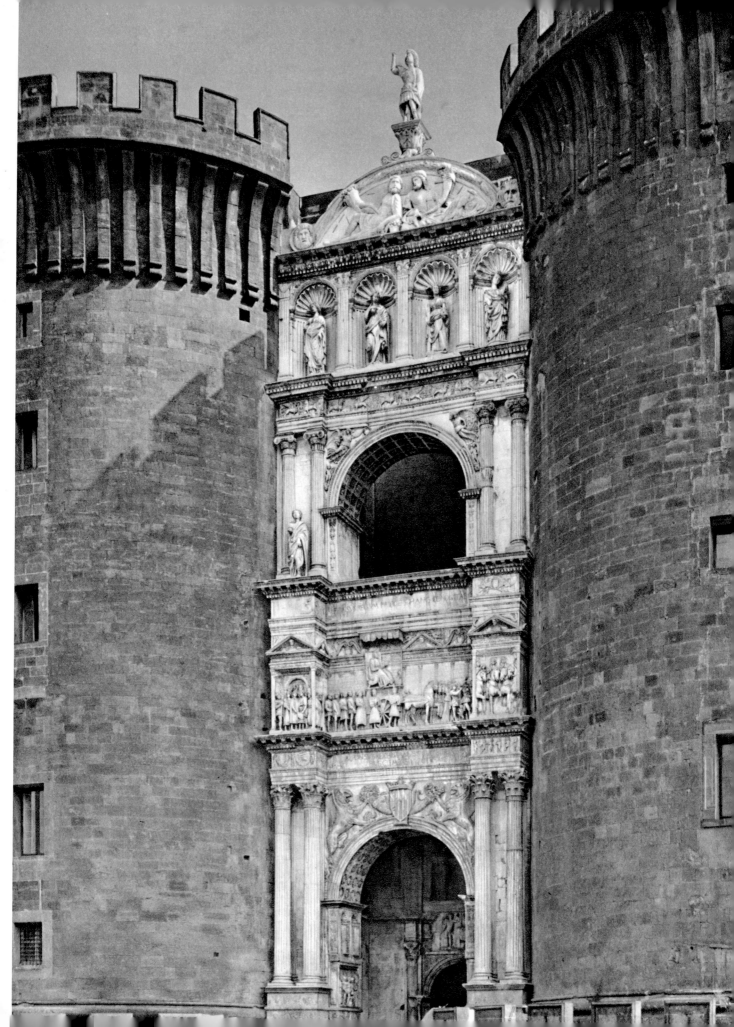

87 - FRANCESCO LAURANA (ATTR.). ARCH OF ALFONSO OF ARAGON (DETAIL): GRIFFIN — NAPLES.

was completed in 1466. Twenty years later, after 1485, the connections of the King of Naples with Florence bore their fruit: the second monumental work of the fifteenth century, the Capuan Gate, is evidence of a more definite conversion to the classicizing tendencies than is the romantic archway of the Castelnuovo. What amount to copies of Florentine works were produced in Naples at this time: Benedetto da Maiano completed the decoration of the Monte Oliveto church (Sant' Anna dei Lombardi), where in 1470 or thereabouts Antonio Rossellino had constructed the tomb of Maria of Aragon, an exact transposition of the tomb of the Cardinal of Portugal. In about 1489 Maiano adorned the Mastrogiudici chapel with a superb relief of the Annunciation, which Vasari described in detail. (The *bozzetto* for it is in the Metropolitan Museum, New York.) The stalls by Fra Giovanni da Verona contribute the abstract tone of marquetry, and the group of the *Pietà* by Mazzoni (1482) add a popular note.

It was at Court level that Tuscan influence really manifested itself: in quick succession Maiano built for Alfonso, at Poggio Reale, a *villa extra muros* that was to be one of the most advanced of the period, and Sangallo

94

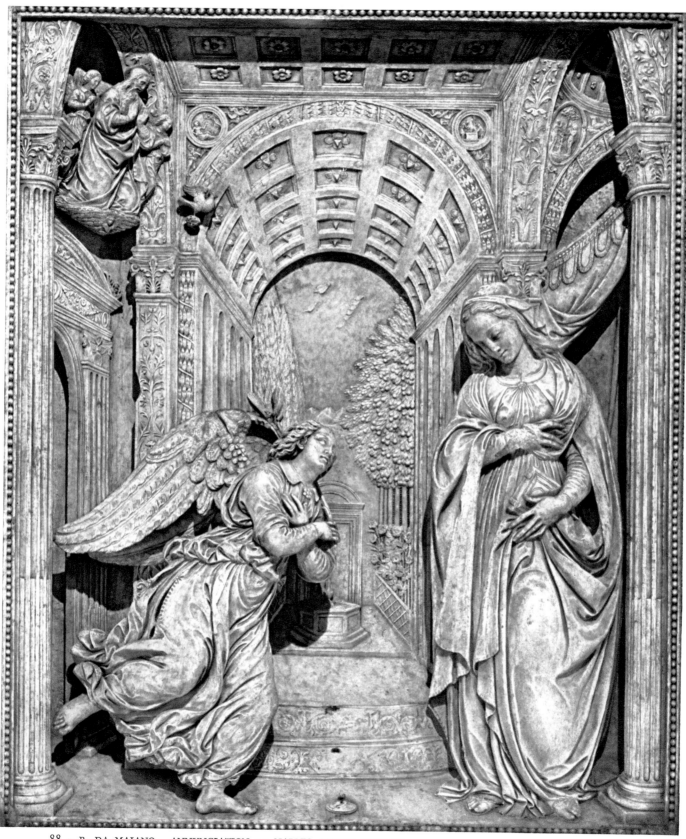

88 - B. DA MAIANO. ANNUNCIATION — NAPLES, MONTE OLIVETO.

89 - A. COLANTONIO. ST VINCENT FERRER APPEARS TO A WRECKED SHIP — NAPLES, SAN PIETRO MARTIRE.

presented Ferdinand with designs for castle with an ultra-moderna portico and inner courtyard.

Naples held a surprise in reserve. The kingdom had become Aragonese: the excursion in 1458 of René d'Anjou, king of Provence, had not been very important (it was the prelude to a similar short-lived fiasco by Charles VIII): but these facts remind us that Naples and Palermo, Provence and Valencia compose a kind of 'Tyrrhenian' quadrilateral. It was the scene of artistic interrelations that are still mysterious—at least in the sense that the routes of exchange are no longer clear and that all we can detect is a regular osmosis and some surprising analogies of style (between, for instance, the

96

90 - ANTONIO COLANTONIO. POLYPTYCH (DETAIL): ST VINCENT FERRER AND CHRIST — NAPLES, SAN PIETRO MARTIRE.

91 - M. COSTANZO, ST JEROME (DETAIL) — SYRACUSE CATHEDRAL.

Master of the Aix *Annunciation*, Colantonio, and Jaime Huguet). On close inspection, Campagna appears as a nursery of half-Flemish painters; for the problem common to all the painters of this 'Tyrrhenian' group was to assimilate the example of Van Eyck, Rogier van der Weyden and their school, in a Southern manner. The important place given to Jan van Eyck—*Johannes Gallicus pictorum princeps*—by the Neapolitan humanist Fazio, and the paintings found in the Neapolitan collections, are facts that are constantly, and rightly, emphasized. But there existed both an esoteric influence and a popular assimilation; for side by side with clearly identified Sienese or Spanish painters, there were local artists attentive to the fine handling and density of the Northern artists—for instance, the creator of the Piazza Armerina Crucifix, or that unpretentious painter Marco Costanzo who produced a beautiful *St Jerome* now in Syracuse. Above all, a powerful force took shape in the person of Colantonio, a Neapolitan artist, who sought to introduce the brilliant modelling and subtle light of the Flemish into the ordered space of the South. His pupil Antonello takes his place among the great 'Eyckians' of the fifteenth century and among the rivals of Piero della Francesca.

92 - ANTONELLO DA MESSINA. THE CONDOTTIERE — PARIS, LOUVRE.

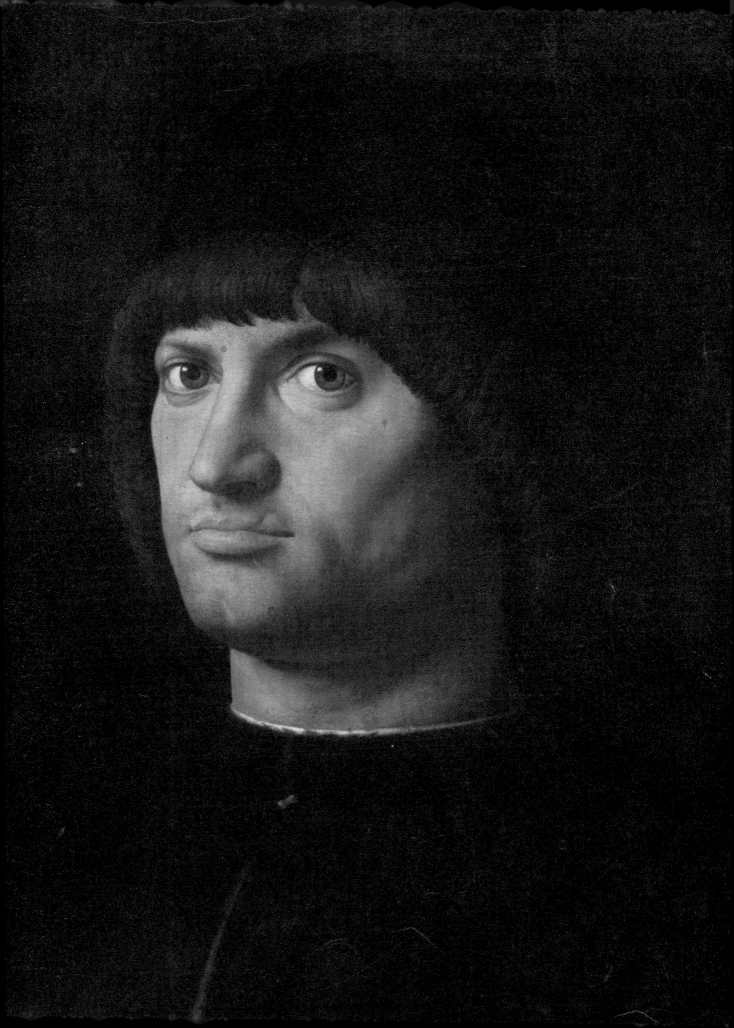

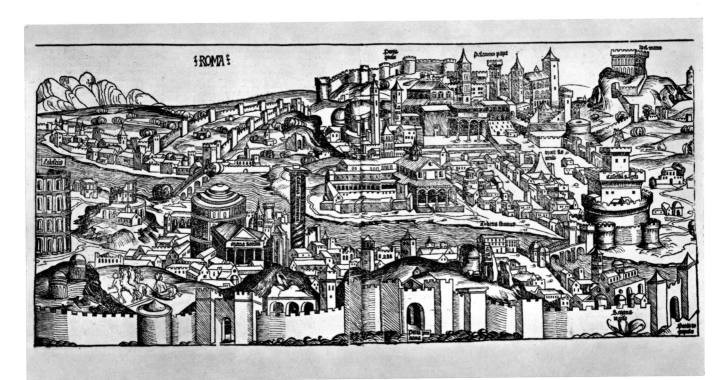

93 - HARTMANN SCHEDEL. LIBER CHRONICORUM. PANORAMA OF ROME — VATICAN LIBRARY.

ROME

The situation in Rome was not yet clear. It was still a far cry to the imperial city of Julius II, which was to attract to it all the ambitious artists. The pontificates following the Council of Basle (1449), which set the seal of approval on the return to monarchy in the Church, were reigns of restoration, in which town planning had a notable place. Thought was given for the first time to the rebuilding of the Basilica of St Peter, but the vast project remained in abeyance—a fact which symbolizes the situation rather well. Pietro Barbo, the collector of antiquities, had built, when Cardinal of Venice, the Palazzo Venezia and the adjacent church of San Marco, and in the (unfinished) *cortile* there emerged for the first time the idea of returning to those porticoes with more than one storey that characterized the cities of Antiquity: of this, Alberti, who was instructed by the Papal Curia to map out Rome and its ruins, was surely not ignorant. A small group of Roman humanists—which indeed went through many vicissitudes—showed a patient attachment to the greatness of the ruined city. But before Julius II, Rome still seemed paralyzed by that fundamental paradox of the Renaissance: the ruins were treated as sacred relics,

100

94 · ANON. MIRABILIA URBIS ROMAE.
TITLE PAGE. VATICAN LIBRARY.

and it was chiefly the dead city that imposed itself on the
imagination. But how could men be made to forget the
ruins in order that the Eternal City might be reborn with
the desired monumental grandeur? In thirty years the
tone changed: in 1472 Fonzio, visiting Rome, sadly
enumerated the moving vestiges of the past, but in 1506
Canon Albertini was counting up the magnificent edifices
of the new Rome.

The great project of Nicholas V remained a sketch,
but under the energetic pontificate of Sixtus IV the idea
of the *renovatio urbis* was taken up afresh. Witness a
small work by an English humanist, entitled *Lucubratiun-
culae tiburtinae* (1477), which indeed stresses that the new
buildings are not arches, baths or pagan theatres, and
that Sixtus IV has adorned Rome with '*sanctorum templis
pulchrisque sacellis atque monasteriis et (ut uno plurima verbo
comprendam) numeris praestantibus, utilitas, pietas vel honestas
denique posuit iis quois non pompa aut fastus ...*' In fact, the
activity of Sixtus IV as a Maecenas dominates the end of
the century: in all fields he prepared, at thirty years'
distance, for the achievement of Julius II. A number of
spectacular gestures stressed the imperial significance
of the city and the Pope's claim to be founding the univer-
sality of the Church on the memory of Roman greatness.

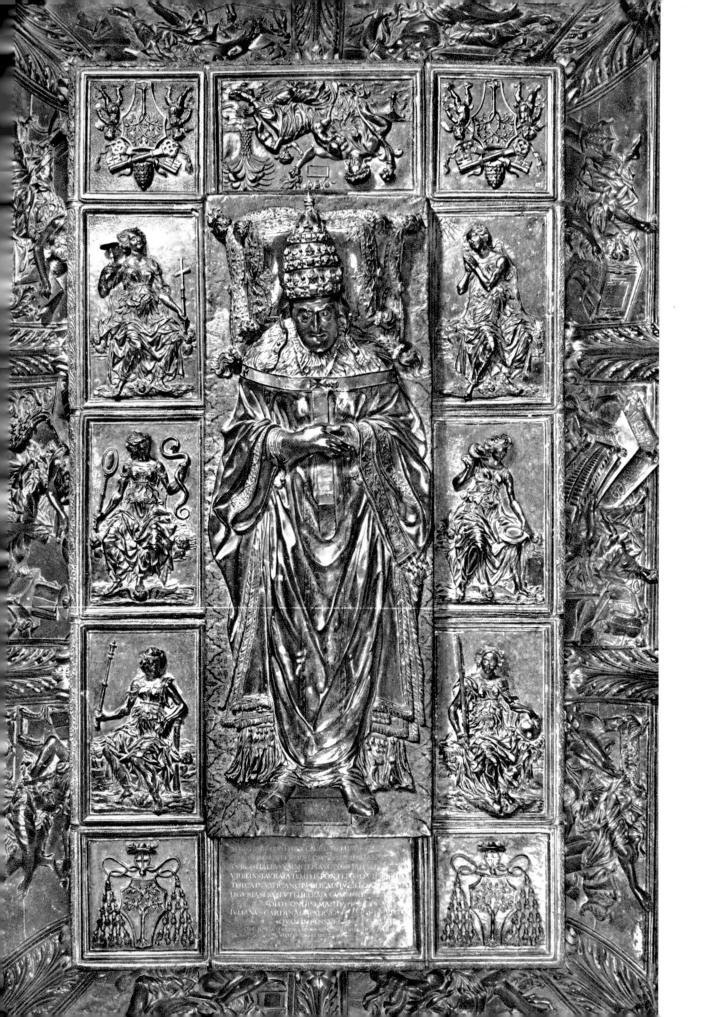

The returning of the bronze She-Wolf (two small children were added to it by a sculptor of the time) to the Capital, where it was placed on to the façade of the Palazzo dei Conservatori, was perhaps the most typical of these facts. The great bronze tomb commissioned from Antonio Pollaiuolo in honour of the Pope at his death is an exceptionally fine work.

Rome is a city of tombs. Till then many of the commissions for these had gone to Lombard sculptors, also to Florentines, not to mention a Dalmatian master, Giovanni da Traù, who worked by turns with the Lombard Andrea Bregno at the Minerva and with the Florentine Mino da Fiesole in the Vatican. Bregno's work in Rome was spread over some time, and included the tombs of the della Rovere family in the Santi Apostoli (1495): one can observe very clearly how his style gradually became dry and composite; yet his studio acted as a kind of continuous school, and its importance is incontestable. There was no longer a Roman school of painting: Fra Angelico and Piero had in turn been called in under Nicholas V and Pius II. Sixtus IV, determined

96 - ANTONIO POLLAIUOLO. TOMB OF POPE SIXTUS IV (DETAIL) — GROTTE VATICANE.

95 - ANTONIO POLLAIUOLO. TOMB OF POPE SIXTUS IV. GROTTE VATICANE.

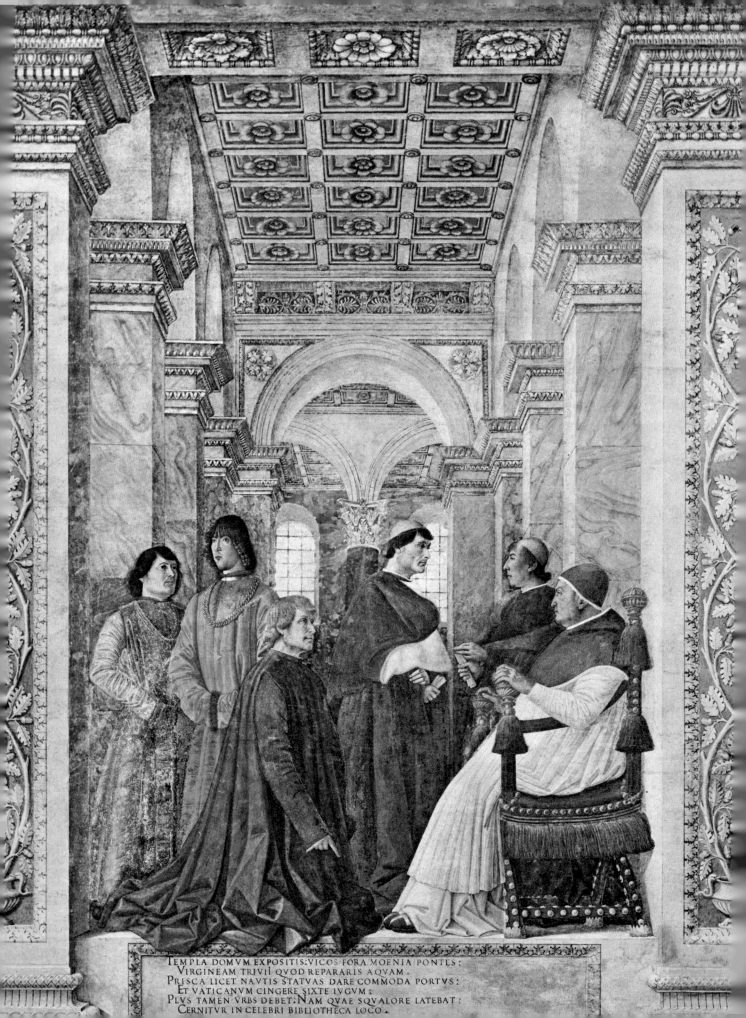

TEMPLA DOMVM EXPOSITIS; VICOS FORA MOENIA PONTES:
VIRGINEAM TRIVII QVOD REPARARIS AQVAM.
PRISCA LICET NAVTIS STATVAS DARE COMMODA PORTVS:
ET VATICANVM CINGERE SIXTE IVGVM:
PLVS TAMEN VRBS DEBET: NAM QVAE SQVALORE LATEBAT:
CERNITVR IN CELEBRI BIBLIOTHECA LOCO.

98 - PINTURICCHIO. ST ANTONY, AND ST PAUL THE HERMIT (DETAIL): THE TEMPTRESSES — VATICAN, BORGIA APARTMENTS.

to do great things, summoned the pick of the Umbrian and Tuscan painters to Rome as soon as his conflict with Lorenzo de' Medici was over, and organized between the different teams a real competition for the decoration of his new chapel (1481-1482). It became the most spectacular ensemble of the period. At the same time the Pontiff had enticed to Rome Melozzo da Forli, who celebrated in painting the historic dates of the Vatican and decorated the apse of the Santi Apostoli. Near the end of the century there took shape—with Antoniazzo and even with Pinturicchio—a definite Roman taste. This became

97 - MELOZZO DA FORLI. POPE SIXTUS IV APPOINTING PLATINA VATICAN LIBRARIAN. VATICAN, PINACOTECA.

99 - A. BREGNO AND BRAMANTE. ROME, PALAZZO DELLA CANCELLERIA, FAÇADE.

clearly individualized between 1490 and 1500 with the incredibly quick spread of the enthusiasm for fantastic ornamental motifs suggested by the remains of Nero's golden house on the Aquiline: Pinturicchio was to exploit these in the Vatican and in the Castello Sant' Angelo. The 'grotesques' were born.

It is hard to get a clear idea of the building activity in Rome during the last quarter of the century. It was certainly considerable: in 1475, on the occasion of the Jubilee, there is mention of '*molte nuove chiesette*'. San Pietro in Vincoli (founded in 1471) and San Pietro in Montorio (1472-1484) were evidently among these. Vasari later attributed to the Florentine Baccio Pontelli, architect to Sixtus IV, a whole series of buildings, including the Ponte Sistino, the Library and Sistine Chapel, and the Santi Apostoli[10]. The attribution is disputed, and indeed these buildings, especially the churches, are modest and flat in style. What adds to the perplexity of the historian, and to the interest of the period, is that

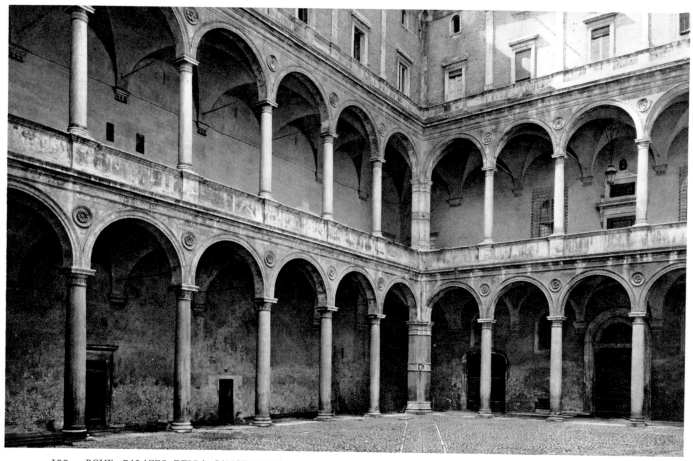

100 - ROME, PALAZZO DELLA CANCELLERIA. THE COURTYARD.

a major building made its appearance—the palace of
Rafaello Riario, Cardinal of San Giorgio, the Pope's own
nephew (enlarged and completed to join the Corso, the
building later became the Papal palazzo della Cancelle-
ria). Its three-storey elevation, introduction of rhythm-
ical rows of windows (which seemed to have been
forgotten since Alberti) and its *cortile* with two loggias one
above the other, make it, along with Laurana's palace at
Urbino, the most noteworthy building in Central Italy at
this time. It was planned as early as 1480, and most of the
work on it went on from 1483 to 1489 and again
from 1489 to 1495. In any case, this first campaign
came before Bramante's arrival in 1501. The documents
mention that Montecavallo (that is to say, Andrea Bregno
the sculptor) was involved, but it is difficult to attribute
to him the responsibility for the whole. The presence of
Antonio da Sangallo in Rome must also be mentioned:
ten years younger than his brother Giuliano (who had
himself worked in Rome from 1465 to 1470, and returned

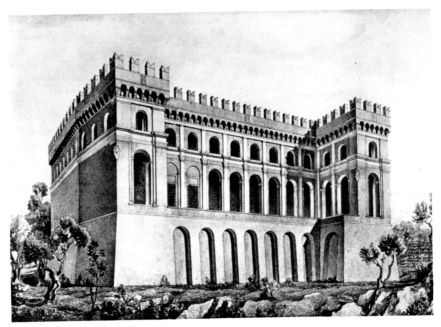

there in 1500), Antonio lived in the Papal City from 1490 to 1495; he directed the alterations to the Castello Sant' Angelo in the Borgo Nuovo, and saw to the quarrying of the travertine for the Palazzo Corneto (later Torlonia). The Palazzo Corneto was begun in 1496 and, like the Cancelleria, was attributed by the seventeenth-century guides to Bramante.

At the same moment, near the Vatican, a building of exceptional interest was rising; it was to be the principal artistic contribution of Innocent VIII, a Pope less inclined to patronage of the arts and less enamoured of magnificence than Sixtus IV. The creation of the Villa del Belvedere (1489-1492) on the hill to the north of the pontifical palace was an important stage in the development of Rome. This was the first Roman *villa extra muros* for a long time. Its plan was a wholly modern one, with an open loggia looking out over the city and framed between towers. One of its original features was the important share given to painting: there were views of cities—Rome, Milan, Genoa, Florence, Venice and Naples—painted by Pinturicchio '*alla maniera de' Fiamminghi*'; and the chapel of St John the Baptist had its vault and walls entirely decorated by Mantegna with a network of panels, chiaroscuri and ornamental motifs which looked, according to Vasari, like the work of a miniaturist.

In the last years of the century building enterprise in Rome came to a stop. Alexander VI, with his Spanish

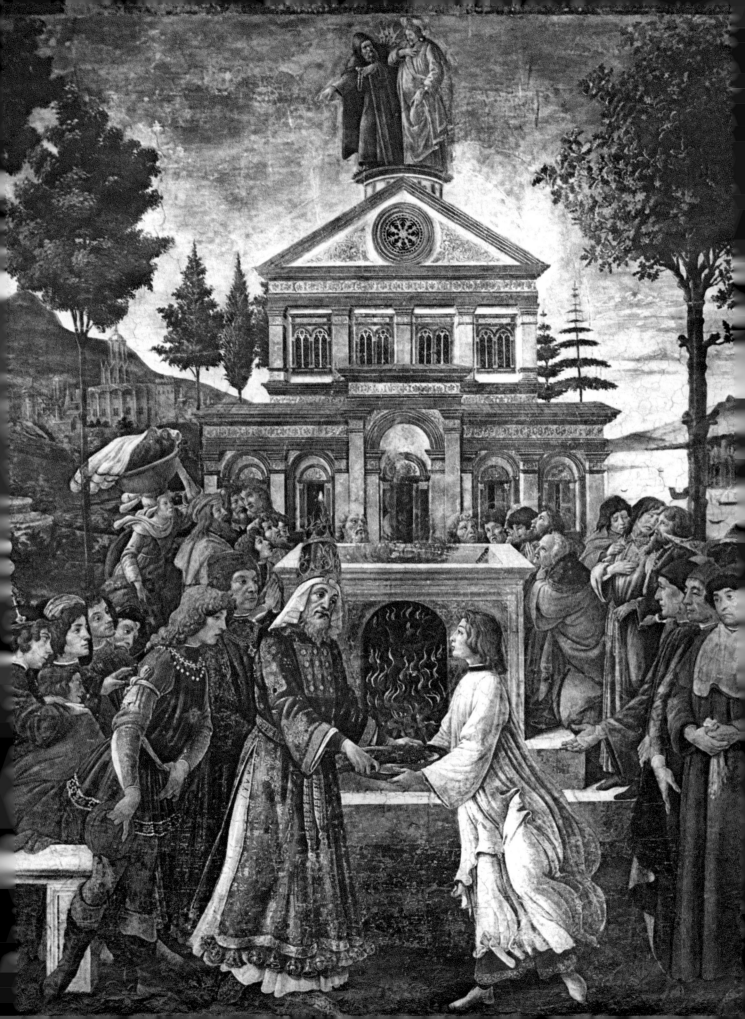

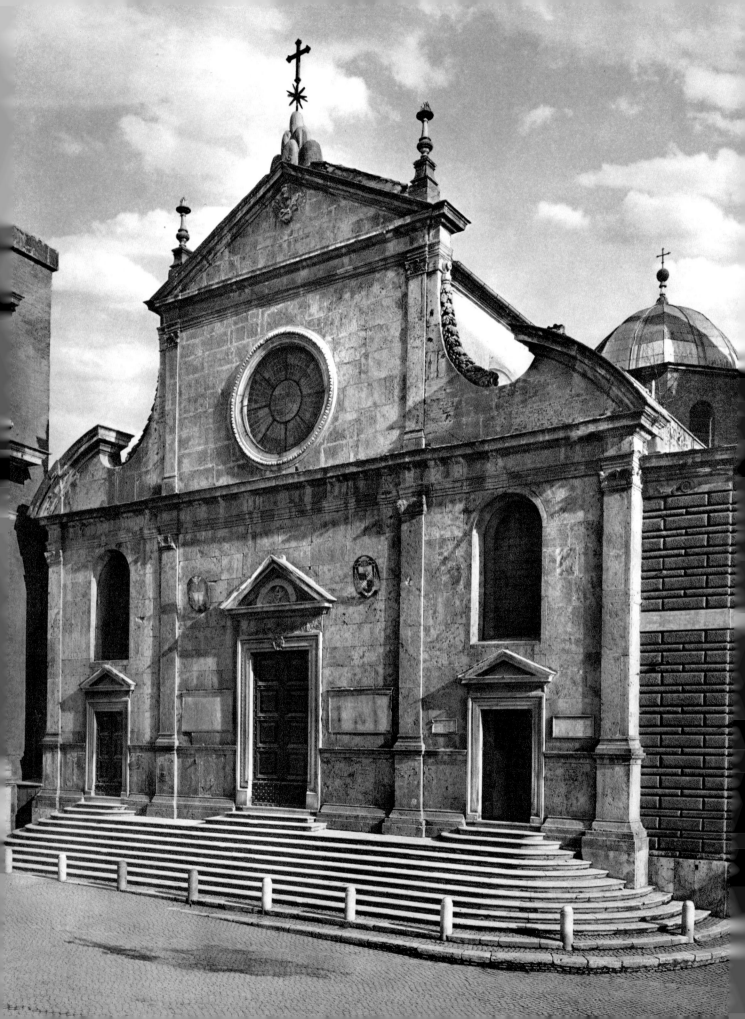

taste, tumultuous court and somewhat facile ostentation, was not attached to the Roman myth. Pinturicchio, who had painted a chapel in the Aracoeli (1490), decorated the Borgia apartments in the Vatican in a highly seasoned and often curious style: he reminds us of the 1482 masters. In 1500 Rome appeared poor and badly maintened. Yet her historical prestige had never stood so high.

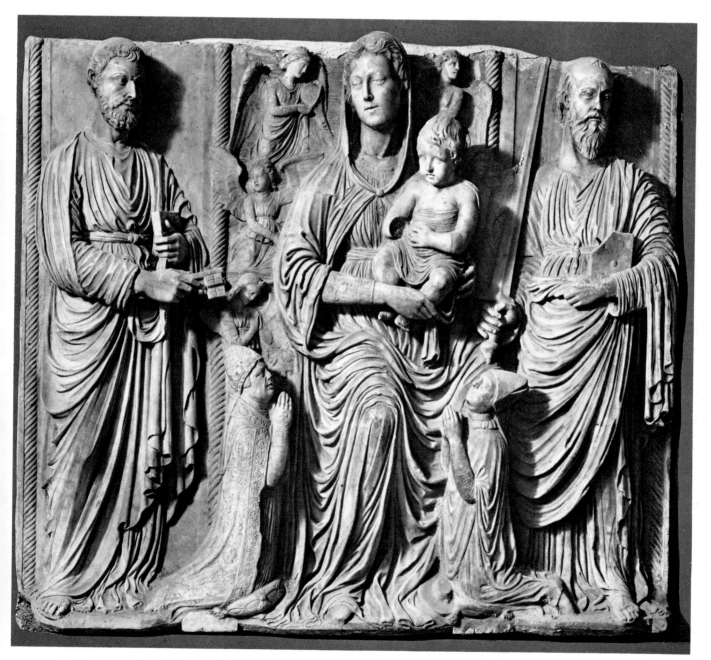

104 - ISAIA DA PISA. VIRGIN AND CHILD WITH SS. PETER AND PAUL AND TWO DONORS — VATICAN.

103 - ROME. SANTA MARIA DEL POPOLO.

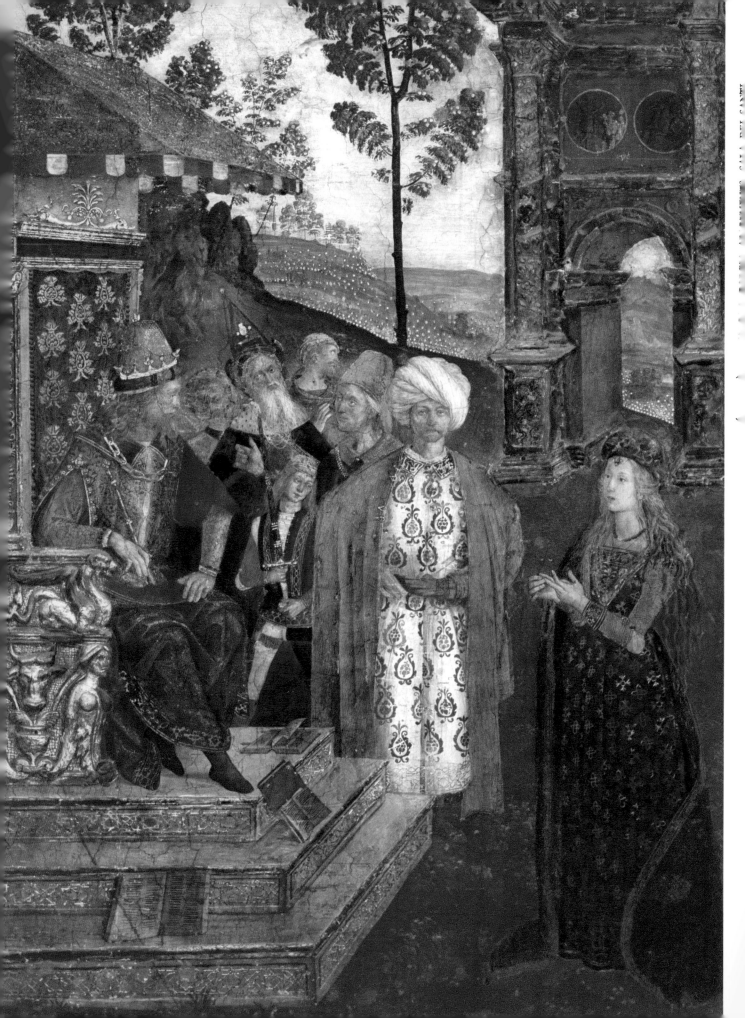

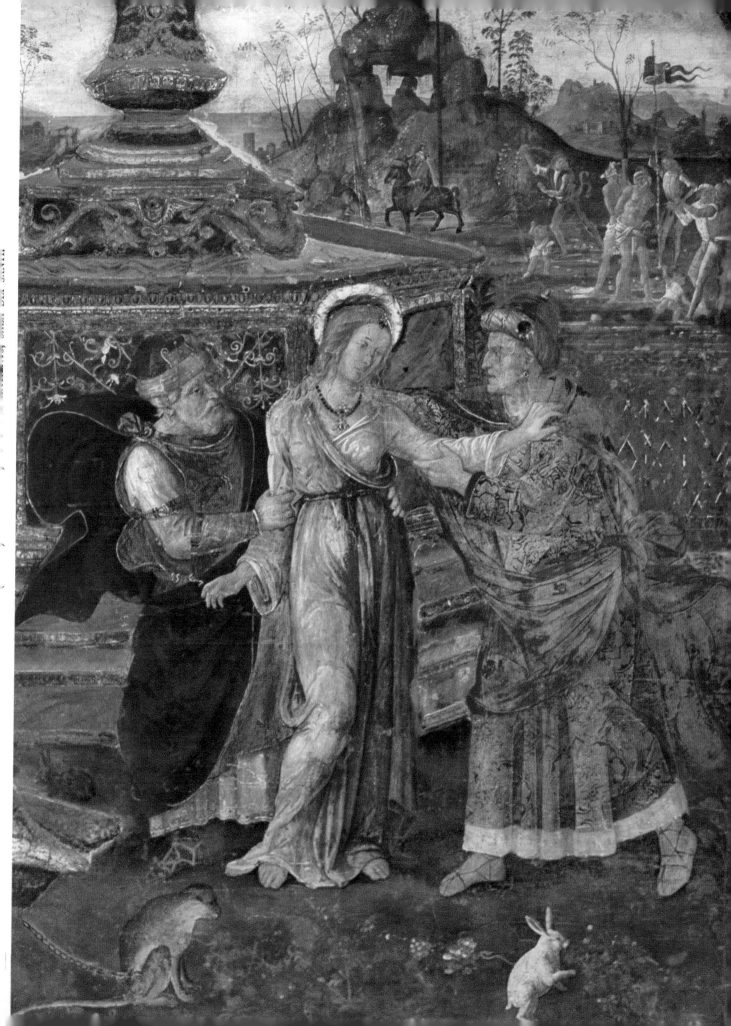

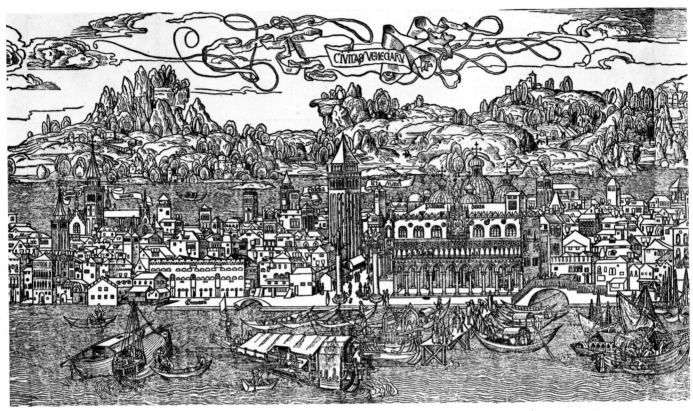

107 - ERHARDUS REEUWICH. VIEW OF VENICE (DETAIL) — PARIS, BIBLIOTHÈQUE NATIONALE.

VENICE

As regards Venice, what was new at this time was not her contribution to the common culture—this had never been more slight: it was rather her definitive entry into Italy, with all that this represented, after having stayed aloof for five centuries, as a Mediterranean empire moored to the peninsula. With the annexation of Padua, and then of Brescia and Bergamo, Venice had accepted contact with the continental forms of art; at the same time there had been a gradual exhaustion at home, and even in the mosaics of St Mark's the aid of Tuscan masters was being frequently enlisted. There was a first period, round about 1430-1440, when these dominated but still did not destroy the edifice of Byzantine tradition in Venetian art. Certainly the presence of Lippi and Donatello in Padua could not leave the Venetian workshops indifferent. After them Mantegna, though he did not set up a studio on the lagoon or produce for Venice, attracted and held the attention of the enamellers and ornamentists of Murano. But the development was slow: Venice is the only city in Italy to give the impression

114

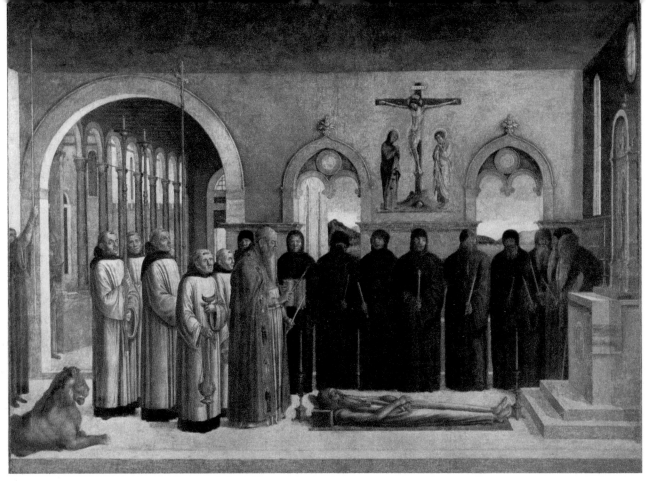

that there may have been, about 1460, an attitude of
suspicion towards the new styles and a real defensive
reaction against them. When, in 1461, Francesco Sforza
wished to have built for him, on the Grand Canal, an
important palace with Florentine rustication and a modern
layout, he sent for Filarete, who criticized 'el desegno
mal ordinato' of the Venetian architect who preceded him.
But the enterprise was never completed[11].

 After a moment of indecision, there was a sudden
new development in Venetian painting between 1470
and 1500, with consequences that could not have been
foreseen. Jacopo Bellini had already become aware of
the problems and of the urgency of a reform, which his
sons, especially Giovanni, were to carry out, with the
necessary prudence and skill. The decisive date, as will
be seen, is about 1475. The great series of decorative
paintings commissioned by the Serenissima in imitation
of the Signorie of the peninsula led the studios to speed
up the movement. The cycle of paintings in the Sala del
Gran Consiglio, executed in 1480 and destroyed in 1577,
was one of the occasions for shaping the new style;
so also, perhaps, was the cycle of very large pictures

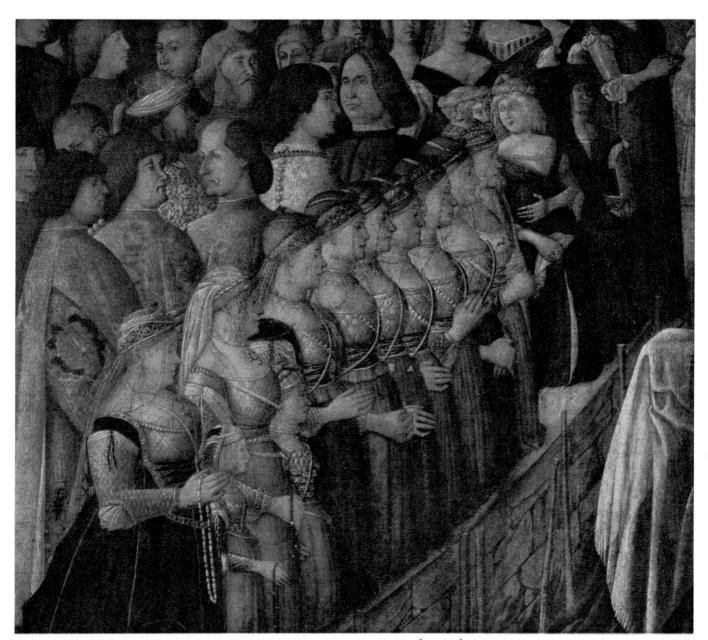

109 - GENTILE BELLINI. MIRACLE OF THE TRUE CROSS (DETAIL) — VENICE, ACCADEMIA.

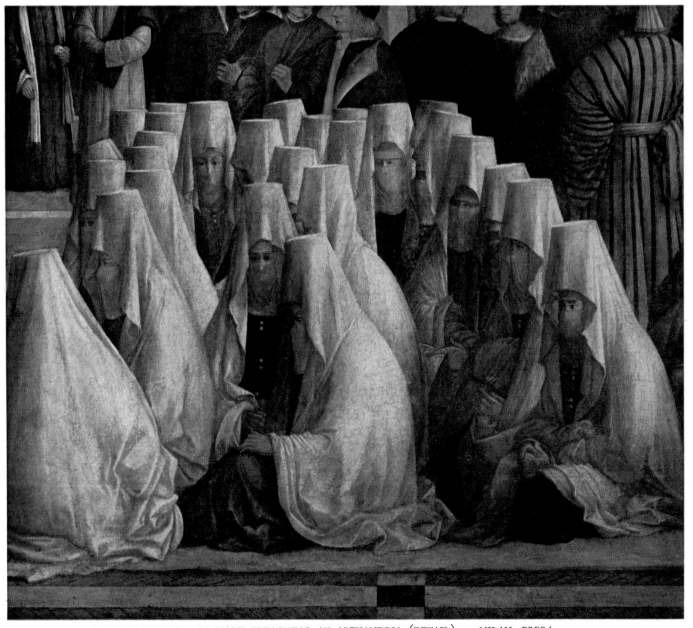

110 - GENTILE BELLINI. ST MARK PREACHING AT ALEXANDRIA (DETAIL) — MILAN, BRERA.

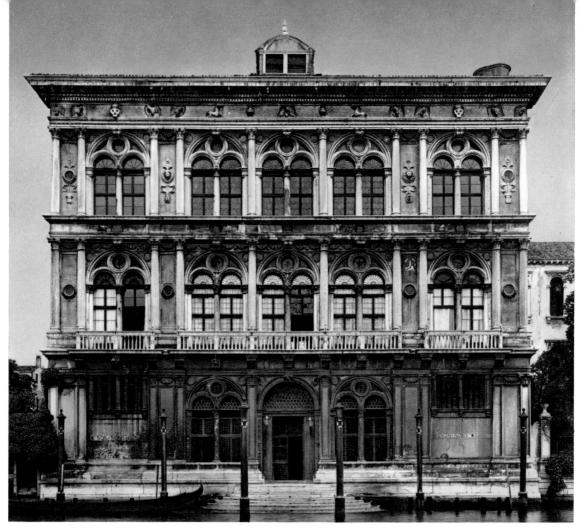

111 - M. CODUCCI AND THE LOMBARDI. VENICE, PALAZZO VENDRAMIN-CALERGI, FAÇADE.

painted by Gentile Bellini, Mansueti, Carpaccio and others for the Scuola di San Giovanni Evangelisto from 1494 onwards, in a building just finished by Coducci.

This architect found a lively solution into the problem of integrating modern—that is 'regular'—architecture into the Venetian setting. The Palazzo Vendramin Calergi (1481 onwards) is an Albertian composition translated into the colourful style of Venice, just as the Palazzo Riario is an adaptation of this to the Roman style. In the church of San Giovanni Crisostomo (after 1497) Coducci returned to the Greek cross type. His whole activity was aimed at perpetuating the peculiarly Venetian qualities within systems of new forms. To do this had become necessary at the moment when, in the Foscari arch and in Santa Maria dei Miracoli, a certain Lombard domination was increasing. This, both in decorative sculpture and in architecture, had been constantly in evidence since 1470, in the persons of Antonio Rizzo, the Bregnos and Lombardi brothers. Their ornate style, effects of contrast

118

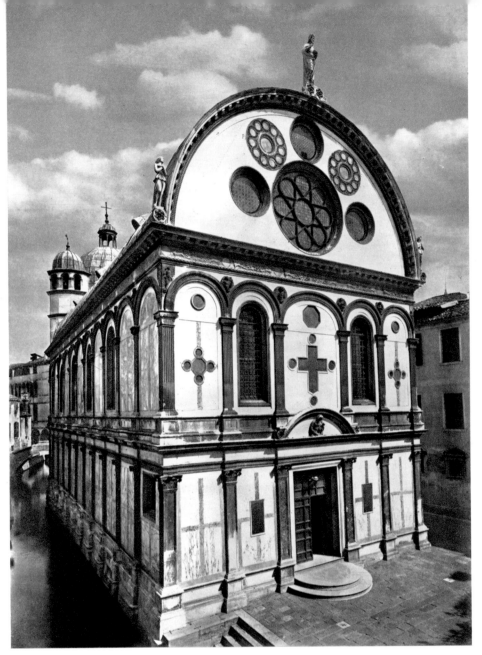

112 - PIETRO LOMBARDO AND HIS SONS. VENICE, SANTA MARIA DEI MIRACOLI, FAÇADE.

and delicate relief carving suited Venice; on the monu-
mental staircase of the Ducal Palace—later called the Scala
dei Giganti—Rizzo covered what was the most solemn
architectural composition of the end of the century with
a delicate screen of ornamentation.

It would not be true to describe what happened as
the capitulation of the stronghold of the Byzantine and
Gothic to a new style: rather, it was the absorption into
these of the characteristics of Adriatic taste. Venice
yielded in appearance only, and by returning to her palaeo-
Christian inheritance. She still honoured the picturesque,
even picturelike, treatment of screen-like façades, even

113 - HERO AND LEANDER. — PARIS, BIBLIOTHÈQUE NATIONALE.

when these were provided with classical orders; and in painting, the studios of the Rialto were soon suggesting all kinds of formulae and devices making for 'tonal' harmony, while in sculpture Venice became one of the centres of small-scale work '*all' antica.*'

Above all, Venice laid a lasting hold on the revolutionary technique of printing and engraving. A city of shipbuilders and traders, Venice had never been considered a centre of culture: in his 1460 letter B. Dei accused the Venetians of being the profiteers of modern Italy and of relying on '*duchatazzi d'oro*' and not on creative labour. But now, in about 1480, by an extraordinary reversal, Venice found herself extending her role of broker to the field of culture. Humanism developed slowly, through the Latin studies instituted by Ermolao Barbaro in 1484, the activities of Bernardo Bembo (ex-ambassador to Florence) and, after 1490, the arrival of Aldus Manutius and the establishment of his printing works close by Sant' Agostino. Her reaction to the new philosophies was one of eclecticism, based on a lively feeling for communication and sociability. This vocation found a unique chance of exercise in the book, which answered well to the practical and concrete interests of the Venetians, and which printing was turning into an important commercial product. Between 1489 (when Giovanni da Spira founded

114 - HYPNEROTOMACHIA. GROUP IN A GARDEN — PARIS, BIBLIOTHÈQUE NATIONALE.

the first Venetian printing-house) and 1500, more than
two hundred printing shops came into being. In a few
years Venice was at the head of yet another market; she
produced some of the master-pieces of the new art, and
brought together typography and wood engraving to
serve the spread of the most modern forms. Thus it was
in Venice—recently converted—that the boldest examples
of the return to Antiquity, of the spacious woodcut, and
of the clear and elegant page, were to be found.

PRESSURE FROM THE EXTREMES

In the middle of the century the Gothic style, common to the whole of the West but already strongly diversified in the different countries, underwent a final transformation. We can distinguish opposing tendencies, characteristic of 'late Gothic.' Under the shock caused by the Eyckian revolution and by the art of Sluter, a shock reinforced by the introduction of Italian 'space' and the Italian repertory of motifs, there was a movement towards extreme solutions and a certain dissociation of the components of the style. On the one hand there was, both in architectural elements and in sculpture, a return to the monumentality of the romantic period, manifested in massive forms like the semicircular arch and a thickening of the walls; on the other hand, the display of fantasy and luxuriance of ornamentation characteristic of late Gothic increased, stimulated by the new naturalism. So what we see is the parallel development of what might be called a neo-Romanesque style side by side with a hyper-Gothic. At the same time architecture, sculpture and painting were developing at quite different speeds.

This disintegration of Gothic in its last phase coincided with the beginnings of the Italian Renaissance. One may, indeed, interpret the Italian Renaissance as the Mediterranean variant, and an original continuation, of the general crisis in the arts; or, inversely, one may interpret this crisis as a prelude to the North Italian Renaissance, which would then incorporate Southern elements. It hardly matters which, since the evolution of art in the peninsula was not homogeneous, and the European success of what came to be called the Renaissance could not be explained without taking into account the analogies between the flamboyant and a certain 'romanticism of Antiquity,' or those between the Romanesque tendency and the Italian taste for the sturdy structures of Roman architecture. In France, from 1490

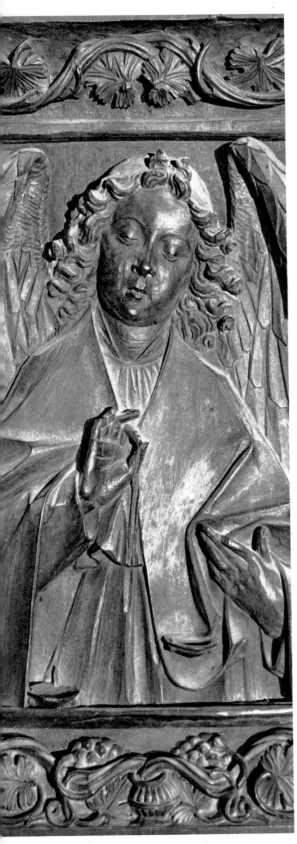

onwards, because of the division or doubling within the Gothic, osmosis with Italy became so much easier that this country was soon one of the favoured places for the spread of 'Italianism' throughout Europe. The confrontation to be observed at the end of the fifteenth century was not between Gothic and classical art, but between a loosened and unstable Gothic and an Italian formal order at the experimental stage. It is therefore essential to examine whether the flowering of the styles took place equally all over Italy, in what forms it took place, and at which centres. But this question is itself incapable of being clearly resolved, unless account is taken of the permeability of Italian art to the forms prevailing in the neighbouring regions, especially to those of German sculpture and Flemish painting.

The number of wooden statues and reliefs of German origin to be found in various parts of Italy was relatively important at the end of the fifteenth century. When in 1468 the Franciscans of Venice wished to ennoble the choir of the Frari with elaborate stalls, they commissioned for the backs of these a series of fifty panels—head-and-shoulders images of Christ and various saints—from a master who came from Strasbourg: he collaborated with Marco Cozzi of Venice who was responsible for the frames, with their vine-leaf motifs, and for the marquetry panels[12]. The contrast between the two styles could not be more explicit: the robust yet broken-up style of the Alsatian sculptor places him close to Gerhaert von Leyden and H. Iselin, while Cozzi's small abstract figures are exquisite examples of Quattrocento 'cubism' and should be compared with the art of the Lendinara brothers (disciples of Piero della Francesca who, indeed, were themselves later to be found working in the Sacristy of the Frari). This is no isolated case: the number of Bavarian or Rhineland sculptors known to have worked in Italy at this time is extremely high. They came to execute sharply etched stalls, *pietàs* and devotional panels crowded with figures, for the sanctuaries of Friuli, the Veneto and the Marches, and even in the Abruzzi. Their broken-up forms and faces full of pathos were not rejected, any more than were the packed and realistic Flemish *tavolette*, in the Campagna or in Tuscany. While the popular success of the expressionist carvings must be given its due, we must also realize that in the Quattrocento the art patrons with a taste for modern pieces had nearly always a fibre in them that was sympathetic to the style of Northern Europe—at least to those aspects of its sculpture and painting with something fresh, something of a renewal, to offer.

116 - STALLS (DETAIL). SANTA MARIA DEI FRARI, VENICE.

117 - MARQUETRY (DETAIL): STILL LIFE — PISA, CATHEDRAL SACRISTY.

The meeting of the two manners in the Frari stalls shows clearly that the Venetians who ran the monastery were anxious to combine the advantages of two modernities and to unite two styles—perhaps without perceiving how opposed they were. After all, what was happening in painting was not clear-cut either: the style of the Vivarinis aims at an enamelled and lucid effect, of which undoubtedly there was no conception north of the Alps, but it does so within a repertory of dry, clear and broken-up forms, continuous with one part of Gothic taste. The same, to some extent, might be said of Mantegna. In 1468 Giovanni Bellini had not yet adopted so precise a course. Yet Dürer, when for reasons not fully known he came to Italy in 1495, and again in 1505, was to receive from these painters a shock he would never forget: what he found there, in the Bellinis and their circle, quickly revealed to him the authenticity of an artistic world to which Gothic practice had no access, and which his Italian friends were by now aware they could offer him.

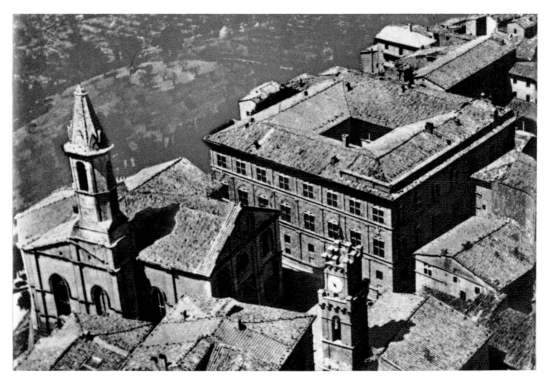

118 - PIENZA. AERIAL VIEW.

Venice may be considered a special case; but the situation in Milan was not so very different, and we may clarify the picture completely by taking the creation of the city of Pienza, south of Siena, as typical of the climate prevailing in the years around 1460. Aeneas Sylvius had left Italy in 1432; he returned in 1458 to become Pope Pius II. He then called upon Rossellino—who was evidently recommended by Alberti—to raise, on the site of the village of Corsignano, the new city that was to bear the Pontiff's name. The palace was directly inspired by the Palazzo Rucellai—which had had no sequel in Florence (this building in Pienza proves, at least, that it had aroused interest in Rome)—and occupies one side of a trapezoidal piazza about the cathedral. The instructions for the building of the cathedral are precise, and the Pope's *commentarii* explicit: it is a church of the hall type with a nave and two aisles, altogether Gothic, and these have no frescoes, only the stained-glass windows, which make it a house of coloured glass, while the vaults are covered with a blue wash and a sprinkling of golden stars. All this conforms to the wishes of the Pope, *qui exemplar apud germanos in Austria vidisset*. What we have, then, is a church in the German style side by side with a copy of the most 'modern' palace of the time. The

126

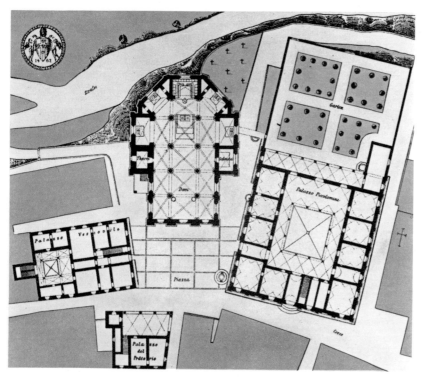

119 - AFTER MAYREDER. A PLAN OF PIENZA.

altarpieces in the church were entrusted to Sienese
painters (and these, it should be noted, were not all
chosen from the most advanced ones: Matteo di Giovanni,
Vecchietta, Giovanni di Paolo and Sano di Pietro.)

This was an instance of eclecticism bound up with a
personal experience; but there are too many instances of
similar decisions in all parts of Italy for us to be able to
escape the generalization that, in the fifteenth century,
Italian patrons of the arts were not afraid of the typical
examples of foreign art at the precise moment when
they were trying to evolve their own style. They looked
everywhere at the same time: just as the delicacy of
Hellenism (with Desiderio) and all the elements of
palaeo-Christian art were added to the Roman foundation
of a Donatello or a Mantegna to make up what is called
the 'style of Antiquity,' so Burgundian solidity, Flemish
precision and German expressionism were easily brought
together to sustain a naturalism that aimed at modernity.
What strikes us as a combination of disparate elements and
a juxtaposition of diverse manners is simply evidence of
the Italian patrons' desire to be complete in all fields.
Sure of themselves as regards monumental order, they
let nothing escape them that might be useful in the
sculpture and painting of the North. They—and first

127

121 - DONATELLO. HIGH ALTAR (DETAIL): THE MIRACLE OF THE REPENTANT SON — PADUA, SANT' ANTONIO.

and foremost the Florentines—watched these closely. As Panofsky has said: 'the same Donatello who gives to his biblical figures the charm of the ancient world is the inventor of perspective relief, and introduced into sculpture the "free space" fundamentally rejected by Antiquity; the same Pollaiuolo who repeats to the point of satiety the formulas of antique pathos, paints landscapes *alla fiamminga*, and gives to his David a contemporary costume in which he treats the fabrics and furs with the same love as a Flemish painter.'

These foreign examples, then, stimulated and helped to shape the tendencies that were proper to Italian art. By about 1460 the general diffusion of Tuscan forms was an accomplished fact: its stimulus was everywhere. But this innovating contribution rested on an ambiguity: it included both a new will to expressiveness—destructive of the gentle charms of the Gothic—and a new insistence on style, of which the watchword was *maniera antica*. We are in the presence of two imperatives: intensity of

120 - DONATELLO. A PROPHET — FLORENCE, OPERA DEL DUOMO.

129

122 - ANTONIO POLLAIUOLO. TOMB OF POPE SIXTUS IV (DETAIL): ARITHMETIC — GROTTE VATICANE.

image, dignity of forms. To masters like Brunelleschi, Donatello and Filippo Lippi, the two were one: these men attained both at a blow. But after 1460—if our description is right— things became less simple: naturalism grew more complicated and required interpretation, while the grand style was confronted by the diversity of regional forms. As a result the main phenomenon of the years 1460 to 1490 seems to be the appearance of two extreme trends—that mark the originality of the period, together with a manifest determination to face up to the most complicated requirements and to assert the artistic intention uncompromisingly. They deserve to be considered separately, because they tended to apply to different arts and to give these a common measure. One of them is based on intensity of expression and on the repertory of forms, the other on power of style. The former is 'Squarcionism,' with its initial centre at Padua; the other is the line of inspiration that came from Piero della Francesca, and showed itself in its full vigour at Urbino.

123 - ANTONIO AND PIERO POLLAIUOLO. TOBIAS AND THE ARCHANGEL RAPHAEL — TURIN, PINACOTECA.

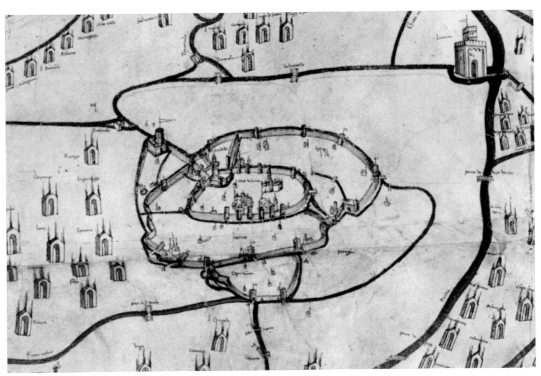

124 - PLAN OF PADUA (DETAIL) — PADUA, MUSEO CIVICO.

PADUA: SQUARCIONISM

The Paduan circle has not always received sufficient attention, and the attempts to restore to it its due importance have not always succeeded. The delicate—and highly controversial—point is how to assess Squarcione himself and his studio. Squarcione, who was born in 1397 (or 1394) and died in 1468, began as a tailor and was, according to the documents, given commissions for small jobs—decorating shrines, painting armorial bearings, etc.—rather than major works; the polyptych (Museo Civico, Padua) which he painted for the family of Leo de Lazara in 1449-1452—that is to say, on the eve of the great collective enterprise of the Eremitani—is a harsh and curious piece. But already in 1431 Squarcione was collecting pupils and in the course of his career he had, it seems, more than a hundred: hence his fame as '*pictorum gymnasiarca et primum omnium sui temporis.*' The texts of the contracts are extremely precise, and show that the master meant to derive concrete advantages from a teaching whose resources he sets out in detail—construction in perspective, presentation of models, and so on. A series of law-suits with his pupils—including Marco Zoppo (in 1455) and Mantegna (in 1456) have created

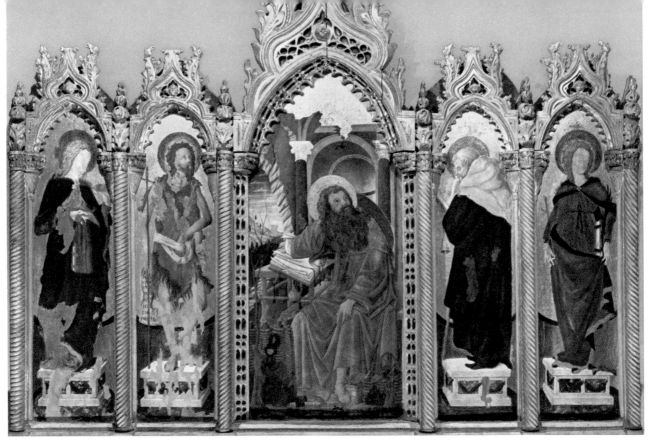

125 - FRANCESCO SQUARCIONE. POLYPTYCH — PADUA.

an atmosphere of suspicion about this teacher, in spite of
the extreme consideration with which he is treated by the
local historians, especially Scardeone (who had access to
autobiographical notes). Scardeone credits him—'*sicut ipse
de se asserit*'—with 137 pupils, and speaks of travels in Greece
and Italy and of remarkable teaching methods. These prai-
ses have been subjected to merciless criticism, from which
there emerges what looks like the figure of a charlatan
—the travels seem quite possibly to have been a profitable
fable—and a profiteer: the young pupils were enticed by
fine promises and then, to put it bluntly, exploited.
Squarcione may have had no share in the chapel in the
Eremitani, the commission for which went direct to
Giovanni d'Alemagna and Antonio Vivarini on the one
hand, to Pizzolo and Mantegna on the other. Some of
these accusations are impressive, especially those of
Angelo di Bartolomeo, the last apprentice engaged by
Squarcione in 1465, who stated at the trial: '*el fa finta de
insegnar, ma nol pol insegnar perché nol sa*'—a strange case of
breach of trust' But a clue is given by the chroniclers of
the time. 'Squarcione possessed many statues and pic-
tures,' says Scardeone, 'of which he made more use, in
instructing Andrea (Mantegna) and the other pupils,
than he did of models supplied by himself.' Vasari

133

states that the Paduan master trained Mantegna by means of casts from ancient carvings and pictures 'which came from various cities, especially from Tuscany and from Rome.' Thus Squarcione's part as an eminent teacher is reduced, so it seems, to the more modest one of a clever individual—perhaps rather a swindler—who knew how to get the most out of his collections.

Behind the controversy about the personality of the Paduan impresario there lurks the question of the sources of Mantegna's art: were they indigenous sources, which would make the hard heroic style the supreme flowering of a school? Or were they foreign sources, chiefly Tuscan? The problem of the Renaissance in Northern Italy hinges much upon the right interpretation of the somewhat confused studio of a tailor who became a painter. Where he did succeed, it seems, was in breaking down all the compartments between the disciplines. This craftsman who played the humanist went much further than Ghiberti, who contemplated his few specimens from Antiquity with veneration but without humour. It is very difficult to form a clear idea of what Squarcione's gallery contained; but in such a region, where the trade in statues, medals, inscriptions, etc., went back a long way, he must have possessed some interesting pieces, some of them, perhaps, brought back from Greece (as had Cyriacus of Ancona at the same period). These fragments were no doubt chosen not for their 'harmony' but for their vigour, their strangeness, and Squarcione invited his pupils to exploit them for all they were worth in their paintings. This was the prelude to that injudicious overloading with archaeological detail, the most explicit exponent of which turned out to be his pupil Mantegna. We shall never manage to reconstitute the lessons of Squarcione, but he played his part in attracting attention to new subjects, and one may attribute to him, without fear of contradiction, a precocious bringing together of archaeology and modern art. This is not to deny that he drew profit from the exceptional circumstances created by the successive visits of Florentine masters to Padua: Filippo Lippi (1434-1437), Uccello (before 1435), Donatello (from 1443 to 1452) and Andrea del Castagno (who in 1452 was responsible for the San Tarasio chapel frescoes in the church of San Zaccaria in Venice). Squarcione made play with curiosities; the Florentines demonstrated style.

A fresh vitality had been breathed into the expressionism of Northern Italy by the example of Donatello: in his low reliefs (or *storie*), a complex space packed with events yet dominated by perspective; and in his figures, a

majesty almost unknown till then, an unflagging boldness of accent in the treatment of drapery, and a Roman quality nevertheless subordinate to faces that are fearsomely impressive and filled with passion. These conflicting elements are all caught together and given unity. The radicalism of the sculptor had never been better understood than by those Paduan craftsmen, who let the great inspiration escape them, of course, but delighted in formulating a new and often rather absurd repertory of motifs. Garlands of fruit and foliage, apparently strung on a steel wire, were soon sagging in front of small, heavily outlined, prominently moulded niches. A whole world of pseudo-Antiquity condensed here, in sharp contrast to the subtle silhouettes and harmonious motifs which Pisanello had derived from the sarcophagi. The Veronese painter had died only in 1455 or thereabouts; the Squarcionesques were deliberately moving away from his 'flowery manner,' and they could legitimately consider that they were striking a fatal blow at the graces of Gothic in its last manifestations, and at its inevitable excess of charm.

In their taste for a powerful image, the Paduan circle —continuing to follow Donatello's example—showed preference for uncommon iconographic themes, allowing of emphatic pathos: thus Donatello's theme of the *Dead Christ* separated by *putti* was treated again by Schiavone in the polyptych that dates from about 1460, and again in about 1472, in a picture by Crivelli. The result was an imagery so bold as to be macabre, so complicated as to be sometimes absurd, a mingling of decoration and imitation whose effects are sometimes surrealist, making us wonder whether what lies behind them is humour or an irresistible love of the fantastic.

The sheer number of artists who show traces of it, having passed through Padua and visited the *boutique fantasque*, is worth attention. They are to be found widely scattered: if a precise enough chronology of the movement could ever be established, an important chapter of the history of the Quattrocento would immediately be recorded. Mantegna stood out from it in triumphant eminence with his work in the Eremitani. As early as 1457 Ludovico Gonzaga tried to entice him to Mantua; in the following year he succeeded and, in January 1459, was flattering himself that he held in his service '*egregium virum Andream Mantegnam pictorem de Padua.*' Thus Padua lost her star. She still had Squarcione with his shop, his methods and his models from Antiquity: he died in 1468. Who was there besides! Zoppo and

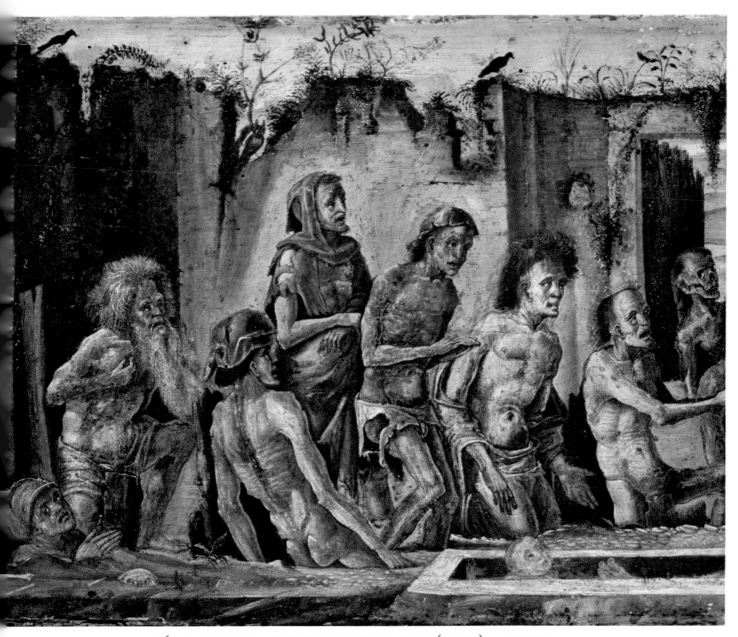

126 - B. PARENTINO. FRANCISCAN MYSTICAL SCENE (DETAIL) — VENICE.

Giorgio Chulinovitch (known as 'il Schiavone,' whose dry and broken-up manner was soon continued in a more inventive—and indeed aberrant— way by Bernardo di Porenzo, in a more relaxed way by Jacopo da Montagnana. The continuity is worth noting—it extended down to Paduan engraving at the end of the century, and to the sculpture of Riccio. It might be that 'Paduanism' possessed an upper register in Mantegna and a lower, more artisan-like one, in the so-called Squarcionesques.

127 - ANDREA MANTEGNA. TRIPTYCH (DETAIL) — THE CIRCUMCISION — FLORENCE, UFFIZI.

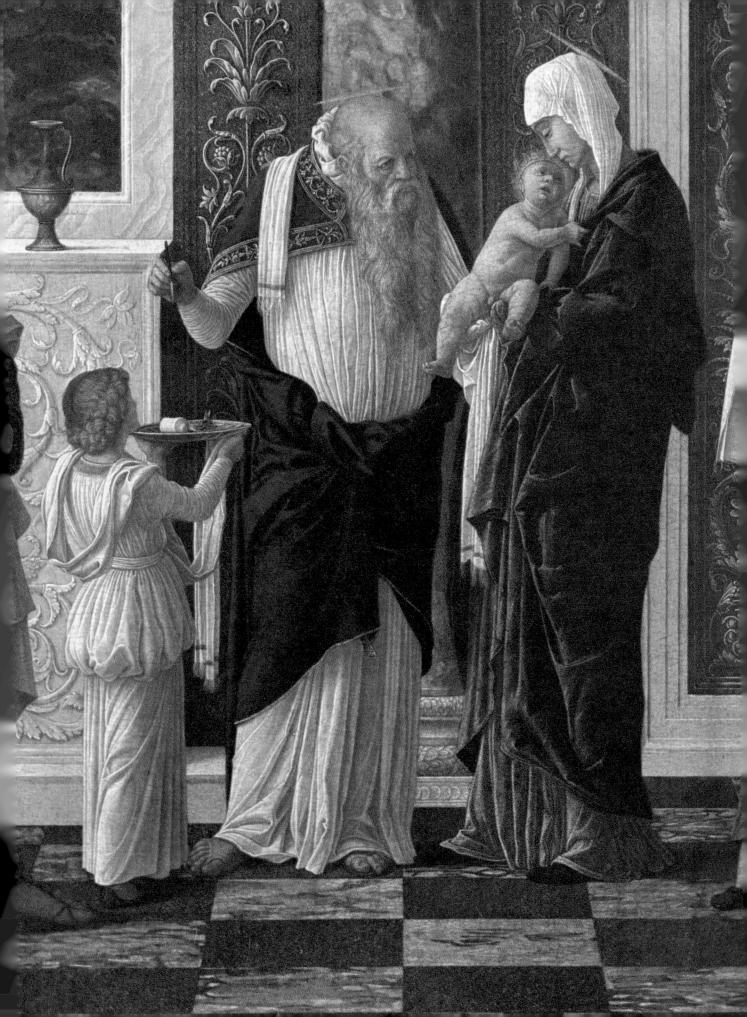

129 - IL SCHIAVONE. VIRGIN AND CHILD — BALTIMORE, WALTERS ART GALLERY.

128 - JACOPO DA MONTAGNANA. THE ARCHANGEL MICHAEL —
PADUA, BISHOP'S PALACE.

130 - IL SCHIAVONE. VIRGIN AND CHILD — TURIN, PINACOTECA.

131 - MARCO ZOPPO. VIRGIN AND CHILD
BOLOGNA, COLLEGIO DI SPAGNA.

OPERA DE ZOPPO DAROLO

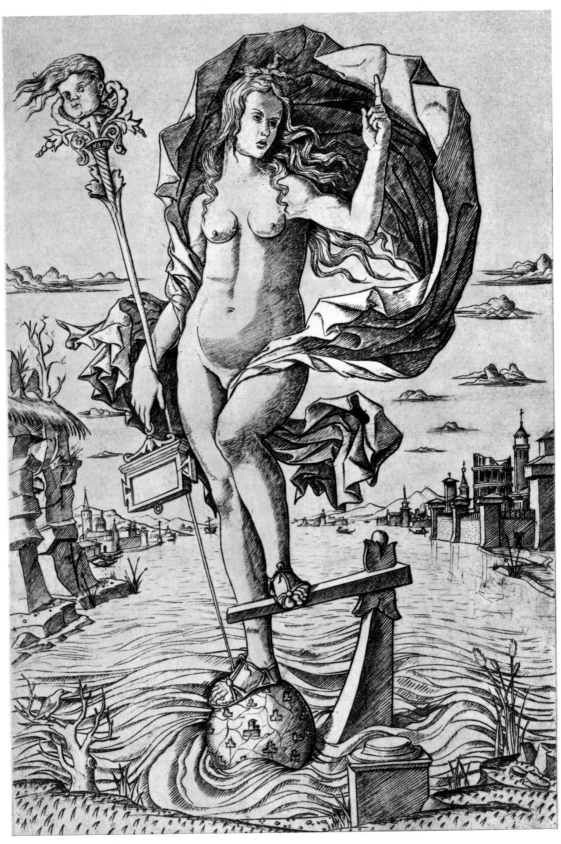

132 - NICOLETTO DA MODENA (ATTR.). FORTUNA — LONDON, BRITISH MUSEUM.

133 - ANDREA RICCIO. WARRIOR ON HORSEBACK —
LONDON, VICTORIA AND ALBERT MUSEUM.

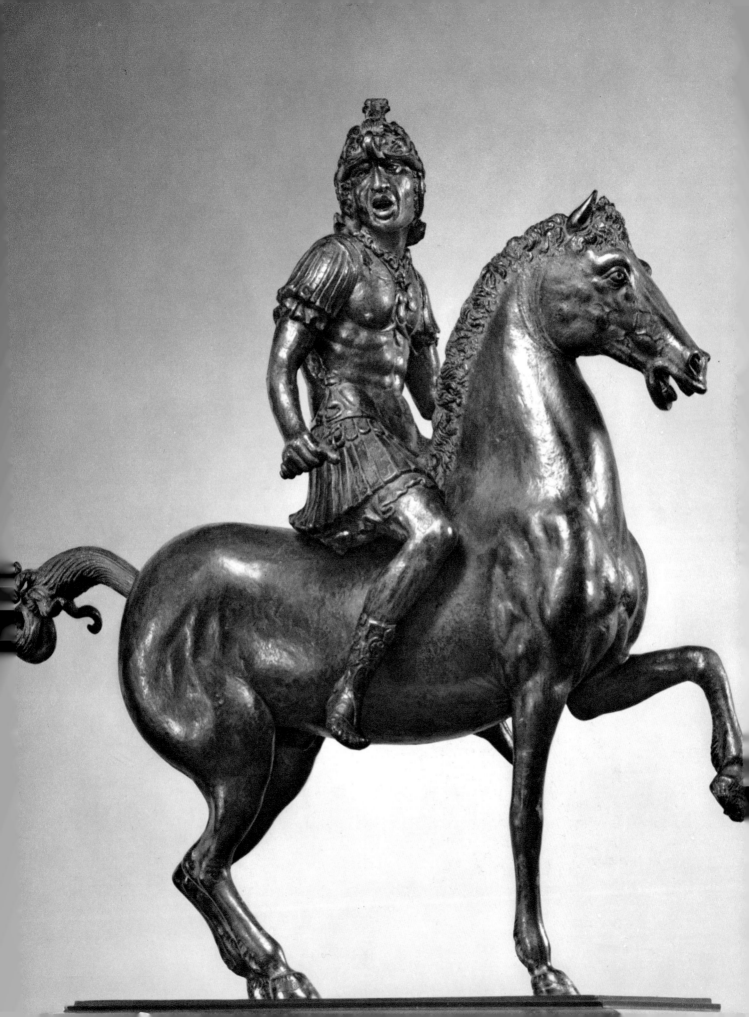

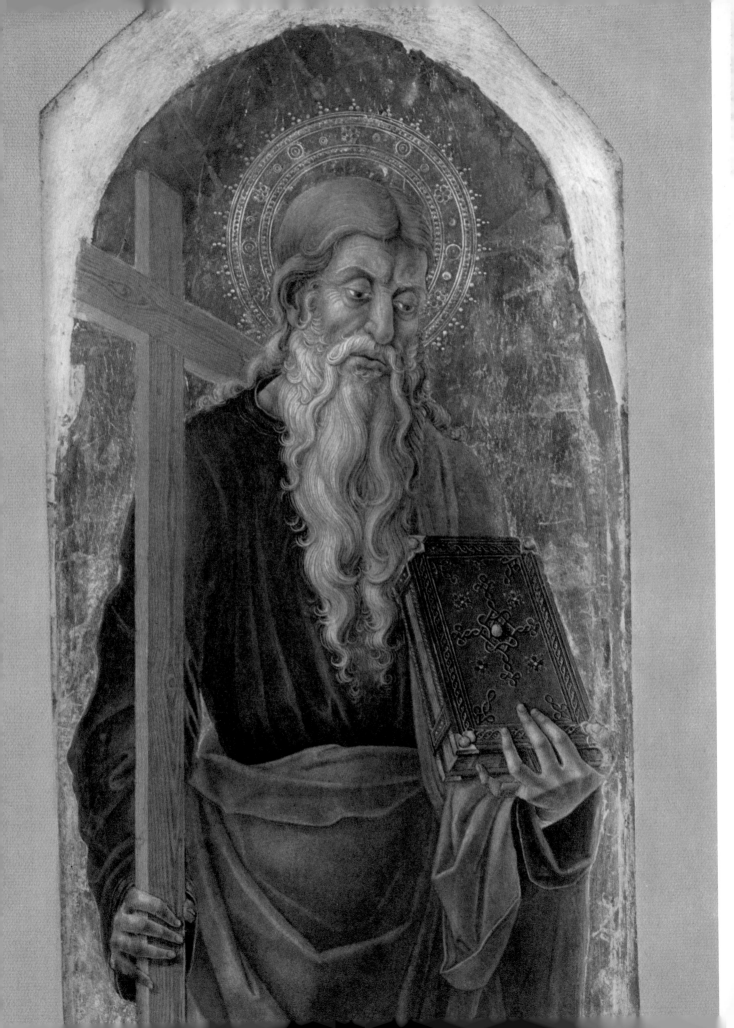

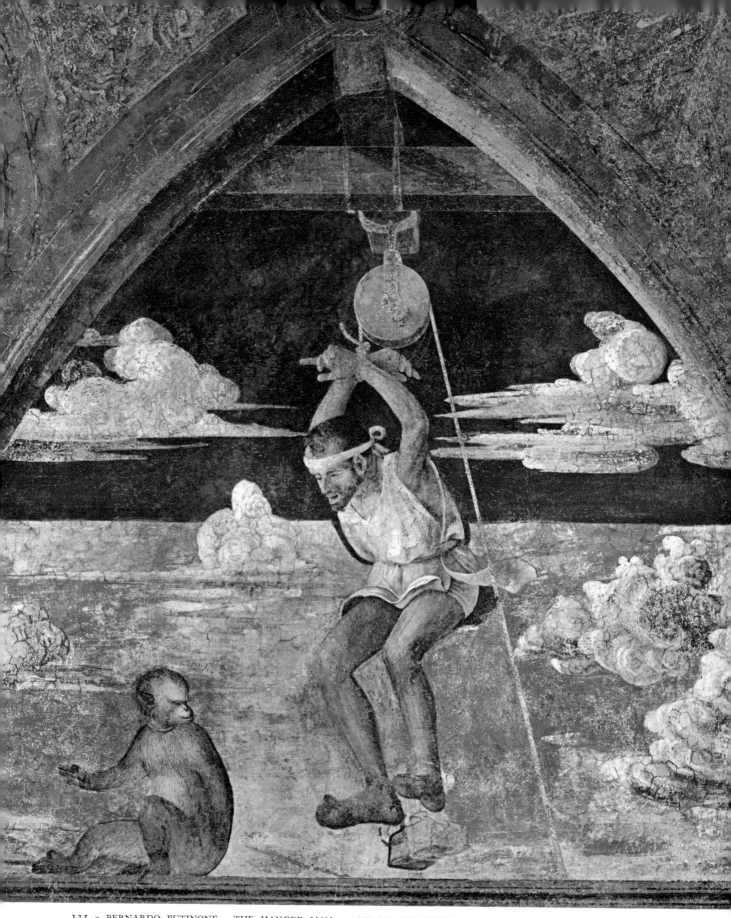

135 - BERNARDO BUTINONE. THE HANGED MAN — MILAN, SAN PIETRO IN GESSATE, CAPELLA GRIFI.

134 - BARTOLOMMEO VIVARINI. ST ANDREW — VENICE, ACCADEMIA.

145

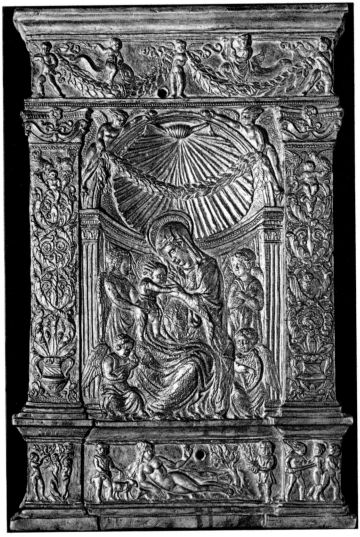

136 - FILARETE. VIRGIN AND CHILD — PARIS, LOUVRE.

In any case 'Squarcionism,' with the somewhat singular quality it had retained from its initiator, may be regarded as the final mutation of the Gothic forms under the pressure of naturalist curiosity, whose impulses were allowed to develop into a love of oddity, with its correlative, an exploitation of the remains of Antiquity treated (not always with any serious cultural aspiration) as *rariora*, or singularities; all this with a strong dose of decorative obsession and determined formalism. In short, it was the equivalent, in painting and in bronze sculpture, of what the Lombards were working out in marble and other stone, but with more imagination and less taste. This line of inspiration was carried to Verona by Domenico Morone, manifested itself in Liberale, stimulated

146

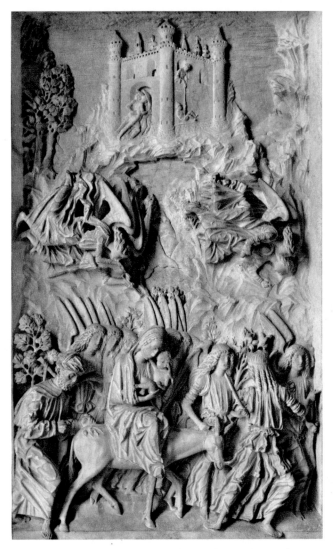

137 - G. A. AMADEO. THE FLIGHT INTO EGYPT — PARMA.

Venice through Jacopo Bellini and Bartolomeo Vivarini, acted on the Marches through Crivelli, was an important influence on the Ferrarese artists (who understood what remained to be done in order to draw from it an elevated style) and may have exerted a direct influence on Lombardy through Foppa. All things considered, it forms a kind of ideal province, which might well be marked out on the map—a powerful cultural and artistic massif (for which it would be an exaggeration to assign the whole responsibility to Mantegna) extending alongside Venice, just as the Marches-Umbria massif (to be discussed later) extends alongside Florence. It was one of the formations peculiar to the last part of the Quattrocento, and was destined to dissolve at the coming of the great style[13].

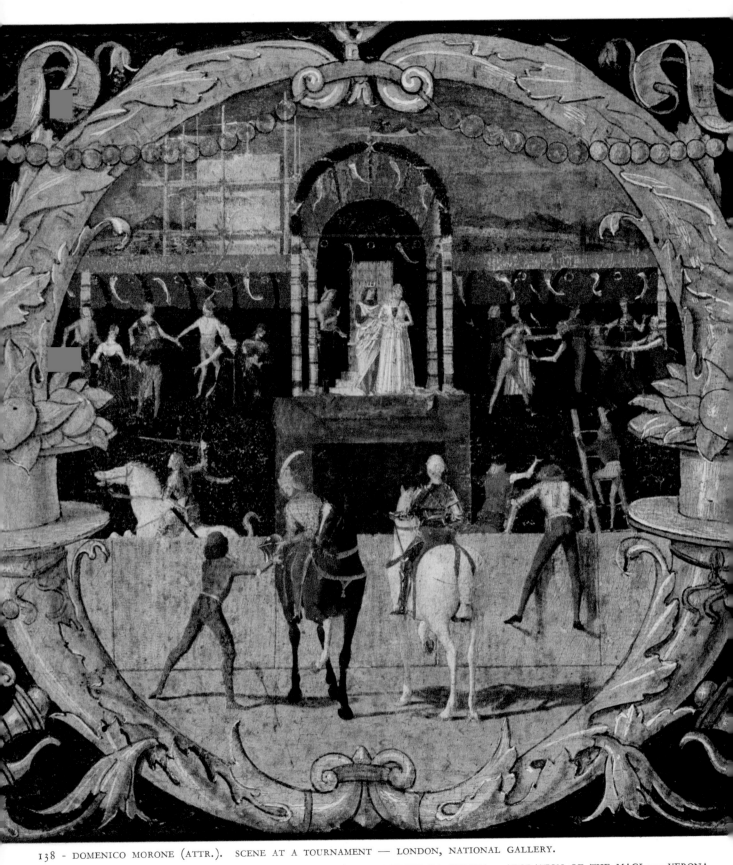

138 - DOMENICO MORONE (ATTR.). SCENE AT A TOURNAMENT — LONDON, NATIONAL GALLERY.

139 - LIBERALE DA VERONA. ADORATION OF THE MAGI — VERONA.

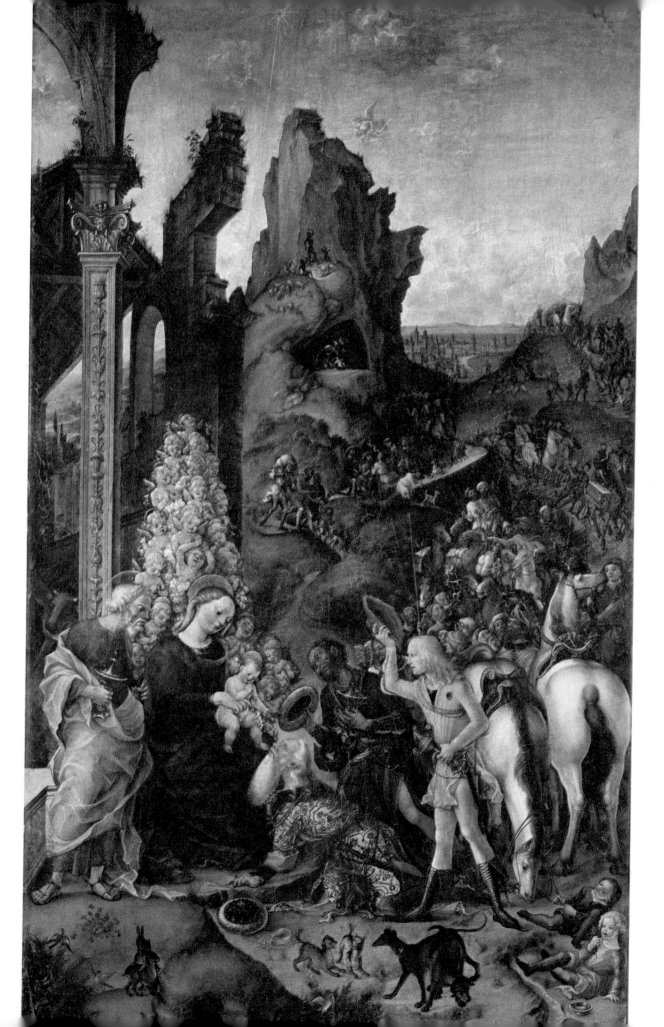

141 - CARLO CRIVELLI. POLYPTYCH (DETAIL) : PIETA — ASCOLI PICENO CATHEDRAL.

140 - CARLO CRIVELLI. TRIPTYCH (DETAIL): ST MARY MAGDALENE —
 MONTEFIORE DELL'ASO, SANTA LUCIA.

143 - SCHOOL OF FERRARA. VIRGIN AND CHILD — EDINBURGH.

142 - F. DEL COSSA. THE MONTH OF MARCH (1ST DECADE)
FERRARA, SCHIFANOIA PALACE. 153

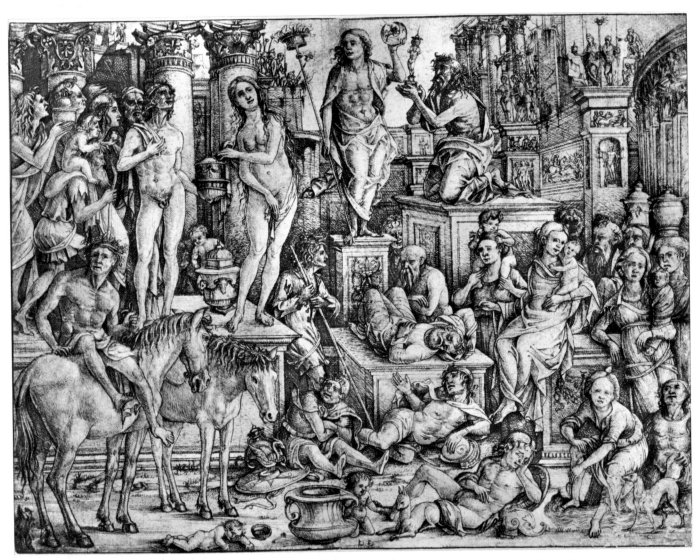

144 - MASTER SIGNING HIMSELF 'P. P.' ALLEGORY: THE TRIUMPH OF THE MOON — LONDON, BRITISH MUSEUM.

145 - ALLEGORY: THE TRIUMPH OF THE MOON (DETAIL).

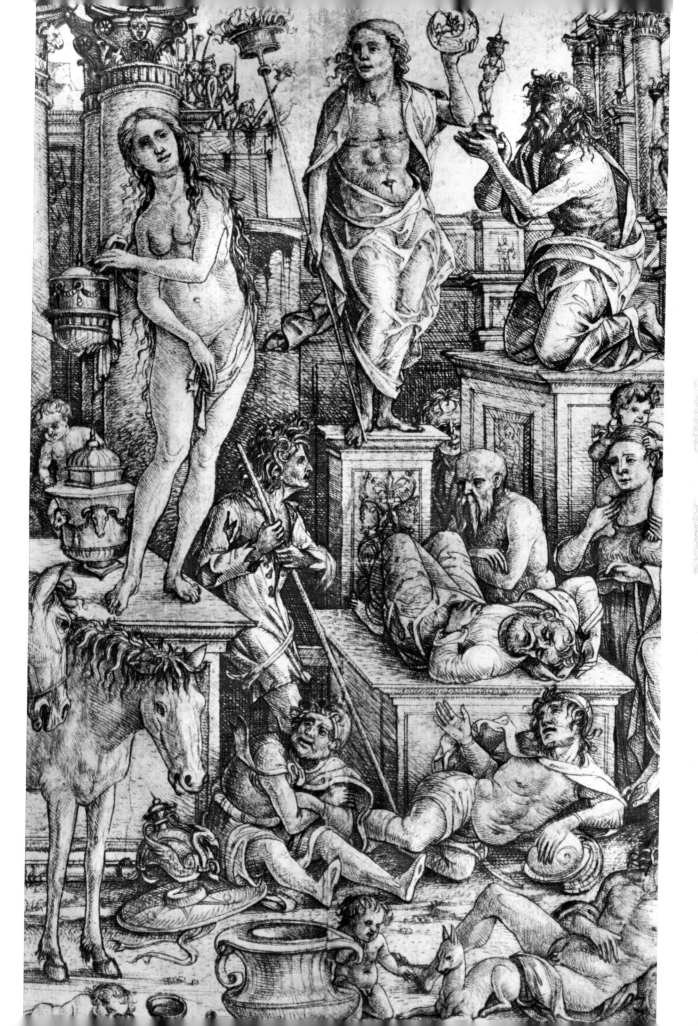

146 - BARNARDINO PARENTINO. TEMPTATION OF ST ANTONY — ROME, GALLERIA DORIA.

The arrival of the Lendinara brothers after 1462 to embellish the choir of the Santo with marquetry stalls, is worth attention: it produced one of those meetings of incompatibles, of which the period offers so many examples. The geometrical and abstract style of the two *intarsiatori* belonged to a line of inspiration as remote from Paduanism as could be, as it often came from Urbino—that intellectual anti-Padua. It is true that in the style of the figures, especially of the painted Madonnas which can be attributed to them, the twisted and constrained drawing of the Lendinara's corresponds, to some extent, to the Paduan type; there were even, before long, oddities of composition in some of the intarsia panels.

But on the whole, marquetry remained an art which escaped from the Squarcionesque side of Paduanism. This was not true of sculpture: especially in bronze in the cases of Bellano and later of Riccio, it remained closely bound up with that style, sharing its spirit of fantasy and inventive curiosity. Above all, Squarcionism found its most effective continuation in the art of engraving, which developed a wealth of ornamental motifs round about 1490. There is, for instance, the work of a late fifteenth-century Paduan engraver, which has been regrouped about a print erroneously entitled a *Triumph of Silenus* (it is really a 'Triumph of the Moon,' and therefore part of a series on the planets). His work is characterized by an erudite style of drawing, a very lively taste for accumulated detail and a strong curiosity—its quality might indeed be called the 'archaeological fantastic.' It has been supposed that the device—PP—which figures on these engravings indicates not the engraver but the author of the original drawings, and the name of Bernardino Parentino has been put forward: he placed the signature P.P. (*Parentinus Pictor*) on a graphic composition—an allegory of Victory—which is very close to the print in question. All this bears witness to the strength of Squarcionesque romanticism, and authorizes us to consider it as the cultural basis that supported a certain sort of love of the marvellous in both decorative sculpture and architecture. It would be wrong to separate it from the tendency so clearly represented by Filarete and Amadeo in Lombardy.

Paduan miniature painting in the last third of the century cannot be clearly demarcated; but a late addition to the spreading influence of Squarcionism was made by Liberale da Verona. Born in Verona in about 1445, he lived to be eighty. He came to Padua before he was twenty, and must have seen the flowering and triumph of Squarcionism in a number of places. In due course he himself became its carrier to the school of Siena; he was invited there by the General of the Olivetans to paint some liturgical books, and was retained by Cardinal Piccolomini to work for the cathedral from 1466 to 1476, being joined, in 1472, by a colleague, Girolamo da Cremona. Their activity as illuminators, which is continued in such a masterpiece as the *Christ* of Viterbo (1472) was important for Siena. Siena, like Verona and Padua, moved to the second place, and Rome—a city that, in 1470, was not much more than a literary fiction—developed, with Raphael and his group, the noble and lasting version of the artistic archaeology of the 'Squarcionisti.'

147 - LIBERALE DA VERONA. CALLING OF ST MATTHEW — SIENA.

157

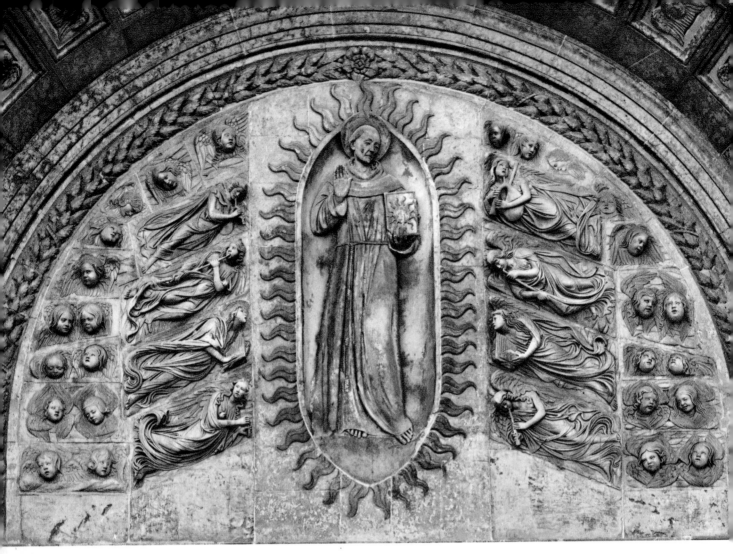

148 - AGOSTINO DI DUCCIO. PERUGIA, SAN BERNARDINO, TYMPANUM.

THE NOBLE STYLE OF URBINO AND ITS CONSEQUENCES

During the period 1470-1490, Perugia became a vital point for the history of painting—in many respects more important than Florence. The development that took place there illustrates very clearly the powerful action which was required in order to raise the whole conception of art, an action which, it seems to us, must be attributed to the example set by Piero della Francesca. Perugia in about 1460 was—far more than Siena—the centre of all the pretty forms and devices of that exquisite art, whose expression in architecture is the façade of the Oratory of San Bernardino (1457-1461) by Agostino di Duccio: the painters Giovanni Boccati, Bonfigli and Caporali were elaborating a kind of refined concoction of the colourful manners of Fra Angelico, Domenico Veneziano and Benozzo Gozzoli. Their art aged quickly, but something of its suavity and elegance persisted in the

149 - AGOSTINO DI DUCCIO. PERUGIA, SAN BERNARDINO, FAÇADE.

158

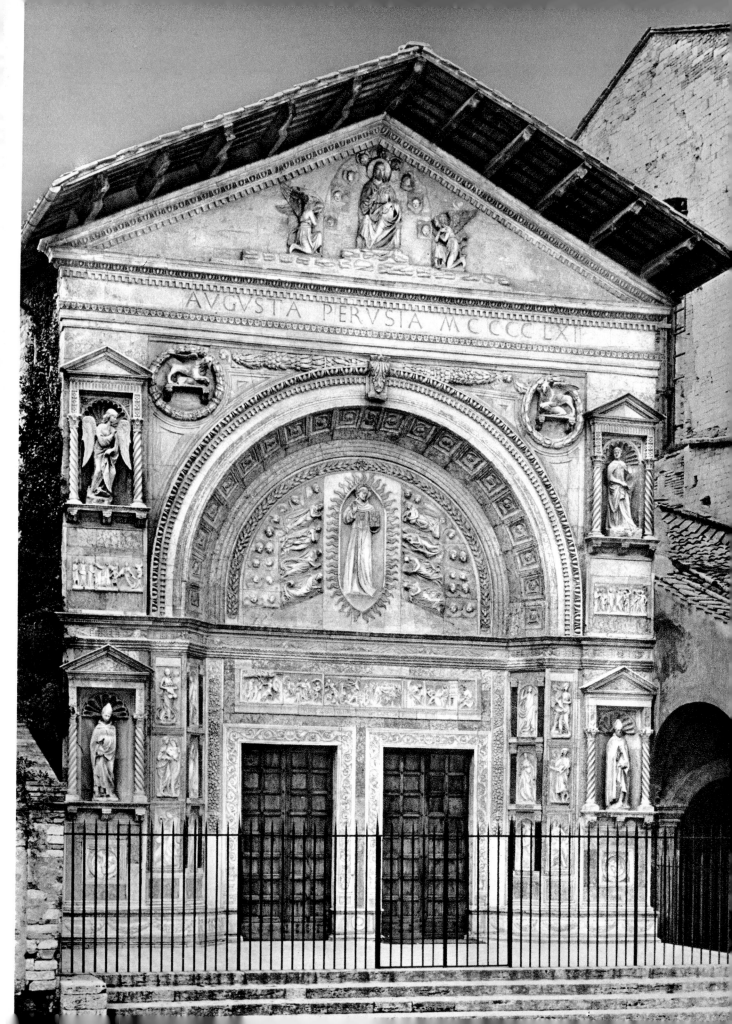

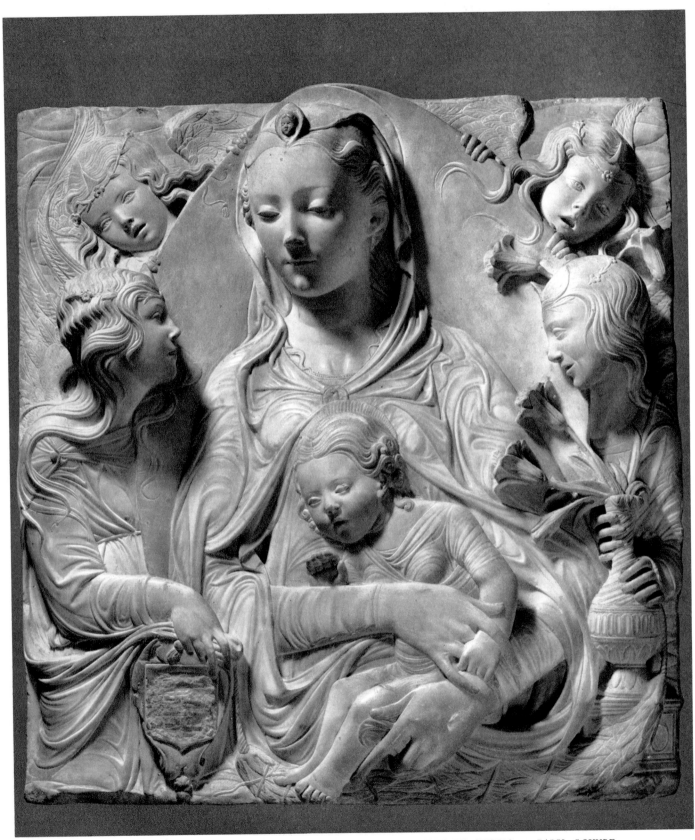

150 - AGOSTINO DI DUCCIO. VIRGIN AND CHILD SURROUNDED BY ANGELS — PARIS, LOUVRE.

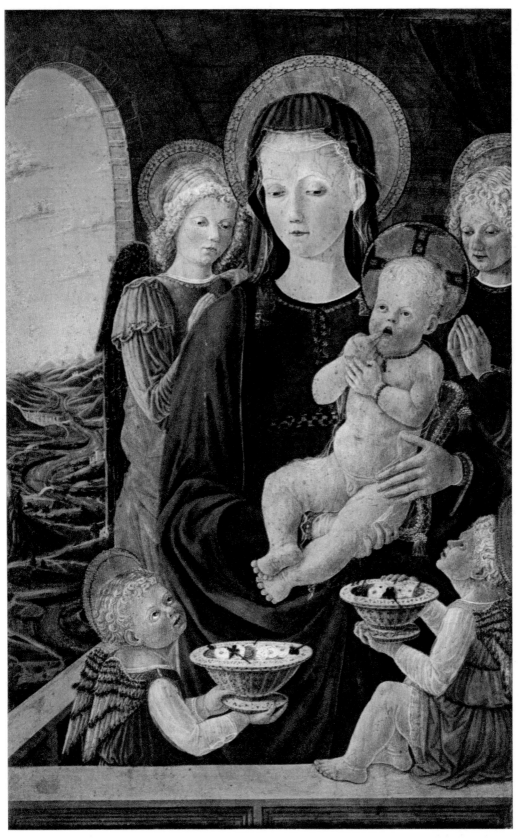

151 - GIOVANNI DI BOCCATI. VIRGIN AND CHILD SURROUNDED BY ANGELS — SETTIGNANO, BERENSON COLL.

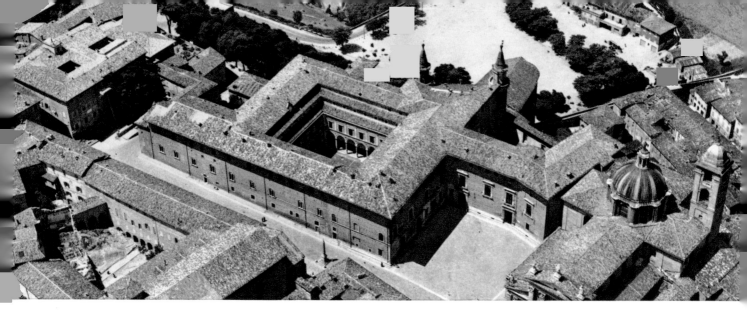

work of the two major artists who were to dominate the end of the century, Fiorenzo di Lorenzo and Pietro Vanucci (known as Perugino). They worked together on the most significant decorative ensemble of that privileged moment, the ravishing series of seven panels of the *Life of St Bernardino* (1473), which embodies the triumph of that rose-pink, magic, dream-like architecture which is one of the great inventions of the Quattrocento. Two discoveries were to draw Perugino out of that charming but minor line of inspiration: the firm style of painting, practised in Florence by Verrochio, and also the grand style, the idea of which would never have come to him without Piero. Perugino evolved, and all too quickly arrived at a depressing commercial formula, while Fiorenzo di Lorenzo restricted himself, all too soon, to the provincial speciality. In spite of everything, Perugino's achievement was so lofty that the young Raphael Sanzio came down from Urbino to Perugia to work with the fashionable master on the decoration of the *Cambio* (1500).

Perhaps Raphael's only reason for joining this school was to find in Perugino the last echo of Piero's art; and it seems legitimate to turn away in order to stress what was happening, between 1460 and 1490, in another of those ideal provinces, a short-lived one, the zone where the influence of Piero della Francesca was exercised. In it his presence renders intelligible certain ambitious developments and a changed accent, not only in painting but in all the arts. To take the city of Urbino as the centre of this domain is not arbitrary: Piero went there early, and seems to have found the environment he needed. It was there, also, that he painted his last pictures, the

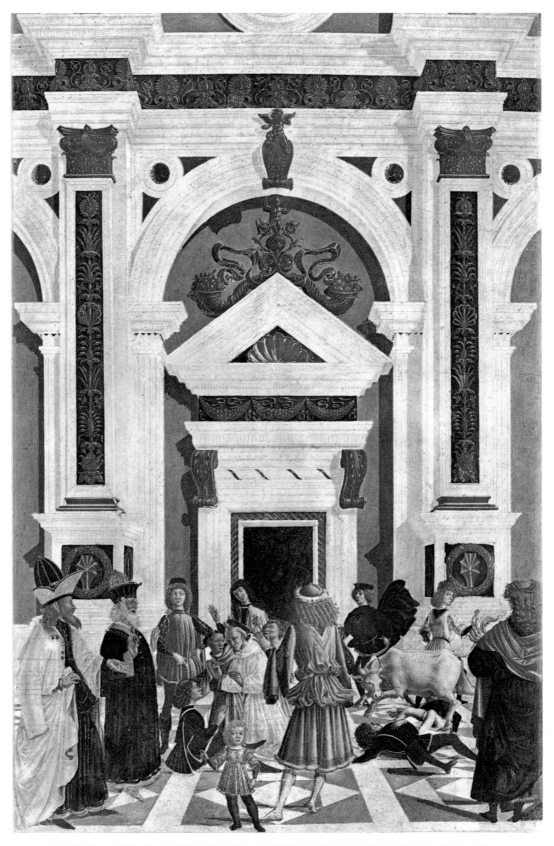

153 - PERUGINO. LIFE OF ST BERNARDINO. HEALING OF THE MAN INJURED BY A BULL.
PERUGIA, NATIONAL GALLERY OF UMBRIA.

double portrait of Federico da Montefeltro and Battista Sforza (1465), the Sinigallia *Madonna*, and the Montefeltro *pala* (*c.* 1495). Everything suggests that we should situate there the centre of gravity of a noble and abstract inspiration which, theoretically, was the counterbalance to that of Padua and, in fact, was often intertwined with it.

Baldassare Castiglione chose, as the setting for his description of the accomplished man in his book *The Courtier*, conversations supposed to have taken place in Urbino in 1506. The book begins with the praises of its marvellous situation, where the healthy air and a wonderful Apennine landscape had continued to delight those admirable princes, Federico da Montefeltro (1422-1482) and his son Guidobaldo (1472-1508): 'Among other enterprises worthy of praise, he [Federico] raised on the rocky site of Urbino a palace—which is, according to the general opinion, the most beautiful in all Italy; and so judiciously did he arrange it that it was no lon a palace, but a city in the form of a palace'. Th applies to the scale of the building rather than to its its construction, in fact, extended over thirty ye involved a succession of architects. It began as mous gothic edifice and developed to include more classical motifs, among which is the grand courtyard; but the final impression is a mixe or several styles are juxtaposed, and even the decoratic composite, with some features that are Florentine and others that are Lombardo-Venetian. It is difficult to determine which artists were responsible for which parts, and perhaps the prince's direction has received too much credit. Nonetheless, the originality of the 'climate' of Urbino is unmistakeable.

Federico was attracted by literature: he loved the flattering dedications of the humanists, he bought the finest manuscripts, and in each of his castles he had built for himself a study *(studiolo)* which was unique. Urbino became celebrated for its spectacles: in 1474, for instance, the *Judgment of Cupid* (for having tried to ravish Persephone from Pluto) was staged in honour of Federico of Aragon. But the feature most relevant to our problem— it has already been stressed—was that concentration of mathematical culture represented by the conjunction of Alberti, Piero della Francesca and Pacioli. Around 1480 to 1490 Urbino was, so to speak, the capital of 'intellectual' art—the art, or rather, the learned play, of the artist-mathematicians. Pacioli stated this in that well-known passage of his *Summa*, in which the constellation of the masters is grouped about Piero.

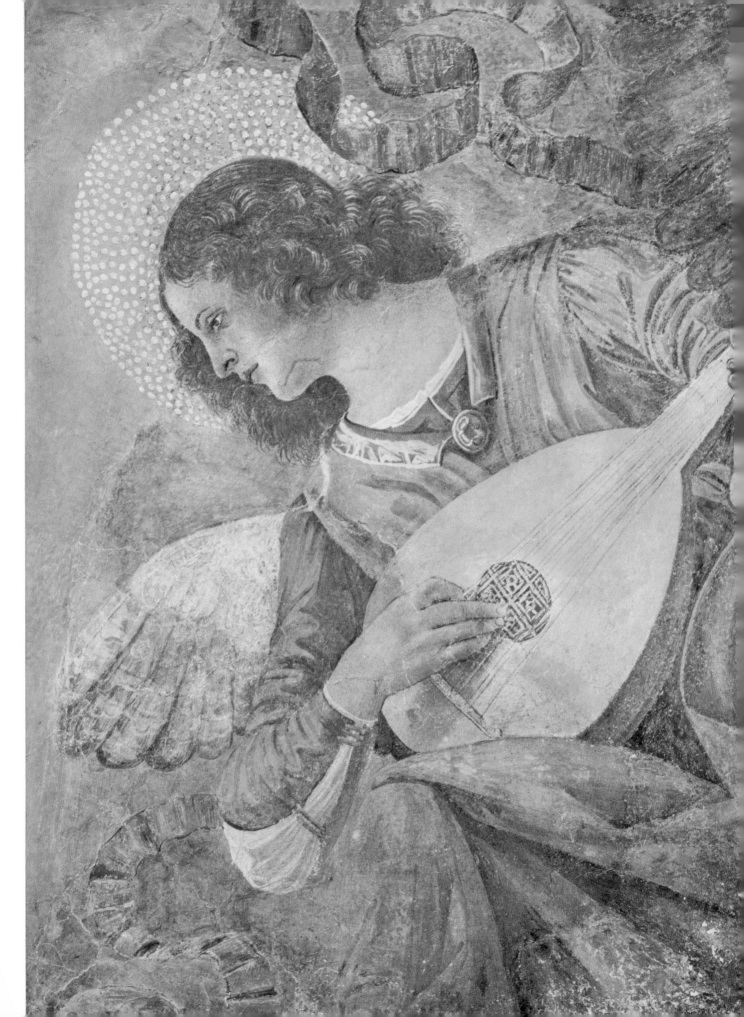

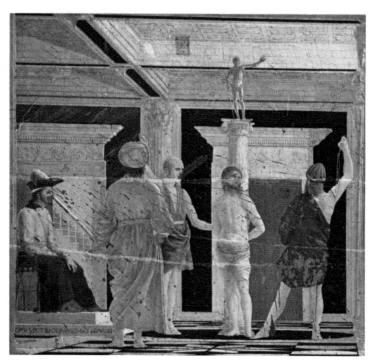

157 - PIERO DELLA FRANCESCA. THE FLAGELLATION — URBINO.

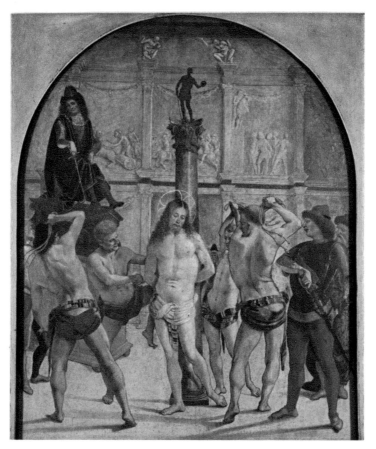

158 - LUCA SIGNORELLI. THE FLAGELLATION — MILAN, BRERA.

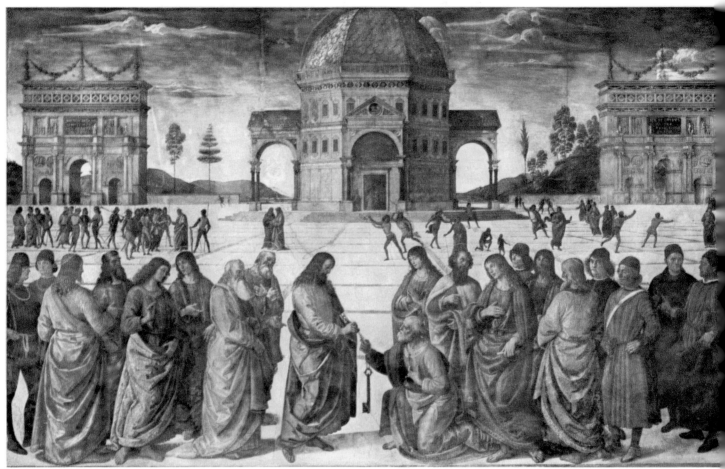

159 - PERUGINO. THE REMISSION OF THE KEYS TO ST PETER — VATICAN, SISTINE CHAPEL.

He is supported by a lesser author, Camillo Leonardo (of Pesaro), in *De lapidibus* (1502): 'In painting there is no-one above Piero of Borgo and Melozzo of Ferrara [lapse for Forlì] who with precision and with an admirable practical and theoretical strictness have established the geometrical laws of painting upon rules of arithmetic and perspective, as their works show clearly, and as the ancients did not succeed in doing so fully.'

These indications make it fairly easy to grasp the significance that 'Pierfrancescanism' had in painting, and to group together a few great examples: the *Life of the Virgin* (1464) by Lorenzo da Viterbo, Melozzo's beginning of the Vatican Library frescoes (1464), Signorelli's *Flagellation* (c. 1475) and—one of the summits—Perugino's *Remission of the Keys* (1481) in the Sistine Chapel. That imperious articulation of the space, that architectural setting out of the forms, the way they are centred, the multiple relations between full-face and profile obtained

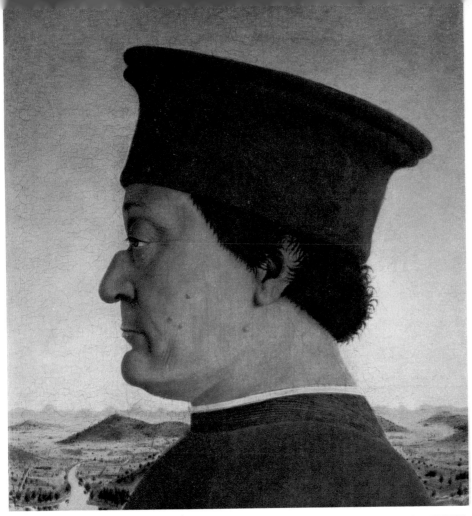

160 - PIERO DELLA FRANCESCA. FEDERICO DA MONTEFELTRO — FLORENCE, UFFIZI.

by simple, boldly emphasized pivotings of the figures, together with an impeccable scansion of the empty and the full areas, produced a majestic overall impression. Here was a grave plasticity that lay at the opposite pole to the complicated manipulation of Squarcionism, and a vigour that expressly contradicted the sharp effect of the ornamental detail and of the artificially silhouetted figures in the work of the Paduans. Putting as it did an unlimited trust in architecture, this art quite naturally accorded a place to the classical orders and, what was more, provided a field of exercise for the constructive imagination. No better confirmation can be found than the importance acquired by the forms of architecture —side by side with 'geometrical' objects—in intarsia decoration: marquetry was, in fact, given fresh life by the school of Piero, and its new qualities flowed directly from the graphic method of the artist-mathematicians. Its most memorable successes are to be seen in Urbino and at Gubbio.

In the city of the intellectuals and artists, at the

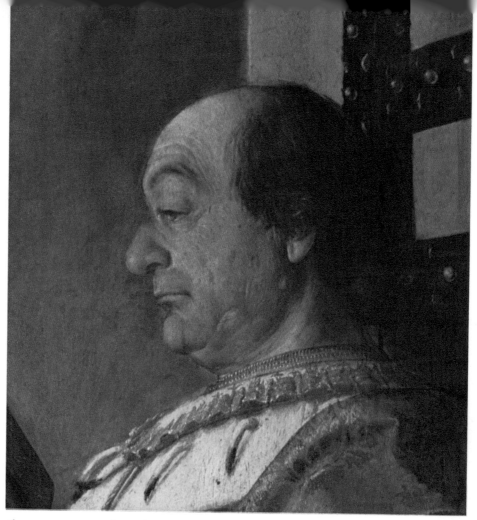

161 - BERRUGUETE (ATTR.). F. DA MONTEFELTRO AND HIS SON (DETAIL) — URBINO.

height of its development, there occurred in about 1470 a somewhat surprising reversal. Piero and Uccello being now too old, Federico could not find a painter who suited him—these were, indeed, years of weakened resources. Therefore he sent for a foreigner; and so, paradoxically, Urbino became the point of impact of the Northern style—or, more precisely, one of the points along a line of influence in which the arrival of Antonello in Venice in 1475 was to prove far more important. What is interesting is the glimpse we catch of a moment where the 'Flemish drugs' and the fine *matière* of oil painting were assimilated by the friends of Piero. Indeed Piero himself had already profited by these, at least in the Senigallia *Madonna*. This capacity for assimilation was one of the strengths of 'Pierfrancescanism,' and made it a generator of power—we need only consider the influence it exercised in two main directions, Venice and Ferrara. In Venice it appeared as the corrective to the foregoing Paduanism, and the conversion of Bellini was to be reinforced by Antonello's visit in 1475. Thus its noble *moduli* and

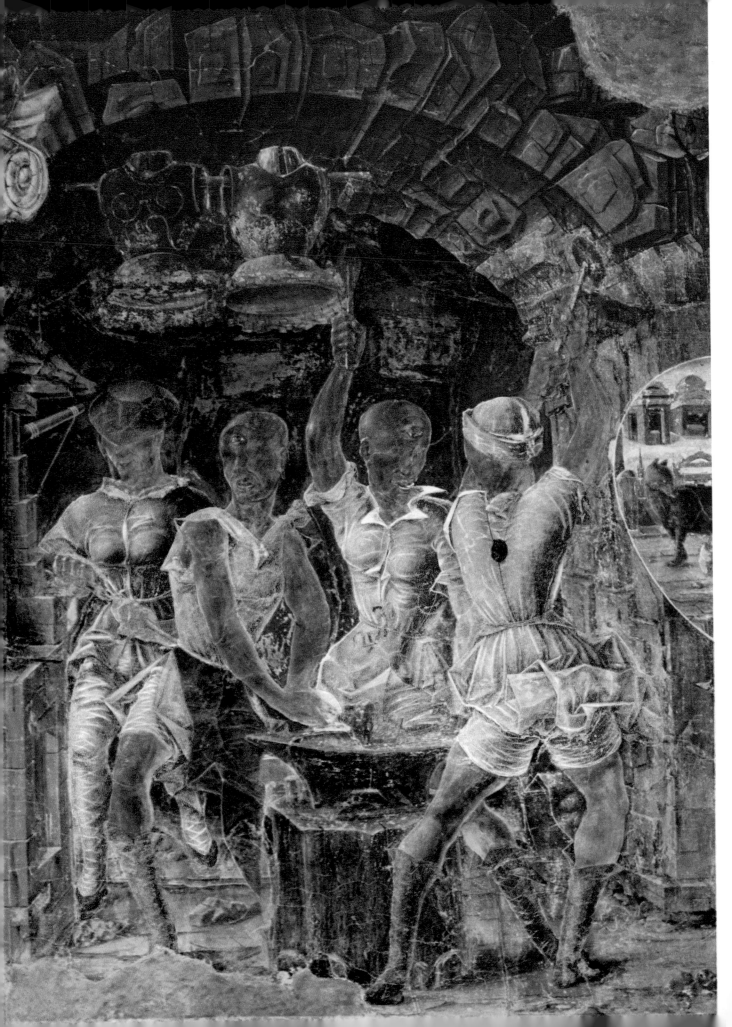

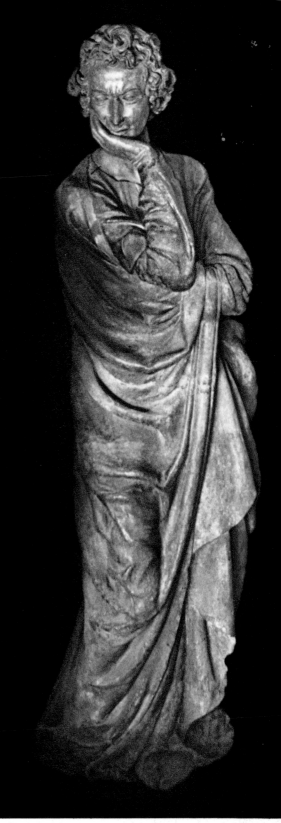

peculiar ornamental forms soon spread to the North and East of the Apennines: in the work of an isolated artist like Crivelli one can feel how dramatic a problem their adoption set to a painter wedded to gold and to the meticulous hard effect of Gothicized Paduanism.

But the scene of the most striking encounter was Ferrara: Piero's short visit to that city in 1449 had not passed unnoticed. Without him it would be impossible to explain the bold devices of the Schifanoia, the elaborate structures of the altarpieces, the sculptural power of the figures. At the same time each of the Pierfrancescan virtues was contradicted by an opposing principle. In Cosimo Tura Squarcionism, reinforced by the example of Mantegna, found ready to hand an inexhaustible, characteristically Ferrarese interest in a whole repertory of the mineral, the metallic and the fantastic treated as elements of luxury on a grand scale, and in pathos and the unusual—in short, in all those elements of which the Roverella altarpiece (*c.* 1470) was a kind of manifesto. Never was the clash between the expressionist principle and the grand style more spectacular than at Ferrara. Not that this tension by itself explains everything, for there was added a constant inflow of German and Flemish examples, and also—at least in the case of Cossa—information gathered from the Florentines. But the crossing of the two main stylistic forces of the period gives us a clear idea of the exceptional position of the Ferrarese group. This, as is well known, extended its influence to Bologna, where the Griffoni polyptych for the church of San Petronio holds a prominent place, and to Modena, where Bonascia continued—and hardened—the lesson of Cossa and Tura with, sometimes, a stronger dose of 'Pierfrancescanism.' There was a tendency towards a style common to all the arts. As has often been stressed, it was chiefly in sculpture that anything analogous to Ferrarese expressionism appeared: the *Pietà* by Niccolo dell'Arca in Santa Maria della Vita is, with its extreme violence, a kind of testing of the limits of one particular development.

162 - ERCOLE DEI ROBERTI. VULCAN'S FORGE — FERRARA, SCHIFANOIA PALACE.

163 - NICCOLO DELL'ARCA. DEPOSITION FROM THE CROSS (DETAIL): ST JOHN — BOLOGNA.

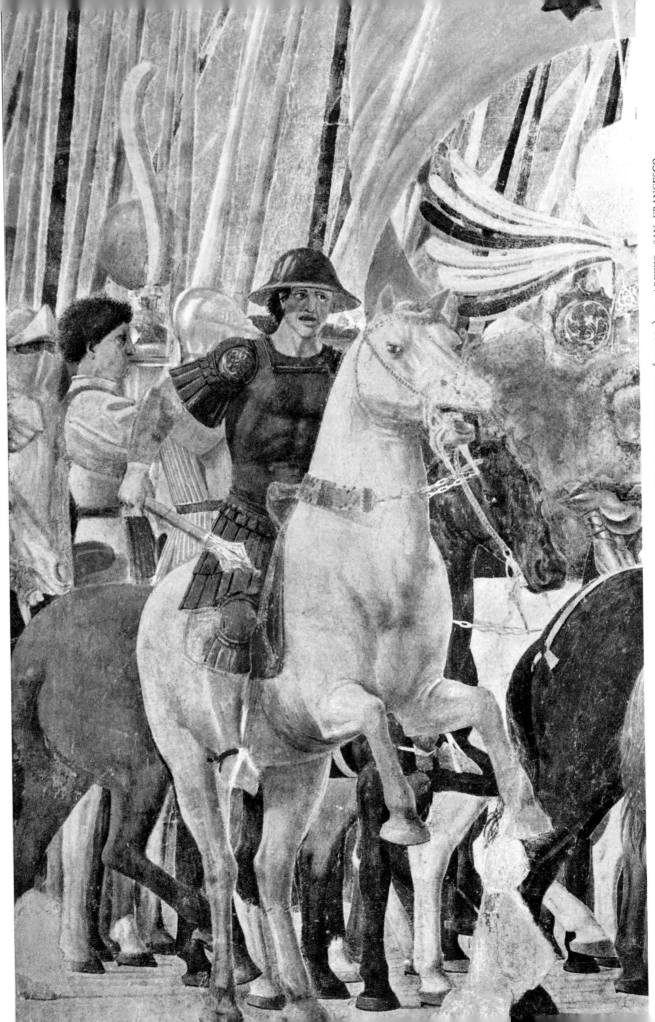

164 - PIERO DELLA FRANCESCA. THE STORY OF THE TRUE CROSS. VICTORY OF CONSTANTINE (DETAIL) — AREZZO, SAN FRANCESCO.

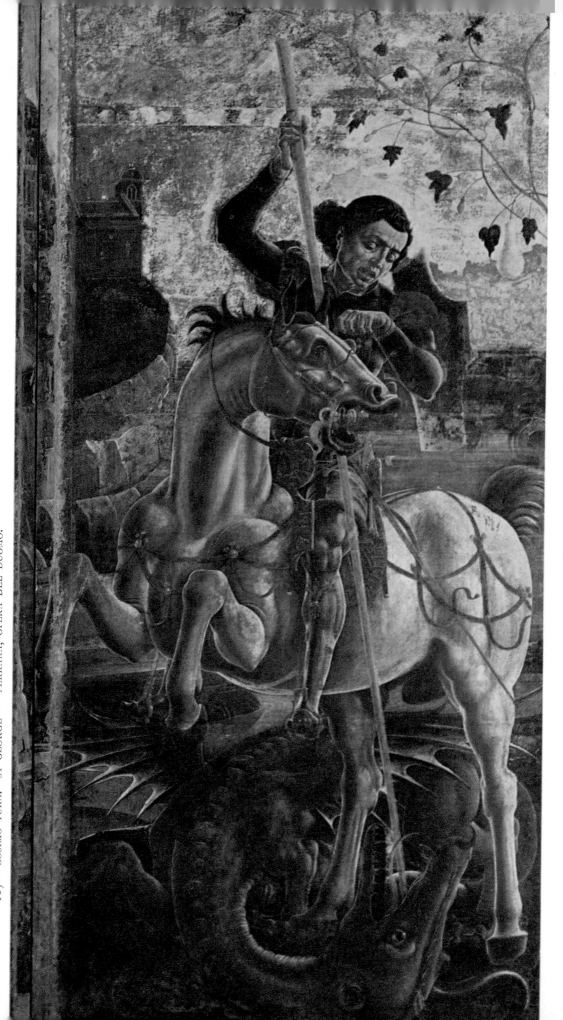

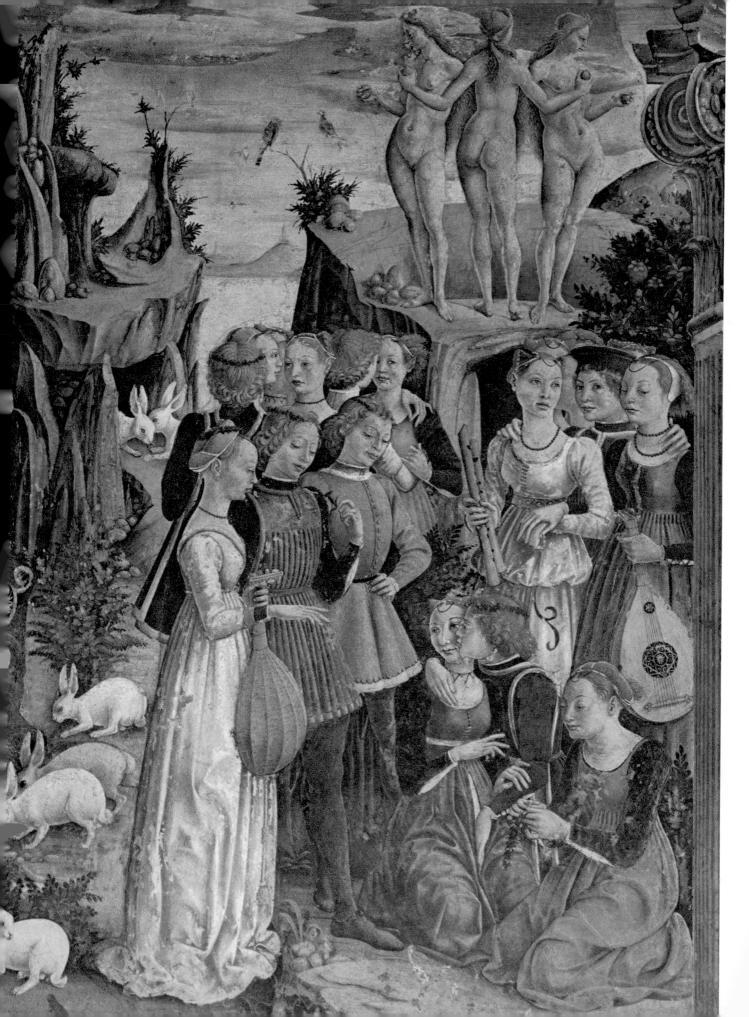

167 - F. DEL COSSA. THE GARDEN OF LOVE (DETAIL) — FERRARA, SCHIFANOIA PALACE.

Thus the city of the d'Este family held an exceptional position in the time of Borso (1413-1475); it was he who held the power in 1450[14]. The paths of the most diverse artists crossed there, not only Piero and Mantegna, but Pisanello, Jacopo Bellini and perhaps Rogier van der Weyden. Display was the great preoccupation: court life became scenery and costumes, and was celebrated in the frescoes of the Schifanoia palace with a dazzling conviction. Ferrara was a centre of culture in a quite different sense from Florence: it was the capital of a modern poetry that was courtly and romantic. To this, in its own way, the painting bears witness. Another characteristic of Ferrara was its encouragement of the theatre; this was important enough for many scholars to have found it reflected in the pictures, at least in the way the figures are placed on a kind of stage under strong lighting and are given tableau postures. There is also as late as the sixteenth century (Baruffaldi) evidence of the use of puppets in various shows that were staged: these small figures were employed for the legendary and historical floats, which were a frequent feature of the festivals. These festivals added an original and attractive note to Ferrara, that anti-Florence of the fifteenth century.

166 - FRANCESCO DEL COSSA. THE MONTH OF APRIL (DETAIL) — FERRARA, SCHIFANOIA PALACE.

CONFLICT OF THE MAJOR ARTS AND NEW TECHNIQUES

T HE Renaissance was characterized, on the whole, not by major technical innovations but by an impulse towards experiment and initiative. Coherence and systematization were not essential. Thus, looking now at the professional side, we have to note: first, certain disharmonies between the main traditional forms of art, the most typical being the conflict between monumental painting and architecture; secondly disparate elements within the representative arts, the most remarkable instance being the divergence between the forms of ornamentation and those of the figure; and, finally, the importance acquired after 1460 by certain new techniques—or at least the new developments that appeared in engraving and marquetry.

PAINTING AND ARCHITECTURE

A s even a superficial enquiry demonstrates, it was only exceptionally that the cycles of modern frescoes were executed in modern buildings. It was in a completely Gothic fourteenth-century chapel, on the axis of the church of San Francesco at Arezzo, that in 1447 Bicci di Lorenzo began the mural paintings for which the responsibility passed in the end to Piero della Francesca—and this painter's formal repertory was already free from Gothic elements. The same was true of Ghirlandaio's frescoes for the Sassetti chapel in Santa Trinità, of the frescoes in the Tornabuoni chapel in Santa Maria Novella,

168 - LUCA SIGNORELLI. STUDY FOR THE RESURRECTION
OF THE DEAD (DETAIL) — ORVIETO CATHEDRAL.

and of Filippino's frescoes in the Caraffa chapel in the Minerva at Rome, and of those in the Strozzi chapel. In this last case Filippino, as though to stress the problem, gave the long Gothic bay of the chapel wall a painted frame—a kind of fantastic triumphal arch. The examples of these disharmonies are innumerable. Setting aside the funerary chapel of the Cardinal of Portugal and the Portinari chapel in the church of Sant' Eustorgio in Milan, effective collaboration between architect and painters was rare. The great Renaissance paintings were usually inserted into buildings whose style was that of a different period and did not harmonize with theirs. The conflict was emphasized by one authoritative artist: Mantegna's *pala* in Verona, which he finished in 1459, has the effect, with its imaginary *tempietto*, of installing beneath the vaults of San Zeno an architectural space in plain contradiction with the church.

The Mediterranean tradition of great chambers with beamed roofs continued into the fifteenth century. This meant that walls were still set free for the painters; for instance, in the Ducal Palace of Venice, in the Sistine Chapel, and finally, at the beginning of the sixteenth century, in the hall of the Palazzo Vecchio in Florence. But this long-standing practice must not be allowed to mask the new opposition between the two arts. To interpret this as a historical accident resulting from the density of religious foundations together with the Italian tendency to keep the same building and go on improving it, is not sufficient, for there is evidence of a definite reserve on the part of the new architecture towards decorative painting. The Brunelleschian principles tended to create a building with a rhythm that did away with the plain walls suitable for fresco painting; the Albertian theory, with its exaltation of pure spatial relations, involved an implicit condemnation of mural painting and it is noteworthy that at Pienza, in his pseudo-Gothic cathedral, Pius II followed the ideas of Alberti's disciple Rossellino and demanded bareness and whiteness—*candorem*—for the walls. In the church of the Annunziata, about which Alberti was consulted, the frescoes were relegated, as his *De re aedificatoria* recommends, to the northern courtyard, walls; Baldovinetti's *Nativity* was painted there in 1461.

In the great churches built at the end of the Quattrocento, such as Santa Maria del Calcinaio at Cortona, Santa Maria presso San Satiro at Milan, Santa Maria delle Carceri at Prato, and the cathedral of Pavia, the architect devoted all his talent to organizing the surfaces by means

170 - LODI. SANTA MARIA L'INCORONATA, INTERIOR.

of architectural rhythms alone, by the arcades and the play of the ornamentation. If there is an effect of colour, it is due to the variety of the materials used: Brunelleschi's practice was to stress the limbs of the structure by means of *pietra serena*, and the North Italian style did so by the play of medallions and friezes—in the Consolazione at Lodi, for instance. Tabernacles, framing niches and other forms of what may be called 'edicular' structure were introduced and tended to create a purely plastic order, which no longer left the wall free.

A consequence of the new reform of architecture was the elimination of frescoes. In the old-style buildings, where it still had its *raison d'être* and to which it was relegated,

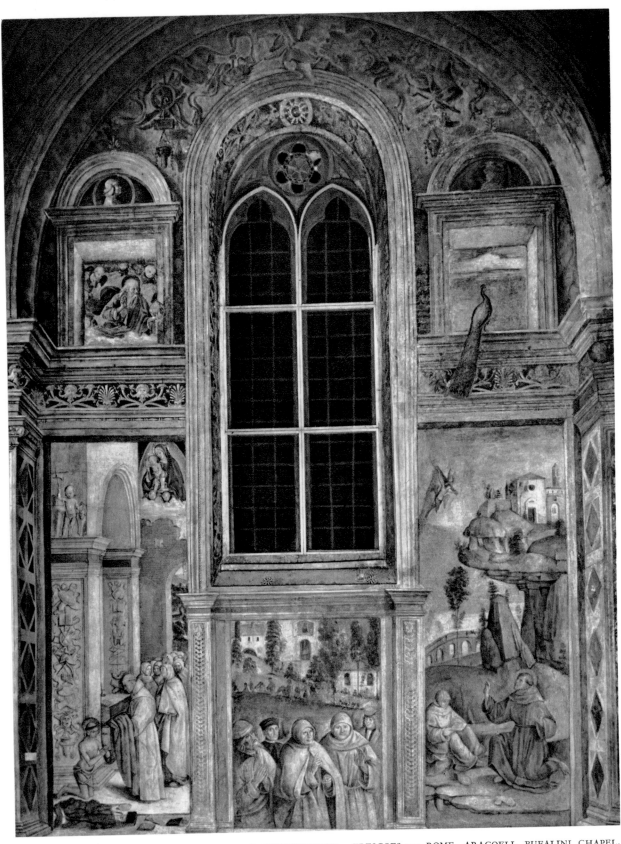

171 - BERNARDINO PINTURICCHIO. FRESCOES — ROME, ARACOELI, BUFALINI CHAPEL.

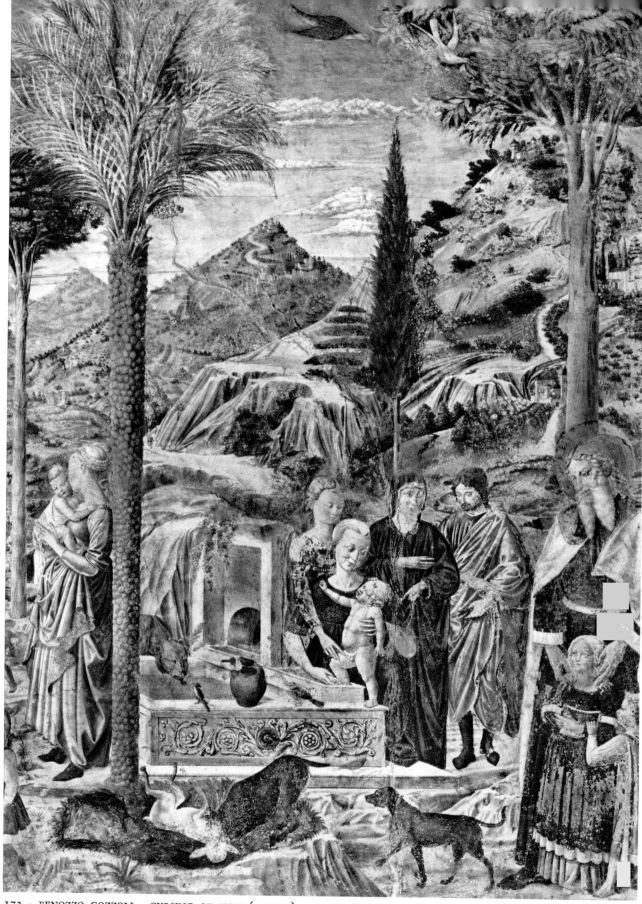

172 - BENOZZO GOZZOLI. CURSING OF HAM (DETAIL) — PISA, CAMPO SANTO (SERIOUSLY DAMAGED IN 1944).

173 - BENOZZO GOZZOLI. BUILDING OF THE TOWER OF BABEL (DETAIL) — PISA, CAMPO SANTO (SERIOUSLY DAMAGED IN 1944).

painting took its revenge by depicting ideal places, such as the basilica in which St Lawrence performs his miracles, in the paintings in the chapel of Nicholas V (1449); the setting for the martyrdom of St Stephen, in the fresco at Prato; and, still more spectacular, Perugino's setting for his *Remission of the Keys* in the Sistine Chapel (1482). 'Where architects were trying to emphasize the opaqueness and structural clarity of walls, the painters were bent upon dissolving them with views of landscapes, loggias, niches, or whatever their fancy (spurred by perspective) contrived' (Eve Borsook, *The Mural Painters of Tuscany*, p. 25). Here, too, tradition was on their side: Benozzo Gozzoli gave himself up with delight to covering the walls of the Campo Santo (already decorated in the fourteenth century) with views of the Val d'Arno and of imaginary cities. His manner may have been regarded with some disdain by the great masters; it is nonetheless a revealing instance of the new tendency of painters not to take account of the wall—not as much for example, as Piero della Francesca had done. The end of the fifteenth

174 - PIERO DELLA FRANCESCA. THE STORY OF THE TRUE CROSS (DETAIL) — THE CITY OF JERUSALEM — AREZZO, SAN FRANCESCO.

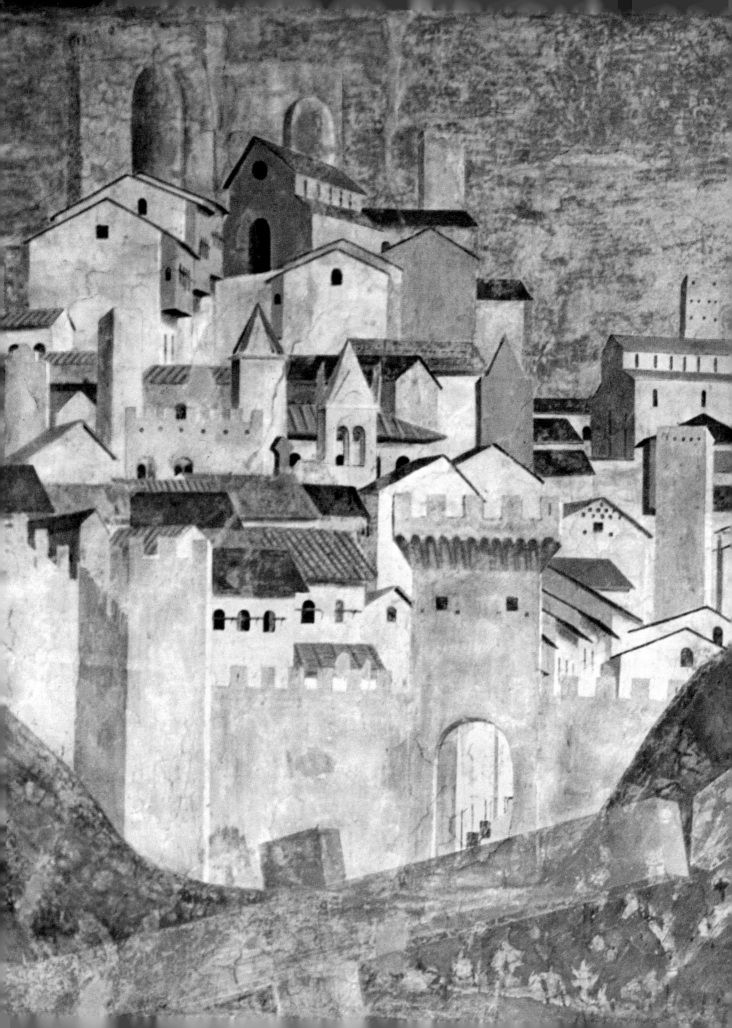

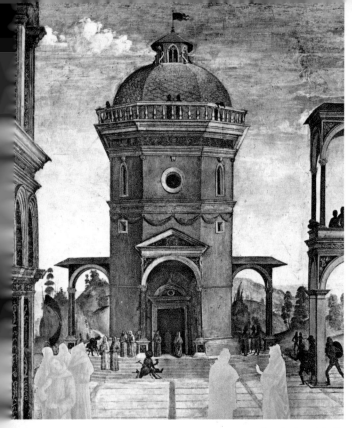

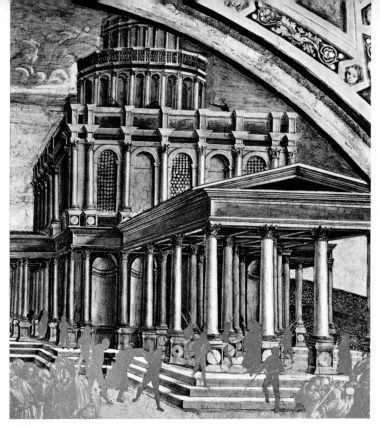

175 - PINTURICCHIO. FUNERAL RITES OF ST BERNARDINO — ROME.
Shaded for demonstration. See list of illustrations.

176 - LUCA SIGNORELLI. THE ANTICHRIST (DETAIL) — ORVIETO.
Shaded for demonstration. See list of illustrations.

century was to be a time particularly favourable to illusionist decoration, to which a spectacular development would be given by the Umbrians, by Pinturicchio in Rome (especially in Santa Maria del Popolo and at the Aracoeli) and by Signorelli at Orvieto.

With increasing frequency painters gave their treatment of space the combined form of architecture and landscape; in secular or sacred interiors they deployed a complete imaginary setting, as for instance in the Sala degli Sposi at Mantua, in the Belvedere Villa (with its decoration of landscapes and loggias that anticipates the Farnese), and in the now vanished chapel whose interior, it seems, was entirely covered with frescoes. The painter's assurance was complete in such rooms as the Borgia apartments or the Cambio at Perugia and the Sala della Segnatura: he designed a lower range of marquetry panels, above these a tier of frescoes, and above these a vault, also painted, with ornamental motifs giving a precisely calculated atmosphere to the whole. The *camera picta* was not a new invention, it was an old form of art that became particularly vigorous at the end of the fifteenth century. Leonardo's wonderful interlacing of branches in the Sala delle Asse in the castle of Milan demonstrated how painting could create the whole quality of an interior space: the ambition to do so appears as the counterpart to

177 - ANDREA MANTEGNA. MANTUA, DUCAL PALACE, SALA DEGLI SPOSI.

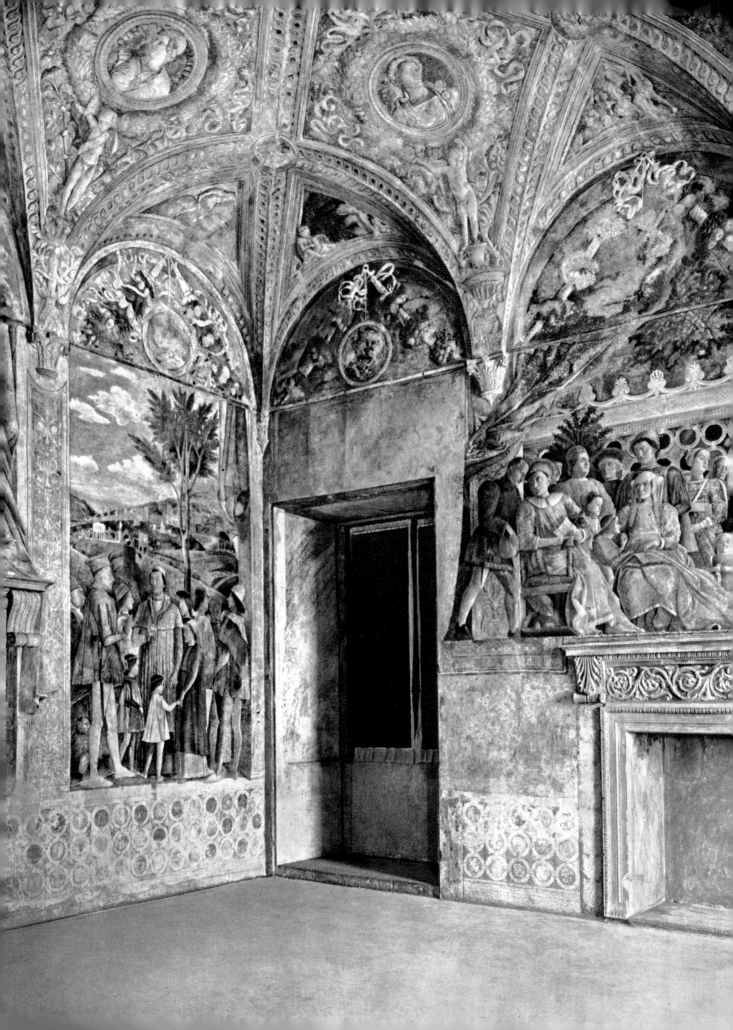

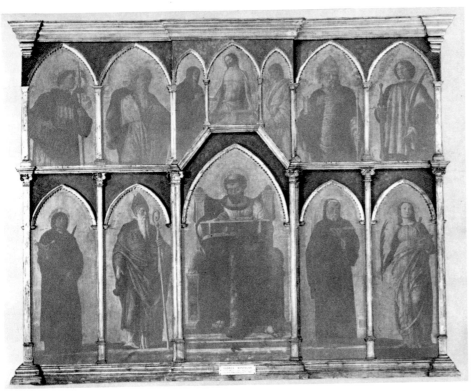

178 - ANDREA MANTEGNA. ST LUKE POLYPTYCH — MILAN, BRERA.
Shaded for demonstration. See list of illustrations.

the tendency towards a self-sufficient architecture.

In the new churches, from which mural painting seemed to be excluded, the altarpiece—in the majestical form of the *pala* with compartments—now enjoyed a notable success. The period 1470-1500 should be regarded as the golden age of the monumental altarpiece in Italy. Empty chapels were now embellished, and in Emilia, in the Marches and in Lombardy the high altar became a kind of gigantic scaffolding or stand providing frames for medallions and painted panels This fashion for the *pala* was an Italian answer to the great winged altarpieces of the Flemish painters. During one or two decades at least the traditional structure of the *pala* was still attuned to that of the Gothic churches, with frames made up of pointed arches and miniature columns heightened by small pinnacles and crowning flourishes. But the frame of gilded wood might contain panels in which the setting—and sometimes the figures—broke with the Gothic formula. The conflict between building and painting arose afresh between frame and picture. In the St Luke polyptych, painted in 1454 for the church of Santa Giustina in Padua, Mantegna's frame is faithful to the system of distinct panels under

188

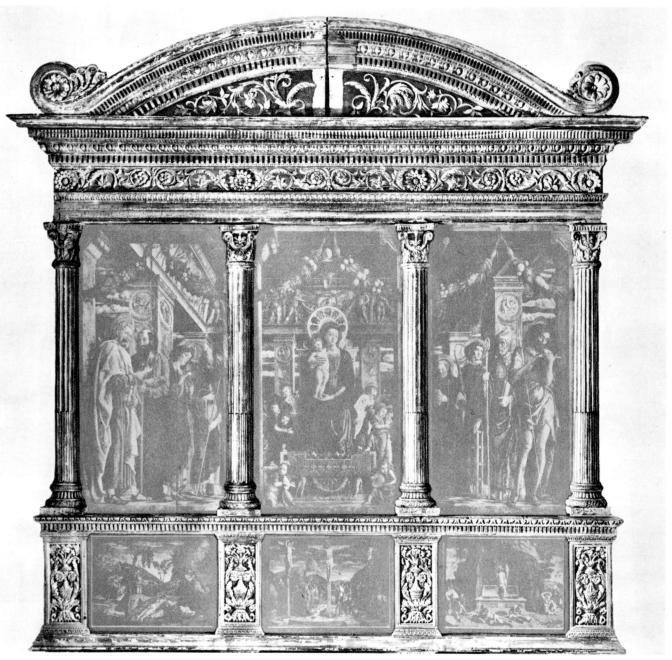

179 - ANDREA MANTEGNA. RECONSTRUCTION OF THE SAN ZENO ALTARPIECE.
Shaded for demonstration. See list of illustrations.

pointed arches and with gold backgrounds, but the per-
spective pavement, the marble table in strong relief and
the throne of the saint break with this style. The painter
was so keenly aware of this that, in his next work—the
powerful San Zeno altarpiece he deliberately arranges the
eight figures within a single imaginary edifice contained
by the huge pediment.

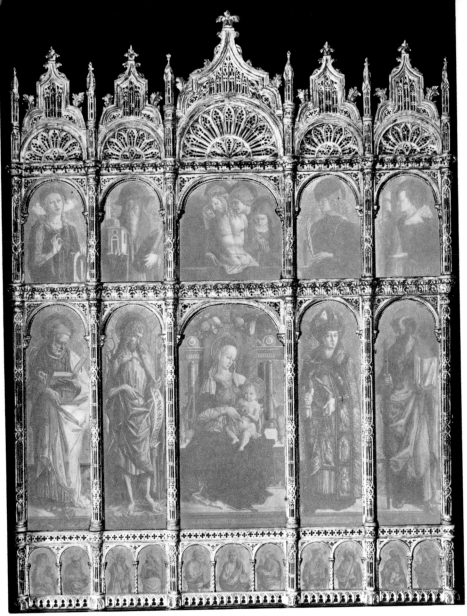

180 - CARLO CRIVELLI. POLYPTYCH. — ASCOLI PICENO CATHEDRAL.
Shaded for demonstration. See list of illustrations.

But not many painters were prepared to go so far in the direction of a modern frame. The compartmented altarpiece with old-style frames was still often adopted, although the painted panels now contained shrines, thrones, *tempietti* and more or less classical geometrical forms. In a work like the *Coronation of the Virgin* at Modena, painted by the brothers Erri in about 1465, the contradiction is worrying; it is rather less so in Zoppo's polyptych, of about the same date, in the Collegio di Spagna at Bologna. Unexpected formulae began to appear, dictated by the temperament and conviction of individual painters: in 1473, at Ascoli Piceno, Crivelli took advantage, with considerable virtuosity, of a 'flamboyant' complex in which, this time, the arches are

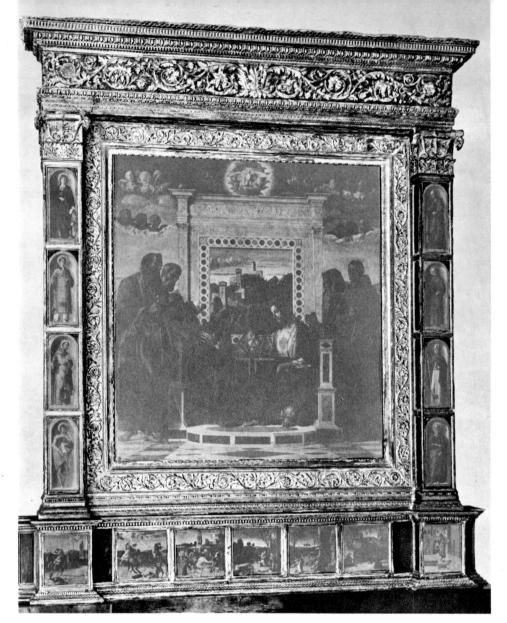

181 - GIOVANNI BELLINI. PESARO ALTARPIECE — PESARO, MUSEO CIVICO.
Shaded for demonstration. See list of illustrations.

semicircular; and in 1475 Giovanni Bellini, in his Pesaro
altarpiece, set the example of a classical structure—indeed
the marble throne of God in the picture acts as a reduplica-
tion of the new rectangular frame with its horizontal
cornice. Thus the complex frame of carved and gilded
wood set fresh problems: the old arrangement of panels
may even have influenced the evolution of painting in
some cases, but in the end account had to be taken of the
models supplied by the new repertory of forms within
the pictures themselves. Before 1450-1460 the difficulty
had hardly been apparent; after 1500 it was already solved.

The depiction of architecture and of ornamental
details had become the fashion in painting. Already in
the middle of the century Fra Angelico and Fra Filippo

had given currency to flights of steps, pilasters, cornices and arcades of a classical type; a painter with no pretension except to be fashionable, like the Umbrian Bonfigli, gives us in his *Annunciation* a version of all this that is already commonplace. This repertory was felt to be a reappearance of the ancient Mediterranean stock: it was still partial, incomplete and subject to competing interruptions. But the same was not true of the depiction of people: this was dominated by a concern—also in the ascendant—for realism and topicality. Memories of the Giottesque, the lessons from Northern Europe, the innovations of the great draughtsmen and other factors had helped to raise the style, as the art of Piero della Francesca proves; but even in his work the effect of classical example is as slight on the style of the figures as it is powerful on that of the setting. Just when settings were becoming classical, costume and the shape of the figures were growing more and more decidedly contemporary. Thus, round about 1450-1460, we see, as Panofsky has remarked, 'a stylistic disharmony between an architectural, decorative envelope, which has been recast in accordance with classical norms, and the figures, which are dominated by non-classical traditions and influence.' This situation, as it turned out, could not have been more stimulating: all sorts of devices were tried in order to reduce the disharmony between the two sets of forms.

In G. di Boccati's modest but subtle *Marriage of the Virgin* (Berenson Collection) the space is clearly articulated by columns which stress the *all'antica* intention; the figures are distributed with clarity, sometimes taking up their position under the capitals; and, following a hint from Piero, the sober folds of the clothes answer the lines of the architecture naïvely. It can hardly be doubted that the scene gets its unity from a precise stylistic intention; this is made plain by the perfectly placed oblique lines of the long slender trumpets. But this achievement was easy with a generic architecture and with figures of a rather imprecise type. The small panel by Matteo di Giovanni (Johnson Collection, Philadelphia), which is also a modest picture, proclaims an intention of the opposite kind: the painter crowds the figures, takes up again types from the Trecento or from Masolino, and unfolds before us a grey and rose-pink architecture in which enormous cockle-shells occupy the apsidal compartments of an edifice that is as crowded and varied as the group of people. Some of these are wearing mantles and caps in the current fashion, but their outlines are still freakish, unreal; and the wall surfaces

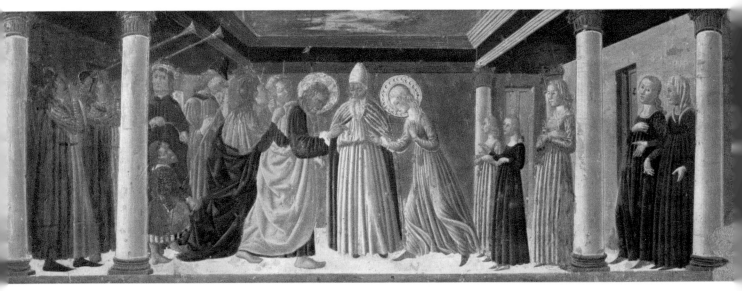

182 - GIOVANNI DI BOCCATI. MARRIAGE OF THE VIRGIN — SETTIGNANO, BERENSON COLLECTION.

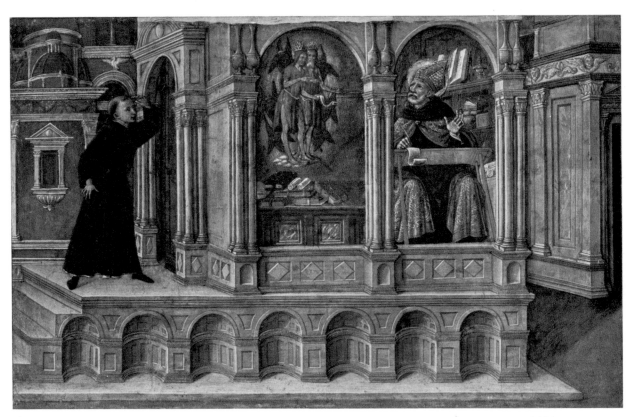

183 - MATTEO DI GIOVANNI. APPEARANCE OF SS. JEROME AND JOHN TO ST AUGUSTINE — CHICAGO.

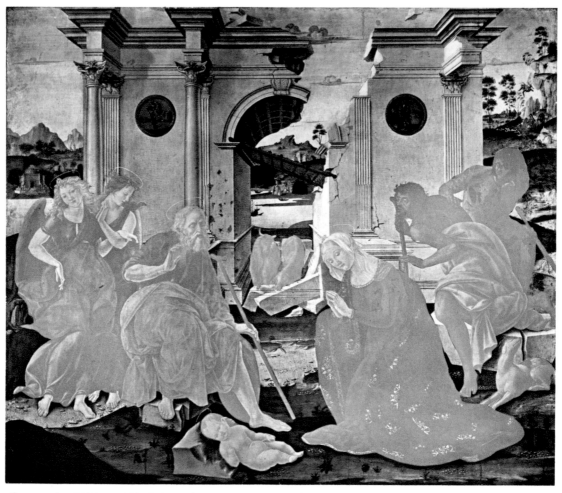

184 - FRANCESCO DI GIORGIO. NATIVITY — SIENA, SAN DOMENICO.
Shaded for demonstration. See list of illustrations.

are heightened by modern incrustations, yet the space
is naïve, unstable and dreamlike. It is easy to see what
was bound to happen at higher levels: if a more sustained
style were required, a clear decision would have to be
taken to harmonize the type of the figures with that of
the architecture, and there would have to be an extra
effort of imagination to give the forms more definition.
Since the polarity between the strict style and the imagi-
native style came in at every stage, there were four
possible cases: there could be, within a firm, true and
habitable *all'antica* setting, either 'true' figures treated
in the same spirit, or figures obeying a non-classical canon
and treated with fantasy; again, there could be, within
a more or less classical but fantastic and deliberately
imaginative setting, either figures in a strict style or non-
realistic figures. In both the cases where figures and setting
agree, we are in the presence of a generalization of the

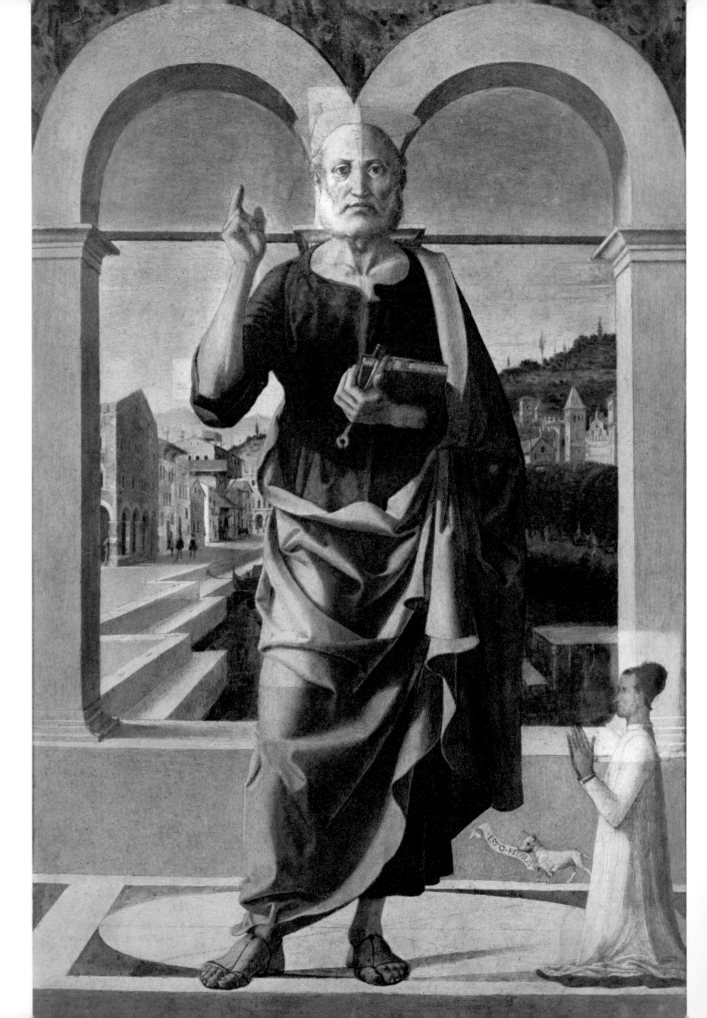

style—of the ordered style or the picturesque, as can be illustrated by comparing the manner of Francesco di Giorgio with that of Perugino in the Sistine Chapel: both are successful 'integrations' of figure and setting. Thus when Francesco di Giorgio undertakes, in the manner of the Umbrians and Tuscans, to introduce a classical triumphal arch into the painting of the *Nativity* for San Domenico at Siena, he is obliged to shatter a building and to exaggerate its angles in order to obtain a tolerable background for his twisted and agitated figures. To this tense organization of space, the easy rhythm and the platform composition, which Perugino established for the reception of elegant figures that are as stable as the central plane unifying the distance, make a complete contrast. It was inevitable that architecture, viewed as the necessary setting for the deployment of the figures, had a powerful effect on the evolution of painting. Even as regards composition, it would be hard to find between 1460 and 1480 a fresco or a picture that escapes from its authority. The attraction of the monumental is clearly seen in the use made by the Italian painters of the 'platform' arrangement, which they borrowed, towards the middle of the century, from the Flemish—to be more precise, from Jan van Eyck through Mantegna: in this a perfectly horizontal foreground plane is set next to a far distance which throws it into relief. So, for instance, in a Crucifixion, the Cross is made to stand out high up against the sky, and this device was valued by painters and was used to give force to the isolated figure: looked at from the base upwards, the Cross dwarfs the horizon which is brought down to the level of its foot; but it needs to be framed, and so the picture is given a vertical format and the scene is contained within a semicircular arch whose top touches the top line of the picture frame. There are innumerable examples of this arrangement dating from round about 1490. The figure is rendered heroic by the monumental treatment. In ambitious compositions a complex setting was required, and the monumental architectural motif grew so overpowering that in some schools there was hesitation about its use. In Venice the authority of Giovanni Bellini tended to formalize arrangements which the experimental curiosity of Carpaccio and, above all, of Mansueti might easily have brought into disfavour (Mansueti's *Crucifixion*, painted in 1492, is a typically confused work). At Ferrara, in the San Lazaro altarpiece, Ercole arranged figures of irresistible grandeur and monumentality on a kind of scaffolding which seems to be unstable; but at that

187 - GALASSO (?). MUSE — BUDAPEST, MUSEUM OF FINE ARTS.

186 - BARTOLOMMEO MONTAGNA. ST PETER — PADUA, PRIVATE COLLECTION.

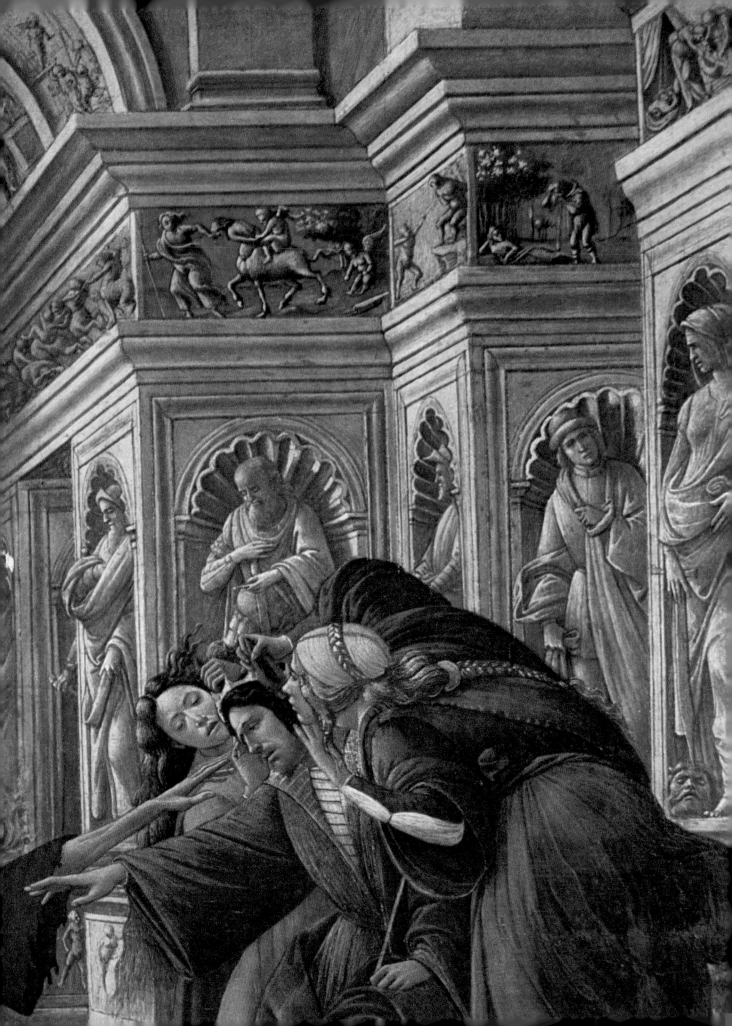

same moment Cossa, in his Osservanza altarpiece, placed the Annunciation beneath a double arcade to whose style he is evidently bent on giving a regularity modelled on the Roman colonnades. From about 1480 onwards, there was a constant pressure in favour of well ordered pilasters, sharply outlined capitals and well defined flutings. Botticelli, for instance, never ceased to stress the animation, floating draperies and flexibility of his figures, but in his last period he made them glide in front of noble architectural settings. In his *Calumny*, which must date from after 1490, he hit on an original way out of the difficulty of harmonizing figures and architecture: the reliefs, the painted statues in the niches and the miniature gilded friezes are all calculated to work the transition between the somewhat sober structure and the silhouettes in motion.

A factor that made possible—and in some places inevitable—an increasing precision of classical architecture in painting, was the number of collections of drawings placed at the disposal of the painters by the architects and designers of ornamentation. Botticelli learned from Giuliano da Sangallo—indeed took from him, in all probability, the documentation for his monumental backgrounds, and perhaps even their design. The collections of drawings included reliefs, and these were sources for figures that would harmonize with the setting. The most methodical and strict effort in this direction was Mantegna's: he set out deliberately to combine an architectural type of setting with a sculptural style in the figures. Results were often unsuccessful and jarring, but Mantegna's imaginative power and ability to assimilate—in spite of appearances— contributions from north of the Alps gave him complete authority. At least in appearance, the problem was solved; but the very quality of the style, in which the fundamental Paduan harshness reappears, often suffered from this dominance by hard, cut-out forms. Its influence did not spread into the central regions of Italy: there, a kind of discouragement gradually took shape. Distrust of the classical forms even altered the basic conception of the painter's problem to the extent of setting the picture free from the obsession with architecture: the sign of this is the increasing emancipation of the landscape, together with the tendency to give the figures an idealized type of costume more or less close to what was then worn. In about 1480-1490 the alliance of Perugino, Giovanni Bellini (in his *St Francis of Assisi* in the Frick Collection) and Leonardo reinforced the new attitude, shared by painters determined to escape from the problems that had been so pressing in 1460.

Zuanne de Bavona

ARCHITECTURE AND SCULPTURE

A certain rivalry between sculpture and architecture is not hard to discern. What has been said about fresco painting, which the modern system has tended to separate from architecture, applies also to all the genres in which, between 1440 and 1460, the new monumental ambition of sculpture was revealed. Large-scale funerary monuments multiplied in such churches as Santa Croce in Florence and—after 1460—Santa Maria della Minerva, Rome, and SS. Giovanni e Paolo, Venice, with whose Gothic structure, ill-divided space and undistinguished ornamentation they were quite simply at variance. They amount to giant architectural designs, which with their cornices and entablatures assert an order that can no longer be reconciled with the churches sheltering them. Here again the Renaissance reveals itself in and through the disparate. The wall tombs take possession of the sides of chapels with their intercolumniations. The tabernacles become complete small-scale buildings, making the effect by the subtlety of their outlines. In certain tempietto compositions, such as the Cappella del Santo Volto, it is hard to decide whether the work is a piece of sculpture or of architecture—and indeed it matters little, since the composition is an independant statement. This had become a general tendency.

ANTONIO PISANELLO. PROJECT FOR THE GATE
OF THE CASTELNUOVO, NAPLES — ROTTERDAM.

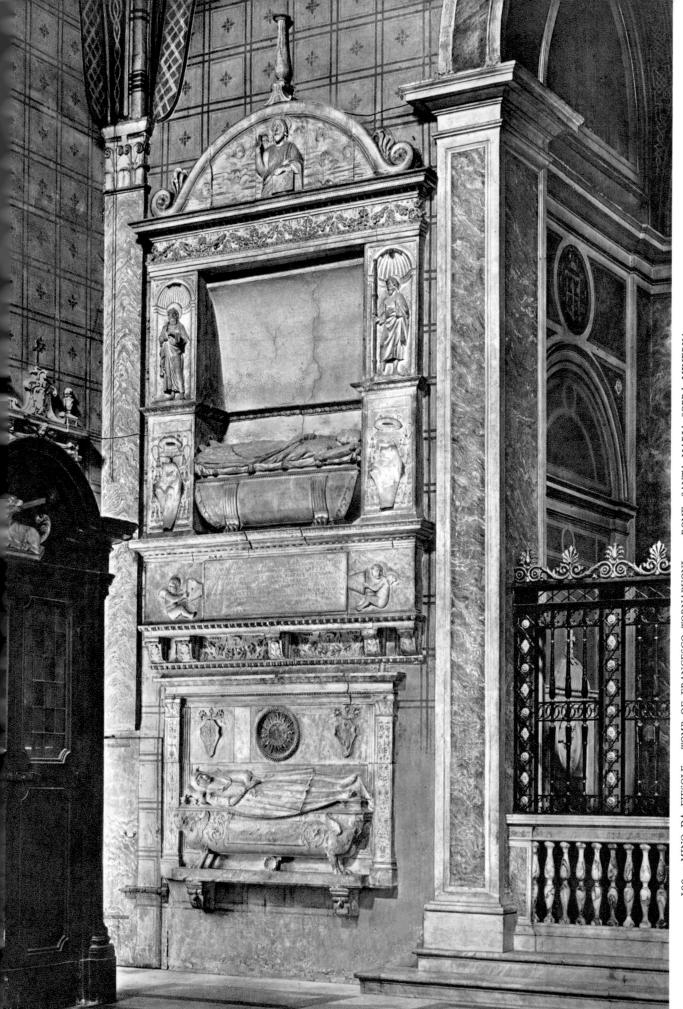

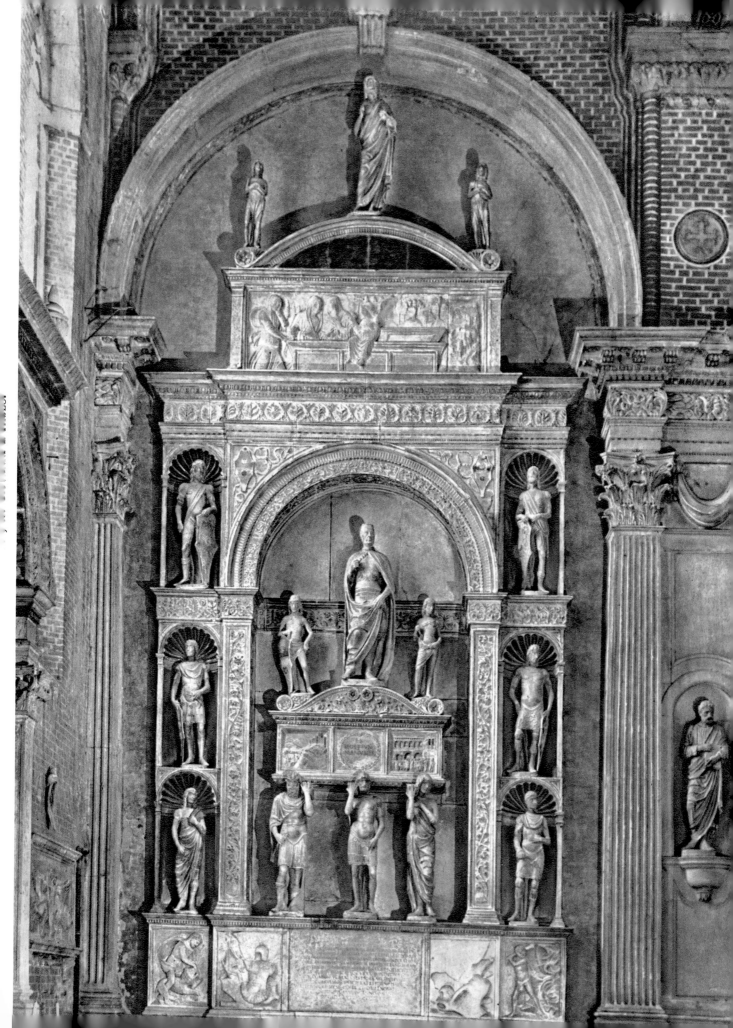

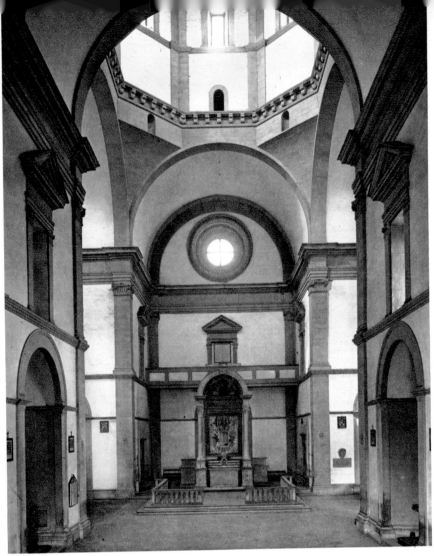

192 - FRANCESCO DI GIORGIO. CORTONA, MADONNA DEL CALCINAIO, INTERIOR.

The new architecture tended to exclude mural painting and to favour the altarpiece; it also tended to localize the sculpture. But at the same time sculpture was given more opportunities the nearer Quattrocento architecture came to asserting itself as an edicular system,—that is, as based on a series of regularly repeated frames, niches and bays, which reproduced the modular character of the building's structure.

The components of this structure were clearly distinguished, and the empty and the filled surfaces were expressed with equal lucidity by multiplying these forms as *edicula*, (these being, in fact, characteristic of the second half of the fifteenth century), and so the sculptor and designer of the *edicula* acquired more and more consequence and scope. The use of colour and accessory ornaments increased the frequency of decoration in low relief garnished with carved figures and other motifs.

193 - GIOVANNI DA VERONA. BRESCIA, SANTA MARIA
DEI MIRACOLI, FAÇADE.

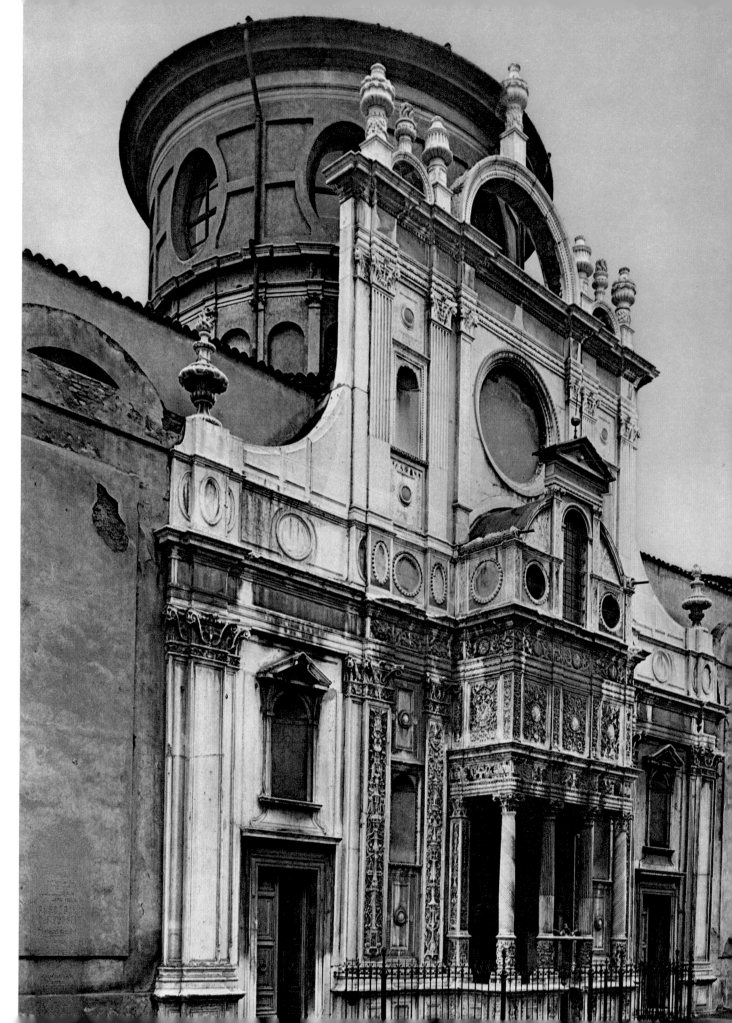

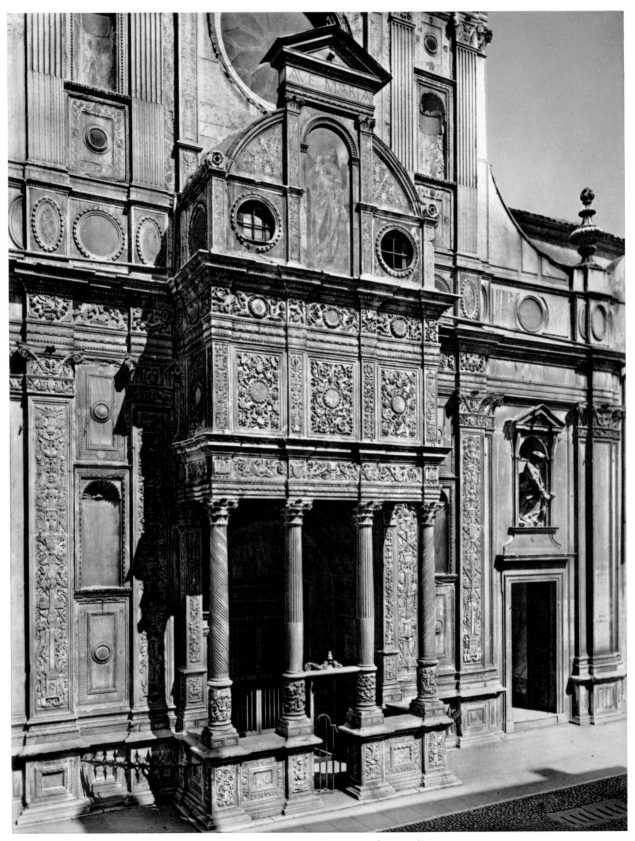

194 - BRESCIA, SANTA MARIA DEI MIRACOLI, FAÇADE (DETAIL).

195 - T. RODAVI. COMO CATHEDRAL, FAÇADE (DETAIL).

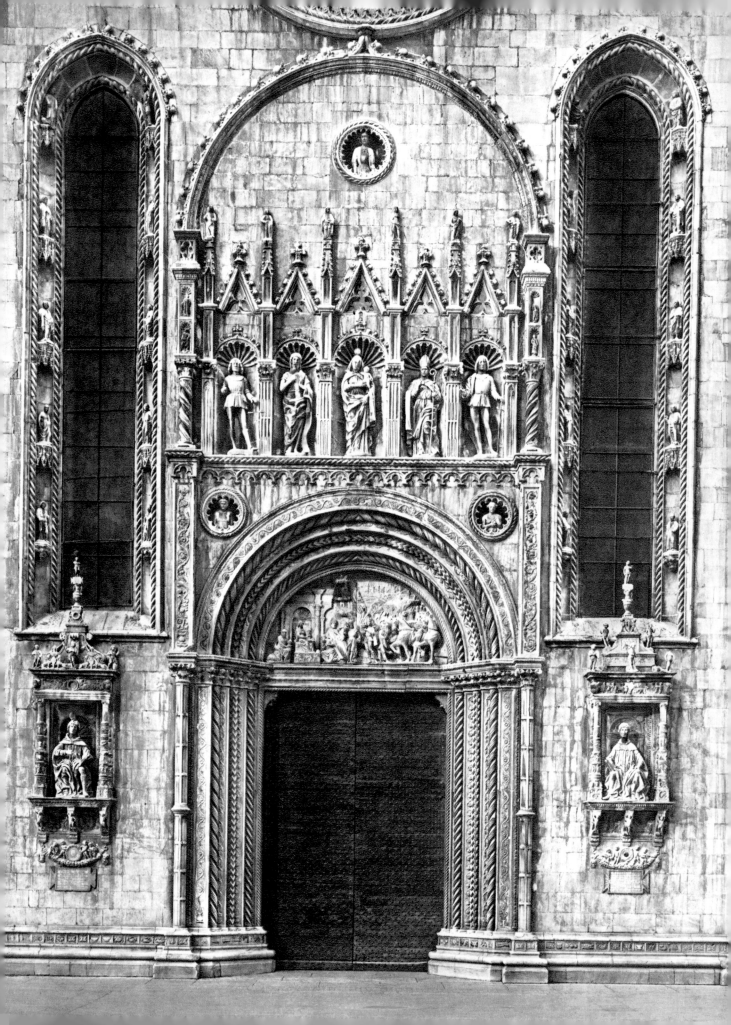

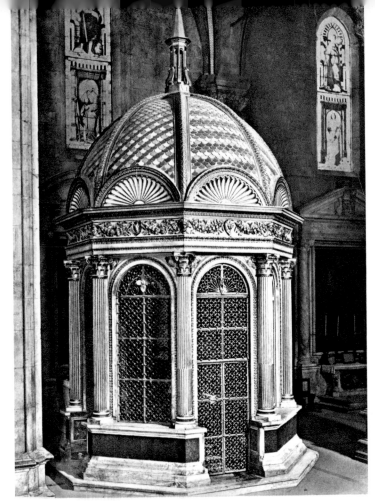

196 - CIVITALI. LUCCA CATHEDRAL, 'TEMPIETTO' DEL VOLTO SANTO.

The Tuscans maintained a certain reserve towards this pressure of ornament. But in the other provinces there appeared forms—often of Tuscan origin—distributed apparently at random over the walls, which had become supports (or fields) for medallions and low reliefs. The façade of the small oratory of San Bernardino, Perugia, completed in or about 1460, is a charming example of domination by sculpture; it was to be followed up, less than fifteen years later, at Bergamo in the Colleoni chapel.

The whole period is full of similar phenomena, in which the edicular system leads to an almost complete subordination of the architectural forms to the frieze, facing, relief carving, medallion, niche and bust, which now expand in an astonishing variety. The candelabrum-column, whose popularity has already been mentioned, is perhaps the perfect symptom of that temporary domination by sculptured forms—of its insinuation into the monumental structures themselves.

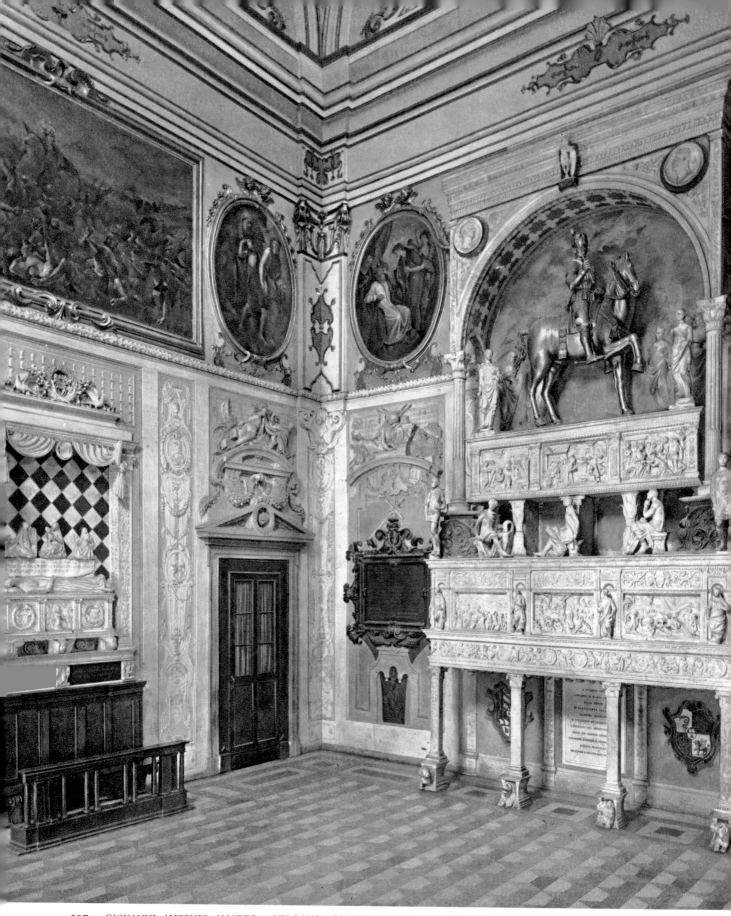

197 - GIOVANNI ANTONIO AMADEO. BERGAMO, COLLEONI CHAPEL, INTERIOR.

‡LINVS‡MVSICCO‡EPOETA‡

‡MVSEVS‡MVSICCO‡EPOETA‡

198 - MASO FINIGUERRA. FLORENTINE PICTURE-CHRONICLE. LINUS AND MUSAEUS — LONDON, BRITISH MUSEUM.

RISE OF THE GRAPHIC ARTS

Paper of fine quality became available in the second half of the century: hence many sheets of studies have been preserved, and drawing acquired a new importance. The part it played during this period of intense competition and constant exchanges became the more active since engraving—assisted by the printing of books—came in at the psychological moment and speeded up exchanges of all kinds. Drawing was recognized as the common source of all the visual arts or 'arts of design', and it was observed that the importance of sketches and models extended to the decorative techniques, to goldsmiths' and silversmiths' work, to pottery and to embroidery.' A typical document is the *Chronaca Universale*, illustrated in about 1460 with drawings by a Florentine who can only have been the goldsmith Maso Finiguerra; in it the theatrical presentation of the 'heroes' of the great periods of world history gives the opportunity for a procession of figures that illustrate fashion, as well as for a play of ornaments, forming an exceptional and copious vocabulary.

To the accepted techniques—silverpoint, pen and wash, pencil and black chalk—there were added, towards the end of the century, red chalk and a kind of pastel. Artists were not satisfied with the neutral background: one of the most charming productions of this period, especially in Florence, is that of drawings on '*carta tinta*' —paper tinted salmon-pink, rose-pink, blue and other colours. Delightful examples have survived from the pupils of Fra Angelico, such as Gozzoli, from Filippo Lippi or Lorenzo di Credi (di Credi seems to have had a passion, almost a mania, for this delicate exercise of skill). Vasari stresses the importance of such studies to Raffaellino del Garbo, an associate of Filippino Lippi: they were done, he says, 'on sheets coloured with highlights

199 - FILIPPINO LIPPI. DRAWING OF A YOUNG GIRL — FLORENCE, UFFIZI.

in white gouache,' and were carried out with 'admirable pride and ease.' Their subjects were almost always figures in outline, faces and draperies, the accents being stressed in gouache in accordance with the practice of Verrocchio and Leonardo, and this brought them into line with the researches into texture and modelling that were the special province of oil painting.

212

200 - BENOZZO GOZZOLI. PORTRAIT OF A LITTLE GIRL — FLORENCE, UFFIZI.

201 - LEONARDO DA VINCI. DRAPERY STUDY FOR A SEATED FIGURE — PARIS, LOUVRE.

214

202 - LORENZO DI CREDI. ANGEL — LONDON, BRITISH MUSEUM.

204 - LORENZO DI CREDI. HEAD OF AN OLD MAN — PARIS, LOUVRE.

203 - FILIPPO LIPPI. VIRGIN AND CHILD WITH
ST. JOHN THE BAPTIST — FLORENCE, UFFIZI.

205 - DOMENICO GHIRLANDAIO. HEAD OF AN OLD MAN — STOCKHOLM, ROYAL LIBRARY.

206 - LEONARDO DA VINCI. HEAD OF A WOMAN — PARIS, LOUVRE.

207 - LIBERALE DA VERONA. ANGELS PLAYING MUSICAL
INSTRUMENTS — LONDON, BRITISH MUSEUM.

208 - ANTONIO POLLAIUOLO. HERCULES AND THE HYDRA — LONDON, BRITISH MUSEUM.

209 - GIOVANNI BELLINI (ATTR.). PORTRAIT OF A MAN — OXFORD, CHRIST CHURCH LIBRARY.

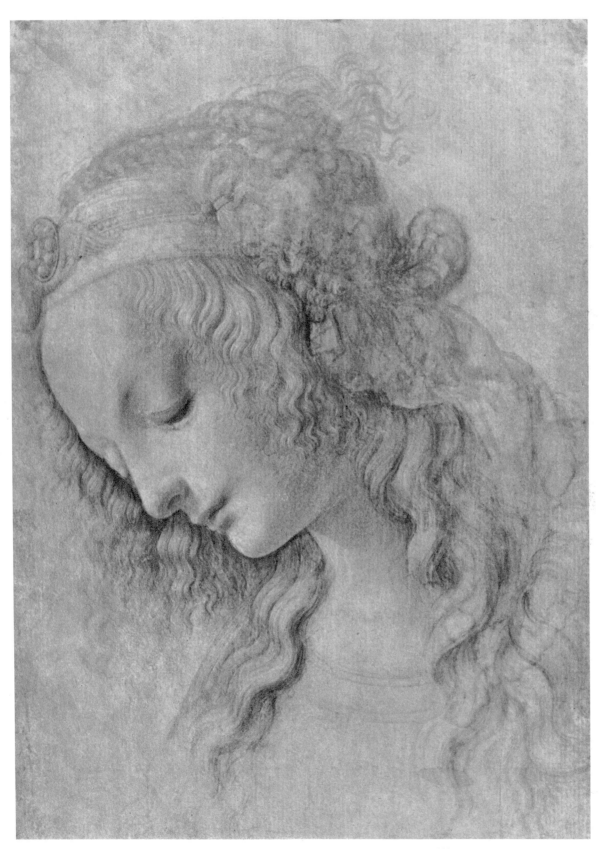

210 - LEONARDO DA VINCI. STUDY: VIRGIN OF THE LOUVRE ANNUNCIATION (?) — FLORENCE, UFFIZI.

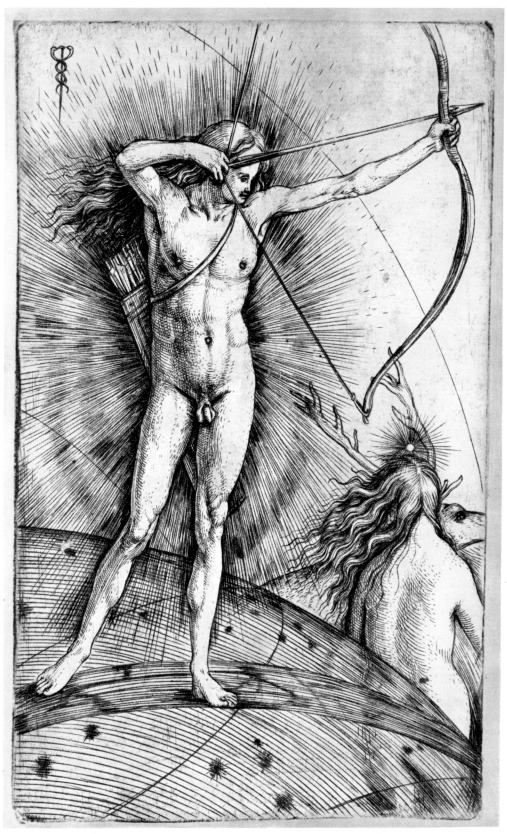

211 - JACOPO DE' BARBARI. APOLLO AND DIANA — PARIS, BIBLIOTHÈQUE NATIONALE.

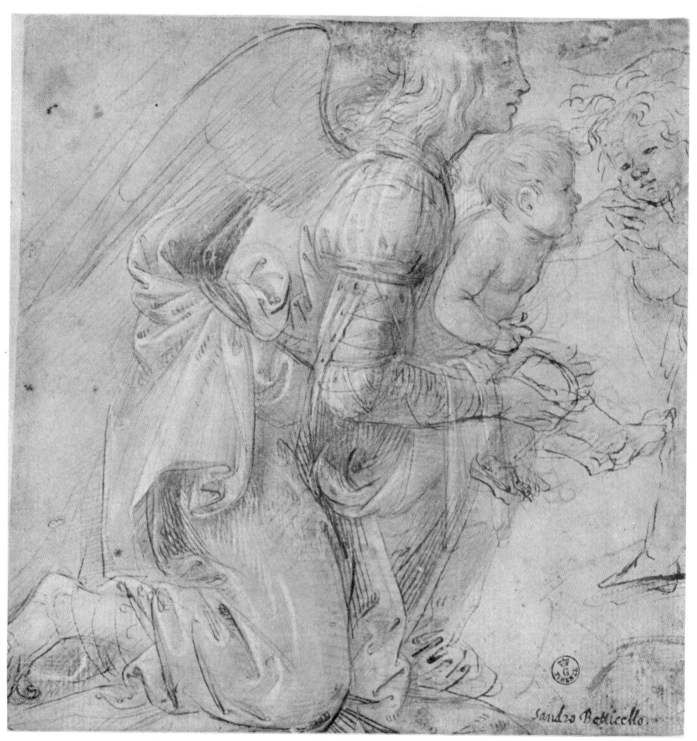

212 - RAFFAELLINO DEL GARBO. ANGEL HOLDING THE INFANT JESUS — FLORENCE, UFFIZI.

225

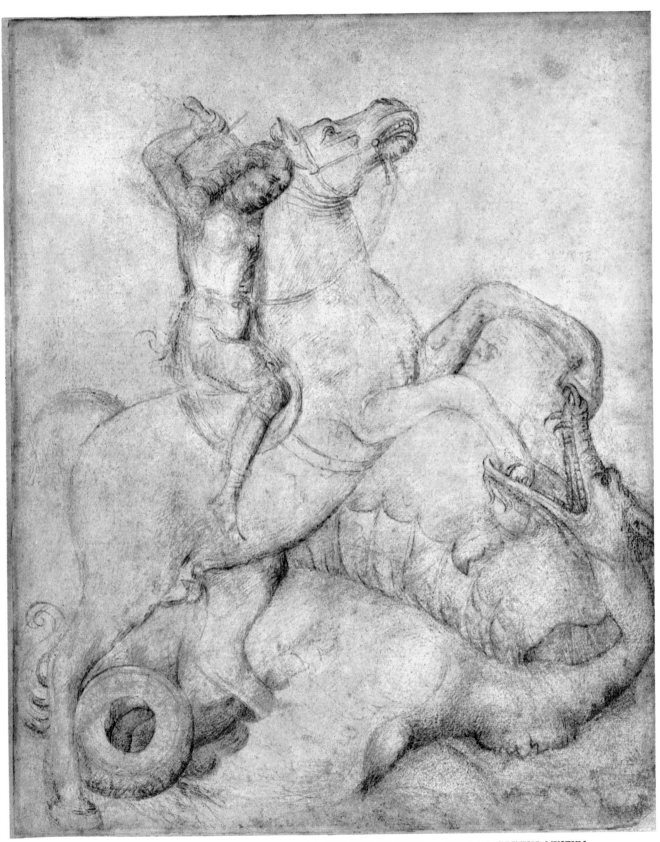

213 - JACOPO BELLINI.　ST GEORGE AND THE DRAGON — LONDON, BRITISH MUSEUM.

214 - LEONARDO DA VINCI. STUDY OF AN ANGEL, RIDERS AND OTHER FIGURES — WINDSOR CASTLE, ROYAL LIBRARY.

There were two other types of notation and drawing: the diagrams of ornamental motifs, architectural detail, accessories, etc.; and complete compositions, such as are to be found in the famous drawing-books of Northern Italy, like those of Marco Zoppo or Jacopo Bellini, which are definitely vocabularies of forms for use in the studio. There is a similar drawing-book, full of motifs borrowed from various sources, by a Florentine sculptor, Francesco di Simone[15]. There are, lastly, the books of architectural designs or of fragments from Antiquity, of which the most remarkable and best known is the 'book' of Giuliano da Sangallo. As for Leonardo's notebooks, begun in about 1480 and continued till his last years with the volubility and universality that we all know, they develop all these lines, with the passion of the naturalist and engineer gradually replacing the humanist interest[16].

Drawing was both the means of making a great many rapid notes and the instrument for slow, prolonged study: it could both pin down an intuition and form a

227

215 - FRANCESCO DI SIMONE (ATTR.). STUDIES: SAINTS AND PUTTI — LONDON, BRITISH MUSEUM.

216 - FRANCESCO DI GIORGIO (ATTR.). STUDIES OF NUDES — FLORENCE, UFFIZI.

ERCOLE

217 - MASO FINIGUERRA. FLORENTINE PICTURE-CHRONICLE. DEATH OF HERCULES — LONDON, BRITISH MUSEUM.

basis for elaboration. On the wall of a house that belonged to Mino da Fiesole after 1465 sketches have been found which are certainly by the artist himself working in full freedom. Other artists, like Credi, painted on paper. There was even a painter called Agnolo di Donnino, a friend of Cosimo Rosselli, whom Vasari mentions as having ended his days in utter poverty because he spent his time on his drawings and could no longer bring himself to paint. In the space of one generation, drawing had become the perfect medium for recording everything, especially those innumerable observations now carried out in the studios on the mechanisms of the living body and the morphology of natural objects. So the general expansion of graphic work enables us to follow the relations between art and science, besides helping us to understand how the most complex relations could arise between architecture and painting, between painting and the arts of decoration. The end of the Quattrocento saw what amounted to the predominance of those types of knowledge that can be transmitted by graphic means, and this indeed, on the technical side, seems a possible definition of the Renaissance[17].

Just when Italy felt ready to receive all the heritages, the introduction of engraving enormously increased the speed of exchanges and the interplay of the various contributions. The controversy on whether the invention of printing had its origin in Italy or in the Rhineland is chiefly interesting for its reminder that the new techniques were exploited with skill and passion in both the rival regions.

Vasari thought he could assign a precise date and origin to the invention of engraving on metal: it goes back, he wrote, to Maso Finiguerra of Florence 'in about the year 1460 of our salvation,' and was followed up by Baccio Baldini. The new technique reached its full development with Mantegna 'who had heard tell of it in Rome.' Then 'the method passed into Flanders, where there was Martin [Schongauer] then Dürer.' The invention may have been Italian, but its history could only be told as part of Italo-German relations : 'Although these masters were at that time highly thought of in their own country, their own works are only admired among us Italians for the precision of their cutting.' This way of presenting the facts is useful in bringing out the Italian antecedents and the part played by the niellists; its purpose was to plead the cause of Marcantonio and of the late Quattrocento Italians Robetta of Florence and Jacopo Ripanda of Bologna (the 'Master of the Bird') against the fine German technique[18].

218 - CRISTOFORO ROBETTA. FAITH AND CHARITY (DETAIL). PARIS, BIBL. NATIONALE.

219 - ANON. FLORENTINE. THE FLAGELLATION — VIENNA, ALBERTINA.

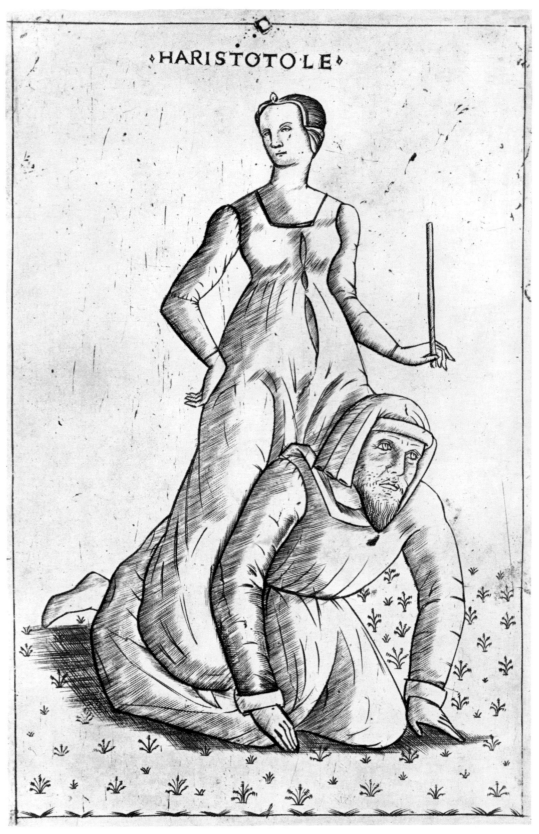

HARISTOTOLE

220 ANON. FLORENTINE. ARISTOTLE AND PHYLLIS — HAMBURG, KUNSTHALLE.

233

221 - LUCANTONIO DEGLI UBERTI. SEATED WOMAN WITH TWO CHILDREN PLAYING — LONDON, BRITISH MUSEUM.

222 - THE MASTER OF THE BIRD. ST. SEBASTIAN — LONDON, BRITISH MUSEUM.

223 - ANDREA MANTEGNA. BATTLE OF THE SEA GODS — LONDON, BRITISH MUSEUM.

224 - MANTEGNA. MADONNA AND CHILD.
VIENNA, ALBERTINA.

The full exploitation of this '*comodità veramente singularissima*,' with its power to make works of art known at a distance, was due almost inevitably to that practical and well organized artist Mantegna. In a letter written in 1491 to Gianfrancesco Gonzaga he explains that he has easily managed to repeat a picture—it was probably a small seated *Madonna*—which the prince had sold, because he had its *stampe*. Thus Mantegna had understood perfectly the two 'photographic' functions of engraving, as an individual document, equivalent to a copy kept for reference, and as an instrument for making models more widely available[19]. Some of the models used in drawing and painting owed to engraving a continuation of their authority: for instance, the pre-Botticellian

225 - ANTONIO POLLAIUOLO. BATTLE OF THE NUDES — PARIS, PETIT PALAIS.

draperies and the marvellous costumes of the 1460
Chronaca were made widely known through engraving,
which gave to purely graphic style the support of a
technique based on outline and line. In this way the
taste for dancing figures in outline and for arabesque-like
draperies was maintained by engraving, which also gave
wider circulation to the motif of the **nude**, admirably
treated by Pollaiuolo in a memorable print later found
useful by Mantegna's school and by Dürer.

To take an example in the field of ornament, it seems
legitimate to attach some importance to Finiguerra's
extravagant decoration in his engraving, the *Beheading
of a Prisoner*. The gesture of the woman executioner is
given an accompaniment of fantastic creatures and of

237

226 - ANON. FLORENTINE. BEHEADING OF A PRISONER — HAMBURG, KUNSTHALLE

227 - PAVIA, CERTOSA (DETAIL): WINDOW.

monstrous architecture, and it is not without interest to note that the motif of the candelabrum-column, formed of a series of flat sections and vases piled on one another, appears in the context. One of Mino's improvisations on the walls of his house, mentioned above, is a delicate vertical study of a candelabrum—evidence that the motif was a current one. At Arezzo, Piero treated it as a column, using it as a support for the astonishing throne of Chrosoes, near which the throat of the Persian king's son is being spectacularly cut. With the Venetian painters of the Bellini group the ornamental motif of the candelabrum emerges as a transformation of the giant chandelier theme, as a careful drawing in the Ufizzi shows; at Ferrara the painters and ornamental designers constantly returned to the special combinations of forms made possible by this picturesque type of column; and finally it became part of architectural decoration. In Lombardy it was first outlined on the pilasters, and then quite openly took the place of a support: it is prominent in the case of the mullions of double-arched windows, for instance

228 - ZOAN ANDREA. TWO LOVERS — MILAN, BIBLIOTECA AMBROSIANA.

229 - PREDICA DELL'ARTE DEL BEN MORIRE —
TITLE PAGE — PARIS, BIBL. NATIONALE.

in the Certosa of Pavia. This rapid development was accompanied by many variations in the graphic arts, up to 1500 and beyond.

Engraving also supplied images for the decoration of box lids, chests, small devotional panels, tarot and playing-cards. It helped spread the motifs from the studios far and wide and much more quickly than ever before. And this might suggest that its effect was wholly positive and stimulating, but there was a counterpart: wood-engraving, which was soon taken up by the book trade, had a retarding effect because it was designed for popular appeal. Its main subjects were the saints, and prognostications; in both cases it was adapted to the illustration of books for a wide public, and the publishers were content to exploit, in the vignette, the more elementary of the illuminated miniatures, preferably those of the Trecento. Even the travel books were illustrated with conventional views: in Breydenbach's collection of *Peregrinationes*, for instance, only one of the views of cities stands out from the others and is clearly less artificial: that of Venice, which the illustrator based on a panoramic drawing by Gentile Bellini.

The Venetians very soon learned the importance of the book produced on modern lines coordinating text and illustrations and they felt the need to raise the standard of production. One of the first works noteworthy for the careful arrangement of its borders and the beauty of its print is Vindelin's *Livy* (1470), followed by the *Elements geometriae* of Euclid (1482) printed by Erhard Ratdolt. The Venetian printed began to establish their reputation with the *Triumphs* of Petrach (1488, reprinted in 1490 and again between 1492-1493), and the remarkable Herodotus of 1494 printed by Giovanni and Gregorio de Gregoriis.

230 - HYPNEROTOMACHIA. POLIPHILUS IN THE DARK FOREST — PARIS, BIBLIOTHÈQUE NATIONALE.

The *Hypnerotomachia* which came out in December 1499 is a masterpiece. This is borne out by the evenness of the typographical characters, the sharp definition of the illustrations and the arrangement of the vignettes and the plates. Its interest is further augmented by the multi-lingual treatment of the text and by its audacious paganism.

The illustrator possessed a delicacy of touch, and an equally remarkable understanding of the use of symbols and of evocative subject-matter; he shows a preference for fanciful decorative schemes in the antique manner, but also affects stumpy silhouetted and rounded forms. Certain scenes in the illustrations have also been compared to a manuscript of the Bibl. Marciana which is possibly the work of Benedetto Bordone, of Padua. Whatever the case may be the beautiful, clear-cut engra-

231 - HERODOTUS CROWNED BY APOLLO — PARIS, BIBLIOTHÈQUE NATIONALE.

vings of the *Fasciculus Medicinae* (1491), printed by the De Gregoriis may be compared to the *Hypnerotomachia*. This work reminds one of certain Ferrarese productions such as the *De claris mulieribus* of Bergomenis (1497), décorated with numerous linear portraits, or the *Epistles of St. Jerome* (1497) which have the same frontispiece, consisting of an architectural border bedecked with figurines.

The Florentines especially, even if they arrived at less impressive results than in Venice, were responsible for the spread of compositions in a sharp clear-cut style, in books of devotion, such as the *Devote meditationi* of St. Bonadventure (c. 1496) or the numerous writings of Savonarola: the repertory of ornamentation is reduced, but includes strong blacks in the landscape backgrounds or in the paving, and aedicular forms which definitely supersede the gentility of Gothic line.

243

MARQUETRY, GEOMETRY AND PERSPECTIVE

THE success of marquetry is one of the most signifi-
cant facts about the development of taste at this time:
it is evidence of a new artistic conviction. The spread
of intarsia work was not merely an episode in the history
of interior decorating, for the new technique was a
crossroads of the arts. Since wood-working involved
frames and supports, it brought in turners, joiners and
carvers. Its abstract vocabulary revolutionized the for-
mulae of ornament. In such figurative motifs as the still
life and the head-and-shoulders figures, marquetry seems
to have been in advance of painting. And lastly, in its
systematic administration of geometrical forms and
perspective schemes, it was closely bound up with the
genre of the 'architectural view.' We may reasonably
regard it as one of the central phenomena of the period.

The use of unstained wood—cypress, box-wood,
walnut, etc.—was rare in Italy before the fourteenth
century, though it occurred on chests, sacristy furniture
and choir stalls in the form of simple combinations of
geometrical shapes, framed in carved mouldings. With
the success of modern perspective in Florence, the art of
the *intarsiatori* was radically transformed: it became the
main vehicle of pure geometrical ornament and of mathe-
matical space, for the fitting together of bits of wood
with regular shapes made it possible to produce without
fail, through a familiar optical effect, an articulation of the
volumes and lines. This is clearly stated by Vasari *(Vite,*
introduction, chap. XXXVI, *della pittura)* : 'The starting-
point of this work was perspective, because the pieces
ended in sharp edges which, when fitted together, formed
the outlines, and the surface seemed continuous when in
fact it had more than a thousand separate pieces.'

The geometrical perspective, with its intersection of
straight lines that converged at a vanishing-point, led on
quite naturally to a marquetry network. Its use pre-
supposed the design of an abstract mesh, the fragmen-
tation of the space. It was itself a type of construction.

232 - GIULIANO DA MAIANO. MARQUETRY. THE PROPHET ISAIAH —
FLORENCE CATHEDRAL.

This characteristic, shared by the new perspective and marquetry, was already understood and exploited in Brunelleschi's time: from the middle of the century onwards the *maestri di prospettiva* were closely intermingled with the *intarsiatori*. The chronicler Benedetto Dei tells us, as we have seen, that there were eighty-four of them in Florence in 1462. The studio of the Maiano brothers was important enough to be given the commission for refashioning the marquetry cupboards, which had been built for the sacristy of Santa Maria dei Fiori in about 1440 under the direction of Antonio Manetti, by various decorative artists, among them Masaccio's brother, Scheggia. After 1470 Francione was working at Pisa, Baccio Pontelli at Urbino. In 1480 and the following years a masterpiece of illusionist style was created at Gubbio and a remarkable scheme of decoration for the chapel of San Giovanni in Siena.

At Modena, Parma, Padua and elsewhere, after 1460, choir stalls and sacristy cupboards were produced by the brothers Canozzi of Lendinara, who had been trained by Piero della Francesca; through them the new art of geometry spread as far as Lombardy. In Venice it was represented at this time by Fra Sebastiano da Rovigo, and at the turn of the century his pupil, Fra Giovanni da Verona, displayed the grand style of marquetry, first in his own town and later at the Monastery of Monte Oliveto and at Rome. Interesting examples were created at Bergamo, Genoa and Bologna between 1520 and 1540; these were increasingly complicated, with a tendency to exploit stained woods, the use of which goes back to the Lendinara brothers. Thus the great period of intarsia work extends from 1460 to 1510. It marks the spread of the abstract style, the 'cubism' of the Renaissance.

The central figures in this art were the Lendinara brothers. Their career, now fairly well mapped out, moved essentially between Ferrara, their starting-point, and Padua, the centre of their success. That their work made its name rather quickly is shown by this fact: in 1463, when Marco Cozzi of Vicenza was working on the choir stalls for the Frari in Venice, the representatives of the Republic at Padua requested that two stalls recently completed by Lorenzo Canozi should be transported '*pro monstra a Venexia*'. Maestro Andrea da Ceneselli, a *marangonus* (joiner), had had four sons, all of whom were brought up in his trade and were known by the name Canozi; the family came from the Rovigo region and had settled at Lendinara. The most famous of them were the two elder brothers, Lorenzo and Cristoforo: we find

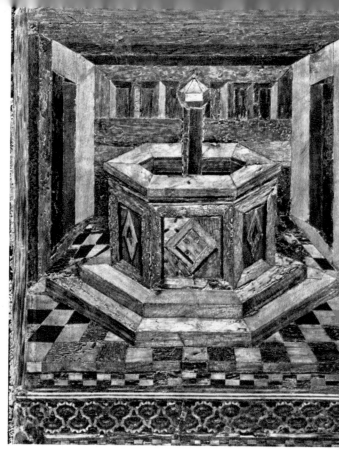

233 - MARQUETRY. STALLS (DETAIL) — VENICE.

234 - MARQUETRY. STALLS (DETAIL) — VENICE, FRARI.

them working at Belfiore, therefore in the service of Borso d'Este, from 1449 to 1453, and then, in 1456, at the cathedral of Ferrara. It is clear, therefore, that they met Piero della Francesca, who in 1449 was decorating the palace of the Corte Vecchia (destroyed in 1480) and the (now vanished) chapel of the Augustinians; they entered the 'Pierfrancescan' constellation and were soon carrying on the noble lessons of his art. From 1460 to 1465 the two brothers were at work on the marquetry decoration at Modena; here their 'geometrical' style makes its statement within a famous Romanesque church. It was in a no less famous Gothic church than the Santo in Padua, that from 1462 to 1469 they executed a large-scale scheme of decoration in carved wood and marquetry panels. The work in the two places overlapped: *Cristoforus de Zanexinis de Lendinara* was the dominant partner at Modena, and Lorenzo at Padua (G. Fiocco). The Evangelists in the Modena sacristy belonged to a second bout of work, the San Giovanni being signed and dated 1477[20]. Lorenzo died in 1477. His brother worked at Parma and then at Lucca, and in 1486 took part in the competition for the choir stalls at Pisa, where he died in 1491. His assistants, among them his son Bernardino, finished the work in 1494.

247

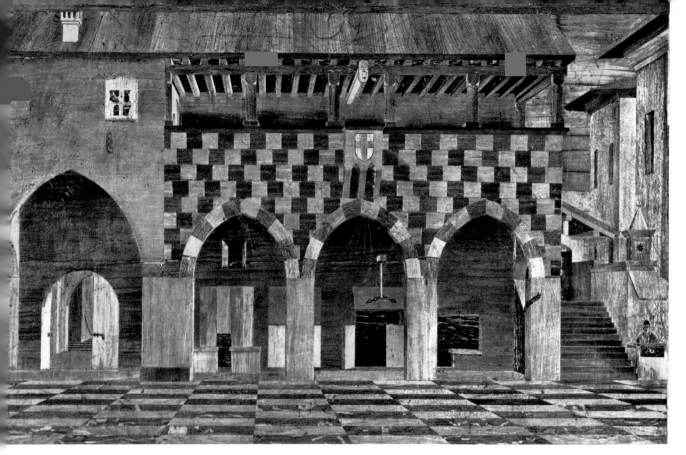

235 - CRISTOFORO LENDINARA. MARQUETRY. VIEW WITH SQUARE AND PORTICO — PARMA CATHEDRAL.

An enthusiastic description by a Sicilian traveller, Matteo Calazio *(De coro divi Antonii Patavii*, Venice, 1486), shows that the now lost work of the Lendinaras at Padua made a great impression and that its abstract style was considered up-to-date in that sanctuary of Squarcionism. It was continued by Pierantonio degli Abati, Lorenzo's son-in-law, who has now been identified, and who was an architect. The series of the Doctors —seen in perspective—in the Library of San Giovanni di Verdara, on which Pierantonio worked in association with B. Montagna, amounts to a translation into painting of those effects of depth within a frame that belong specifically to marquetry. As we have seen, intarsia had been introduced into Venice with the panels and bands of the Frari stalls; but other works in marquetry were also to be seen there, in particular the sacristy cupboards by Giovan Marco, the son of Lorenzo di Lendinara. The main contribution of the Lendinara brothers was to spread the taste for cubic forms and architectural schemes. What is known of Lorenzo's work as painter and typographer (he founded a printing-press at Padua) confirms the evidence of his love of geometry which had impressed Pacioli and was based on the authority of Piero della Francesca.

236 - CRISTOFORO LENDINARA. MARQUETRY. ST. MATTHEW — MODENA CATHEDRAL.

Marquetry was no less successful in the Marches, in the palaces of Federico da Montefeltro. The work here consisted of surprisingly ambitious and wide-ranging schemes of decoration on secular subjects, to which there is nothing comparable either before or after: large panels, resembling those of sacristy cupboards, are combined with stall-size panels to compose a continuous series all around the interior of the *studiolo*, while above them there are pictures of *uomini famosi* in loggias with false perspective. In this way intarsia work created a strange climate of geometry and illusion, intimacy and allegory, marvellously expressive of the Quattrocento spirit. The Urbino decoration was finished in 1476 by Baccio Pontelli; that at Gubbio was not completed till after 1482 (as is clear from the inscription GBALDO DX, which refers to Federico's son). The designs for the work at Urbino may have been supplied by Botticelli—certainly this is true of the door panels, on which his mark, the silhouette of Minerva, occurs; those for the work at Gubbio may be due to Francesco di Giorgio, from whose hand there exist several perspective drawings clearly intended for intarsia work. The part played by Francesco di Giorgio in the last phase of the building of Urbino gives serious ground for this hypothesis; and indeed something of Francesco's quality—its combination of strictness with a certain unevenness—reappears in the fine marquetry executed by Barili for the cathedral of Siena. This forms a second group of works in marquetry, in which the human figure and even landscape suddenly acquire importance, introducing an animation that was not present in the work of the Lendinaras.

238 - BOTTICELLI AND PONTELLI. MARQUETRY. LANDSCAPE (DETAIL) — URBINO, DUCAL PALACE.

237 - PIERANTONIO DA MODENA. MARQUETRY. IDEAL CITY —
PADUA, CATHEDRAL SACRISTY.

239 - PONTELLI. MARQUETRY. INTERIOR OF THE STUDIOLO OF F. DA MONTEFELTRO — URBINO, DUCAL PALACE.

As it spread into the most diverse artistic circles, marquetry became more and more varied, and added constantly to its technique. With Fra Giovanni da Verona, the use of stained woods made it possible to attain finer nuances, and an unsurpassable virtuosity was shown in the fitting together of the pieces. At the same time the motifs had crystallized, and the repertory of marquetry was now well defined. On the panels of choir stalls and sacristy cupboards, false cupboards with their doors ajar alternated with city views or landscapes seen through an arcade. In the decorations of libraries, prominence was given to the instruments for measuring space and time, together with the symbols of knowledge and of music. The perfection of illusionism was realized in those

240 - BOTTICELLI AND PONTELLI. MARQUETRY. CHARITY — URBINO, DUCAL PALACE.

252

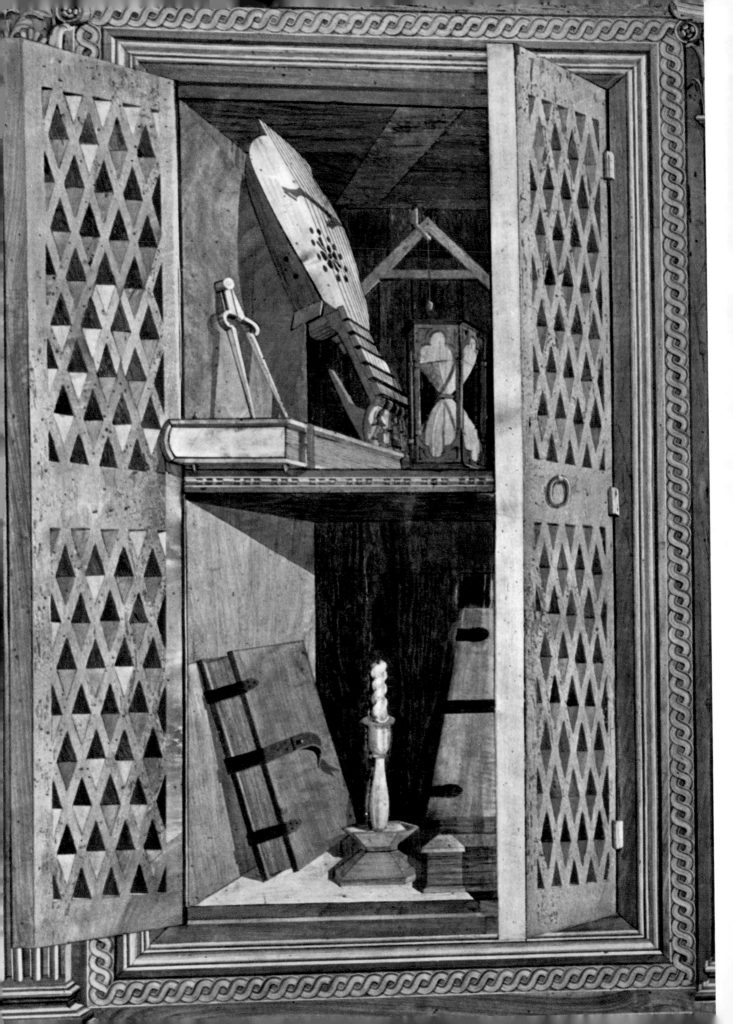

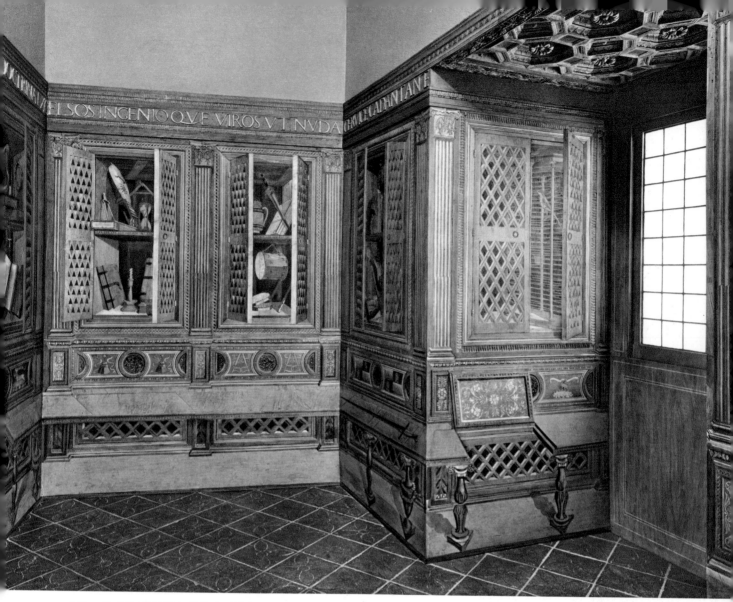

242 - F. DI GIORGIO AND B. PONTELLI. MARQUETRY. STUDIOLO OF F. DA MONTEFELTRO AT GUBBIO —— NEW YORK.

intarsia panels on which the still life was promoted to the place of honour. The choir stalls of San Petronio in Bologna, dated 1477, are fine examples of this stock of forms, with plane, cope, censer, book, organ, fountain, water-clock, vases, candles, and so on. The finest viols made in the Quattrocento were those of Urbino and Gubbio. The virtuosity of the inlayer resulted in the isolation of motifs to which no one had thought of according a special position in painting. Intarsia brought with it a quite new development of the still life and of landscape, bound up with the *trompe-l'œil* panel and the theme of an arcade opening on to space; it helped in the shaping of these two types of subject which later became the preferred field —in due course the refuge—of naturalism in painting. By the Lendinara brothers and their successors these

241 - F. DI GIORGIO AND B. PONTELLI. MARQUETRY.
STUDIOLO OF F. DA MONTEFELTRO AT GUBBIO (DETAIL) —
NEW YORK, METROPOLITAN MUSEUM. 255

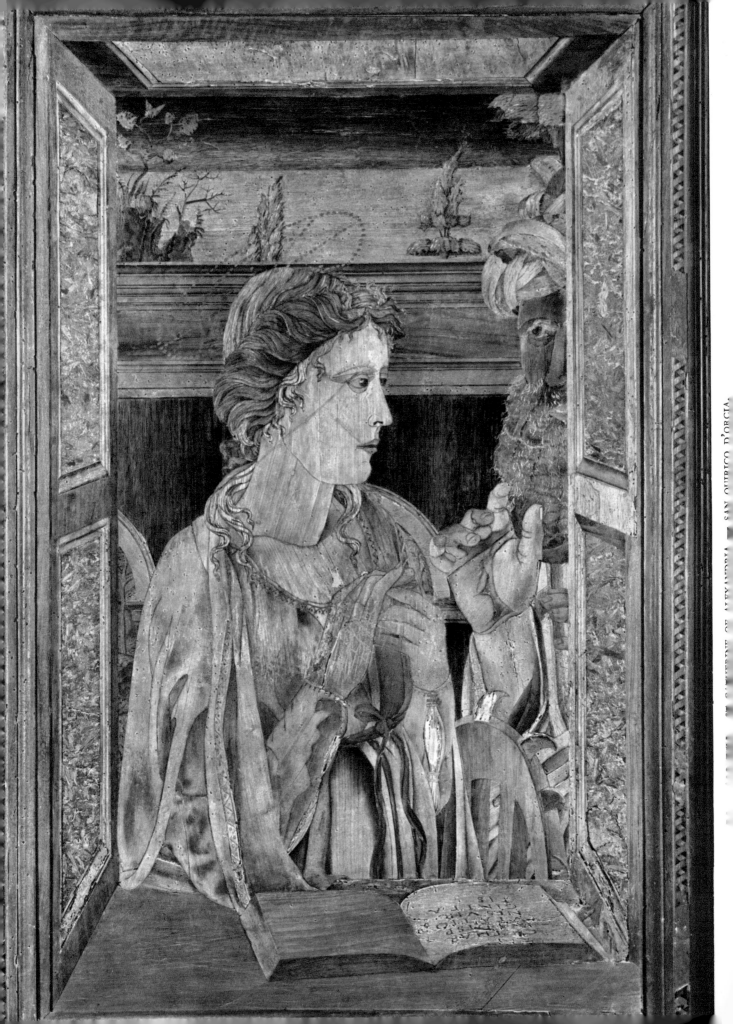

PLATE VI. ST. CATHERINE OF ALEXANDRIA · SAN QUIRICO D'ORCIA

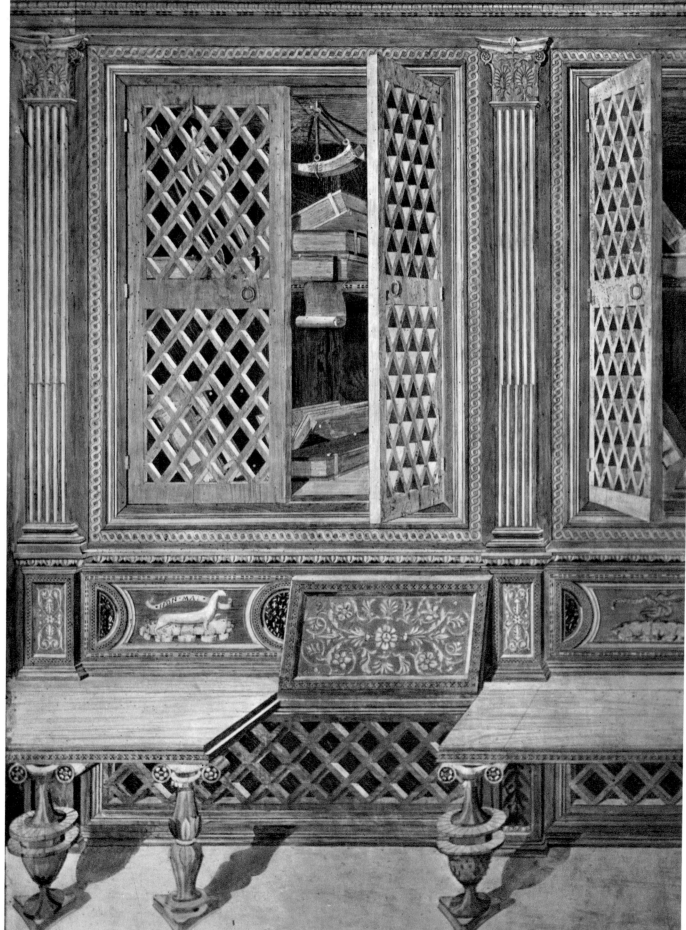

ASPICIS AETERNOS VENERAND

247 - MARQUETRY. MANDOLIN — GENOA, SAN LORENZO.

subjects were practically separated off, their forms were articulated and their poetic possibilities developed. So it happened that the two types of subject that are descriptive *par excellence* were first formulated with the help of the most geometrical and abstract development in Renaissance art. Space in marquetry was at first indicated by regular flagged pavements with their strict lines of recession, and sharply distinct geometrical volumes were clearly the natural content of this pure containing element. But soon profiles and silhouettes made their appearance as one of the outstanding accomplishments of this technique. In the panels by the Lendinara brothers the figures built up out of fitted pieces of wood were still treated with a certain plainness. The stylization of the horizon, of trees, figures and animals, became a kind of exercise in construction of which there are charming examples at Urbino, Monte Oliveto and Siena. The authors of the designs do not seem to have considered that these were *tours de force* foreign to the vocation of intarsia work: right down

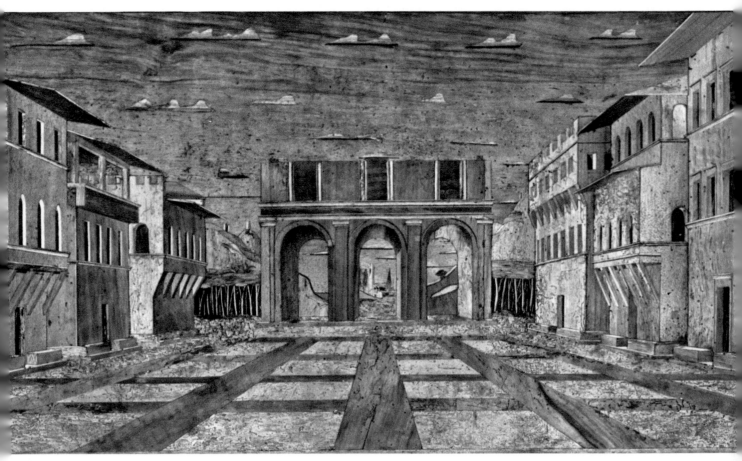

to Lotto's astonishing panels for the cathedral at Bergamo, marquetry seems to have taken its field of representation as identical with that of painting and relief carving. The elementary forms had an authority that made it possible to shape an ornamental norm, a 'pattern' valid for all natural objects.

Intarsia work maintained, in spite of everything, the attraction of a strict abstract style, whose result was both to gather city views and architectural perspectives into a play of cubes and of simple volumes suggestive of familiar objects and—conversely—to bring out, even from the disorder of a half-open cupboard in which a waterclock, a folio and a branched candlestick are to be seen, a kind of architectonic scheme of ridges and folds.

In this way decoration acquired the power to express the higher values which it shared with painting. On one of the Monte Oliveto panels, a regular panoply of compasses and set squares hangs—between a *mazzocchio*, the symbol of solid geometry, and a facetted sphere—from a

261

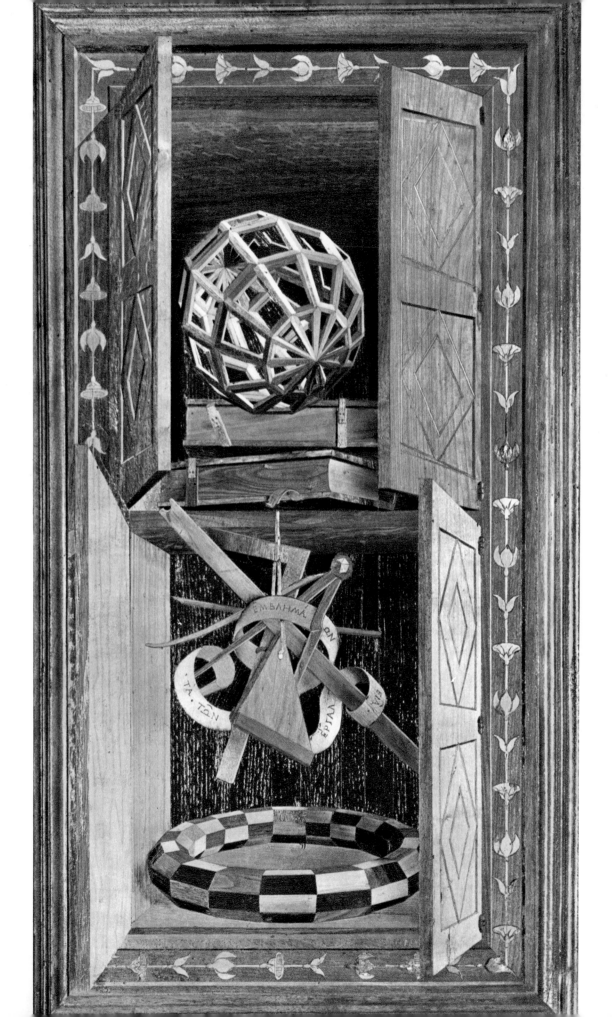

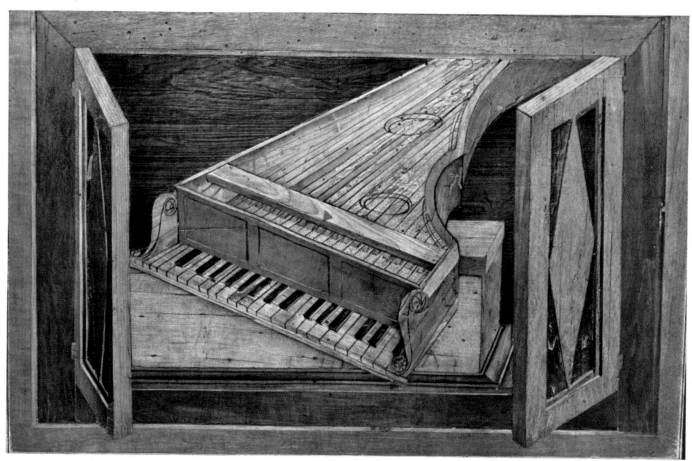

250 - MARQUETRY. SPINET — GENOA, SAN LORENZO.

ribbon bearing in Greek the inscription: 'the instruments of inlaying.' There can be no doubt that the artists were aware of the implications. It is this that makes so interesting the geometrical ornamentation that reigned over a wide region of Italian fifteenth-century art (but did not reign alone; ornamentation taken from living forms competed with it and stimulated it). It was the expression of that same fascination with pure volumes and with the geometrical properties of space, whose emergence into prominence marquetry had made possible at the psychological moment. Following Piero della Francesca, Pacioli had propounded the idea that the use of the decorative forms in practice is based on the same principles as the representation of natural objects. Possession of these rules became thus an immensely influential doctrine. They acquired the value of a *mysterium*, of an occult and marvellous teaching. And they, no doubt, are the 'secret' which Dürer, in 1506, went eagerly to Bologna to learn: *um der 'Kunst willen in heimlicher Perspectiva.'*

249 - FRA GIOVANNI DA VERONA. MARQUETRY. STILL LIFE — MONTE OLIVETO MAGGIORE.

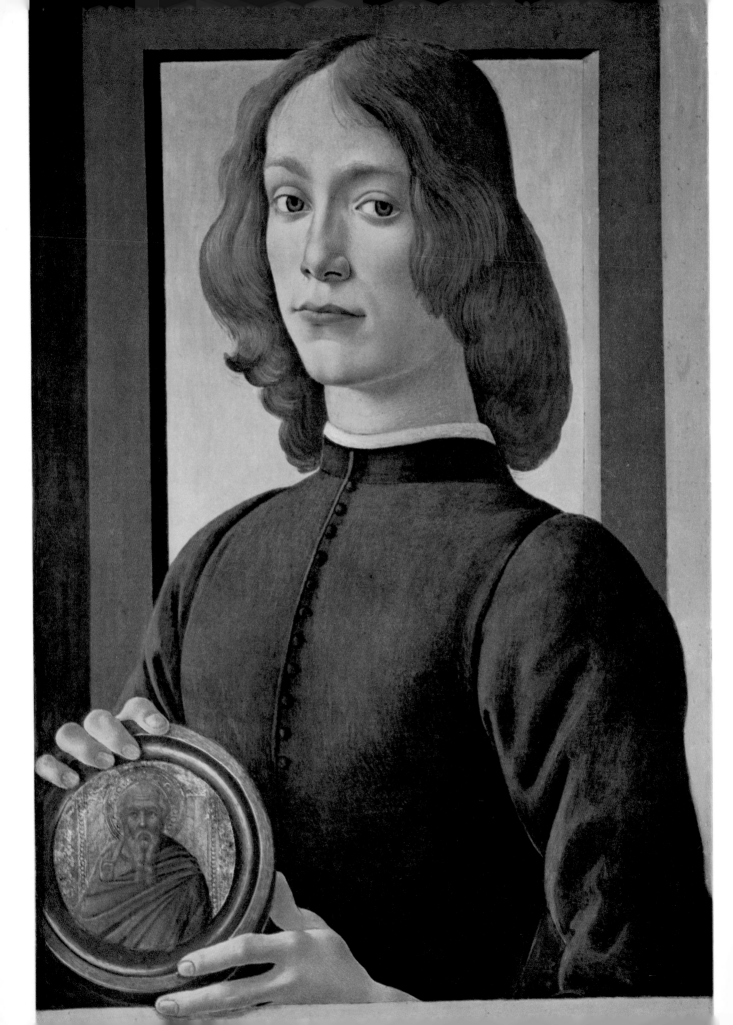

CONCLUSION

ITALY AND THE WEST

ROUND about 1460 the reaction of the regional centres was strong enough to overcome the principle of unity represented by the spread of Tuscan forms in Italy. At the end of the century the direction had been reversed: the unification of the styles was going forward, and almost everywhere one of the factors of development was an interest in those masters and works of art from the national past that were now considered exemplary.

The important part played in Flemish painting by the 'return to the masters' or 'archaism of 1500' has often been pointed out. It was a phenomenon that emerged clearly in Gerard David, who in his *Crucifixion* in the Thyssen Collection harked back both to Jan van Eyck and to the Master of Flémalle, and in Quentin Metsys, both in his *Madonna Enthroned* (Brussels Museum) and in his *Moneychangers* (Louvre), where we find the reoccurrence of definite motifs from Eyckian art. The models at which these painters looked were the great works of the years 1420 to 1440. What makes the phenomenon more significant is that this 'return to the masters' gave the young generation the full assurance they needed in order to welcome the Italian innovations within a traditional framework. It coincided with a new self-awareness in the Northern European regions[21].

LOCAL RENAISSANCES

Something analogous occurred in Italian art, though here the movement is often almost masked by the originality of the strong personalities concerned. The assurance with which the Italian masters absorbed the examples from the North presupposed, in fact, a reinforced self-

251 - BOTTICELLI, PORTRAIT OF A YOUNG MAN —
LONDON, ROYAL ACADEMY.

252 - BOTTICELLI. DANTE'S DIVINA COMMEDIA. PARADISO, CANTO XXI — BERLIN-DAHLEM.

awareness: there was a strong feeling of the originality and resourcefulness of art in the South, though it was somewhat generic and sometimes confused. The change of course towards simplicity and monumentality, which became marked in Italy (as indeed in the North) after 1490, provoked there a renewal of interest in the artists who, around 1400, had played the same part in Italy as the Van Eycks in Flanders.

A well-known note by Leonardo (Cod. Atl. f⁰ 141 a) declares that painting declines regularly whenever it seeks its models in art rather than in nature, that Giotto brought it back to nature once, and Masaccio did so again; and these are the only examples worth mentioning. The condemnation of the two intermediate generations

266

253 - MICHELANGELO. DRAWING AFTER GIOTTO — PARIS.

254 - GIOTTO. ASCENSION OF ST JOHN — FLORENC

is implied; it was in the minds of all those masters who, in sculpture as well as in painting, sought for the calm and simplified style, following the example of Perugino. Michelangelo's earliest drawings are studies based on Giotto's *St John* in the Peruzzi chapel and on Masaccio's figures in the Carmine; we find in them grand draperies whose long falls are exactly the opposite of the broken lines and fluttering folds that were common in the style of Filippino and Botticelli, not to speak of the Ferrarese. It seems at first difficult to decide if, in these cases, the young Buonarroti was acting on the advice of his patron, like the apprentices of the time, or if this was a personal initiative, to which the same polemical value might be attributed as to Leonardo's statement.

255 - ANDREA MANTEGNA. JUDITH — FLORENCE, UFFIZI.

256 - MICHELANGELO. DRAWING AFTER MASACCIO — VIENNA, ALBERTINA.

Towards 1490 interest in the Master of the Carmine was increasing in all those studios where the fashionable mannerisms and easy tricks were resisted. Ghirlandaio, in his work for the cloister of the Sagra (later destroyed), had already taken his inspiration from Masaccio's figures. Vasari strongly emphasizes the 'importance of this 'return to Masaccio'. The passage in which he sets out the history of the Masaccians is worth reading in its entirety; it includes all the great names—Verrocchio, Botticelli, Leonardo and others. Almost all the artists he mentions were Florentines; but Vasari explains that he has chosen only the most celebrated from among the '*molti forestieri e molti fiorentini*' whom he might have mentioned. Apart from the last eight in the list (who belong to the 1510-1520 generation) and from the first two (who were contemporaries of Masaccio), the most significant names in it are those of fifteen artists whose greatest activity was between 1470 and 1490 or whose training was between 1490 and 1500. The list therefore provides useful evidence about the moment at which the vogue for Masaccio reached its height, involving both the generation of Verrocchio, Botticelli and Perugino and that of Michelangelo, Fra Bartolommeo and Raphael. The decisive moment of the 'return to Masaccio' was clearly in about 1490-1495[22].

Savonarola's 'reforms' had the effect of bringing the Florentine artists back for a moment to the canons of the Dominican tradition: Filippino Lippi even painted, for a *piagnone*, a *Crucifixion* with a golden background. The result was not a new style; but Fra Bartolommeo, who in 1500 went into the monastery of San Marco at the age of twenty-eight, was easily able, starting from the tradition of Fra Angelico and the followers of Giotto, to join up with the teachings of Leonardo and Raphael and to assimilate them. There was thus a tendency towards the establishment of a kind of common basis, at the expense of the generation of Botticelli and of Mantegna, or of Cossa. Indeed the nostalgia for the fourteenth century, and even for Byzantine forms, was far from having sunk below the horizon. It reappeared not only in Venice, but was important, for instance, in shaping the art of Antoniazzo Romano, who played an essential part in Rome during the last third of the century. He can be considered as an archaizer in his copy of Giotto's *Navicella* (Lyons Museum); in his figures that stand out against a dark background (Modena Museum) or golden background (the Montefalco frescoes); and in his *Road to Calvary* (Pesaro) and *Crucifixion* he has 'the simplicity of a thirteenth-century

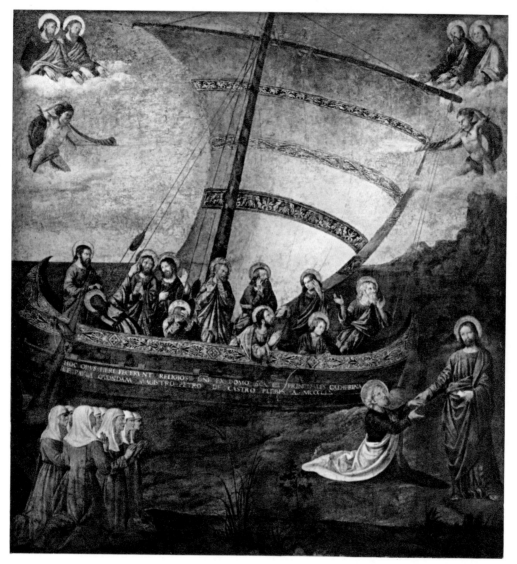

257 - A. ROMANO. COPY OF THE 'NAVICELLA' BY GIOTTO — CAMPANA COLLECTION.

painter.' But what matters is not so much the deliberate
archaism as the way he has of regaining the firmness of
the old style in the unfolding of the modern forms.
Antoniazzo simply exemplifies a provincial effort to follow
that path along which, after 1490-1495, several masters
were to achieve spectacular progress.

The phenomenon, then, was not a mere local episode.
Its equivalent seems easily found in sculpture, not only
in Michelangelo, who recognized no masters in this
field except Donatello and classical Antiquity, but more
generally in that extraordinary flowering of the forms of
ornamentation, in which Antiquity and the Romanesque
were constantly pushing through the Gothic repertory

271

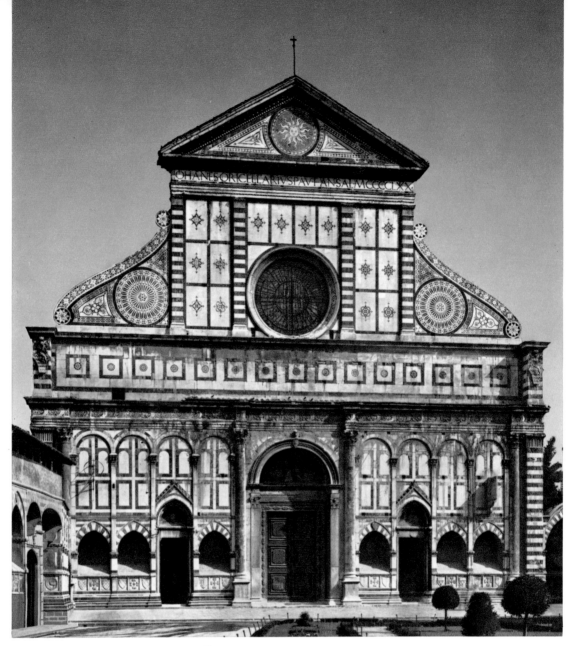

258 - FLORENCE. SANTA MARIA NOVELLA, FAÇADE.

of forms to take part in the successful examples of the
modern. In Florence the 're-Tuscanization' of architec-
ture was marked by a revival of interest in the Roma-
nesque forms: the façade which Alberti designed for
Santa Maria Novella, was a highly exact reminiscence of
the arcades, flat surface and harmonious design to be
seen in that of the Romanesque church of San Miniato
al Monte. Never had there been a clearer leap across the
Gothic. Examples became numerous after 1460—for
instance, with the small church at San Miniato by Cronaca.

Something analagous took place in Lombardy—this
time in the form of a resistance to importations from

272

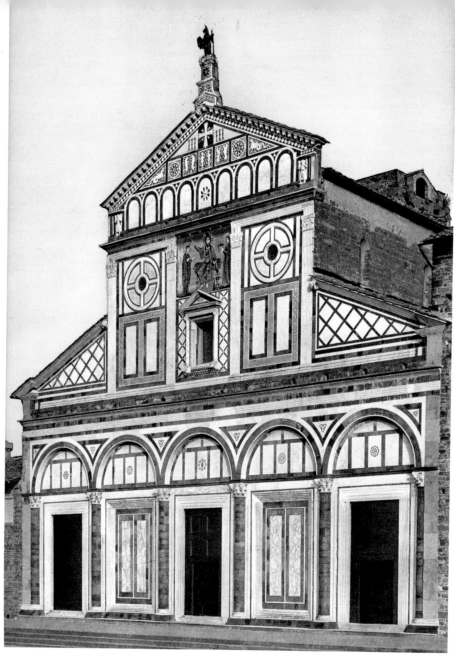

259 - FLORENCE. SAN MINIATO AL MONTE, FAÇADE.

Tuscany. The Lombard regional tradition, disturbed by the Gothic invasion which had gone on without a break since the end of the fourteenth century, reasserted itself in a return to certain Lombard habits of the Romanesque period: in the plan of the Certosa of Pavia the bays take us back to Viboldone (end of the twelfth century), the sexpartite vaulting to Piacenza (beginning of the thirteenth century), while the tower at the crossing is a Romanesque—that is, non-Gothic—stressing of Florentine forms, though distinct from these. The round churches at Lodi and Crema evoke the analogy of the great twelfth-century and early thirteenth-century baptisteries.

273

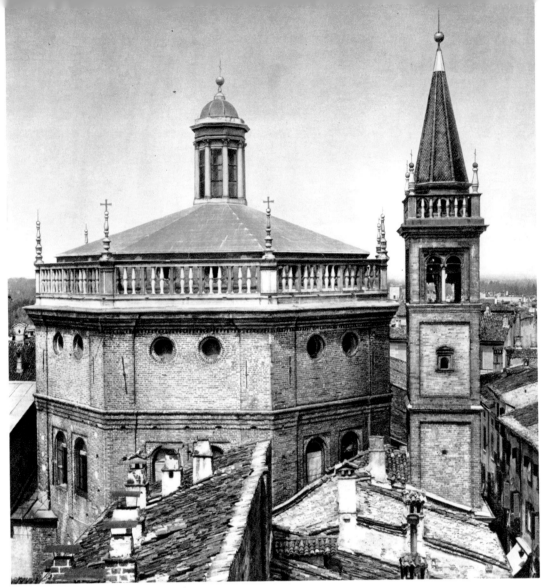

260 - LODI, SANTA MARIA INCORONATA.

The movement of return was so general that it can also be observed in Venice. Never had the centralized plan been so scrupulously observed as in the case of San Giovanni Crisostomo on the Rialto, where the palaeo-Christian type reappears in all its purity. A rapid enquiry is enough to show that, throughout Italy, from about 1480 onwards, a concern for local traditions caused a new crop of ground plans and compositions that were Romanesque, Romanesque-Byzantine or strictly Byzantine. The semi-circular arch and the thick wall acquired once more an authority that might have been thought banished. As the century advanced, the tendency took clearer shape and spread wider, while the real destiny of the movement revealed itself: this reaffirmation of old models and masters was, in fact, a series of regional 'renascences' which, though in danger of sinking into provincial pettiness,

274

261 - PARMA, BAPTISTRY.

were on a larger view indispensable as a preparation and support for the complete Renaissance (J. Ackermann). The revival of the local forms was the prerequisite for the reappearance of the forms of classical Antiquity—to which indeed, in many different places, it acted as the support. Romanesque led back to Roman. The transition from the semi-circular arch and thick construction to the orders and to articulated forms was perfectly natural.

So it came about that, on a grand scale, the Mediterranean forms were reactivated within regional systems of long standing, which were now won back from the vestiges of Gothic. The phase of the Renaissance we have just been studying ends with the affirmation of an apparent contradiction : regional originality and a universal vocation. But in the last resort the former carried the latter, and this gives us the measure of the progress accomplished.

262 - ALBRECHT DÜRER. YOUNG WOMEN OF NUREMBERG AND OF VENICE.
FRANKFURT, STÄDELSCHES KUNSTINSTITUT.

PRESTIGE AND THE ROLE OF ITALY

B Y the beginning of the sixteenth century, Italian cul-
ture had acquired a cohesion which, fifty years earlier,
it had lacked. A firmer awareness of its historical position
consolidated this unity. The movements set going by the
French invasion, the political and diplomatic activity,
more intense than ever and more closely linked with
European affairs as a whole, soon accelerated the spread
of Italian motifs. In his retreat from Naples in 1495
Charles VIII carried off books, statues, pictures, craftsmen,
—all he could lay hands on. Plunder became yet another
mode of artistic borrowing. It was merely one aspect of
that more general process of interpenetration, on which
it is natural to conclude this part of an essay on the
Quattrocento, whose aim has been to show that the art of
Italy was the only one fitted to meet the requirements of
the arts in the various European countries, because it
had assimilated or dissolved in itself their vital elements.

This overall reciprocal movement is the more interest-
ing since the flow of craftsmen from the northern countries
to Italy — of Rhineland masters to Lombardy, of
Bavarian sculptors to the Marches, of Flemish painters
to Genoa and Naples — did not cease: it was now
reinforced by Frenchmen, such as Perréal, painter to the
king, who met Leonardo in Milan, and by Spaniards, such
as 'Ferrando Spagnolo' (probably Yañez da la Almedina)
who worked with Leonardo in Florence in 1505 on the
Battle of Anghiari; and also by official visitors—in 1508
Gossaert, accompanying the bastard Philip of Burgundy,
passed through Verona, Florence, Rome and Venice.
The idea of *Wanderjahre*, including a stay in the peninsula,
was initiated by Dürer, who went to Italy in 1495 and

263 - MICHEL COLOMBE. ST GEORGE AND THE DRAGON — PARIS, LOUVRE.

returned there in 1505-6; and his attitude is generally
illuminating. These painters and sculptors from the
North and from the West now brought to Italy less than
they took away, though we must not minimize the benefits
in such matters as the technique of oil painting and
engraving still derived by Italian artists from these
contacts. What the whole of Europe would very soon be
receiving from Italy was not a series of recipes, but a new
direction, an invitation to a new realm, a faith in a kind
of *tertium regnum*—that of art and culture.

The emigration of Italian artists to the European
courts now acquired the scale of an expansion. It was a
far cry from the time when Francesco Laurana and a
craftsman from the Como region, Tomaso di Malvito,
had discreetly decorated the chapel of Saint-Lazare at
Marseilles for King René; and it was no longer a matter of

264 - PIERRE FAIN. CHATEAU DE GAILLON, ENTRANCE.

secondary figures like the Neapolitan medallist Giovanni
di Candida, who went to the Low Countries and then to
France, where he became secretary to Charles VIII. It
was for the Abbey of Saint-Denis that the Giusti (Tuscans
settled at Tours) went to work. At Gaillon the Cardinal
of Amboise gathered together works of art prepared for
him in Genoa and Milan, and he brought well-known
craftsmen there to elaborate a new style, with such

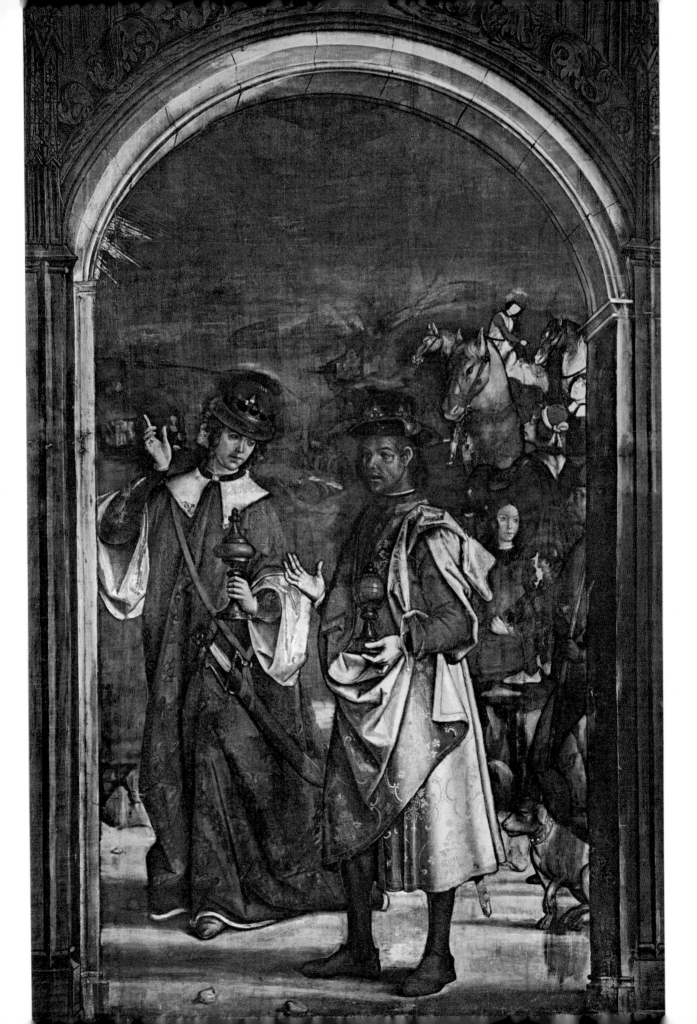

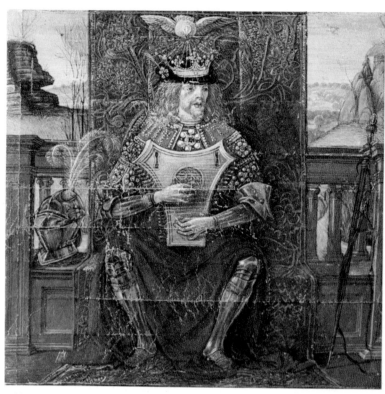

266 - BIBLE OF MATTHIAS CORVINUS — FLORENCE, BIBL. LAURENTIANA.

success that, twenty years after the great enterprise at Fontainebleau, Gaillon was to astonish the Italians themselves. Florentine and Lombard taste, both of them held in honour, met in Spain; the resulting movement took shape in the time of the Borgias, for instance with the career of Domenico Fancelli—while Andrea Sansovino, invited to the Court of Portugal, introduced Tuscan clarity there. A few years later Berruguete returned home from Urbino and Yañez from Florence, and in a sustained effort of great formal dignity they showed what the new taste could do. In a quite different direction, the end of the fifteenth century saw the propagation of Italian forms in Central and Eastern Europe. The Hungary of Matthias Corvinus was filled to overflowing with Tuscan illuminated manuscripts and reliefs. In Moscow, at the court of Ivan III, constant use was made of Northern Italians[23] during the final construction of the Kremlin: from 1490 onwards Solari, who came from Milan, was working on the fortress walls and on the Diamond Palace—of which the former are reminiscent of the Castello Sforzesco, the latter of the ornamentation of buildings in Ferrara. Already in 1475 Aristotele Fioravanti, from Bologna, had built the Cathedral of the Assumption in Moscow, impos-

265 - BERRUGUETE (ATTR.). ADORATION OF THE MAGI (DETAIL) — MADRID, PRADO.

267 - ANTONIO FILARETE. MILAN, CASTELLO SFORZESCO, CLOCK TOWER.

268 - PIETRO ANTONIO SOLARI. MOSCOW, DIAMOND PALACE.

ing regularity on the Byzantine convention of the centralized ground plan with five cupolas. And lastly, at the beginning of the sixteenth century, there came the church of the Archangel Michael with its fairly clear derivation from the style of Mauro Coducci.

Particular attention was given to the innovations that appeared in Italy in the years 1480-1495: they were understood as answers—which indeed they were—to the problems of the time. Thus emancipation from the traditional types of castle was made easier by the new art-form, the villa. The creations of the Florentines, based on non-Tuscan elements, were scrutinized and understood—especially Poggio Reale, that elegant country palace built just outside Naples by Giuliano da Maiano, with its open arcades and well laid-out gardens. The success of this formula may be noted in two Western countries: to King John II of Portugal Lorenzo sent Andrea Sansovino, who built close to the Tagus 'a castle with four towers' (like Poggio Reale); and at the request of Cardinal Giulio della Rovere, Sangallo offered to the King of France a design for a modern castle that was evidently inspired by the same principles. The Cardinal 'presented to the King the model of a palace, made for him by Giuliano: this model was marvellous,

270 - N. CHANTERENE. PULPIT — COIMBRA.

enriched by many decorative motifs, and so large that it
could lodge the whole Court. The Court was at Lyon
when Giuliano came to present the model; it gave such
pleasure to the King that he rewarded the artist and was
untiring in his praises; he made known all his gratitude
to the Cardinal in Avignon.' This gift is more likely,
in our opinion, to have been made in the spring of 1496,
after the Naples adventure, than in 1494 during the
preparations for the 'descent' upon Italy; and if so, we
may suppose that the design was based on the Neapolitan
palace, by which the King of France had been so much
attracted when he resided there in the winter of 1494-95.
Interest in these models was later kept going by Leonardo
da Vinci, when in 1507 he entered the service of Charles
of Amboise, and afterwards in his plans for Francis I;
Serlio, who arrived in 1540, confirmed it with his book
of designs, among which the famous Poggio Reale
figures prominently.

The effect of Italian art in Muscovy was not, it is
true, as strong as in France or in Portugal. In the field
of sculpture the divergencies of style were greater than
elsewhere. The end of the fifteenth century was an
important period for sculpture in Central Europe, with
Grasser working in Munich, Bernt Notke in the Baltic

272 - HERMANN AND HEINZ. EFFIGY OF LOUIS I (DETAIL) — MARBURG, ST ELIZABETH.

271 - TULLIO LOMBARDO. VENDRAMIN TOMB (DETAIL) —
BUST OF A WARRIOR — VENICE.

273 - HEAD OF YOUNG MAN. MOULINS, MUSÉE DÉPARTEMENTAL.

region, and Veit Stoss at Nuremberg and Cracow. For a long time this art retained its authority, which it owed to the tendency of the figure to occupy all the dimensions of space, and to the 'physiognomic' stress that had already become marked in about 1470 in the work of Nicolas Gerhaert of Leyden. The encounter between this hard, sharp style and the repertory based on classical Antiquity proved dramatic and difficult, and went on throughout the sixteenth century. But this was not the case in those regions, such as Normandy, where the dominance of the ornamentation which we prefer to call 'hyper-Gothic' allowed of a firm alliance with the

274 - STUDIO OF M. COLOMBE. VIRGIN AND CHILD — PARIS.

Lombard repertory, nor in places where the noble and 'relaxed' style of Burgundy and Languedoc was reinforced by the Tuscan contribution. These stimulating interventions of Italianism took place, round about 1500, in the name of the forms of the Quattrocento; they spread the effect of Italianism outside Italy just as, within Italy, the success of the Roman style was on the point of outmoding and practically outlawing them.

In the field of engraving, which naturally amplified these exchanges, the two-way movement is quite plain. In Italy the prints produced in Northern Europe were still admired: Dürer, who owed much to Mantegna, in turn impressed many young artists, especially painters of the 1515-1520 generation. But in about 1500 he himself had been drawing upon Italian symbolism, mathematics and formal order. Besides Mantegna, Paduans such as Paren-

276 - ALBRECHT DÜRER. RAPE OF THE SABINE WOMEN — BAYONNE, MUSÉE BONNAT.

tino (the master who signed P.P.) were imitated in Germany. And, still more typically perhaps, various unpretentious devotional prints produced north of the Alps reveal an effort towards the simple layout of Italian popular compositions like the *St Anthony of Padua*. Venetian, Lombard and Florentine illustrated books were soon stimulating the simplest and easiest kind of borrowing from Italy, the borrowing of ornamental motifs. The pilaster with foliage and the candelabrum quickly became favourite stylistic devices throughout Europe.

So it came about that highly differentiated artistic circles in Western Europe pushed late Quattrocento Italian ideas far beyond anything that had been thought of in Italy: striking instances of this are the Manueline style in Portugal and what might be called the 'Valois' style in France between 1500 and 1540. The conclusion

seems clear, that the power of Italian art came from its
contradictory forces as much as from its unity: the
originality of various regional formulae caught on in
this or that place where it met with affinities, while the
ideal of modern art was accepted everywhere without
discussion. The forms of 1480-1490 were the ones that
thus achieved continuation and showed their fruitfulness
beyond the Alps, not those of 1460-1470, nor those
belonging to so-called 'classical' art, which was taking
shape in Rome just when the peripheral countries were
reacting to the Italian art that had immediately preceded it.
This can easily be seen in the case of painting: the definite
influence outside Italy was exercised not by the work of
the Squarcionisti, still less by that of the great Ferrarese
painters, but by the second phase of the style, the phase
represented by the Lombard sculptors or by such artists
as Parentino; and again, not by Piero della Francesca,
but by the tepid Perugino, who provided an edulcorated
and easily assimilable version of Piero's style. It might
be said, somewhat simplifying the matter, that the real
forces of Italian art were soon obscured by loosened and
vulgarized forms, until Bramante, Raphael and Miche-
langelo imposed fresh ones. In the case of Perugino, for
instance, the situation is clear. As Vasari says: 'His

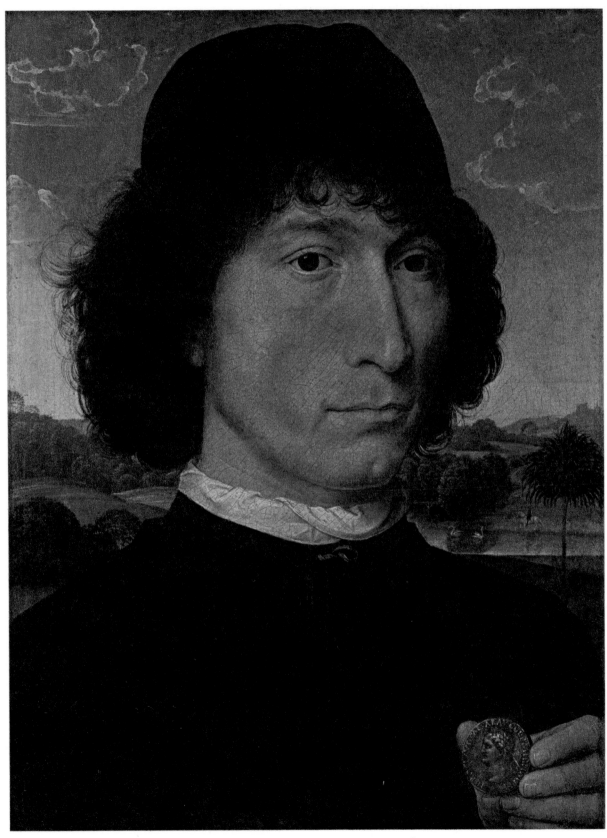

278 - HANS MEMLING. PORTRAIT OF A YOUNG ITALIAN — ANTWERP, KONINKLIJK MUSEUM VOOR SCHONE KUNSTEN.

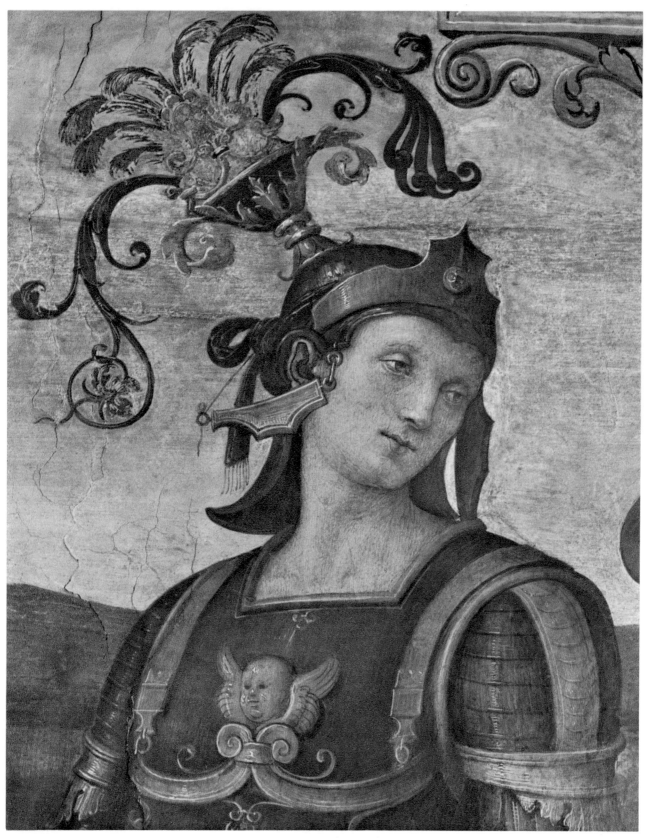

279 - PERUGINO. VIRTUES AND HEROES (DETAIL) — PERUGIA, COLLEGIO DEL CAMBIO.

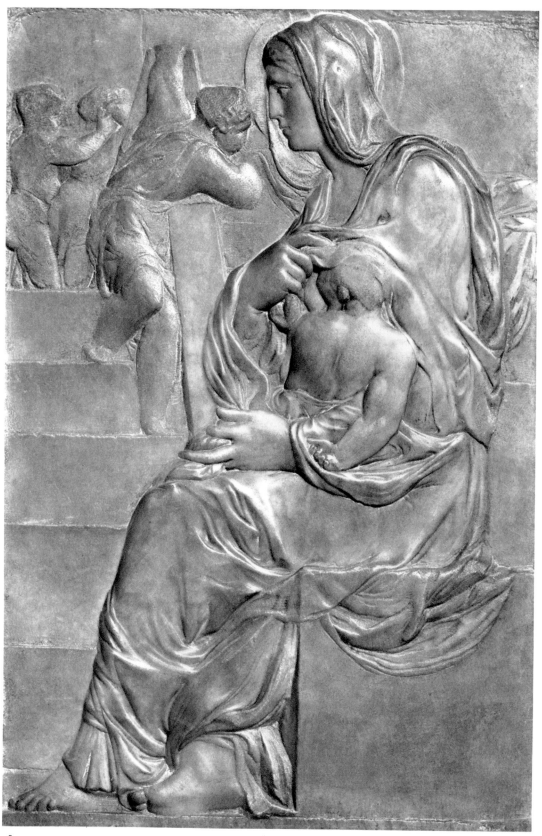

280 - MICHELANGELO. MADONNA 'DELLA SCALA' — FLORENCE, CASA BUONARROTI.

manner was found so pleasing in his time that a great number of painters came from France, Spain and Germany and other regions to study it. There was a great commerce in his works and they were sent by dealers to various countries, before the manner of Michelangelo opened up the good and true way for the arts.' But the much admired Perugino, though he handed on principles of composition and a sense of space derived from Piero, was, on the other hand, doing little more than restoring to the countries of the North a sentimentality already assimilated through Flemish examples: the envelope was new.

Thus the last generation of the Quattrocento in Italy was in an exceptionally favourable position for setting Western culture on a new course. With that generation the general return to Mediterranean forms, the 're-Mediterraneanizing' of art, was achieved. Fifteenth-century Italy had been as vigorously concerned with nature as with culture: the result had been a great many harshnesses and naïvetés, often of great charm, all kinds of inspired inventions which were destined to be thrown overboard; but this very dualism had, as Panofsky observes, 'rendered the Quattrocento fit to hand on to the North the artistic experience of Antiquity.' The sculptors of Gaillon, the ornamental artists of the Loire, Dürer and Altdorfer, Quentin Metsys and Gossaert sought in late fifteenth-century Italian art the contemporary form of a power whose great past astonished them and exceeded their grasp. The triumphal welcome given to Italianism throughout the West was a welcome to the most active and articulate carrier of the myth of the 'modern'; success was accorded to the giver of the means of exalting life through culture and expanding the present through history. It was this that was to be known as the Renaissance.

PART TWO

Illustrated Documentation

MEDALS OF POPES, PRINCES AND CONDOTTIERI

The revival of the medallist's art in XVth century Italy was determined by the collections of Roman coins and by the prevalent feeling for the glorification of individuals. Collections of medals were numerous in Northern Italy, especially Venice, by the end of the XIVth century : from 1450-60 onwards they increased everywhere, and some of them grew very large,—those of the Medicis for instance, since in 1464 Lorenzo managed to acquire the collection already gathered by the Pope (see R. Weiss, *Un humanista veneziano, Papa Paolo II,* Venice, 1958). The Renaissance medal took over from the ancient coin its small scale, so that it became a portable portrait : the obverse displayed the portrait of the individual who was being honoured, the reverse an allegory expressing his personality or a scene evoking some noteworthy episode from his life. The medal struck by Pisanello for John VIII Palaeologus is a typical example. There was now no prince, prelate or humanist who did not have his 'portrait' in metal.

Florence and Siena. The most famous medallists of these cities are: Niccolo Spinelli (known as Niccolo Fiorentino), to whom many portraits can be attributed with certainty, including one of Lorenzo the Magnificent; Antonio Guazzalotti da Prato (1435-1495), whose best-known works are the medals of Sixtus IV, Nicolas V and Alfonso of Calabria; and Bertoldo di Giovanni, whose style was less sure but had plenty of life, and who made a celebrated portrait of Mahomet II. The medallists were in some cases also sculptors, painters and architects, as for example Francesco di Giorgio and Michelozzo.

Northern Italy and Venice. Matteo dei Pasti was influenced by Pisanello; after working at Verona, he left for Rimini: Portrait of Sigismondo Malatesta.

At Mantua various artists were employed to glorify the court of the Gonzagas. Jacopo Illario, known as l'Antico, possessed a decorative feeling and a neo-classical refinement which account for the nickname.

In contrast, Sperandio Savelli was a realistic portraitist. He worked in Milan, Venice and Bologna, where he made the portrait of Giovanni II Bentivoglio. To Gianfrancesco Enzola, who came from Parma, we owe a series of portraits of the Pesaro Sforzas.

In Venice, Camelio, a producer of small portraits, became in 1506 Maestro della Stampa at the Zecca—of capital importance in this connection—and made coinage for the Doges. Another artist, Pietro da Fano, is notable for his medals of Pasquale and Giovanni Malipiero. But a painter such as Giovanni Bellini would also turn his hand to medal-making : another celebrated medal of Mahomet II was executed by him (1480).

Central Italy. Caradosso, after a long time spent in the service of the Sforzas (portrait of Lodovico il Moro, c. 1488), came to Rome, to the court of Julius II, whose portrait he made, with a view of St. Peter's on the reverse.

Artists like Guazzalotti of the Florentine school and Cristoforo di Geremia from Mantua are also found working in Rome; and a sculptor, Giancristoforo Romano, likewise worked there as a medallist.

Outside Italy. The productions of the Italian medallists were appreciated beyond the Alps. In particular, Giovanni da Candida, who came from Naples, served on diplomatic missions in Flanders and in France and brought the art to them.

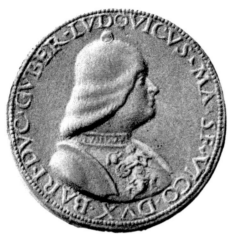

281 - LODOVICO SFORZA.

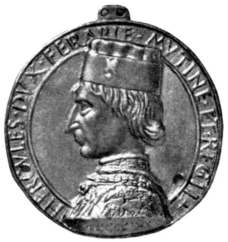

282 - ERCOLE D'ESTE.

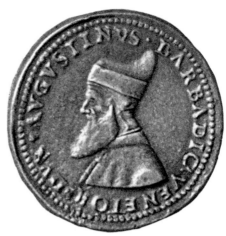

283 - AGOSTINO BARBARIGO.

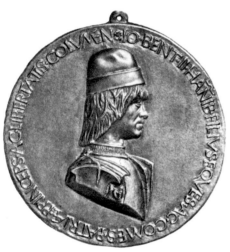

284 - GIOVANNI II BENTIVOGLIO.

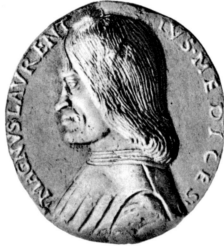

285 - LORENZO THE MAGNIFICENT.

286 - FEDERICO DA MONTEFELTRO.

287 - ALFONSO OF ARAGON.

288 - SIXTUS IV.

289 - ALEXANDER VI.

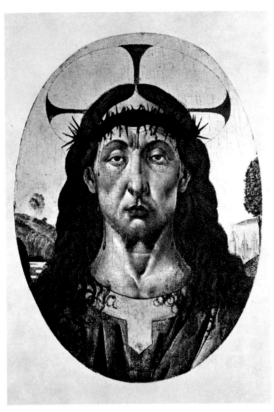

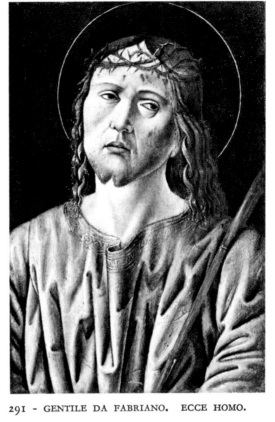

290 - G. B. UTILI DA FAENZA. ECCE HOMO.

291 - GENTILE DA FABRIANO. ECCE HOMO.

292 - MASTER OF THE SFORZA ALTARPIECE.

293 - MELOZZO DA FORLI (ATTR.). SALVATOR MUNDI.

302

REPRESENTATIONS OF THE CHRIST OF THE PASSION

It is convenient to distinguish, at the end of the Middle Ages, the Holy Face, the Ecce Homo, and the Entombment. The evolution and intersection of the three themes led, at the end of the XVth century, to many original developments (see E. Panofsky, in *Festschrift für Max Friedlaender, zum 60 Geburtstag*, Leipzig, 1927).

Ridolfi in *Le meraviglie dell' arte* (Venice, 1648, p. 55), provides interesting evidence on both the iconography and the treatment of the theme in a *Saviour giving His blessing,* which Giovanni Bellini painted for the church of Santo Stefano with such exactitude and carefully worked out expressiveness. This can probably be identified with the picture from the Orloff collection, acquired by the Louvre in 1912 and discussed by Tancred Borenius in *The Burlington Magazine,* 1915, p. 205.

E. Panofsky, in his study of an 'Ecce Homo' which he attributes to Jean Hey, a Flemish painter in the French style (see *Bulletin des Musées royaux de Belgique,* June 1956), has stressed the amplitude taken on by the formula of the *Man of Sorrows* (which is, so to speak, an extract from the *Ecce Homo,* showing merely the bust and torso of Christ, with crown of thorns, hands bound and—sometimes—the sceptre of the Mocking), in competition with the theme of the *Salvator Mundi,* crowned, with a noble instead of a suffering expression, holding the symbolic orb (or, more rarely, the book) and giving the blessing. This iconographic pairing is to be found in Italy as well as in Flanders : the first theme in, for instance, the frontal picture attributed by Berenson to G. Utili, and the second in the Urbino half-length picture— much damaged, unfortunately—which belongs to the circle of Melozzo. We have here two variants of the archaic manner of presentation—as an icon—, which was gaining a fresh authority from the plastic power of the modern style. But, as was to be foreseen, there are also instances of a three-quarter-face presentation, which is given more life, either through the suffering expression, as in the picture by Francesco da Fabriano, or by gesture and intensity of modelling, as in the picture which R. Longhi rightly attributes to the Master of the Pala Sforzesca (see R. Longhi, *Ampliamenti nell' Officina ferrarese,* Florence, 1940; and no. 335 in the exhibition *Italian Art and Britain,* London, 1960). In these four cases the devotional image corresponds very closely to changes in portraiture at that time.

Fine textiles formed a by no means negligible sector of Quattrocento production, and there is ample evidence that models or stencils, sometimes by eminent artists, were used for them. The attention paid to rich stuffs by the painters is itself significant. Some artists were veritable dress designers, and their paintings contain important evidence on the fashion for floating flower-sprinkled robes (Botticelli) and for oriental lamé cloths (Crivelli).

Vasari has a long passage on the activity of a painter —Raffaellino del Garbo—who became a designer of textiles. He lays stress on the contribution of the Florentine studios to this branch of art (the activity of the 'Murati' in the via Ghibellina, engaged in supplying vestments for ecclesiastics, is well known).

He also describes a set of embroideries executed for the Baptistry of Florence, —a cope, chasuble and dalmatic with borders and painted motifs which included twenty-six scenes from the life of St John the Baptist. The work was carried out between 1466 and 1480, —not by Paolo di Verona alone, but also by eleven craftsmen who included Coppino di Giovanni da Malines and Piero da Venezia, the designs being supplied by Pollaiuolo. Vasari stresses the excellence of the 'col punto serrato' technique, whose disappearance he regrets and which, in a seamless cloth, really gave the impression of a 'pittura di pennello'. White bands forming frames were designed by Francesco Malocchi,—who no doubt also conceived the ornamental motifs in such an important composition as the *paliotto* presented by Sixtus IV to Assisi in about 1477, with its figures by Pollaiuolo.

The taste for sumptuous colours manifested by a whole group of artists from Crivelli to Pinturicchio, fits in with the fashion for velvets, silks and embossed materials, which Venice, Lucca and Genoa continued to produce and export, throughout the fourteenth and fifteenth centuries, using luxuriant designs that were often of oriental origin. This taste won over the new centres; in the middle of the century, for instance, Filippo Maria Visconti sent for a Florentine to act as '*Universum laborerium totamque artem sirici*' ; he also brought in from Venice craftsmen specialising in velvet, together with an organisation of more than sixty skilled workers. We must therefore assign to the Lombard textile industry such fine heraldic pieces as the Varese *Paliotto* (1491) and the *paliotto* which belonged to Santa Maria delle Grazie (in the Poldi Pezzoli Museum).

294 - EMBROIDERY. ST JOHN (DETAIL) — FLORENCE.

295 - C. CRIVELLI. MADONNA (DETAIL) — MILAN.

296 - CUT VELVET (DETAIL) — PARIS.

297 - CUT VELVET (DETAIL) — PARIS.

305

298 - MARQUETRY DESIGN — URBINO, DUCAL PALACE, STUDIOLO OF FEDERICO DA MONTEFELTRO.

MARQUETRY

The *Studiolo* of Federico da Montefeltro was the first complete manifestation of a taste closely determined by humanist culture. (On the spirit of Duke Federico's court, see chapter 2 of the present book and, more generally, A. Chastel, bibliog. no. 69). In it a rather naïve and narrow sense of history is associated with an impeccable feeling for decorative values and for the nobility of forms.

This feeling for decoration finds expression particularly in the gallery of *Uomini famosi* arranged in what seemed like theatre boxes or windows along the upper part of the walls, as if the whole intellectual activity of the ruler of Urbino—bibliophile, collector and friend of philosophers and mathematicians—was intended to be played out under their gaze.

The feeling for nobility of forms is realised, to a quite exceptional degree, in the marquetry wall panelling : they suggest a set of secular choir stalls, in which the benches and lower panels are given *trompe-l'œil* treatment, while between the niches containing the figures of the Virtues and the full-length portrait of the Duke, there are panels representing cupboards, whose doors are half open to disclose measuring instruments, emblems, books, etc.,—and even a false bay with a land-

scape against which a squirrel stands out. Here, in short, is the full repertory of *intarsia* which — at least in its treatment of the theme of cupboards containing what would later be called 'still lives'—was definitely in advance of the stage reached by painting (see C. STER-LING, *La nature morte de l'antiquité à nos jours,* 2nd edition, Paris 1959, ch. IV). The connecting bands are covered with the Duke's emblems, such as the ostrich, and those of the honours he had received, such as the Order of the Garter.

The execution of this wonderful *ensemble* took place in 1475 and the years immediately following. The Lendinara brothers seem to have been responsible for the lower part, and the studio of Baccio Pontelli for the figures of the Virtues, based on cartoons by Botticelli. The subtle golden shades of the wood give this master-piece an intense, almost unique effect. There were, indeed, few imitations of it, the chief one being in the castle of Gubbio, not far away; here there is more virtuo-sity in the treatment of the panels, and these now contain only still lives, with *trompe-l'œil* treatment.

The *Studiolo* of Isabella d'Este in the castle of Mantua, executed in the first years of the XVIth century, was to reveal a quite different spirit and to give more impor-tance to the minutiae of decoration and to painting.

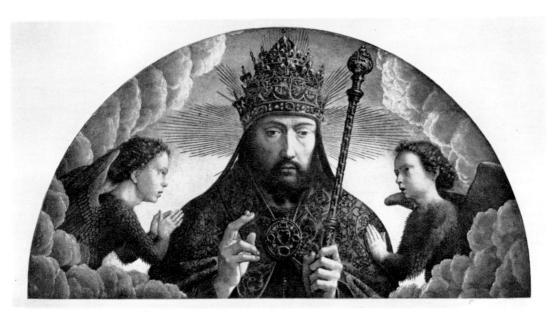

299 - GERARD DAVID (ATTR.). GOD THE FATHER GIVING HIS BLESSING — PARIS, LOUVRE.

300 - ZANETTO BUGATTI. ST JEROME — BERGAMO.

301 - NEAPOLITAN SCHOOL. FLIGHT INTO EGYPT.

FLEMISH AND ITALIAN ARTISTS

The history of the relations between the painters of the North and those of Italy, seen from the southern point of view, is yet to be written. In the second half of the XVth century, the movement was stronger from North to South; in the next century it was the other way round. The journeys made by Flemish artists to Italy—as for instance those of Rogier van der Weyden (who possibly came to Italy in 1450, and was in any case in contact with the Sforzas), Petrus Christus (to Milan in 1487) and Justus of Ghent (to Urbino in 1472)— and by Spaniards from the Flemish school like Berruguete, were important; but most important of all was the acquisition of Flemish pictures : these began to appear, as early as 1444, in the Medicean inventories (see E. Panofsky, *Early Netherlandish Painting,* 2 vols, Harvard, 1953) and have also been noted in Venetian and Neapolitan collections (see L. Baldass, *Van Eyck,* London 1952). We must add the commissions placed by Italians, —such as Memling's *Last Judgment* (painted for the Florentine Angelo Tani), that for the portraits of Maria and Tommaso Portinari, and that for the triptych painted (c. 1475-80) by Hugo Van der Goes and sent to Florence by the Portinaris to the church of Sant' Egidio and later moved to the hospital of Santa Maria Nuova (see bibliog. no. 222).

The connections between the two schools became particularly close in Naples, where there are many anonymous paintings that have recourse to the vertical composition and rounded forms of Bruges, and in Lombardy, where Zanettò Bugatti openly adapted Flemish types of composition (see Malaguzzi-Valeri, *Pittori lombardi del XVo s.,* Milan 1902, and for the *St. Jerome,* P. Wescher, *Zanetto Bugatti and Rogier Van der Weyden,* in 'The Art Quarterly', XXV, 1962, and Causa, *Zanetto Bugatti,* in 'Pa.', no. 25 1952.

A later but still typical instance is the large-scale polyptych commissioned from Gerard David for the abbey church of Cervara in Liguria : this has long been dispersed; the *God the Father* of the lunette (now in the Louvre) is a characteristic example of the return to Van Eyck which took place round about 1500. (See G. V. Castelnuovi, *Il polittico di Gerard David nell' Abbazia della Cervara,* in 'Commentari', Rome, III, 1952.

The whole problem of the so-called 'Mediterranean Primitives' was raised by a rather confused exhibition presented under this title at Bordeaux in 1952 (see in particular P. Bologna, in '*Paragone*', no. 37, 1953). Stretching from Aragon through Provence to Southern Italy, there was a kind of 'Tyrrhenian element', with a fairly marked taste for robust, full forms under a strong light : this, as early as 1440, was shared by such masters as the painter of the Aix *Annunciation* and Colantonio. The relations between these schools became more complex in the second half of the XVth century, especially round about 1470-1490, when traceable links were established between various painters of Provence, Castile and Andalusia,—such as the St. Sebastian master (recently the subject of a study by C. Sterling, in '*La Revue du Louvre*', 1964, no. 1) or Juan de Borgoña, on the one hand, and Italians such as Cristoforo Scacco on the other : artists, that is to say, who reacted in the peninsula itself to Flemish formulae, especially as regards the texture of the pictorial *matière* and as regards precision of effect.

Berruguete's place stands out as interesting in this context: when he returned to Castile in 1482/83, he managed to bring with him from Urbino the elements of a mixed Italo-Flemish culture; for at Urbino he must have come in contact with Justus of Ghent. This artist is first mentioned in the accounts in 1472 and disappears from them in 1475, " Pietro Spagnuolo " being mentioned afterwards, in 1477, so that Berruguete cannot have been the collaborator of Justus—as J. Lavalleye (*Le palais ducal d'Urbin,* 'Corpus des primitifs flamands', 7, Brussels 1964, p. 44 et seq.) makes him, after a detailed but partial study of the material—but must have been his successor.

The part played by Scacco, who was active in Naples, Palermo and Nola between 1493 and 1500, is worth considering : in a signed triptych by him, figures that seem rather knotted appear under a kind of portico, which is narrow and abstract (G. Fogolari, *Cristoforo Scacco da Verona pittore,* in the *Gallerie nazionali italiane,* V, 1902). In the saints by Quartararo, a Palermo and Naples painter, we again find draperies full of movement together with a striking lack of elegance; and we may observe something like an echo of the rather constrained gravity of the Madonna in the picture—more ambitious but somewhat stiff—by an Italian who came to work in Spain in 1471 known as Pablo da San Leocadio.

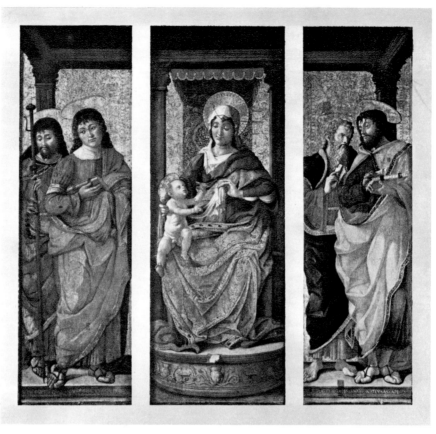

302 - SCACCO. TRIPTYCH: VIRGIN AND SAINTS — VENICE.

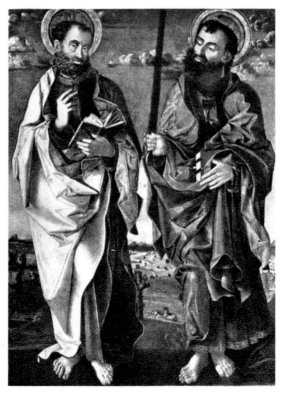

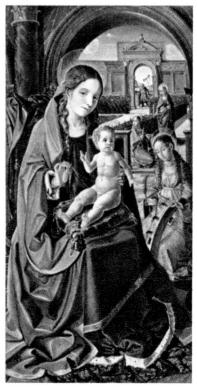

303 - R. QUARTARARO. ST PETER AND ST PAUL. 304 - P. DA SAN LEOCADIO. MADONNA.

311

305 - T. RIEMENSCHNEIDER. 306 - NARCISIO DA BOLZANO. 307 - T. RIEMENSCHNEIDER.

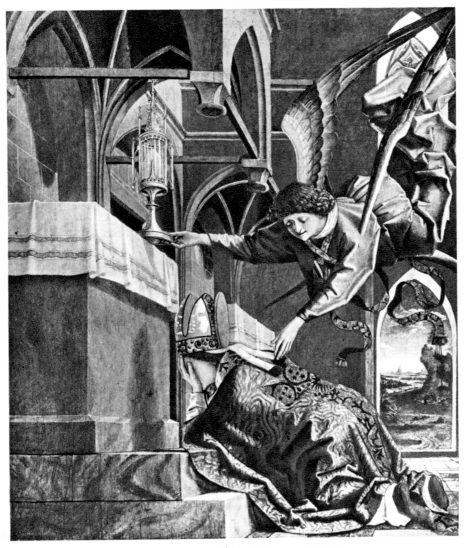

308 - MICHAEL PACHER. ST WOLFGANG'S PRAYER — MUNICH. 309 - UMBRIAN SCHOOL.

ITALIANS AND GERMANS

The collision between German and Italian art at the end of the XVth century was extremely violent and led to results that are often unique. The attraction felt by the masters of the Danube and Swabian Schools for the organised forms of the Tuscan school is quite clear, but so is the incompatibility between two tastes which, when taken to their extreme in the years round about 1480, became the embodiment of two equally strong and intense attitudes. This conflict, which goes beyond that between an exacerbated 'Gothic' and the 'classicising' feeling, occasioned in Wölfflin some attentive but rather inconclusive reflections (H. Wölfflin, *Italien und das deutsche Formgefühl,* Berlin, 1931; English translation, *The Sense of Form in Art,* New York, 1958).

R. Longhi's *Arte Italiana e arte tedesca,* Florence 1941, enters more deeply into the historical material and provides a useful frame of reference by laying stress on the complexity of Italian art, which makes it possible to go beyond contrasts, that are in the last resort rather theoretical and to identify various definite contacts and affinities.

Before Dürer, the Austrian Michael Pacher (c. 1435-1498) represents the first success in harmonising the two artistic worlds, —with foreshortenings, oblique vistas and formal connections that rather suggest a germanised Antonello (see R. Salvini, *Sulla posizione storica di M.P.* in '*Archivio dell' Alto Adige*', XXXIII, 1937).

The position of Riemenschneider (c. 1460-1531) is no less revealing : wood-carving was the great excellence of the North, and the German master took quite a long time to absorb the new elements (see K. Gerstenberg, *Tilman Riemenschneider,* Vienna 1941). Provincial craftsmen, such as those of the Adige or of Friuli, remain close to the models which the German carvers of the *Pietà* were spreading as far as the Appennines (cf. bibliog. no. 169).

But when Riemenschneider softened his manner, as in the Würzburg St. Sebastian, his authority stands out, the moment we compare the fullness of his forms with those of the Italian provincial craftsmen (see E. Carli, *La scultura linea Senese,* Florence 1951, and *La Sculpture de bois polychrome,* Paris 1960).

NOTES

1 In an unpublished inventory of Careggi (1482), Warburg has noted sixteen *panni dipinti*, paintings on canvas, of Flemish origin—ten religious subjects and six profane. A 'Lenten bacchanalia', which was in a room of the Medici Palace, was no doubt an imitation of the Flemish fantasias. See A. de Witt, *Per l'attribuzione di una vecchia stampa* in 'Rivista d'Arte', XIII, 1931, pp. 225-229.

Equally definite exchanges took place in the field of textiles: Flemish cloths were renowned for their quality and were sought after in Italy. It is even probable that workshops were set up to produce them in the peninsula. At Gubbio there is a *piviale* which, with its damasked yellow silk and the delicate violet tones of its scenes from the life of Christ, comes close to the fineness of Northern work. This piece, whether made in Italy or not, has been attributed to the visit of Justus of Ghent. See A. Venturi, *Paramenti istoriati su disegno di Giusto da Gand (o di Luca Signorelli)* in 'L'Arte', XV, 1912, p. 249; A. Santangelo, *Tessuti d'arte italiani*, Milan, 1959, pp. 38-39, considers that it was made in Cologne or Flanders.

2 The French princes represented themselves in Italy as promoters of peace: the medal of René of Anjou (1469), by Laurana, bears the inscription *Pax Augusti* under the image of *Minerva Pacifica*.
For the entry of Charles VIII into Florence in November 1494 Filippino Lippi constructed in his honour a '*Trionfo della Pace*', and the medal of the French prince bears, below the inscription *Victoriam Pax Sequitur* an image of Victory whose chariot is led by a man with an olive branch.

3 While stressing the part played by Italian geography, I am not forgetting the ample and early development of Majorcan and Portuguese cartography. In the second half of the fifteenth century the updating of sea charts and the more precise delineation of the longitudes westwards were not the work of Italians. On the giant map by Juan de la Cosa, which was elaborated from 1500 onwards and sums up Portuguese and Spanish knowledge at that time, the world is formed of two masses that ride, so to speak, on the Tropic of Cancer. See A. Ballesteros-Beretta, *La marina cantabra y Juan de la Cosa*, Santander, 1954, ch. XVI; J.-M. Millas-Vallicrosa, *Nautique et cartographie de l'Espagne au XVIᵉ siècle*, Colloque de Royaumont, 1957, Paris, 1960, p. 30 *ff*.

There is also the problem of the *mappae mundi*. B. Fazio noted in 1456 that Jan Van Eyck had made for Philip the Good an astonishing '*mundi comprehensio orbiculari forma*'. See L. Baldass, *Jan Van Eyck*, London, 1952, p. 86. Another was in the possession of Pope Pius II who in 1462 received his *mappa mundi* from a certain Antonio Leonardi; another was in the Palazzo di San Marco in Rome, in the possession of his successor, Paul II, and in 1466 Borso d'Este had another, for which he paid ten gold ducats to the same Antonio Leonardi. There is mention also of large maps in the Ducal Palace in Venice in 1479: they were destroyed in the fire of 1483. The *mappae mundi* spoken of in the chronicles, and the one Leonardo da Vinci left for safekeeping with his friend Giovanni Benci in Florence, were probably not models in globe form, since these were used only to represent the celestial field—at least till the end of the century. They are more likely to have been flat diagrams representing the curved surface of the earth in accordance with systems of projection which, at that time, were difficult and arbitrary. See M. Fiorini, *Le sfere cosmografiche, specialmente le sfere terrestri*, Rome, 1894.

With the fashion for printed maps, such as those published at Bologna in 1474, and with the illustrated editions of Ptolemy, such as those of Bologna in 1477 and Rome in 1478 (see A.M. Hind, *Early Italian Engraving*, 7 vols, London, 1938-48, vol. I, p. 289 *ff*., nos. 476-485), the whole subject became of general interest. Even before 1492 when Martin Behaim made his 'terrestrial sphere' (0,54 m, Germanisches Nationalmuseum, Nuremberg), after having spent the years 1484-1490 in Portugal, the letter from the Florentine Paolo Toscanelli to Canon Martinez of Lisbon in 1474 on the problem of the westward sea routes was, in all probability, accompanied by drawings.

4 On the revival of the dome it is clearly impossible to agree with H. Glück, *Östliche Kuppelbau-Renaissance und St. Peter*, in 'Monatshefte für Kunstwissenchaft', XII, 1919, pp. 153-165, who suggests a pure and simple derivation of Italian domed architecture from that of the Ottomans. This was a development of the hypothesis of J. Strzygowski (*Leonardo, Bramante, Vignola im Rahmen vergleichender Kunstforschung*, in 'Mitteil. des Kunsthist. Instituts in Florenz', 1919), which rests on imaginary connections, such as a supposed journey of Leonardo to Armenia. Nonetheless the problem of the parallel development of the church and the mosque during the Renaissance is worth raising. It should be remarked, as F. Babinger has reminded us, that the great mosques were built by architects who were renegade Christians.

5 In 1459 Pope Pius II, in a letter which, though surprising, is unquestionably genuine—and conforms to the ecumenical spirit—promises to recognise the conquest of Eastern Europe provided that the Sultan becomes a convert to Christianity. See H. Pfeffermann, *Die Zusammenarbeit der Renaissancepäpste mit den Turken*, Wintherthur, 1946.

6 See O. Benesch, *A new contribution to the Problem of Fra Luca Pacioli* in G.B.A. LXIV, 1954, pp. 203-206. He gives a resumé of the earlier contributions of C. Ricci, in 'La Rassegna d'Arte', III, 1903, p. 75, who casts doubt on the attribution to Jacopo de' Barbari, and of G. Gronau in *Id*, V, 1905, pp. 25-29. In his *Jacopo de' Barbari*, Venice, 1944, p. 149, Servolini put forward the name of Jacopo Barocci. A passage in Baldi, praising Pacioli highly, indicates that the picture was considered at the end of the sixteenth century as being by Piero himself: '*Né vi fu pittore scultore o architetto de' suoi tempi che seco non contrahesse strettissima amicitia: fra quali vi fu Pietro de' Franceschi suo compatriota, pittore eccellentissimo e prospettivo, di mano di cui si conserva ne la Guardaroba de' nostri serenissimi Principi in Urbino il rittratto al naturale d'esso frate Luca col suo libro avanti de la Somma di aritmetica et alcuni corpi regolari finti di cristallo appesi in alto, ne' quali e da le linea e da' lumi e da l'ombri si scopre quanto Piero fosse intendente ne la sua professione.*'

('There was not in his time a painter, sculptor or architect who was not on terms of close friendship with him; one of them was Piero della Francesca, his compatriot, an outstanding painter and master of perspective, from whose hand there exists, in the Wardrobe of our most serene Princes of Urbino, the portrait, from life, of the said Fra Luca, with a copy of his *Summa* of arithmetic before him and with crystal models of various regular bodies suspended above,—in which it can be seen from the lines, highlights and shadows how well Piero understood his profession.')

7 Vasari (*Vite*, ed. Milanesi, III, 567): '*Bisogna partirsi di quivi e vender fuora la bontà dell'opere sue e la reputazione di essa città, come fanno i dottori quella del loro studio. Perché Firenze fa degli artifici suoi quel che il tempo delle sue cose, che, fatte, se le disfà e se le consuma a poco.*' ('The artist has to go away and sell elsewhere the quality of his work and the reputation of this city, just as professors sell that of their universities. For Florence does with its craftsmen what time does with all things: no sooner are they created than time begins to consume them away.') Already quoted in *Art et Humanisme*, p. 15, no 3 and p. 192, with further notes.

8 Round about 1400, Milan cathedral had been a meeting-place for both the 'Gothic' architects and those of Italy, and it remained partly in the hands of Burgundian and Rhineland craftsmen, at least until about 1460. After 1470 Hans Hammer, the Strasbourg *maître d'œuvres*, still intervened as adviser. These prolonged contacts may well have familiarised the Lombards with the *quadratura* or geometrical projection—at least if we accept the view of H. Siebenhüner, *Deutsche Künstler am Mailänder Dom*, Munich, 1943; see also *Arte lombarda dai Visconti ai Sforza*, exhibition catalogue, Milan, 1958.

One of the sculptors of the busts that are set between the arches on the western and southern sides of the small cloister of the *Certosa* was unquestionably Luca d'Alemagna, *magister a fictilibus seu imaginibus terrae* (master in ceramics or earthenware figures), whose presence is attested at Milan in 1455 and at Pavia in 1459. See E. Arslan, *Appunti sulla scultura lombarda del Quattrocento*, in 'Atti del Convegno par i rapporti italo-svizzeri', Milan, 1956, pp. 322-327.

9 It should be recognised that Lodovico il Moro had real cultural ambitions, incontestably stimulated by the desire to rival Florence. The abundant evidence collected by Malaguzzi-Valeri has been reinforced by E. Garin (*Storia di Milano*, VII). As at Mantua, ideas for town planning came to the fore with Leonardo da Vinci's projects. Evidence of these is set out afresh in L. Firpo's *Leonardo architetto e urbanista*, Turin, 1963, p. 63 *ff*.

10 According to Vasari, Baccio Pontelli (*c.* 1450-1492) built the Ponte Sistino, the Sistine Library and Chapel, San Pietro-in-Vincoli, the Santi Apostoli, the Palazzo dei Penitenti and Santa Maria del Popolo; but in connection with the Sistine Chapel the documents mention one Dolci, a Florentine who was active from 1450 to 1486, and Santa Maria del Popolo, to which an inscription gives the dates 1472 and 1477, seems to have been the work of Meo del Caprina (1430-1501). The whole question, therefore, needs to be reviewed: there is, to begin with, doubt as to who Pontelli was; he may have been merely someone with the same name as the Florentine decorative artist, who indeed is known to have worked at Pisa from 1471 to 1479 and at Urbino from 1479 to 1481. See P. Giordani, *Baccio Pontelli a Roma*, in 'L'Arte', XI, 1908, pp. 96-112; E. Lavagnino, *L'architetto di Sisto IV*, in 'L'Arte', 1924, pp. 7-13.

It is in connection with buildings not mentioned by Vasari that we can trace Pontelli: the fortress of Ostia, on which his name is carved, and probably Santa Maria della Pace (*c.* 1480), perhaps also San Pietro in Montorio. These churches are of a modest type; the ground-plan a simplified basilical one and the façades simple screens with pediments and with their divisions marked by bands. This style is common to them all, and the architect of the church of Sant' Agostino (built for Guillaume d'Estouteville between 1479 and 1481), Giacomo di Pietrasanta, assisted by a Florentine called Bastiano, knew no other.

11 On the Ca' del Duca, of which there remains a rusticated base at the corner of the Grand Canal near San Samuele, L. Beltrami (*La Ca' del Duca sul Canal Grande*, Milan, 1900, revised edition privately issued 1906) completes and corrects the indications given by Paoletti (1893, I, p. 34): in 1458 the site on which Andrea Cornaro had planned to build a '*magnifico e stupentissimo lavoro*' was given to Francesco Sforza. The architect Benedetto Ferrini was vigorously criticised by Filarete, who came in 1460. Filarete's treatise (ms. Magl. 169 v° *ff*., Florence, Bibl. Naz.), shows the new project, which was not carried out.

12 On the master who worked at the Frari in 1468 see J.A. Schmoll gen. Eisenwirth, *Zum Werk des strassburger Frari-Meisters von 1468* in 'Beiträge für mittelalterlichen Plastik in Lothringen und am Oberrhein', Records of the Sarre University, VII, 1958, pp. 265-278. It has been possible to attribute to the same Strasbourg master a relief of the *Adoration of the Magi*, which is in the Bargello, and a panel showing the Virgin, which came from Venice and is now in the Hartford Museum: they confirm the success his work met with in Northern Italy. There is also evidence of other German sculptors working in Venice—one Giovanni d'Alemagna (1495), one *Lardo* (Leonardo) *tedesco* who was working at San Giovanni in Bragora (1491-1493). See G. Otto, *Die Reliefs am Chorgestuhl der Frari-Kirche in Venedig* in 'Mitteil. d. Kunsthistor. Instit. in Florenz', V, 1937-40, pp. 173-182.

13 A statement by C. Gould is worth bearing in mind: 'The style of painting which we may call Paduanism was evolved, largely by Mantegna, from a study of Donatello's reliefs, superimposed in the local (Venitian) tradition of rich and bright colours, and presupposing an intellectual preoccupation with antique literature and the antique way of life'. See '*An Introduction to Italian Renaissance Painting*', London, 1957, p. 67.

14 Though Ferrara was not a city of a very highly developed culture, the painters were sometimes in close touch with the poets. In his *Pliniana defensio* (1493) Collenuccio, a court humanist, makes mention of his friend Ercole de' Roberti: '*Sed et rarissimus pictor ferrariensis Hercules nostri Apelles temporis, vir diligens, nativum cinnabaris fructum, quod in Italia rarum inveni affirmat, nobis donavit.*' ('But that eminent Ferrarese painter, Ercole, the Apelles of our age, a man of great diligence, has brought us the natural cinnabar, because, as he says, it is rarely found in Italy.') See Claudio Varese, *Pandolfo Collenuccio*, in 'Storia e Politica nella prosa del Quattrocento', Turin, 1961, pp. 177-178.

The number of great Ferrarese schemes of decorative painting that have been lost is considerable, and this helps to explain the difficulties scholars have had in reconstructing the course of art in Ferrara. Polyptychs have almost all been dismantled.

One of the most remarkable of the great ensembles was the series of illustrious men and poets painted by Cosimo Tura in the Mirandola Library from 1465 onwards: it included twenty-four pictures and six panels, with allegorical triumphs—as at the Schifanoia—in the lunettes. We know of it from a dialogue by G. Giraldi, quoted by H.J. Hermann, *Minaturhandschriften aus der Bibliothek des Herzogs Andrea Matteo III Aquaviva*, in 'Jahrbuch d. Kunstsamml der A. H. Kaiserbaum', Vienna, XIX, 1898, p. 207 *ff*.

15 The *taccuino* of Francesco di Simone has been reconstituted by regrouping a number of double-page sheets of studies (dimensions: 0,26 × 0,20 m) which certainly seem to have been part of a single drawing-book; 8 at Chantilly, 3 in the Louvre, 2 in the École des Beaux-Arts, 1 at Dijon, 1 at Berlin, 1 at Hamburg, 2 in the British Museum and 2 in British collections. This studio notebook was formerly attributed to Verrocchio, but G. Morelli (1893) more plausibly advanced the name of the sculptor Francesco di Simone Ferruci (1437-1493). Gronau, though in the 'Jahrbuch der Kgl. preuss. Kunstsamml'. Berlin, XVII, 1896, pp. 65-6 he put forward further similarities that reinforce this view, nonetheless hesitated to adopt it finally. Today it seems the only correct one, and is admitted by A.E. Popham and P. Pouncey (*Italian Drawings, Op. cit.*, nos 56-57, p. 38 *ff* and supp. no 57a).

One of the pages (at Chantilly) bears the inscription 1487, another (in the École des Beaux-Arts) 1488, and this dates the drawing-book. Its interest is that it shows how a good Tuscan artist, close to Verrocchio, worked, and what subjects he preferred: studies of proportion and, more particularly, of standard subjects; many variations on the *putto*, running, flying, dancing, etc.; and no lack of notes taken from Antiquity,—the draping of the toga, Apollo and Marsyas, etc.

16 The circulation of technical diagrams was much quicker and more regular than is usually supposed. Thus an important manuscript in the British Museum (Catalogue of Drawings, XIV-XV, *op. cit.*, no 55, 88 fos.), which, if not an autograph, is at least a presentation copy, and includes sketches of machines and of military engines. Preceded as it is by a preface addressed to Federico of Urbino, this book must date from about 1475; it throws light on the connections between Francesco di Giorgio and Leonardo.

17 Drawing as the 'primary' art, the importance of drawing as the source of all the visual arts and of the crafts, were commonplace ideas with the theorists. See, for instance, this characteristic passage of Leonardo's about *disegno* (Ms. Trivulziano, fo. 23; published by J.A. Richter, *Paragone*, London, 1949, p. 64.: '*Questa* (i.e. painting) *col suo principio cioè il disegno insegna allo architettore fare chel suo edifitio si renda grato al'occhio, questa alli compositori di diversi vasi, questa alli orefici, tessitori, recamatori; questa ha trovato li carratteri con li quali si esprime li diversi linguaggi. Questa ha datto le carattere alli aritmetici, questa ha insegnato la figuratione alla geometria, questa insegna alli prospettivi et astrologi et alli machinatori e ingegneri.* ('Painting with its main principle—that is, drawing—teaches the architect to see that his building is agreeable to the eye; and it does the same for the makers of vases of different kinds, for goldsmiths, weavers and embroiderers; it has also invented the characters used in the expression of the various languages. The mathematicians have got their signs from it, the geometers have learned their figures from it, and to its school have gone the artists in perspective, the astrologers, the inventors of machines and the engineers.')

317

18 'The invention of engraving on copper came from Maso Finiguerra of Florence in about the year 1460 of our salvation. Engraving silver plates with a view to embellishing them with *nielle*, he took a print in clay and poured on to it melted silver, in which it became imprinted, and this he dipped in lamp black mixed with oil; thus he obtained the same image as on the silver. He did likewise by applying a damp sheet of paper [to the silver] blackened by the same process, pressing it with a perfectly even roller, which made the printed forms emerge as though drawn'. (Vasari ed. Milanesi Milan, Bk. V). This well-known account occurs at the beginning of Vasari's *Life of Marcantonio*, and only in the 1568 edition; it is, therefore, a later addition. It completes the short mention of Finiguerra as one of the niellists, which is to be found in a preliminary chapter on the various techniques, containing no more than a comparison between the *niello* and actual printing (Ch. 33). The additional passage may have been an answer to Cellini, who in the same year, 1568, published his treatises on the goldsmith's art and on sculpture, the introduction to which became famous and ends with these praises of Finiguerra: 'When I began, in 1515, to learn the goldsmith's art, the art of *niello* engraving had been entirely abandoned; but there were old men still living who never ceased speaking of the beauty of this art, and good masters who still practised it, above all Finiguerra. As I was very anxious to learn, I set myself with great ardour to imitate Finiguerra's models, and made rather a good impression with my work...' There follows a very detailed chapter on the niellist's art, described by Cellini from the point of view of the goldsmith, not of the engraver (B. Cellini, *I Trattati dell' oreficeria*, etc., Florence, 1857, pp. 18-19). Vasari's account certainly does not reconstitute the facts and inventions in their true order, but his three principal points—the Italian antecedents of engraving in the strict sense along with *niello* work (for which there is evidence from about 1440), the importance which the experiments of the Florentine niellists of about 1460 had in the development of copper-plate engraving (especially of what has been called the *maniera fina*) and the part played by Maso Finiguerra himself—are now admitted. J. Goldsmith Philips, *Early Florentine Designers and Engravers*, Cambridge (Mass.), 1955, and J. Laran, *L'Estampe*, 2 vols, Paris 1959, pp. 39-40.

As regards the knowledge of German engraving in Italy, Vasari had in his collection—and mentions in his *Vita di Gherardo miniatore fiorentino* (ed. Milanesi, III, p. 240)—some prints copied by this Florentine from '*alcune stampe di maniera tedesca fatte da Martino*' (i.e. Schongauer, c. 1440-1491) '*e da Alberto Duro*' (Dürer, 1471-1528). In his *Life of Marcantonio* he specifies that the first of these was a 'Christ on the Cross with Saint John and the Madonna' and that the work was done at the very end of Gherardo's life (he died in 1497). To this same period (1490-1495) belongs the young Michelangelo's painted copy of Schongauer's *Temptation of St Anthony*. Schongauer, however, is only a generic name (Vasari gives, as an identification for his engravings, the signature M C, which is really that of Martin Van Cleef). The engraving in question cor-responds to Bartsch, VI, p. 25. There is a copy (Italian) in Berlin, generally attributed to Robetta.

19 Mantegna is incontestably one of the great figures in fifteenth century engraving; his contribution falls between 1460 and 1490. P. Kristeller (1901), who classified the works in question, regarded them as coming from Mantegna's own hand, while H. Tietze (*Was Mantegna an engraver?*, in 'Gazette des Beaux-Arts', Dec. 1943, and *Mantegna*, London, 1955, p. 241 ff.) thinks they were merely executed under the artist's supervision, and that he himself only used the engraving tool occasionally.

As regards the origin of Mantegna's engraving technique, Vasari, after praising him for taking up this *commodità veramente singularissima*' (III, p. 402), indicated in the 1568 edition (V, p. 396) that Mantegna must have heard of it in Rome. This would mean postponing to 1488-9 a discovery which the Mantuan master certainly had the opportunity of making during his visit to Florence in 1466-7—even if he did not come across specimens of Rhineland or Tuscan engraving at Padua as early as 1455-1460. Attention has been drawn to an interesting letter written in 1475, in which Simone Ardizzone, a painter-engraver, tells how he came to Mantua on the strength of attractive promises from Mantegna, but preferred to work with Zoan Andrea —which led to reprisals against him from Mantegna. This suggests that Mantegna was seeking to organise an engraving studio: he seems to have succeeded in doing so only in about 1490 (see H. Tietze, *op. cit.*, p. 25), that is, after the journey to Rome. It would be interesting to know which engravings were done under his direction, and which by Antonio da Brescia and others after works of his; but this distinction is still somewhat theoretical. A. Hind, V, nos 1-31, does not take it into consideration; E. Tietze-Conrat, *op. cit.*, pp. 241-244, treats it as important.

20 Vasari attributes to Lorenzo a twofold activity, as painter and as sculptor: '*Furono concorrenti d'Andrea*' (that is, Mantegna) '*Lorenzo da Lendinara, il quale fu tenuto in Padova pittore eccelente, e lavorò anco di terra alcune cose nella chiesa di S. Antonio*' (*Life of Andrea Mantegna*, ed. Milanesi, III, p. 404). Nothing is now known of his work as a sculptor, but he was probably the master of Matteo Civitali (G. Fiocco and A. Sartori, *op. cit.*, p. 17). As for his work as a painter, traces of it were long sought for in the Eremitani, on the basis of Vasari's obscure reference, but this idea is now altogether rejected. Michiel mentions a *St. John the Baptist* (vanished) by Lorenzo in the Santo. There exists (in the Modena Pinacoteca) a panel signed by Cristoforo, the *Madonna of the Rosary*, dating from 1482, a picture that is clearly transposed from an *intarsia* composition.

Failing the Madonna from the former L. Douglas Collection, in which R. Longhi (*Officina ferrarese*, 1934) saw the work of Lorenzo, G. Fiocco suggests the Madonna in the Musée Jacquemart-André (Paris),

attributed by Berenson to D. Morone, and that in the Musée Tadini at Lovere, should be assigned to him.

An important statement by Luca Pacioli confirms that Lorenzo was active as a painter and links his work with Piero della Francesca; it also throws light on the close connection there was, in this circle, between marquetry, geometry and perspective. It occurs in the *De divina proportione*, ch. LXXI (ed. Winterberg, Vienna, 1889, p. 123): '...*prometto darti piena notitia de prospectiva, medianti li documenti de nostro conterraneo e contemporale, di tal facultà ali tempi nostri monarca, maestro Piero de Franceschi; ... e del suo caro quanto fratello maestro Lorenzo Canozo de Lendinara, qual medesimamente in dicta facultà fo ali tempi suoi supremo, ch' e dimostrano per tutto le sue famose opere si in tarsia el degno coro del sancto a Padua e sua sacrestia e in Vinecia ala ca' grande, come in la pictura neli medemi luoghi e altrove assai.*' ('I promise to give you a full knowledge of perspective, by means of the works of our compatriot and contemporary, Piero della Francesca, the supreme master of this discipline in our time; ... and of the master dear to him as a brother, Lorenzo Canozo di Lendinara, who was likewise eminent in the same discipline while he lived, as is everywhere shown both by his celebrated works in marquetry—such as the solemn choir of the Santo at Padua and its sacristy and, at Venice, his work in the Ca' Grande—and by his paintings there and elsewhere.')

21 The idea of a 'return to the masters' around 1500 was put forward by L. Baldass, *Gotik und Renaissance im Werke des Quentin Metsys*, in 'Jahrbuch der Kunsthist. (Samml., Vienna N.F., VII, 1933), p. 137 *ff.* and in his *Early Netherlandish Painting*, 2 vols, Princeton, p. 350 and p. 508, E. Panofsky brought out the interest of this phenomenon of 'archaism'.

As regards Italy, stress has chiefly been laid on the general aspect of that 'return to the Roman which is characteristic of the Renaissance. See H. Tietze, *Romanische Kunst und Renaissance*, in 'Vorträge der Bibliothek Warburg', 1926-7, p. 43 *ff.* A judicious view of the development of architecture in Lombardy in the fifteenth century and of the 'regional' character of the Renaissance has been set out by J. Ackermann, *The Certosa of Pavia and the Renaissance in Milan*, in 'Marsyas' (V, 1950, pp. 24-37).

22 Here is Vasari's enumeration of the painters who studied Masaccio, especially at the Carmine: '*Tutti i più celebrati scultori e pittori... studiando in questa cappella sono divenuti eccellenti e chiari: cioè Giovanni da Fiesole, Fra Filippo, Filippino, Alesso Baldovinetti, Andrea del Castagno, Andrea de Verrocchio, Domenico del Grillandaio, Sandro di Botticello, Leonardo da Vinci, Pietro Perugino, fra Bartolommeo di San Marco, Mariotto Albertinelli, ed il divinissimo Michelagnolo Buonarroti. Raffaello ancora da Urbino da quivi trasse il principio della bella maniera sua; il Granaccio, Lorenzo di Credi, Ridolfo del Grillandaio, Andrea del Sarto, il Rosso, il Franciabigio, Baccio Bandinelli, Alonso Spagnuolo, Jacopo da Pontormo, Pierino del Vaga e Toto del Nunziata*, ed. Milanesi, II, p. 294. ('The numerous painters and sculptors who have studied in this chapel have become famous and highly skilled: Giovanni da Fiesole, Fra Filippo, Filippino, Alesso Baldovinetti, Andrea del Castagno, Andrea del Verrocchio, Domenico Ghirlandaio, Sandro Botticelli, Leonardo da Vinci, Pietro Perugino, Fra Bartolommeo of San Marco, Mariotto Albertinelli and the divine Michelangelo. Raphael of Urbino has himself derived from it the principle of his fine style, as have Granacci, Lorenzo di Credi, Ridolfo Ghirlandaio, Andrea del Sarto, Rosso, Franciabigio, Baccio Bandinelli, Alonso the Spaniard, Jacopo de' Barbari, Perino del Vaga and Toto del Nunziata'.)

Masaccio's fresco in the Sagra, representing the procession of the Florentines for the consecration of the Carmine church, was painted above a door in the cloister in 1423-24. (It was destroyed in 1612.) It was one of the Masaccio paintings most studied by the young painters. See E. Berti Toesca, *Per la 'Sagra' di Masaccio*, in 'Arti figurative', I, 1945, p. 148 *ff.*)

All that we know of it now are some details—figures and groups—handed down to us through copies: three figures drawn by Michelangelo, now in the Albertina (see C. Tolnay, *The Youth of Michelangelo*, 2nd edition, Princeton, 1947, no 74); a group drawn at the beginning of the sixteenth century, now in the Uffizi (see M. Salmi, *Masaccio*, Milan, 1947, pl. 220-1); and later (c. 1560) pen drawings, now in the Folkestone Art Museum (see K. Clark, in 'The Burlington Magazine', 1958, p. 177, fig. 36). This last piece of evidence has made it possible to establish that Ghirlandaio, in his work in Santa Trinità was directly inspired by the Masaccio fresco. See M. Chiarini, *Una citazione della 'Sagra' di Masaccio nel Ghirlandajo*, in 'Paragone', no 149, May 1962, p. 53 *ff.* See also E. Boorsook, *The Mural Paintings*, op. cit., p. 159.

A strange case is that of the portrait (in an English collection) of a young man holding a gold medallion, which R. Offner, considers to be a bust of a Saint painted by the Master of the Sheepcote (mid-fourteenth century). The insertion of the medallion, taking the place of an ancient coin, is surprising; but the small *tondo* seems to belong to Botticelli's original composition, and must be evidence of some particular fidelity to the object or to the Saint and, at the same time, of a deliberately stressed interest in an archaic medallion. See exhibition catalogue of the Sir Thomas Merton Collection, 'Italian art and Britain', London, 1960, n° 345.

A. Scharf, 'Catalogue of Pictures and Drawings from the collection of Sir Thomas Merton', no III, 1950, p. 14, suggests that the sitter should be identified with Giovanni Pierfrancesco (1467-1498), a cousin of Lorenzo the Magnificent, who was *ornato di singolare gratis*'. The frame recalls Botticelli's Giuliano de' Medici (National Gallery, Washington). The pose may be compared with that in the picture in the National Gallery, London, which is accepted by Mesnil (*Botti-*

celli, Paris, 1938, p. 221), in which we see a medallion of Cosimo in the sitter's hand.

23 Several authors, Russian and Italian, including S.V. Servinskij (*Venesianizmy moskovkago archanhelkago Sobora*, in 'Moskovskij Mercur', 1917), E. Lo Gatto (*Gli artisti italiani in Russia*, I, Rome, 1934), S. Bettini (*Un grande artista veneto in Russia: Alvise Lamberti da Montagnana*, in 'Le Tre Venezie', 1944, nos 7-12) and G. Fiocco (*Alvise Lamberti da Montagnana*, in 'Bollettino del Museo Civico di Padova', XLV, 1956)—have laid stress on the presence in Moscow of a Venetian architect (who is called Alvise Novi in documents), in response to an embassy sent by Ivan III in 1494. S. Bettini, in the article mentioned above, identifies him with Alvise Lamberti da Montagnana and assigns to him the Cathedral of Montagnana and the church of Santa Maria dei Miracoli at Lonigo. According to Giovanni Lorenzoni (*Lorenzo da Bologna*, Venice 1963), the church at Lonigo is the work of Alvise, but Montagnana Cathedral is not—it must be assigned to the Paduan architect Lorenzoni.

CHRONOLOGICAL TABLE

	ENGLAND	LOW COUNTRIES/BURGUNDY	FRANCE
1460		Institution of the first international Stock Exchange at Antwerp. Birth of Gerard David (*c.* 1460-1523).	Fouquet : *Portrait of Guillaume Jouvenel des Ursins.*
1461	Lancastrians lose Battle of Towton; Edward IV proclaimed king with the support of Warwick 'the King-maker'.		Death of Charles VII. Accession of Louis XI (1461-1483). Abolition of the Pragmatic Sanction of Bourges. Publication of Villon's *Testament.*
1462		Van der Weyden, triptych : *Adoration of the Magi.*	John II of Aragon cedes Roussillon and Cerdagne to Louis XI.
1463		Completion of the Hôtel de Ville at Louvain.	Philip the Good sells the cities of the Somme to Louis XI.
1464	Secret marriage of Edward IV to Elizabeth Woodville begins alienation of Warwick from Edward.	Dieric Bouts, polyptych : *The Last Supper* (1464-1468).	Château of Plessis-lès-Tours.
1465		Battle of Monthléry. Treaty of Conflans and St-Maur. Liège under Charles the Bold. Birth of Quentin Metsys (1465-1530).	
1466		Destruction of Dinant by Charles the Bold.	*La Farce de Maître Pathelin (c.* 1466).
1467		Charles the Bold (1467-1477) succeeds Philip the Good. Revolt of Liège.	
1468		Treaty of Péronne between Louis XI and Charles the Bold. Marriage of Charles the Bold to Margaret of York.	
1469	Warwick revolts, temporarily controls Edward.	Charles the Bold buys the Haute-Alsace from Sigismund of Austria. Probable date of the birth of Erasmus in Rotterdam.	
1470	Warwick flees to France, becomes reconciled with the Lancastrians, and drives Edward from England.	Hugo van der Goes : *Adoration of the Magi* (1440-1480).	
1471	Edward IV regains England, Warwick killed at Battle of Barnet.		
1472		Charles the Bold besieges Beauvais.	
1473			
1474		Alsace revolts against Burgundy. Hans Memling in Bruges.	
1475	Edward IV lands at Calais, conducts brief war against the French.	Death of Georges Chastellain the ' rhétoriqueur ' of the court of Burgundy. Hugo van der Goes : *Adoration of the Shepherds.*	
1476			
1477		Battle of Nancy. Death of Charles the Bold. Louis XI annexes the Duchy of Burgundy.	
1478	Extension of the powers of the Star Chamber. Birth of Thomas More (1478-1535).		Peace of St-Jean-de-Luz between Louis XI and the Catholic Kings. Louis bans the Inquisition in the Alps.
1479			
1480			Death of King René. Louis XI takes Barrois and Anjou.

SPAIN - PORTUGAL	ITALY	GERMANY
	Maso Finiguerra : *Florentine Picture-Chronicle.* Mantegna begins his service with the Gonzaga family.	Birth of the sculptor Tilman Riemenschneider (1460-1531).
The Cortes of Catalonia depose John II. Peter of Portugal elected King of Aragon.	Birth of the philosopher Pomponazzi (1462-1525). The rebuilding of Corsignano (renamed Pienza). Marsilio Ficino translates the *Poimandres* of Hermes Trismegistos. Death of Pius II. Election of Paul III. Felice Feliciano publishes the *Jubilatio.* Death of Cosimo de' Medici. Accession of Piero the Gouty.	Peace between Frederick III and Matthias Corvinus.
		Austria revolts against Frederick III. Styria revolts against Frederick III.
Isabella made heir to Henry IV of Trastamara by the Castilian nobles.	F. Laurana works at the palace in Urbino. Paul II arrests the members of the Roman Academy.	
Marriage of Isabella of Castile to Ferdinand of Aragon (Ferdinand the Catholic).	Death of Piero de' Medici. Accession of Lorenzo. Birth of Machiavelli (1469-1527). Bessarion publishes *In calumniatorem Platonis.*	
	The Tolfa alum war. Alberti : Façade of Santa Maria Novella. Boiardo starts *Orlando Innamorata.* Livy published in Venice. Death of Paul II. Election of Sixtus IV.	Birth of Albrecht Dürer (1471-1528) in Nuremberg Johann Müller, known as Regiemontanus, sets up the first astronomical observatory in Nuremberg.
John II of Aragon recaptures Barcelona and makes peace in his kingdom.	Death of Bessarion. F. Berlinghieri publishes his *Sette Giornate della Geographia* (c. 1472).	Birth of Lucas Cranach (1472-1553).
	G. Solari works on the church of the Certosa di Pavia.	
Isabella succeeds Henry IV of Trastamara.		Revolt of Cologne, Charles the Bold besieges Neuss.
	Sixte IV opens the Piccolomini library to the public. Antonello da Messina in Venice (1475 to 1476). Birth of Michelangelo (1475-1564). Landino's *Disputationes camaldulenses* written (c. 1475) and published in Florence (c. 1480.)	
	Revolt of Lodovico il Moro in Genoa. Berruguete in Urbino (1477-1482).	Marriage of Maximilian of Austria to Mary of Burgundy there by adding Burgundy and the Low Countries to the Empire.
	The Pazzi conspiracy in Florence. Sixtus IV interdicts Florence. Bramante : San Satiro, Milan. G. Dati : Popular edition of his *Sfera.*	
Death of John II of Aragon. Ferdinand the Catholic succeeds him.		
	Work begun on decorating the Sistine chapel (1480-1482). Otranto taken by the Turks. Pulci : The *Morgante.* Piero della Francesca : *De perspectiva pingendi.*	Birth of Altdorfer (1480-1538).

SPAIN - PORTUGAL	ITALY	GERMANY
Renewed war between Castile and Moslems of Granada.	Bertoldo : *Medal of Mahomet II.* Competition for the design of the cupola of Milan cathedral. Bramante in Milan. Leonardo da Vinci in Milan (1482-1499).	
Berruguete returns to Toledo.	Euclid's *Elements* published. Competition for the decoration of the Sistine chapel.	
		Birth of Grünewald (?) (between 1470 and 1483). Birth of Luther.
	Death of Sixtus IV. Election of Innocent VIII. Foundation of Ermolao Barbaro's Latin studies group in Venice.	
Ferdinand of Aragon occupies Navarre.	Translation of Plato by Marsilio Ficino.	
The Catholic kings bring about peace in their Kingdoms.	Pico della Mirandola : *Oratio de hominis dignitate.* Sulpicius publishes the first edition of Vitruvius (Rome-Florence).	
Ferdinand of Aragon captures Malaga.	Pico della Mirandola censured by the Pope.	
	Pico della Mirandola : *Heptaplus.* D. Spreti publishes *De amplitudine, de vastatione et de instauratione urbis Ravennae* in Venice.	
The expedition of the Catholic kings against Granada is repulsed.	Competition for the design of the façade of Florence cathedral (1480-1490).	
Capture of Granada by the Catholic kings. Edict against the Jews in Spain.	Death of Innocent VIII. Election of Alexander VI Borgia. Amadeo at the Certosa di Pavia. Death of Lorenzo de' Medici. Savonarola : *Triumph of the Cross.* First edition of Boethius' *De Musica* in Venice.	Death of Schongauer.
	Pico della Mirandola: *Disputationes adversus astrologiam divinatricem.* Luca Pacioli (1445-1514) publishes the *Summa de arithmetica, geometria, proportione et proportionalita* in Venice. Charles VIII in Italy. Lodovico il Moro duke of Milan. Fall of the Medici. Charles VIII enters Florence.	Accession of the Emperor Maximilian (1493-1519).
Accession of Manoel the Fortunate, King of Portugal (1495-1521).	Charles VIII takes Naples. Battle of Fornovo. A. da Sangallo works on the interior of the Castel Sant'Angelo.	Diet of Worms. Berthold of Henneberg proposes a plan to reform the Empire. Dürer in Italy.
		Birth of Melanchthon (1497-1560).
	Savonarola has the *Disputationes adversus astrologiam divinatricem* published. Death of Savonarola.	
Portuguese commerce sets up an agency in Antwerp.	Alliance between Louis XII, Venice and Florence. Louis XII in Italy. Milan and Genoa captured. Publication of the *Hypnerotomachia Polyphili* in Venice. Lodovico il Moro beaten and taken prisoner at Novara.	

	ENGLAND	LOW COUNTRIES/BURGUNDY	FRANCE
1481			Louis XI suppresses the Franche-Comté and acquires Provence and the Maine. Mantegna's *St Sebastian* at Aigueperse (now in the Louvre).
1482		Treaty of Arras. Maximilian restores Picardy and Burgundy. Death of Hugo van der Goes.	St François de Paule in France.
1483	Death of Edward IV. Richard III siezes the crown (1483-1485).		Death of Louis XI. Accession of Charles VIII (1483-1498). Anne of Beaujeu Regent.
1484			Estates-General meet at Tours.
1485	Richard III killed at Bosworth by Henry Tudor who becomes Henry VII (1485-1509); establishes strong monarchy.	Birth of Patinir (*c.* 1485-1524).	The 'Mad War'.
1486			
1487	Revolt of Northumberland.		Suppression of Guienne. The Beaujeu forces occupy St-Ouen.
1488		Maximilian transfers the commercial privileges of Bruges to Antwerp.	End of the 'Mad War'. François II of Brittany dies. Anne, his daughter, succeeds him. Crusade against the Vaudois in the Alps.
1489	Treaty of Medina del Campo — beginning of the long Anglo-Spanish alliance.	Memling: *Shrine of St Ursula.*	
1490			Marriage, by proxy, of Anne of Brittany to Maximilian of Austria.
1491			The French occupy Brittany. Anne of Brittany marries Charles VIII.
1492	Henry VII besieges Boulogne. Treaty of Étaples.		
1493	Henry VII transfers Wool Market from Antwerp to Calais.		
1494			Birth of François of Angoulême. Charles VIII prepares for war with Italy.
1495			
1496	War between England and Scotland (1496-1497).		
1497	Perkin Warbeck invades from Ireland, but is ·captured.		In Paris, Lefèvre d'Étaples publishes Aristotle's *Nichomachean Ethics*.
1498	Wool Market transferred back to Antwerp.		Death of Charles VIII. Accession of Louis XII (1498-1515).
1499	Henry VII orders the execution of Perkin Warbeck.		Marriage of Louis XII to Anne of Brittany. Palais de Justice at Rouen.
1500	Revolt of Suffolk.	Erasmus writes his first *Adagia*.	

CENTRAL EUROPE - MUSCOVY	OTTOMAN EMPIRE	GREAT DISCOVERIES
Podiebrad conquers Silesia.	The Turks destroy the despotate of Morea.	Benedetto Dei's voyage to Timbuktu and the Levant. Death of Henry the Navigator.
The Swiss take Thurgau from Sigismund of Austria. Alliance between Scander-Beg and Ferdinand of Naples.	Collapse of the Greek empire of Trebizond.	
Reign of Ivan III (1462-1505). Death of Albert of Austria.		
Paul II excommunicates Podiebrad, King of Bohemia.	Herzegovina invaded by the Turks.	
Matthias Corvinus invades Bohemia.	Albania open to the Turks.	
Matthias Corvinus proclaims himself King of Bohemia.		
	The Turks take Euboea from the Venetians. Kritoboulos: *History of Mahomet II.*	
Death of Podiebrad. Vladislav Jagiello becomes King of Bohemia. Revolt of Hungary. Matthias Corvinus has to leave Bohemia. Ivan III siezes Novgorod. Matthias Corvinus repulses Vladislav Jagiello. War with Poland.		
Matthias Corvinus invades Austria. Fioravanti goes to Moscow.	Mahomet II invades Walachia.	Toscanelli's letter to Canon Martinez of Lisbon regarding the possibility of reaching the East by crossing the Atlantic.
Construction of the Cathedral of the Assumption in Moscow (1475-1479).	Kaffa (Theodosia) taken by the Turks. Stephen the Great drives back the Turks.	
The sculptor Veit Stoss in Cracow till 1496. (Known in Poland as Wit Stwosz.)		
Peace of Olmütz between Hungary and Poland.	Turks sign the Peace of Venice. Lorenzo the Magnificent negotiates with Mahomet II.	

CENTRAL EUROPE - MUSCOVY	OTTOMAN EMPIRE	GREAT DISCOVERIES
Matthias Corvinus invades Austria.	Death of Mahomet II. Accession of Bayezid II.	
Prague revolts against Vladislav Jagiello.		The Portuguese explore the Congo estuary (1482-1483). Giovanni Michele Alberto Canaro publishes *De constitutione mundi*.
Construction of the Cathedral of the Annunciation in Moscow (1484-1490).	Bayezid's Mosque at Edirne (1484-1488).	
Peace of Kutna Hora between Vladislav and the Czechs. Rebuilding of the Kremlin (1485-1508).		
Construction of the Diamond Palace in Moscow.		Bartholomeu Diaz reaches the Cape of Good Hope (1487-1488). John II of Portugal sends Pedro de Covilha overland to Arabia and India.
	Cyprus becomes a Venetian possession.	
Death of Matthias Corvinus. John Albert and Vladislav Jagiello elected joint kings of Hungary. Solari in Moscow for the decoration of the Kremlin.		Martin Behaim's globe. Christopher Columbus' first voyage, discovery of the New World (1492-1493).
Vladislav Jagiello king of Hungary.		
		Christopher Columbus' second voyage (1493-1496). Treaty of Tordesillas.
		Vasco da Gama discovers the sea-route to India (1497-1499). John and Sebastian Cabot reach Labrador. Christopher Columbus' third voyage (1498-1500).
		Amerigo Vespucci explores the coast of Brazil. Antonio de Ferrariis (Galateo) publishes *De situ terrarum*.

GLOSSARY-INDEX

GLOSSARY-INDEX

ABATE (Pierantonio dell'), mentioned 1462-1488. Master in wood-carving and marquetry: stalls of Sant'Antonio, Padua, of Santa Maria in Monte, Vicenza, and of San Francesco, Treviso. Also active in Ferrara. *p.* 248. *see bibliog.* 108.

ABBIATEGRASSO, centre near Milan, where Bramante worked in 1495: Santa Maria Nuova. *see map* 310.

ABBOZZO *(bozza, bozze)*: sketch for a painting or sculpture: in the case of a painting, an advanced sketch has been made; in that of a sculpture, the block has been reduced more or less to the intended form, but remains rough. Sometimes the work is abandoned at this point—hence arose the concept of the *non finito. p.* 94.

ACCIAIUOLI (Donato), Florence 1429-Milan 1478. Humanist. *p.* 43.

AEDICULE: miniature portico or baldachino, in which usually the Madonna or saints were displayed : developed into a decorative motif closely associated with the architecture of the building in question, with its bays, niches, etc. It came to play a considerable part in the architecture depicted in paintings.

AGAPITO (St), *see* BOLOGNA.

AGNOLO DI DOMENICO DI DONNINO, Florence 1466-c. 1513. Florentine painter close to Cosimo Rosselli. Active in Florence (fresco in the Ospedale San Bonifazio), and Pistoia (fresco in the Audience Hall of the Palazzo dell' Opera di San Jacopo). *p.* 231.

AGOSTINO DI DUCCIO, Florence 1418-1481. Florentine architect and sculptor. Assistant to Alberti at Rimini. Marble *Madonna* for Florence Cathedral (Bargello); façade of the Oratory of San Bernardino, Perugia (1462); altar of the Pietà, Perugia Cathedral (1474). *ills* 36, 148, 149, 150.

ALBERTI (Leon Battista), Genoa 1404-Rome 1472. Humanist, painter, sculptor and architect; born in exile, educated at Venice and Padua, abbreviator to the Papal court. Author of treatises on painting, sculpture and architecture. Active as an architect after 1446 in Rimini, Florence and Mantua. *pp.* 43, 44, 45, 46, 49, 50, 51, 79, 100, 107, 126, 164, 180, 272. *see bibliog.* 122, 204.

ALBIZZI (Giovanna degli, née TORNABUONI), 15th century Florentine noblewoman. *ill.* 75.

ALESSE or ALESSI (Galeazzo), Perugia 1512-1572. Architect. *p.* 91.

ALEXANDER VI, *see* BORGIA; POPES.

ALEXANDRIA, Egyptian city. *ill.* 13.

ALFONSO OF ARAGON, *see* ARAGON.

ALFONSO OF CALABRIA, *see* ARAGON.

ALTDORFER (Albrecht), Regensburg 1480-1538. German painter and architect; visited Venice. *p.* 296.

AMADEO (Giovanni Antonio), Pavia 1447-Milan 1522. Lombard architect and sculptor, followed Filarete. Active in Bergamo (Colleoni Chapel, 1470-1475) and Pavia (façade of the Certosa and—with Giacomo della Porta—tomb of Giovanni Galeazzo Visconti). *pp.* 88, 157; *ills* 81, 84, 137, 197.

AMBOISE (Charles d'), 1432-1511. Military Commander assisted his uncle Georges; his whole career was spent in Italy; Governor of Milan. *p.* 285.

AMBOISE (Georges d'), Chaumont-sur-Loire 1460-Lyons 1510. French cardinal, minister to Louis XII. *p.* 279.

ANCONA, republic, sea-port of the Marches; later attached to the Papal States. *p.* 1. *see map* 310.

ANDREW (St), apostle, brother of St Peter, patron saint of Mantua.
Emblems: saltire (X-shaped cross), fish. *ill.* 134.

ANGELICO (Fra Giovanni da Fiesole, known as Beato), Vicchio di Mugello 1387-Rome 1455. Florentine painter, followed Lorenzo Monaco and the illuminators. Painted altarpieces and the frescoes for the convent of San Marco, Florence. *pp.* 103, 158, 191, 211, 270.

ANGELO DI BARTOLOMEO, painter late 15th century; apprentice in studio of Squarcione. *p.* 133.

ANTELAMI (Benedetto). Sculptor and architect, late 12th-early 13th century.

ANTICO (Piero Jacopo ALARI BONACOLSI, known as Antico), Mantua 1460-Gazzuolo 1528. Goldsmith, sculptor and medallist. *p.* 300.

ANTONELLO DA MESSINA, Messina *c.* 1430-1479. Painter trained in Naples under Colantonio. Active in Messina (1456-1473, altarpiece of San Gregorio) and Venice (altarpiece of San Casciano, 1476, dispersed; fragments in Kunsthistorisches Museum, Vienna). *pp.* 98, 171; *ill.* 92. *see bibliog.* 52.

ANTONIAZZO ROMANO (pseudonym of Antonio AQUILI), 1435-1508. Painter from the Romagna, active in Rome and Latium. Rieti triptych (1464); frescoes for Tor de' Specchi monastery, Rome. *pp.* 105, 270, 271; *ill.* 257.

ANTWERP, Belgian city, important artistic centre in the 15th century. *pp.* 1, 46.

AOSTA, Alpine town at junction of Great St Bernard and Little St Bernard valleys. *see map* 310.

331

APELLES, most famous of ancient Greek painters (4th century BC). *ills* 48, 49.

APOLLONIO DI GIOVANNI, or DA RISPATRA-MONE, 1415-1465. Painter of *cassoni*. *p.* 72; *ill.* 35.

AQUILA DEGLI ABRUZZI, city in the Abruzzi, founded by Frederick II. *see map* 310.

ARAGON, dynasty. Princes of Aragon who ruled the kingdom of Naples, as follows: ALFONSO V (1442-1458) *p.* 300; *ill.* 287; FERDINAND or FERRANTE I (1458-1494) cousin of Ferdinand the Catholic; his son ALFONSO II (1494-1495), duke of Calabria, succeeded him in 1494 for a few months only. After the French invasion the crown passed to FERDINAND II or FERRANDINO (1495-1496), then to FREDERICK (1496-1501), his uncle, and finally to Spain in the person of FERDINAND THE CATHOLIC himself (1503-1516). *pp.* 6, 8, 27, 91, 92, 94, 96.

ARCH (triumphal): edifice inspired by the triumphal monuments of Antiquity (of which the best-known examples, apart from those in Rome, were at Rimini and Ancona). It was also applied to the design of tombs, altarpieces, façades, etc. *pp.* 57, 91, 92, 118; *ills* 86, 87.

ARCA: (etym. 'ark'), a coffer, or chest. The term is used for the monumental receptacle forming part of many tombs. One of the most celebrated is the Arca of St Dominic at Bologna: thence the name Niccolò dell' Arca.

ARCA (Niccolò d'Antonio dell'), 1440-1494. Apulian sculptor who passed through Naples *c.* 1480. Tomb of St Dominic (1469-1473, Bologna). Entombment, terracotta (1485, Santa Maria della Vita, Bologna). *p.* 173; *ill.* 163.

AREGIO (Pablo de), *see* PABLO DA SAN LEOCADIO.

AREZZO, Tuscan city; under Florence from 1384 onwards. *pp.* 179, 239.
Patron saint: Donato d'Arezzo.
Secular buildings: Palazzo della Fraternità dei Laici (1375-1460); porch with Virgin by Rossellino.
Churches: Sant' Annunziata (1491). Badia (13th century), enlarged by Vasari; tabernacle by B. da Maiano.
Santa Maria delle Grazie; portico by B. da Maiano. San Francesco (1322); The story of the True Cross frescoes (1452-1459) by Piero della Francesca. *pp.* 17, 57, 177; *ills* 53, 54, 164, 174.

ARIOSTO (Lodovico), Reggio Emilia 1474-Ferrara 1533. Italian poet in the service of Cardinal Ippolyto d'Este, and later of Alfonso II. Author of the *Orlando Furioso* (1516). *p.* 8.

ARNOLFINI, Luccan merchant, settled at Bruges, where he had his marriage portrait painted by Jan van Eyck. *p.* 5.

ARRICIO: rough coating upon which the mortar for a fresco was laid (*arriciato* is Italian for bristly).

ASCIANO, Tuscan city subject to Florence. *see map* 310.

ASCOLI PICENO, city in the Marches subject to the Papal States.
Patron saints: Emidius of Ascoli, James of the Marches, Helen.
Churches: Cathedral, enlarged *c.* 1482 (restored in 19th century); polyptych by Carlo Crivelli (1474). *p.* 190; *ill.* 180. Sant' Agostino, altered (1485) by Giuliano di Zanobi de San Miniato.
Pinacoteca.

ASSISI, Umbrian city, birthplace of St Francis: in 14th and 15th centuries a possession of the Visconti and the Montefeltre; brought under the Papal States by Pius II. *p.* 304. *see map* 310.
Patron saints: Claire, Francis, Rufino of Assisi, Sabino of Assisi.
Churches: Oratory of San Bernardino (1488) by B. Pontelli. Stalls (1471) in the Lower Church of San Francesco (1228).

ASTI, Piedmontese city: a republic in the Middle Ages, and then a Duchy. *see map* 310.

ATRI, small town in the Abruzzi. *see map* 310.

AUGUSTINE (St) Tagaste 354-Hippo 430. Bishop of Hippo; founder of the Augustines; scholar, author of *The City of God*. One of the four great Doctors of the Church. Very popular in Tuscany. *ill.* 183.
Emblems: Bishop's vestments, dead bird.

AVIGNON, papal city from 1309 to 1377, then a possession of the Church until 1791. *see map* 312.

BADIA POLESINA, Venetian city attached to the Republic of Venice from 1482 onwards. *see map* 310.

BAJAZET II, 1446-1512. Sultan of the Ottoman Empire (1481-1512). *pp.* 14, 18.

BALDINI (Baccio Bartolomeo), Florence 1436-1487. Florentine engraver and goldsmith. Designer of illustrations to Antonio Bettini's *Monte santo di Dio.* *p.* 231.

BALDOVINETTI (Alessio), Florence 1425-1499. Florentine painter and mosaicist, follower of Domenico Veneziano and Andrea del Castagno. *Madonna* in the Louvre (1450); frescoes in the Chapel of the Cardinal of Portugal (1466-1474), San Miniato al Monte). *p.* 180.

'BAR... JACO...', Late 15th century; Venetian painter, follower of Antonello and of Giovanni Bellini. Produced alterpieces. *p.* 50; *ill.* 45.

BARBARI (Jacopo de'), Venice *c.* 1440-Brussels 1516. Venetian painter, pupil of Alvise Vivarini. Produced polyptychs and altarpieces. *p.* 50; *ill.* 211.

BARBARIGO (Agostino), Venice 1419-1501. Doge (1486-1501). *ill.* 283.

BARBARO (Ermulao) Venice 1453-Rome 1493. Humanist. *p.* 120.

BARBO (Pietro), Venice 1417-Rome 1471. Italian Cardinal; Pope under the name of Paul II (1464-1477). *pp.* 44. 100.

BARILE or BARILI (Antonio di Neri), Siena 1453-1516. Woodcarver and marquetrist, active in Siena. In 1484, he restored the bridge of Buonconvento. Stalls of the Chapel of San Giovanni in Siena Cathedral, in collaboration with Giovanni Barile and Giovanni di Pietro Castelnuovo. Worked at the Certosa of Maggiano, and the cloister of Santuccio. *p. 251. ill. 245. see bibliog. 236.*

BARTOLOMMEO (Fra) DELLA PORTA, Florence 1472-Pian di Mugnone 1517. Pupil of Cosimo Rosselli: entered Dominican Order (1500), returned to painting in 1508. *Annunciation* in Volterra Cathedral (1497); portrait of Savonarola; frescoes of Last Judgement (cemetery of Santa Maria Novella, Florence). *p. 270.*

BASTIANI, family of Venetian painters. MARCO (1435-1480), specialist of decorative work (Scuola di San Marco, 1472); LAZZARO (*c.* 1430-1512), Marco's brother active after 1484, produced altarpieces, was follower of the Vivarinis, the Bellinis and Carpaccio; Marco's sons: ALVISE active 1457-1485, specialized in panel paintings; SIMONE, active 1459-1473. Lazzaro's sons: JACOPO DI LAZZARO, mentioned in 1471, as working on the Sala del Gran Consiglio; ZUAVE DI LAZZARO, mentioned in 1474; BASTIANO, active 1485-1500; produced paintings (Scuola di San Marco, 1494; delle Misericordie, 1500). *ill. 108.*

BELLANO (Bartolomeo), Padua 1430-1496. Architect and sculptor, pupil of Donatello. Active in Rome, Perugia and Padua (where he carved reliefs in the Santo). *p. 157.*

BELLINI (Gentile), Venice *c.* 1429-1507; Venetian painter, son of Jacopo Bellini, brother of Giovanni. Official portrait painter to the Republic of Venice; portraits of Lorenzo Giustiniani (1465, Accademia), Mahomet II (1480, Basle). *ill. 22.* As a painter-chronicler, he gave a picturesque vision of Venetian life: *Procession in the Piazza San Marco* (1496 Accademia). *pp.* 18, 116, 171, 239, 241, 300; *ills* 13, 22, 109, 110.

BELLINI (Giovanni) or GIAMBELLINO, Venice *c.* 1430-1516. Venetian painter, brother of Gentile and brother-in-law of Mantegna. Painted historical panels in the Sala del Gran Consiglio (1480, destroyed in 1577), and numerous altarpieces: the four triptychs for the Carità (1464, Accademia), polyptych of St Vincent Ferrer (*c.* 1465, SS. Giovanni e Paolo), the Pesaro altarpiece (*c.* 1475), the San Giobbe altarpiece (1486-1487), the San Zaccaria altarpiece (1505). He also created a type of Madonna: e.g. *Virgin and sleeping Child* (*c.* 1470, Accademia), and those (*c.* 1490) at Bergamo and in the Louvre. *pp.* 50, 115, 125, 197, 199, 239, 303; *ills* 13, 209.

BELLINI (Jacopo), Venice *c.* 1400-1470. Venetian painter, father of Giovanni and Gentile. Collections of drawings and perspective studies. *pp.* 42, 43, 115, 147, 177, 227, 239; *ills* 39, 40, 213.

BELLUNO, city in the Veneto, subject to Venice from 1404. *see map 310.*

BEMBO (Pietro), Venice 1470-Rome 1547. Writer. *p. 8.*

BENEDETTO DA MAIANO, Maiano 1442-Florence 1497. Architect, sculptor and craftsman in marble. Active in Florence; collaborated with Cronaca in building the Palazzo Strozzi, Tomb of St Savino (1471-1472, Faenza Cathedral), pulpit of Santa Croce; doorway of Palazzo Vecchio (Florence) ciborium, Siena; tomb of Filippo Strozzi (Santa Maria Novella), bust of Filippo Strozzi, Santa Fina altar (San Gimignano). Collaborated with his brother on the church at Loretto. *pp.* 94, 246. *ills* 69, 88.

BENTIVOGLIO, Italian princely family, ruling Bologna from 1401 to 1506; GIOVANNI I (1401-1402); ANTONIO (1402-1438); ANNIBALE I (1438-1445): GIOVANNI II (1462-1508), *p.* 300; *ill.* 284.

BERENSON (Bernard), Vilna 1865-Florence 1959. Art historian and writer. *p. 303.*

BERGAMO, city in Lombardy: a domain of the Lombard kings, a free commune, and then (1427) under Venice. *pp.* 114, 246; *ills* 80, 81, 197.
Patron Saints: Adelaida of Bergamo, Alessandro of Bergamo, Asteria, Grata, Giulia of Corsica, Lupo of Bergamo.
Churches: Cathedral (1457-1487).
Colleoni Chapel (1470-1475) by G. Amadeo.
Tombs of B. Colleoni and his daughter, by G. A. Amadeo. *pp.* 87, 208, 261; *ills* 81, 197.
Basilica of Santa Maria Maggiore. *ill.* 81.

BERGOMENIS or BERGOMENSE (Giovanni). 15th century humanist in Ferrara. *p. 243.*

BERLINGHIERI (Francesco), 1440-1501. Florentine geographer, author of the *Sette Giornate della Geographia. p.* 9; *ill.* 1.

BERRUGUETE (Pedro), Paredes de Nava, † Avila 1504. Spanish painter, worked at Urbino for the Duke of Montefeltro between 1477 and 1482. *pp.* 281, 309, 310; *ills* 161, 265. *see bibliog.* 151.

BERTOLDO DI GIOVANNI, Florence *c.* 1420-Poggio a Caiano 1491. Florentine sculptor and medallist, pupil of Donatello; taught Michelangelo; keeper of the Medici collections. Worked with Bellano on the pulpits in San Lorenzo, Florence. Produced plaquettes and Madonnas. *pp.* 14, 300; *ill.* 14. *see bibliog.* 46.

BESSARION (Cardinal Giovanni), Trebizond 1403-Ravenna 1472. Archbishop of Nicaea, moved to Italy and was made cardinal by Eugenius IV in 1439 —a great patron of literature and the arts, he gathered a kind of academy about him. *p. 17.*

BICCI DI LORENZO, Florence 1373-1452. Florentine painter and sculptor; produced frescoes, altarpieces, a triptych, terracotta figures. *p. 179.*

BIELLA, Piedmontese town in the province of Vercelli. *see map* 310.

BIFORA: Italian term for a window divided into twin bays under a single round arch. *p. 79.*

BIONDO (Flavio), Forlì 1392-Rome 1463. Humanist and archaeologist; author of *Roma instaurata* (1444-1446). *p.* 43.

BISSONE, North Italian village. *see map* 310.

BOCCATI (Giovanni di PIERMATTEO, known as Boccati) Camerino *c.* 1420-1490. Painter from the Marches. Produced numerous polyptychs. *pp.* 158, 192; *ill.* 182.

BOETHIUS (Anicius Manlius Torquatus Severinus) *c.* 480-525. Roman statesman, poet and philosopher. *p.* 45.

BOIARDO (Matteo Maria), Reggio Emilia 1441-1494. Humanist poet, employed by Duke Ercole I of Ferrara. Author of *Orlando Innamorato* (courtly epic) *p.* 8.

BOLDI, Venetian epigraphist, late 15th century, employed to supply learned inscriptions for medals. *p.* 44.

BOLOGNA, city in Emilia; played important part in the Lombard League between 12th and 13th centuries, governed in 14th and 15th centuries by the Viscontis and the Bentivoglios. *pp.* 9, 190, 246, 255, 263, 300. *Patron Saints:* Agapito, Agricola, Barbatiano of Ravenna, Florian, Nicolo, Petronio, Procule.
Secular buildings: Palazzo Bevilacqua (1481), Palazzo dei Drappieri (1484-1496), Palazzo Fava (1484-1491), Palazzo Pallavicini-Fibbia (1497), Palazzo del Podestà (13th century. rebuilt in 1472), Palazzo Poggi (1472), Zamboni colonnade (1477), columns of Tommaso Filippi, Torre dei Asinelli, Loggia (1488). Collegio di Spagna. *p.* 190.
Churches: San Domenico (1221), containing tomb of St Domenic (1267). Completed by Niccolò dell'Arca (1468-1473) and Michelangelo (1494). Corpus Domini (1478-1480). Madonna di Galliera (façade, 1491) San Giovanni in Monte (major alterations in the 15th century), façade (1474), stained glass by F. Cossa, *Virgin and Saints* (1497) and *Coronation of the Virgin* (1501) by L. Costa. San Michele in Bosco (rebuilt 1494-1510). San Petronio (rebuilt 1445-1525), stalls (1468-1477) by A. de Marchi, *p.* 255. Spirito Santo (1481-1497), terracotta decoration (1497) by Sperandio. *p.* 173.

BOLSENA, city forming part of the Papal States. *see map* 310.

BONASCIA (Bartolomeo), Modena 1450-1527. Architect, painter, marquetrist, influenced by Piero della Francesca and Mantegna. Active in Modena where he worked from 1468 to 1470, for the hospital of the confraternity of San Giovanni della Morte. Only one dated work: *Pietà* (1485, Galleria d'Este, Modena). *p.* 173.

BONFIGLI (Benedetto), Perugia 1420-1496. Painter of the Perugian School; first mentioned, Rome 1445. Working in the Vatican, 1450. Commissioned to decorate new chapel of the Priors, Perugia, 1454. *Adoration of the Magi* and *Annunciation* (in the Perugia Gallery). *pp.* 158, 192.

BORDONE (Benedetto), ?-Venice 1539. Wood engraver and miniaturist. *p.* 242.

BORENIUS (Carl Tancred), Viipuri 1885-1948. Finnish art historian. *p.* 303.

BORGIA, family which came from Xativa in Aragon (Spain). Its most eminent members in the Quattrocento were Popes Calixtus III (1455-1458) and Alexander VI (1492-1503) and his son, Cardinal Cesare Borgia (1474-1507). *pp.* 3, 281.

BORGOGNONE or BERGOGNONE (Ambrogio da FOSSANO, known as) Fossano 1450-1523. Lombard painter, active in Milan and Lodi and at the Certosa of Pavia (1488-1495). Trained by Foppa. Numerous altarpieces; frescoes in church of San Simpliciano, Milan (1522). *p.* 90.

BORGOÑA (Juan de). Spanish painter of French origin, late 15th-early 16th century. *p.* 310.

BOTTEGA: studio of workshop, in which the master worked with the help of assistants and apprentices, whom he trained in their craft and provided with food and lodging. *pp.* 67, 76.

BOTTICELLI (Alessandro di MARIANO FILIPEPI known as Sandro Botticelli) Florence, 1445-1510. Florentine painter, pupil of Filippo Lippi; many altarpieces in Florence; *Adoration of the Magi, Altarpiece of San Barnaba* (1485-1486, Uffizi); *Coronation of the Virgin* (1488, Uffizi). *ill.* 4. Also secular paintings: *Primavera* (c. 1478) *Birth of Venus, p.* 51. One of the painters of the frescoes in the Sistine Chapel, Rome (1481-1482). Towards the end of the century, illustrations for Dante's *Divina Commedia*. *pp.* 50, 51, 55, 76, 199, 251, 267, 270, 304, 307; *ills* 4, 49, 68, 102, 188, 238, 240, 244, 251, 252.

BOTTICINI, family of Florentine artists. Among them: FRANCESCO, Florence 1446-97, pupil of Neri di Bicci, active in Empoli and Florence. Altarpieces: *Assumption* (London), *Madonna and Saints* (1482, Louvre) also predella of the altarpiece of St Sebastian and the Holy Sacrament (1484-91, the Parish church, Empoli). *ill.* 77.

BOZZETTO, *see* ABBOZZO.

BRACCESCO (Carlo), *c.* 1460-1510. Painter of Milanese origin, active in Genoa and Liguria. Only signed and dated work: polyptych in the parish church of Montegrazie (1478). Painter of the *Annunciation* triptych in the Louvre. Attributed to him: an altarpiece of St Andrew (dispersed) and the fresco of the *Coronation of the Virgin* in Santa Maria di Castello, Genoa. *p.* 90.

BRAMANTE (Donato di Angelo), Monte Asdrualdo (Fermignano) 1444-Rome 1514. Painter and architect trained at Urbino. Active in Lombardy 1477-1499: façade of the Palazzo del Podestà, Bergamo; and then in the service of Lodovico il Moro in Milan; sculptural decoration to Casa Panigarola (Men at Arms). Worked on Santa Maria presso San Satiro, on apse of Santa Maria delle Grazie and on Pavia

Cathedral. After 1500, Roman period; cloister of Santa Maria della Pace (completed 1504). Tempietto in San Pietro in Montorio, 1502, and, after 1505, reconstruction of the Vatican; initial work on the new St Peter's (after 1506) of which the central plan design was his, and on the courtyard of the Belvedere. *pp.* 86, 88, 89, 90, 91, 107, 108, 292; *ills* 50, 99.

BREA (Lodovico) Nice, *c.* 1450-*c.* 1523. Painter from Nice, active in the County of Nizza and in Liguria; collaborated with Foppa in 1490 on the polyptych for Santa Maria di Castello, Savona. Painted numerous polyptychs at Nice, Savona, Taggia, Montalto and Genoa. His brother ANTONIO worked with him. *p.* 90.

BREGNO (Andrea), Osteno 1418-Rome 1503. Lombard sculptor, active in Rome. Worked with Pontelli on the façade of Santa Maria del Popolo. In Tuscany he worked on Siena Cathedral and at Monte Oliveto Maggiore. *pp.* 103, 107, 118. *ill.* 99.

BRESCIA, Lombard city, ruled by various overlords; then under Venice from 1426 onwards. *p.* 114.
Patron saints: Apollonius of Brescia, Faustino, Giovita, Gaudenzio, Paterio, Angela Merici, Alfra of Brescia, Giulia of Corsica.
Secular Buildings: Palazzo Communale, loggia (1492-1574). Monte di Pieta (Monte Vecchio, 1484).
Churches: Sant' Agostino (façade with terracotta decoration 15th century).
Madonna del Carmine.
Santa Maria dei Miracoli (1488-1523). *p.* 87; *ills* 193, 194.
San Giovanni Evangelista (15th century).

BRESSANONE, city in the Veneto, an ecclesiastical principality from 1027 to 1803. *see map* 310.

BRUNELLESCHI (Filippo) Florence 1377-Rome 1446. Goldsmith, sculptor and architect, active in Florence in the service of Cosimo de' Medici. Revived architecture. Dome of Santa Maria del Fiore (1420). *pp.* 30, 45, 79, 81, 130, 180, 181, 246.

BUGATTI, *see* ZANETTO.

BURCKHARDT (Jakob), Basle 1818-1897. Swiss historian. *p.* XI.

BUSSETO, commune in Emilia-Romagna; came under the Pallavicinis and then, after 1588, the Farneses. *see map* 310.

BUTINONE (Bernardo), Treviso *c.* 1450-*c.* 1507. Lombard painter trained in the School of Foppa. Produced alterpieces, worked in 1485 with Bernardino Zenale on the San Martino altarpiece, Treviglio. *p.* 147; *ill.* 135.

BYZANTIUM, the capital of the Emperor Constantine. *pp.* 18, 24. *see map* 312.

CAESAR (Caius Julius), Rome 101-44 B.C. Roman politician, general and writer. *ills* 28, 37.

CALAZIO (Matteo), late 15th century. Sicilian traveller. *p.* 248.

CAMELIO (Vittore), Venice 1455/60-1537. Goldsmith, sculptor and medallist, active in Venice and Rome. *p.* 300.

CAMERA PICTA: term used for rooms whose walls are entirely covered with painting, like the Sala degli Sposi, by Mantegna, in the palace of Mantua. *p.* 186; *ill.* 177.

CAMERINO, city of the Marches, centre of the domain of the Varanos from the 13th to the 16th century. *see map* 310.

CAMILLO LEONARDO (of Pesaro). Humanist writer belonging to the entourage of the Duke of Urbino. Treatise (1502) entitled *De Lapidibus*. *p.* 164.

CANDIDA (Giovanni) or FILANGIERI DI CANDIDA, Benevento 1450-1504. Diplomat and medallist; in 1475 he entered the service of Charles the Bold, who sent him on a mission to Venice. Worked for the Colleonis, Frederick III, the Pope and the King of Naples. Went into the service of Louis XI in 1478. Made medals for numerous important people. *pp.* 279, 300.

CANOZZI (Cristoforo and Lorenzo), *see* LENDINARA.

CAPORALI, family of Umbrian artists. JACOPO, ?-1478. Miniaturist, responsible for the illustration of an antiphonary belonging to San Pietro, Perugia. BARTOLOMEO, Perugia *c.* 1420-1508. Painter; worked with Bonfigli, and painted a *Madonna* (Uffizi). GIOVANNI PAOLO, ?-1533. Goldsmith in Perugia, son of Bartolomeo: admitted in 1482 to the Guild of Goldsmiths of Porta Santa Susanna. Worked with Rodolfo Compagni for the Cathedral of San Biagio. *p.* 158.

CAPUA, a fortified city in Campagna, situated on the left bank of the Volturno, built in the 9th century and rebuilt at various times. *see map* 310.

CARADOSSO (Cristoforo FOPPA, known as Caradosso) Mondonico *c.* 1452-1527. Goldsmith, enameller and medallist. *p.* 300; *ills* 24, 281.

CAREGGI, *see* FLORENCE.

CARPACCIO (Vittore), Venice 1455-1526. Venetian painter, pupil of Gentile Bellini and, like him, with a gift for large-scale narrative schemes. The San Giorgio degli Schiavoni cycle (1502-1508) and the St Ursula cycle. *ill.* 25 (1490-1496, Accademia, Venice). *pp.* 18, 55, 115, 197; *ills* 20, 25, 47.

CARTA TINTA: paper prepared so as to give a coloured ground (grey, dark blue, salmon pink, etc.) for a drawing, usually gouache; much favoured by the Florentines of the 15th century, from Gozzoli to Lorenzo di Credi and Leonardo da Vinci. *p.* 211.

CARTOON: a full-scale drawing used as a model for the execution of a fresco, being either copied, if the squaring-out procedure is used, or employed directly by the so-called 'spolvero' method.

CASSONE: a chest, usually of wood; in a more specialized sense, a marriage chest decorated either with the coat of arms of husband and wife or with secular, historical or mythological themes alluding to 'marriage'. In the second half of the 15th century *cassoni* were more and more frequently decorated in marquetry (views of cities, etc.) and sometimes they were of gigantic proportions. *p.* 72; *ills* 35, 64, 65, 67. *see bibliog.* 270.

CASTAGNO (Andrea del), San Martino a Corella 1423-Florence 1457. Florentine painter specializing in large-scale compositions. *p.* 134.

CASTELFIORENTINO, agricultural centre of the district of Florence. *see map* 310.

CASTIGLIONE (Baldassare) Casanatico, Mantua 1478-Toledo 1529. Author of *The Courtier* a breviary of a man of the world, which had an immense success both in Italy and throughout Europe. *p.* 164.

CASTIGLIONE D'OLONA, small city in Lombardy, whose importance was increased by Cardinal Branda da Castiglione (1350-1443). *see map* 310.

CASTRIOTA (Giorgio, known as SCANDER-BEG) *c.* 1403-Leshi 1468. Defender of Albania in 1468. *p.* 14.

CATHERINE OF ALEXANDRIA (St), martyred under Maxentius, revered for her learning and for her resistance to heresy. *ills* 105, 245.
Emblem: a broken wheel (refering to the method of her torture).

CAVALLO: Italian for horse, often used to designate an equestrian statue. Used, in particular, with reference to Leonardo's huge terracotta model in Milan castle for an equestrian statue of Francesco Sforza. *p.* 90.

CECCA (Francesco d'ANGELO, known as IL CECCA), Florence 1447-1488. Architect and engineer. *p.* 30.

CESENA, city in Emilia, subject to Bologna in the Middle Ages, then in the 15th century to the Malatestas. *see map* 310.

CHANTERENE (Nicolas) French sculptor of the 15th and 16th centuries, active in Portugal 1517-1537. *ill.* 270.

CHARLES VIII, 1470-1498, King of France 1483-98, son of Louis XI. Began the Italian wars in September 1494 with an expedition which took him as far as Florence, Rome and Naples but ended in a precipitate retreat (battle of Fornova, 6 July 1495). He brought back from Italy Neapolitan craftsmen and technicians. *pp.* 30, 96, 277, 279.

CHELLINO (Antonio da), mentioned as active in the middle of 15th century. One of Donatello's four assistants in work on the high altar of the Santo, Padua (1446-1448). Sculptor of one of the reliefs representing the symbols of the Evangelists. *p.* 92.

CHIAROSCURO: contrasting use of light and shadow in a painting (as in paintings by Caravaggio). *p.* 108.

CHIGI (Villa), near Siena. *see map* 310.

CHIOS, Greek island in the Aegean, governed by Genoa 1304-1566. *p.* 18.

CHOSROES II, 590-628, Sassanian king. *p.* 239.

CIMA DA CONEGLIANO (Giambattista), Conegliano 1459-1517. Venetian painter, pupil of Montagna, influenced by Bellini. Produced altarpieces; *San Vicenza altarpiece* (1489); *Baptism of Christ*, in San Giovanni in Bragora (1494); *Virgin* in Santa Maria del Carmine (1510). *ill.* 17.

CITTÀ DI CASTELLO, Umbrian city, under the Vitellis from 1450 onwards. *see map* 310.

CIVITALI, family of Tuscan sculptors. MATTEO, Lucca 1436-1501. Sculpted statues for the Chapel of the Volto Santo. MASSEO DI BARTOLOMEO, Nephew and pupil of Matteo, active in Lucca; sculptures on the three doors of the Cathedral. *ill.* 196

CODUCCI (Mauro), Val Brembana 1440-Venice 1504. Bergamese architect, active in Venice; San Michele in Isola (1479); façade of the Scuola San Marco (1485-95); completed the campanile of San Pietro di Castello (1488). *pp.* 115, 118, 284; *ill.* 111.

COLANTONIO (Antonio), first half of 15th century. Neapolitan painter, taught Antonello. Painted altarpiece of San Lorenzo (1460-70) for the Franciscans; of this only the *St Jerome* survives (Naples). *pp.* 98, 310; *ills* 89, 90.

COLLEONI (Bartolommeo), Solza, Bergamo 1400-Malpaga 1475. A condottiere who dominated Bergamo; a lavish patron of the arts (Colleoni Chapel, etc.). In 1456 he became generalissimo to the Republic of Venice. (It is his equestrian statue, by Verrocchio, that stands in the Piazza San Zanipolo, Venice). *p.* 208; *ill.* 197.

COLOMBE (Michel) *c.* 1430-*c.* 1513. French sculptor, active in Berry and Touraine. *ills* 263, 274.

COLONNA (Fra Francesco), Treviso ?-1433-Venice 1527. A monk at the Dominican monastery in Treviso. Author of the *Hypnerotomachia* (1467, published at Venice in 1499 by Aldus Manutius). *pp.* 43, 242, 243; *ills* 41, 42, 114, 230.

COLUMBUS (Christopher), Genoa 1450 —or 1451-1506. Set out in 1492 on his great voyages of discovery in the service of Spain. *p.* 11.

COMO, a city in Lombardy, integrated with the Duchy of Milan in 1335.
Patron saints: Abundius, Carpophorus, the Quattro Incoronati, Liberata, Faustina.
Churches: Cathedral, begun in 1396, completed in 1599; façade and side doors (1498-09) by the Rodaris. *ill.* 195.

CONDOTTIERE: adventurer who led a band of soldiers of fortune and placed himself in the pay of different princes. A condottiere often became lord of a fief, of a city or even of a state —as, for instance,

Federico da Montefeltro at Urbino, Sigismondo Malatesta at Rimini, Francesco Sforza at Milan. *p.* 27; *ill.* 92.

COPPINO DI GIOVANNI, embroiderer from Malines, 15th century. *p.* 304.

CORNARO (Catherine), 1454-Venice 1510. A Venetian noblewoman, who, in 1468, married Jacques II de Lusignan, King of Cyprus. Governed Cyprus as regent after his death, then in 1489 abdicated and retired to her villa in Asolo, where she lived surrounded by poets and artists. *p.* 13.

CORSIGNANO, *see* PIENZA.

CORTEMAGGIORE, ancient city of Emilia, which was replanned in the time of the Marchese Gian Lodovico Pallavicino. *see map* 310.

CORTONA, Tuscan city, subject to Florence from 1410 onwards. *pp.* 180, 204; *ill.* 192.
Patron saint: Santa Margherita of Cortona.
Churches: Santa Maria delle Grazie del Calcinaio (1485) by Francesco di Giorgio Martini. *p.* 180; *ill.* 192.
Church of the Gesù (1498-1505) —now Diocesan Museum.

CORVINUS (Matthias) 1440-90, King of Hungary 1458-1490. Patron of the arts and supporter of humanism, he maintained close ties with artists and humanists, especially from Florence: possessor of a celebrated library, he ordered a whole series of illuminated manuscripts from Florence. *p.* 281; *ill.* 266 *see bibliog.* 139.

COSIMO I, *see* MEDICI.

COSSA (Francesco del), Ferrara *c.* 1436-Bologna 1478. One of the three masters of the Ferrarese school; took part in the decoration of the Palazzo Schifanoia. *ills* 29, 31, 32, 33, 142, 166, 167.
Produced altarpieces at Ferrara and Bologna: Grifoni and San Petronio altarpieces (1473) at Bologna; *Annunciation*, Dresden. *pp.* 173, 199, 270.

COSTANZO (Marco) Ferrara, late 15th century. Painter and medallist active in Naples and Constantinople where he made a portrait of Mahomet II (1485). Identified with Costanzo Lombardo and Costanzo di Moysis. *p.* 98; *ill.* 91.

COZZI (Francesco di Giampietro), mentioned from 1455 to 1464. Sculptor who came from Vicenza and was active in Santa Maria dei Frari, Venice, in San Zaccaria, SS. Giovanni e Paolo, Sant' Elena, Scuola di San Giovanni Evangelista, *p.* 124.

COZZI (Marco di Giampietro). Vicenza ?-1485. Sculptor. *pp.* 124, 246.

CRACOW, city in Poland, capital from 14th to 16th century. *p.* 288.

CREDI (Lorenzo di), Florence *c.* 1459-1537. Florentine painter, Verrocchio's principal pupil along with Leonardo. *Madonnas* (London, Berlin, etc.) close in style to Leonardo and to the Pistoia altarpiece. *pp.* 211, 231; *ills* 202, 204.

CREMA, city in Lombardy, one of the Lombard communes destroyed by Frederick Barbarossa (1159); became subject to Venice in 1449. *see map* 310.
Church: Santa Maria della Croce (*c.* 1500) by Battagio and Montanari. *p.* 273.

CREMONA, city in Lombardy, became a free commune in 1334; came under the Viscontis and the Sforzas in the 15th century. *p.* 88. *see map* 310.
Patron saints: Homobonus, (Omobuono) Himerius (Gismonde), Marius of Persia, Hilary of Padua, Agatha of Catania, Margherita, Eusebius.
Secular buildings: Palazzo Fodri (late 15th century).
Palazzo Trucchi-Raimondi (1496).
Palazzo Stanga (*c.* 1550).
Portico of A. Carrara (1491-1525).
Churches: Cathedral (1190-1273), restoration begun in 1491 by P. da Rho. Bishop's thrones (1482) by Amadeo and Piatti; stalls (1490) by G.M. Platina.
Sant' Agostino (1339), bell tower (1461).

CRISTOFORO DI GEREMIA, Mantua *c.* 1430-1476. Goldsmith, medallist and sculptor. *p.* 300.

CRISTUS (Petrus), Baerle (near Ghent) 1418-1472. Flemish painter. *p.* 309.

CRIVELLI (Carlo), Venice *c.* 1430-*c.* 1493. Venetian painter, who left Venice in 1470 for Dalmatia. Active in the Marches: he painted a number of polyptychs heightened with gilding at Ascoli Piceno (1475), *Annunciation* (1493, London), *Coronation of the Virgin* (1482, Brera). *pp.* 135, 147, 173, 304; *ills* 140, 141, 180.

CRONACA (Simone del POLLAIOLO, Known as Cronaca) Florence 1457-1508. Florentine architect: worked on the Palazzo Strozzi (1489). *p.* 272.

CYPRUS, island in the Eastern Mediterranean, under Genoese and Venetian influence in 14th and 15th centuries; Venetian colony from 1489 to 1570.

CYRIACUS OF ANCONA, Ancona 1391-Cremona 1452. Archaeologist famous for his travels, accounts of which were published after his death. *pp.* 42, 134.

DANTE (Alighieri), Florence 1265-Ravenna 1321. Italian poet, author of the *Divina Commedia*. *pp.* 12, 27; *ills* 69, 252.

DARIO (Giovanni), secretary of the Venetian Republic in Constantinople. In about 1487 he commissioned a palace for himself on the Grand Canal from a Lombard master, possibly Pietro Lombardo. *p.* 14.

DARIO DA PORDENONE, Pordenone *c.* 1420-1498. Painter. *ill.* 2.

DATI (Goro), Florence 1362-1435. Podestà and gonfalonier of Florence: author of a history of the Milanese Duke Galeazzo Visconti (1435) and a poem called *La Sfera*. *pp.* 12, 36.

DATI (Giuliano), late 15th century. Specialist in pious booklets and in sets of verses for the strolling street singers. *p.* 11.

DAVID (Gerard), Oudewater, Gouda *c.* 1460-Bruges 1523. Flemish painter influenced by Italian work. *pp.* 265, 309; *ill.* 299.

DE FERRARI, *see* FERRARI.

DE GREGORIIS, *see* GREGORIIS.

DEI (Benedetto), Florence 1418-1492, Florentine chronicler, agent of the Medici in the Levant and in various Italian cities. Author of a chronicle which was not published. *pp.* 11, 18, 67, 78, 120, 246.

DESIDERIO DA SETTIGNANO, Settignano 1428-Florence 1464: Florentine sculptor specializing in *stiacciato* relief; pupil of Donatello. Worked in Florence and Orvieto. Designed the tomb of Carlo Marsuppini (Santa Croce). *pp.* 68, 127; *ills* 28, 60.

DIAMANTE (Fra), Terranova, Val d'Arno 1430-1498. Pupil and assistant of Filippo Lippi at Prato (1452-1468): Filippino Lippi's first teacher. Worked at Spoleto (1468-69); Rome (1480-81) and Florence.

DISTEMPER: method of painting with water, particularly for frescoes; the colours are thinned out in water, to which a gelatinous substance has been added.

DOMENICO VENEZIANO, *see* VENEZIANO.

DONATELLO (Donato di BETTO BARDI, known as Donatello) Florence 1386-1466. Florentine sculptor, whose force and originality exercised an influence all over Italy. After his work for Or San Michele (the *St George*, 1416) and for Florence Cathedral (*Prophets* for the West front, *c.* 1410; *Prophets* for the campanile, 1433-1439, the Cantoria, 1433-1440), he went to Rome (1432-1433) and then spent a long time (1443-1453) at Padua, where he produced the Gattamelata statue and the altar of the Santo. Returned to Florence and worked on the bronze pulpits in San Lorenzo. *pp.* 54, 68, 92, 114, 127, 129, 130, 134, 135, 189, 271; *ills* 61, 120, 121.

DÜRER (Albrecht), Nuremberg 1471-1528. German painter and engraver; visited Italy; very great influence on the art of engraving at the end of the 15th century. *pp.* 125, 231, 237, 263, 277, 290, 296, 313; *ills* 262, 276.

EMPOLI, Tuscan city, on left bank of the Arno; under Florence from 1182 onwards. *see map* 310.
Patron saint: Andrew.
Secular building: Porta Pisano (1487).
Churches: San Stefano, frescoes by Masolino. Collegiale (1093, destroyed in 1939); in the baptistry, font of 1447 in front of Botticini altarpiece.

ERRI (Agnolo and Bartolomeo degli), second half of 15th century. Painters in Modena, who produced altarpieces. Triptych in the Pinacoteca, Modena. *p.* 190.

ESTE, Italian princely house, which ruled over Este, Ferrara and Modena. *pp.* 6, 29, 307; *ill.* 282.
Beatrice.
Borso. *pp.* 177, 247.
Ercole. *ill.* 282.
Isabella. *p.* 36.
Lionello.

EUBOEA, (known as NEGROPONT in the Middle Ages) island in the Aegean, separated from the mainland of Greece by a narrow strait; a Venetian possession from 1351 to 1470. *pp.* 13, 14.

EUCLID, 3rd century B.C. Greek mathematician and geometer; his best-known work is the *Elements.* *pp.* 45, 241.

FABRIANO, city in the Marches: incorporated in the Papal States in the middle of the 15th century. *see map* 310.

FAENZA, city in the Romagna, a domain of the Manfredis, attached to the Papal States in 1501. Centre of the majolica industry. *see map* 310.

FANCELLI (Domenico) Settignano 1469-Saragossa 1519. Italian sculptor, active in Spain. *p.* 281.

FANO, city in the Marches. Came under the Malatestas in the 15th century. *see map* 310.

FAZIO (Bartolomeo) or FACIO, Spezia *c.* 1400-Naples 1457. Neapolitan humanist, historian to King Alfonso I. *p.* 98.

FELICIANO (Felice) Verona 1433-1489. Humanist, printer and alchemist, author of a collection of inscriptions (1472). *pp.* 41, 42, 43.

FELTRE, a city in the Veneto, at the foot of the Venetian Alps; a Venetian domain from 1404. *see map* 310.

FERDINAND OF ARAGON, *see* ARAGON.

FERRARA, city in Emilia, from 1208 to 1597 a possession of the house of Este. In the 15th century the reigning princes were: Lionello d'Este (1441-1450), Borso d'Este (1450-1471) and Ercole d'Este (1471-1505). *pp.* 2, 6, 17, 29, 31, 55, 57, 91, 147, 171, 173, 177, 197, 239 264, 281.
Patron saints: Barbara, Maurelio.
Town planning: new quarter designed by Biaggio Rossetti (1471-1505).
Secular buildings: Palazzo dei Diamanti (1492) by B. Rossetti.
Palazzo Constabilis (1494). Palazzo Scrofa.
Palazzo Communale, redesigned (1475-81) by Benvenuti and (1493) by B. Rossetti.
Palazzo Pareschi (1475-87).
Palazzo Schifanoia, (begun in 1391 and enlarged 1458-1478) by B. Rossetti, with frescoes (Sala dei Mesi by F. del Cossa, Ercole dei Roberti, Cosimo Tura). *pp.* 36, 173; *ills* 29, 31-33, 162, 166, 167, 177.
Palazzo Sacrati (1493-1500).
Churches: San Benedetto (1496-1554) Cathedral (12th century) with campanile (1425-1495).
San Francesco (1494-1530) by Biagaio Rossetti.
Santa Maria degli Angeli (1471-94).
Santa Maria in Vado (1495-1508).
San Giorgio (1485) by Biaggio Rossetti with the Roverella tomb (1475) by Ambrogio da Milano and A Rossellino.
The Certosa (1461).
Pinacoteca.

FERRARI (Antonio de, known as Il GALATEO) Galatona 1444-Gallipoli 1517. Doctor, philosopher and humanist. *p.* 12.

FICINO (Marsilio) Figline Val d'Arno 1433-Careggi 1499. Florentine humanist who did much to spread and develop the doctrines of Plato by his teaching at the Academy of Florence. An admirer of Savonarola. Author of *Institutiones Platonicae, Theologia Platonica seu de Immortalitate animarum* (1478). *pp.* 24, 36, 45, 46, 51.

FIESOLE, Tuscan town just outside Florence. Its fortunes echo those of Florence from 1125 onwards. *see map* 310.

FILARETE (Antonio AVERLINO, known as Filarete) Florence 1400-Rome *c.* 1465. Florentine architect and sculptor, who worked on the Castello at Milan (1451-1454) and on the Ospedale Maggiore (1456-1465). Major influence on Lombard architecture. Author of a treatise on architecture. *pp.* 49, 87, 115, 157; *ills* 80, 136, 267.

FILIPPINO, *see* LIPPI.

FILIPPO, *see* LIPPI.

FINIGUERRA (Maso) Florence 1426-1464. Florentine goldsmith and niellist. *pp.* 6, 70, 211, 231, 237; *ills* 6, 7, 8, 19, 62, 198, 217.

FIOCCO (Giuseppe), Italian art historian born in Giaccino, 1884. *p.* 247.

FIORAVANTI (Aristotele) Bologna *c.* 1415-Moscow 1486. Bolognese architect, who worked in Bologna, Milan. He was summoned to Moscow by Ivan III. *p.* 281, *see bibliog.* 104.

FIORENZO DI LORENZO, Perugia *c.* 1440-1525. Florentine painter taught by Benozzo Gozzoli and close to the Umbrian school. *Madonna of the Misericordia* (1476) polyptych for Santa Maria Nuova (1487-1493, Perugia). *p.* 162.

FLORENCE, ancient republican city in Tuscany, subject to the Medici after 1434. COSIMO I (1389-1464), PIERO I (1416-1469), LORENZO THE MAGNIFICENT (1449-1492), *ill.* 285, PIERO II (1471-1503) expelled by a revolution in 1494. Savonarola's Christian Republic lasted only until 1498. It was followed by a provisional regime under the gonfalonier Soderini, which prepared the way for the return of the Medicis. This became inevitable when Cardinal Giovanni (1475-1521) was raised to the pontificate under the name of Leo X (in 1513). *pp.* 2, 5, 8, 17, 27, 28, 30, 41, 43, 44, 46, 51, 55, 57, 66-68, 72, 76, 78, 79, 81, 86, 90, 91, 94, 126, 147, 158, 177, 180, 245, 246, 270, 272, 281, 288, 300, 304, 309; *ill.* 59.
Patron saints: John the Baptist, Eugenius of Florence, Frediano of Lucca, Filippo Benizzi of Florence, Filippo Neri, Reparata of Florence, Zenobius of Florence, Miniato, Barnabus.
Secular buildings: Loggia Rucellai (1460) by Alberti.
Palazzo dei Antinori (*c.* 1465) attributed to G. da Maiano.

Palazzo Gondi (1490-1494) by Giuliano da Sangallo. *p.* 78; *ill.* 79.
Palazzo Medici (later Riccardi) by Michelozzo (1444-1460), chapel with frescoes by Benozzo Gozzoli (1459). *p.* 79.
Palazzo Pazzi (1430), continued (1462-1472) by G. da Maiano.
Palazzo della Signoria, containing audience chamber and Sala dei Gigli, doorways and ceilings by G. and B. da Maiano.
Palazzo Strozzi (1489-1536) by B. da Maiano and Cronaca. *pp.* 78,79; *ill.* 70.
Palazzo Serristori (1474) by Baccio d'Agnolo.
Villa of Careggi. *p.* 51.
Villa of Poggio a Caiano, rebuilt for Lorenzo de' Medici by G. da Sangallo (1480-1485).
Villa of Poggio Imperiale, fortified in 1488 by G. da Sangallo.
Uffizi. Palazzo Pitti.
Churches: Santa Maria del Fiori, the Cathedral (1296); dome (1420-1461). Sanctissima Annunziata (1250); tribune rebuilt *c.* 1450 by Michelozzo after Alberti's advice had been sought. *p.* 246.
Badia (10th century), enlarged in 1285 and rebuilt in 1627; doorway (1495) by B. da Rovezzano; tomb of Count Ugo (1469-1481) by Mino da Fiesole.
Santa Croce (13th century); tombs of Leonardo Bruni by B. Rossellino, of Marsuppini by Desiderio da Settignano, *Annunciation* carved by Donatello Capella dei Pazzi, built by Brunelleschi (1429-1444) in cloister next to Santa Croce. Second cloister by Brunelleschi. *p.* 201.
Sant'Egidio, with frescoes (now lost) by Domenico Veneziano, Piero della Francesca and Andrea del Castagno. *pp.* 5, 68, 309.
San Lorenzo by Brunelleschi, finished by A. Manetti (1460); tabernacle in marble by Desiderio, bronze pulpits by Donatello and assistants; in the old sacristy, which was decorated by Donatello (*c.* 1440), is the tomb of Giovanni and Piero de' Medici (1472) by Verrocchio. *pp.* 68, 86; *ills* 60, 61.
Santa Maria Novella (1278-1360); façade (1456-70) designed by Alberti; choir frescoes (1485-1490) by Ghirlandaio; frescoes of Strozzi chapel by Filippino Lippi. *pp.* 179, 272; *ills* 169, 258.
Santa Maria Maddalena dei Pazzi (13th century) rebuilt (1480-1492) by G. da Sangallo.
San Miniato al Monte (1018), containing Chapel of the Cardinal of Portugal (1460). *pp.* 81, 86, 272; *ills* 72, 258, 259.
Ognissanti (1239), with frescoes by Botticelli and Ghirlandaio; cloister by Michelozzo; refectory with *Last Supper* by Ghirlandaio (1480).
Or San Michele (1336), with statues by Donatello, Verrocchio and Luca della Robbia. *ill.* 58.
Santo Spirito (1434-1481), vestibule and sacristy (1489-1494) by Cronaca and G. da Sangallo. *p.* 81.
Santa Trinità (1258-1280) Sassetti Chapel, frescoes by Ghirlandaio. *p.* 179.
Sant'Apollonia, refectory (1445-1450), frescoes by Andrea del Castagno.

FOLIGNO, Umbrian city, attached to the Papal States from 1439 onwards. *see map* 310.

FONTAINEBLEAU, famous royal palace, mainly the creation (1528 onwards) of François I who employed both French and Italian artists. *p.* 279.

FONZIO (Bartolomeo) Florence 1445-1513. Florentine humanist, pupil of Landino. Spent some time at Ferrara in the service of Borso d'Este. In 1481 appointed to the 'Studio' at Florence. In 1483, summoned by Sixtus IV to Rome as professor of the art of poetry. In 1489, visited Hungary. Was at Florence again in 1511. Author of *De Poetica* (dedicated to Lorenzo de' Medici), two books of elegies and a collection of inscriptions. *p.* 101.

FOPPA (Vincenzo), Brescia *c.* 1427-*c.* 1515. Lombard painter, whose activity extended to Genoa and dominated the second half of 15th century in Lombardy. Capella Portinari (*c.* 1468) in the church of Sant' Eustorgio, Milan. Painted polyptychs including one for Santa Maria delle Grazie (in the Brera). He worked with L. Brea on the Cardinal della Rovere altarpiece (1490, Santa Maria di Castello, Savona). *pp.* 86, 89, 90, 147.

FORLÍ, city in the Romagna, subject to the Ordelaffi family from 1315-1480, then to Girolamo Riario till 1500, when it it became part of the Papal States. *see map* 310.

FOSSOMBRONE, city in the Marches, a possession of the Malatestas and then of the Montefeltros during the 14th and 15th centuries. *see map* 310.

FRANCESCA (Piero della), Borgo San Sepolcro *c.* 1410-1492. Tuscan painter, pupil of Domenico Veneziano in Florence: did not return there after 1445. His work was mainly in the courts of Urbino and Ferrara (at Ferrara he executed frescoes now destroyed) and in towns in the Apennines, such as Arezzo, where the church of San Francesco has his *Story of the True Cross* frescoes (1452-1459), *pp.* 17, 51, *ills* 53, 54, 164, and Borgo San Sepolcro. Of his altarpieces, the Montefeltro (*c.* 1470) is in the Brera, Milan; the Sant' Agostino polyptych (1454-1459) is dispersed (in Lisbon, London and in the Frick Collection, New York); The *Senigallia Madonna* is in Urbino, He wrote a treatise on perspective and a study of pure geometric forms which were used by his pupil, Luca Pacioli. *pp.* 46, 50, 57, 67, 68, 98, 103, 124, 130, 158, 162, 164, 169, 170, 171, 173, 177, 179, 184, 192, 239, 246, 247, 248, 263, 292, 296; *ills* 53, 54, 157, 160, 174.

FRANCESCO D'ANTONIO. Goldsmith active in Siena between 1440 and 1480. *ill.* 64.

FRANCESCO DA FABRIANO or DA GENTILE, Fabriano *c.* 1370-Rome 1427. Painter. *p.* 303; *ill.* 291.

FRANCESCO DI GIORGIO MARTINI, Siena 1439-1502. Architect, engineer, woodcarver, painter, sculptor in bronze, decorative designer, — a man whose wide ranging individuality spread its influence from Siena to Urbino, where he took part in the building of the Ducal Palace. Author of a treatise on architecture. *pp.* 91, 197, 204, 251, 300; *ills* 44, 184, 192, 216, 241, 242, 243, 244, 246, 287.

FRANCESCO DI SIMONE, Neapolitan painter 14th-15th century. *p.* 227; *ill.* 215.

FRANCIONE (Francesco di Giovanni di Matteo, known as Francione), Florence 1428-95. Architect, marquetrist and engraver, founder of the Florentine school of perspective marquetry. Active in Rome (1458), Florence, Pisa (stalls, 1474, partly destroyed in 1595; designs for a chapel in the Campo Santo, 1475). Pietrasanta fortifications (1485); fortress of Sarzanello (1492-1495). *p.* 246.

FRANÇOIS I, Cognac 1494-Rambouillet 1547, King of France 1515-1547. *p.* 285.

FRESCO: mural painting, applied direct to wet plaster on the wall, the colours being mixed with water and some adhesive ingredient; this method requires that the painting be done during the time it takes to dry, that is to say, prepared very carefully and then done quickly. *pp.* 181, 184, 186; *ills* 55, 56, 74, 171-177.

FRISONE (Gabriele di Jacopo) Lombard painter, active in Mantua in about 1487. *p.* 91.

FRIULI, region of North Italy, part of Venezia Giulia and under Venetian domination after 1420. *p.* 124.

GAGINI (Domenico) Bissone ?-Palermo 1492. Sculptor who worked in Genoa, Castelverde and Palermo. *p.* 91.

GAILLON, French château built in the 16th century for Georges d'Amboise: it made a great impression on the Italians. *p.* 279, 281, 296; *ill.* 264.

GALASSI-GALASSO or GALASSO DI MATTEO PIVA, Bologna ?-1470. Painter. *p.* 197; *ill.* 187.

GAMBELLO (Vittore), *see* CAMELIO.

GARIN (Eugenio) Italian critic and writer on the history of philosophy; born at Riet in 1909. *p.* 51.

GATTAMELATA (Erasmo da NARNI, known as Gattamelata) 1370-Padua 1443. Paduan condottiere. Subject of equestrian statue by Donatello at Padua. *p.* 42.

GENOA, important maritime city in Liguria; at times during the 15th century was subject to the Dorias. *p.* 1, 2, 8, 11, 13, 91, 92, 246, 277, 304.
Patron saints: Alessandro Sauli of Genoa, Apelles, Catherine, George, John the Baptist, Siro of Genoa.
Secular building: Palazzo Serra (15th century).
Church: San Stefano: tribune 1499.
Gallery of the Palazzo Bianco.

GEORGE (St) martyred in 303. Young legionary.
Emblems: The Saint himself in knight's armour, Dragon, broken lance, banner, sword, (as in Mantegna's *St George*, Accademia, Venice and his *Madonna* in the Louvre). *ills* 165, 213, 263.

GERHAERT VAN LEYDEN (Nicolaus) Leiden *c.* 1430-Wiener Neustadt 1473. Flemish sculptor. *pp.* 124, 285.

GHERARDO DI GIOVANNI, 1445-1497. Florentine painter and miniaturist who, along with Botticelli, the Ghirlandaios and Bartolomeo and Monti di Giovanni, was commissioned to design the ceiling mosaics for the San Zenobius Chapel in Florence Cathedral. Worked for Lorenzo dei Medici and Matthias Corvinus (illuminations of the Bible in the Vatican Library, and the missal in the Laurentian Library, 1494).

GHIBERTI (Lorenzo) Florence 1378-1455. His son VITTORIO I, Florence 1416-96, was a goldsmith and a sculptor, who collaborated with him on the third door of the Baptistry in Florence BUONACORSO, Florence 1451-1516, was an architect, engineer and metal caster, active from 1487 to 1495; he cast cannons during wars fought by Florence against Sarzana and Pisa. *pp.* 68, 134; *ill.* 57.

GHIRLANDAIO, family of Florentine painters. DOMENICO, Florence 1449-94. He was a pupil of Baldovinetti, was influenced by Verrocchio and the Flemish school, worked in the Sistine Chapel (1481) and painted the frescoes in the choir of Santa Maria Novella (1485-1490), his masterpiece. He also produced altarpieces: *Adoration of the Magi* (1488, Ospedale dei Innocenti), *Visitation* (1491, Louvre). DAVIDE, 1452-1525, carried on the studio of his brother Domenico after 1490; specialized in mosaic. BENEDETTO, 1458-1497, the younger brother of Domenico and Davide was a Florentine painter who also worked in France. *pp.* 50, 81, 179, 270; *ills* 75, 205.

GIOCONDO (Fra Giovanni), Verona *c.* 1433-Rome 1515. Architect, theorist and epigraphist from Verona: supplied designs for the Loggia del Consiglio. Was called to Naples for consultation and accompanied Charles VIII back to France, where he made his mark in Paris as an engineer and commentator on Euclid. Took part in Rome in discussions on the new St Peter's. *p.* 42.

GIOTTO, Colle di Vespignano 1266-Florence 1337. Florentine painter, mosaicist and a master-builder; pupil of Cimabue and Cavallini. Active in Padua (Arena Chapel frescoes) and in Florence where he supervised the building of the campanile of Florence Cathedral. *pp.* 266, 267, 270; *ills* 253, 254, 257.

GIOVANNI D'ALEMAGNA or ZUAN TEDESCO, Painter from the North, worked with Antonio Vivarini; died in Padua in 1450. *p.* 133.

GIOVANNI DI PAOLO, Siena *c.* 1399-1482. Sienese painter, influenced by T. di Bartolo and Sassetta. Altarpiece for the University of the Pizzicaioli (1449); Pienza Cathedral altarpiece (1463). *p.* 127.

GIOVANNI DA SPIRA, late 15th century. Founder of the first Venetian printing house. *p.* 120.

GIOVANNI DA VERONA (Fra), Verona *c.* 1457-1525. A Dominican monk, and the most highly esteemed of the marquetrists of the late 15th and early 16th centuries. Church furnishings of Santa Maria in Organo, Verona (1500) and of Monte Oliveto Maggiore. He was also responsible for the marquetry in the Sala della Segnatura, (lost). *pp.* 94, 246, 252. *ills* 193, 249; *see bibliog.* 187.

GIOVANNINO (Italian for Little St John). Patron saint of Florence, to whom the Baptistry was dedicated. St John the Baptist is an extremely popular saint in Italy, revered as the 'little St John' the companion of Jesus.

GIROLAMO DA CREMONA. 15th century painter and miniaturist. *p.* 157.

GIULIANO DA MAIANO, 1432-1490. Florentine architect and sculptor. Worked at Faenza Cathedral (1476), and at Arezzo, Siena and Naples where he built the Porta Capuana (1485). Worked at Loretto with his brother, and with Cronaca on the Palazzo Strozzi, Florence (after 1489). *pp.* 67, 68, 94, 246, 284, 285; *ills* 94, 232.

GIUSTI (les JUSTE), family of Italian sculptors who worked in France in the 15th and 16th centuries. ANTOINE (1479-1519) established himself in France in 1504, worked mainly at Gaillon. JEAN I (1585-1549), his brother, worked at Tours and Saint Denis. *p.* 279.

GONDI, *see* FLORENCE.

GONZAGA, ruling family of Mantua, which became a marquisate in 1433 and a duchy in 1530. GIANFRANCESCO (1407-1444), summoned Pisanello and the humanist Vittorino da Feltre to Mantua. LUIGI III (1444-78) turned his attention to L.B. Alberti and to Mantegna. Under FRANCESCO II, who married Isabella d'Este in 1490, there was a period of brilliant cultural development, culminating in the building and decoration of the Palazzo del Tè by Giulio Romano. *pp.* 135, 236, 300.

GOSSAERT (Jan), *c.* 1472-1533. Flemish painter, who received his training in Antwerp, visited Rome in 1509 and was influenced by the Italian Renaissance artists. *pp.* 277, 296.

GOTHIC: in the 15th century, from the time of Filarete onwards, the term 'Gothic' designated, in architecture, the style prevailing beyond the Alps; in the 16th century it meant all the outworn manifestations of the Middle Ages. The term 'International Gothic' has been created by modern writers to cover the court art of the years round about 1400, together with its romantic and precious continuations in Burgundy, Bohemia, Tuscany and Venice. *pp.* 3, 28, 87, 119, 123, 124, 125, 126, 129, 135, 173, 179, 243, 273, 275, 313.

GOZZOLI, Florentine painters. BENOZZO, Florence 1420-Pistoia 1497. Florentine painter apprenticed to Ghiberti as a goldsmith, pupil of Fra Angelico in painting; helped Fra Angelico in the painting of the chapel of Nicholas V in Rome. After 1449 he became a decorative painter on his own; church of San Fortunato, Montefalco (1450-1452). Work at Viterbo and Rome; Medici Chapel, Florence (1459); frescoes at San Gimignano and the Campo Santo, Pisa (after 1468). BERNARDO, Florence *c.* 1429-? Brother

and collaborator of Benozzo. *pp.* 158, 184, 211; *ills* 172, 173, 200.

GRASSER (Erasmus), Schmidmühlen *c.* 1450-Munich ?-1518. Sculptor and architect from Munich. *p.* 285.

GREGORIIS (Gregorio de). Venetian typographer and engraver, active 1491-1528; associated with his brother Giovanni, active 1491-1505. *pp.* 241, 243.

GRIFFONI (Matteo), Bologna 1351-1426. Notary and poet. *p.* 173.

GROTESQUE: in the years 1490-1495 and thereabouts, the explorations by painters in the 'grottoes' of the Esquiline —that is to say, the ruins of Nero's Golden House— became more and more intensive; the decorative motifs found there began to be exploited by Pinturicchio, Signorelli and Morto da Feltre, until they were fully assimilated in the classical decoration by Giovanni da Udine in the Loggias of the Vatican. *p.* 106; *see bibliog.* 273.

GUAZZALOTTI (Andrea), Prato 1435-1495. Founder and medallist. *p.* 300; *ill.* 288.

GUBBIO, Umbrian city and domain of the Montefeltros until 1508. *p.* 25.
Patron saint: Ubaldo of Gubbio.
Secular building: Palazzo Ducale (1470) based on plans by L. Laurana. *pp.* 170, 246, 251, 307; *ills* 241, 242, 244, 246.
Churches: Madonna fra San Pietro e San Paolo (1473) by Bernardino di Narni.
Chapel of Santa Maria dei Laici (1313): crypt decorated with a fresco cycle of the Passion (*c.* 1460).

HASAN (Uzun) *c.* 1424-1478. Persian prince who presented Venice with a magnificent goblet. *p.* 13.

HEINZ, German sculptor, 15th century, active in Marburg. *ill.* 272.

HERACLIUS, 575-614. Byzantine Emperor. *p.* 17.

HERMANN, German sculptor, 15th century, active in Marburg. *ill.* 272.

HERMES TRISMEGISTOS, Name of hypothetical Pharaoh who was purported to have invented the sciences and to whom was attributed a collection of alchemical writings, the best-known of which, the *Poimandres*, clearly dates from the 4th century AD.

HEY (Jean), Flemish painter, 15th century. *p.* 303.

HUGUET (Jaime). Catalan painter of the 15th century, active in Barcelona from 1448 to 1487. *p.* 98.

HUMANISM (in Italian *umanesimo*): the taste for and practice of *litterae humanitatis*, —that is, of a culture based on the study, spread and use of the ancient Greek and Roman authors. The movement stemmed from Petrarch: its first real effect was on moral philosophy, but after 1450-1460 it spread to each cultural discipline in turn, until it became the characteristic flavour of the central phase of the Renaissance. *pp.* 8, 39, 41-47, 50, 55, 120; *ill.* 3.

HYPNEROTOMACHIA *see* COLONNA.

IESI (Marches), town belonging to the Papal States from 1447. *p.* 91. *see map* 310.

IMOLA, city in Emilia, annexed by the Viscontis of Milan (1424) and then incorporated in the Papal States (1504). *see map* 310.

INNOCENTS (the Holy), the children massacred by Herod in his abortive attempt to kill the Child Jesus. The sudden importance which this theme assumed in Siena from 1480 onwards may be related to the horrors of Otranto. *ill.* 15.

INNOCENT VIII, *see* POPES.

INTARSIA or TARSIA: Italian term for marquetry, a technique which enjoyed a remarkable development between 1460 and 1510. *pp.* 67, 94, 124, 156, 157, 170, 186, 245-248, 251, 252, 255, 260, 261, 263, 306, 307; *ills* 69, 115, 117, 232-250, 298.

INTONACO: Preparatory work for a fresco. *ill.* 168.

ISAIA DA PISA, 15th century sculptor, active in Naples and Rome. *ill.* 104.

ISELIN (H.), Flemish sculptor, 15th century. *p.* 124.

IVAN III (known as the GREAT) 1440-1505; Grand Duke of Muscovy, reigned from 1462 to 1505. *p.* 281.

JACO BAR, *see* BAR... JACO...

JACOPO DA MONTAGNANA, *see* MONTAGNANA.

JACOPO DEL SELLAIO, Florence *c.* 1442-1493. Florentine painter, pupil of Filippo Lippi. Two panels (1480, Castello Frediano); *Pietà* for the Confraternity of San Frediano (1483, Berlin Museum). *ill.* 66.

JAMES THE GREATER (St), the first of the Apostles to be martyred (in 44 A.D.). Patron saint of pilgrims, also of many cities in Italy-Pesaro, Pistoia, Rome, Bologna, etc. *ill.* 38.
Emblems: pilgrim, apostle, scallop-shell.

JEROME (St) 347-420. One of the four Doctors of the Church. Wrote life of St Paul the Hermit and translated the Bible into latin. Led the life of an anchorite in the desert. *p.* 243; *ills* 91, 108, 183, 300.

JERUSALEM. *pp.* 17, 18.

JULES II, *see* ROVERE and POPES.

JUSTUS OF GHENT (Joos Van WASSENHOVE, known as Justus of Ghent). Ghent *c.* 1435-Urbino ? 1480. Flemish painter, active in Urbino between 1472-1475 where he worked for the Duke of Montefeltro. *pp.* 309, 310.

KREMLIN, the complex of Imperial palaces in Moscow, where Italian artists were commissioned to work in the 15th century. *p.* 281; *ill.* 268.

LAGRAULAS (Jean Bilhères de). French prelate, who became Cardinal of Santa Sabina in 1493. In 1497 he commissioned from Michelangelo the *Pietà* now in St Peter's, Rome. *p.* 4.

LANDSCAPE PAINTING: did not become an independent *genre* till the 16th century. But already in the 15th century the part played by views of nature in paintings was growing. The first 'pure landscapes' appear in marquetry.

LAURANA (Francesco), mentioned 1458-1502. Dalmatian architect and sculptor. Active in Naples (Arch of Alfonso of Aragon) and Urbino. Entered the service of King René in Provence. Produced busts of great refinement. *pp.* 92, 278; *ills* 86, 87.

LAURANA (Luciano) Zara *c.* 1420-Pesa 1479. Dalmatian architect, responsible for the rebuilding of the palace at Urbino after 1465. *p.* 107.

LAZZARA (Leon de), Paduan family. *p.* 132.

LEINBERGER (Hans) German sculptor, 15th century. *ill.* 277.

LENDINARA (Cristoforo and Lorenzo Canozzi, known as the Lendinara). Two brothers born in Lendinara; LORENZO, 1425-1477, worked with his brother at Ferrara; designed choir-stalls for the Cathedrals at Modena, Ferrara, and Padua, the stalls for the Santo (partly lost, the remains being preserved in the Museo dell' Arca). CRISTOFORO, 1420-1491, after working with his brother settled in Parma, worked on stalls for the Cathedral there, produced panels adorned with Evangelists for Modena Cathedral and pews and vestment cupboards for Lucca Cathedral (now in the museum there). *pp.* 124, 156, 246, 247, 248, 251, 255, 260, 307; *ills* 235, 236.

LEONARDO DA VINCI, Vinci 1452-Amboise 1519. Painter, sculptor, architect, engineer, who also left notebooks covering a wide range of scientific observations, reflections on the technique and nature of art, etc. Pupil of Verrocchio (1469-1475), —and to this period belongs the unfinished *Adoration of the Magi*. Left Florence in 1481 or 1482 and served Lodovico il Moro at Milan in various capacities till 1499; there he produced the *Virgin of the Rocks*, the *Last Supper* and the full-size model for a great equestrian statue. Back in Florence again 1500-1506; *Virgin and St Anne, Mona Lisa, Battle of Anghiari* (lost). Milan 1507-1513. Rome 1513-1515, in the service of Giulio de' Medici. Amboise 1515-1519, in the service of François I. His output as a painter was relatively small, but his influence was immense particularly his exploration of *chiaroscuro* and the many subtle effects related to it. Leonardo brought to a conclusion the theoretical researches of the 15th century and elaborated, though in fragmentary form, a scientific encyclopaedia of surprising variety and precision. *pp.* 18, 47, 68, 87, 88, 90, 91, 186, 199, 212, 227, 266, 267, 270, 277, 285; *ills* 43, 78, 79, 83, 201, 206, 210, 214, 269. *see bibliog.* 68, 140.

LIBERALE DA VERONA, Verona *c.* 1445-1529. Veronese painter and miniaturist. Frescoes in chur-ches of San Fermo and Sant' Anastasia, Verona; Choir-books at Chiusi (1467-1469) and Siena (1470-1476). *pp.* 146, 157; *ills* 139, 147, 207.

LIPPI (Fra Filippo), Florence 1406-Spoleto 1469. Florentine painter and Carmelite monk, pupil of Lorenzo Monaco and influenced by Masaccio. Frescoes in Prato Cathedral (1452-1464), *ills* 55, 56, 76, and in the choir of Spoleto Cathedral (1467-1469). *pp.* 57, 81, 114, 130, 134, 191, 211; *ill.* 203.

LIPPI (Filippino), Prato *c.* 1457-Florence 1504. Florentine painter, son of Fra Filippo Lippi and of a Prato nun; worked in conjunction with Botticelli. *The Virgin appearing to St Bernard* (1480, Badia) finished the Brancacci Chapel of the Carmine, Florence *c.* 1485. In Rome he worked on the Caraffa Chapel in the Minerva (1489). Again in Florence: Strozzi Chapel in Santa Maria Novella (1495-1502). Also many altarpieces, panel paintings and *cassoni*. *pp.* 50, 76, 180, 211, 267, 270; *ills* 67, 199.

LODI, city in Lombardy, subject to the Viscontis of Milan from 1336 to 1447. Peace signed at (1454). *pp.* 2, 8, 57.
Patron saints: Bassiano, Felix, Nabor.
Churches: Santa Maria Incoronata (1487) by G. Battagio and G. Dolcebuono. *pp.* 87, 181, 273; *ills* 170, 260.

LODOVICO IL MORO, *see* SFORZA and MILAN.

LOMBARDI (Pietro, Antonio and Tullio). Venetian architects and sculptors. PIETRO, Carona *c.* 1435-Venice 1515. Worked at Venice and at Faenza; tombs in SS. Giovanni e Paolo, Venice; reliefs at Faenza. ANTONIO, Ferrara 1458-1516. Pietro's son and assistant. TULLIO, *c.* 1465-Venice 1532. Sculptor: recumbent figure of G. Guidarelli at Ravenna. *p.* 118; *ills* 111, 112, 191, 271.

LONGHI (Roberto) Italian art critic and historian; born in Alba in 1890. *pp.* 303, 313.

LORENZO DA VITERBO, mentioned *c.* 1440-1470. Umbrian painter, active in Viterbo, dominated by Gozzoli. Worked from time to time in Florence and Rome. *p.* 169; *ill.* 155.

LOTTO (Lorenzo), Venice *c.* 1480-Loreto 1556. Painter. *p.* 261.

LOUIS I, prince of Marburg, died in 1458. *ill.* 272.

LOUIS IX (St LOUIS), 1214-1270. King of France from 1226 to 1270. *p.* 13.

LUCA DA CORTONA, *see* SIGNORELLI.

LUCCA, city in Tuscany, flourished as a self-governing community. 1370-1799. *pp.* 247, 304.
Patron saints: Anselm of Lucca, Frediano, Peregrine, Regula, Paulina, Zita, Reparata.
Secular buildings: Palazzo Pretorio (1492-1588) based on designs by M. Civitali.
Palazzo Orsetti (15th century).
Churches: Cathedral (13th century) with *Sacra Conversazione* by D. Ghirlandaio in the sacristy; in the

transept, tombs (1480) by M Civitali, altarpiece of St Regulus (1484); choir and stained-glass windows (1485), stalls (1452) Capella del Santo Volto (1480). *ill.* 196.

LUGANO, city in the Tessino, in the province of Como. Under the Viscontis from the beginning of the 15th century. *see map* 310.

LUNETTE (in Italian *mezzaluna*); this term is used in painting to designate the upper, arch-shaped part of an altarpiece.

LUKE (St). One of the four Evangelists; patron saint of painters. *p.* 188; *ill.* 178.
Emblem: angel.

MACERATA, town in the Marches, belonged to the Papal States after 1445. *see map* 310.

MACROBIUS (Ambrosius Theodosius), late 4th century. Latin grammarian. *p.* 36.

MAGDALEN (St Mary) Mary of Magdala, cured by Christ of possession by devils; became one of his followers. Her cult spread from Provence (where her relics now are) to Italy, especially Senigallia. *ill.* 140.
Emblems: jar of ointment, death's head (referring to her meditation in the desert).

MAHOMET II, Turkish Sultan (1451-1481). *pp.* 14, 18, 300; *ills* 14, 21, 22.

MAIANO (Benedetto and Giuliano), *see* BENEDETTO; GIULIANO.

MALATESTA, important family established in Rimini by the middle of the 12th century; in the 14th century it began to extend its domain over the whole March of Ancona and a part of the Romagna. In the 15th century its authority was firmly established by its most remarkable member, SIGISMONDO PANDOLFO (1417-1468). He transformed the church of San Francesco, Rimini, into the Tempio Malatestiano, to immortalize his last wife, Isotta and his family. *pp.* 29, 300.

MALIPIERO, noble Venetian family which produced the Doges ORIO (1178-1192) and PASQUALE (1457-1462); GIOVANNI struggled heroically but unsuccessfully in the campaign in the Peloponnese in 1500. *p.* 300.

MALOCCHI (Francesco). Italian weaver, 15th century, active in Florence. *p.* 304.

MANETTI (Antonio), Florence 1423-1497. Architect, mathematician and writer. *p.* 246.

MANILIUS (Marcius). Latin poet under Augustus. Composed a treatise on astronomy in five books, which was still used as a scientific manuel in the Renaissance. *p.* 36.

MANSUETI (Giovanni di Niccolo), mentioned *c.* 1485-1527. Venetian painter, pupil of Gentile Bellini. *pp.* 115, 197.

MANTEGNA (Andrea), Padua 1431-Mantua 1506. Mantuan painter and engraver, pupil of Squarcione. Work at Padua included frescoes in the Eremitani (1449-1454). *pp.* 57, 132, 135; *ills* 38, 51, 52; in Verona, the San Zeno altarpiece (1457-1458) at Mantua *p.* 189; *ill.* 179, in the service of the Gonzagas, he produced the frescoes of the Sala degli Sposi (Ducal Palace) and paintings for the Studiolo of Isabella d'Este (the *Parnassus* in the Louvre). Major influence on the artists of Padua, Venice and Ferrara, and on Dürer. *pp.* 41, 42, 50, 57, 108, 114, 125, 127, 132, 133, 134, 135, 136, 147, 173, 177, 180, 197, 199, 231, 236, 237, 270, 290, 300; *ills* 26, 27, 37, 48, 127, 177, 178, 179, 223, 224, 255, 275.

MANTUA, city in Lombardy, enjoyed a period of brilliance under the Gonzagas-Francesco II (1484-1519), husband of Isabella d'Este, and Federigo II (1519-1540). *pp.* 2, 42, 91, 300, 307.
Patron saints: Andrew, Anselmo of Lucca, Longinus, Filippo Neri, Barbara Osanna of Mantua.
Secular building: Palazzo Ducale (13th and 14th centuries) containing Camera degli Sposi (1474, frescoes by Mantegna). Studiolo of Isabella d'Este by Mantegna and Perugino. *pp.* 186, 307; *ill.* 177.
Palazzo del Tè, designed by Giulio Romano.
Churches: Sant'Andrea (begun in 1470) by J. Fancelli from designs by Alberti.
San Sebastiano (1466) by Fancelli from plans by Alberti.

MANUTIUS (Aldus) Bassiano 1449-Venice 1515; Venetian painter, humanist, printer and typographer; ex-Ambassador of the Venetian Republic to Florence. *p.* 120.

MARCANOVA (Giovanni), Venice 1418-Bologna 1467. Paduan humanist, doctor and archeologist, friend of Felice Feliciano. Author of *De antiquitatibus* (1465), a somewhat romantic compilation of archaeology and epigraphy. *pp.* 41, 42.

MARCANTONIO, *see* RAIMONDI.

MARCHIONNI (Bartolomeo) from an Italian family acknowledged by the rulers of Ethiopia at the end of the 15th century. *p.* 11.

MARCO DI COSTANZO, *see* COSTANZO.

MARCUS AURELIUS, Rome 121-Vindobona 180. Roman Emperor. (161-180) and philosopher. *p.* 41.

MARQUETRY, *see* INTARSIA.

MARSUPPINI (Carlo) Genoa 1398-Florence 1453. Florentine humanist. Tutor to the Medici family. *p.* 68.

MARTINI, *see* FRANCESCO DI GIORGIO.

MASACCIO (Tommaso), Castel San Giovanni di Val d'Arno 1401-Rome 1428. Florentine painter, pupil of Masolino and Ghiberti. Worked with Masolino on the Brancacci Chapel in the Carmine, Florence. Exercised great influence on Tuscan art of the Quattrocento. *pp.* 76, 266, 267, 270. *ill.* 256.

MASTER OF THE AIX ANNUNCIATION. Painter of the school of Provence in the first half of the 15th century. *pp.* 98, 310.

MASTER OF THE BIRD, *see* RIPANDA.

MASTER OF FLÉMALLE. Flemish painter, active 1410-1440. *p.* 265.

MASTER OF THE SFORZA ALTARPIECE. Italian painter, 15th century. *p.* 303; *ill.* 292.

MASTER OF SAN SEBASTIAN. Painter active in Spain, identified by Sterling with Joss Lieferinxe, a Flemish painter who worked in Provence between 1505 and 1508 and died at Marseilles. *p.* 310.

MATTEO DE' PASTI Verona ?-Rimini 1467. Veronese medallist and architect. *p.* 300.

MATTEO DI GIOVANNI, Borgo San Sepolcro 1430-Siena 1495. Sienese painter, pupil of Vecchietta. Dominated the Sienese school in the second half of the century. Active in Pienza and in Siena. *Crucifixion* (1460, Asciano); *Assumption* (c. 1475, London); *Massacre of the Innocents* (1482, Sant' Agostino, Siena). *pp.* 127, 192, 194; *ills* 15, 183.

MAZZONI (Guido), Modena c. 1450-1518. Sculptor who introduced woodcarving and terracotta work to Naples. Polychrome groups (San Sepolcro de Monte Oliveto, Naples). Was taken to France by Chales VIII in 1495. *p.* 94.

MEDICI, family of bankers, who dominated political life in Florence after 1431 *see* FLORENCE. Through their interest in the arts and the favours they bestowed on certain masters, its leading members are closely bound up with the development of the arts in the Quattrocento. *pp.* 5, 8, 11, 18, 66, 68, 76, 86, 300; *ill.* 285.

MELOZZO DA FORLÌ, Forlì 1438-1494. Painter from the Romagna, pupil of Piero della Francesca. Worked at Urbino from 1465 to 1475 (the Urbino *Christ*); from 1475-1480 he divided his time between Rome and Urbino (Madonna of Montefalco, Urbino Studiolo). In Rome he decorated the Vatican Library and the apse of Santi Apostoli. Worked at Loretto (1484) and at Forlì until his death. *pp.* 50, 105, 169, 303; *ills* 97, 156, 293.

MEMLING (Hans) Seligenstadt c. 1433-Bruges 1494. Flemish painter. *p.* 309; *ill.* 278.

METSYS (Quentin). Louvain 1465-Antwerp 1530. Flemish painter. *pp.* 265, 296.

MICHELANGELO BUONARROTI, Caprese (Casentino) 1475-Rome 1564. Florentine sculptor, painter and architect. The work of his youth classes him with the second phase of the Quattrocento. Trained in the studios of Ghirlandaio and Bertoldo, he became a protégé of Lorenzo de' Medici. In 1494 he visited Venice and Bologna, and in 1496 went to Rome. Back in Florence in 1502: the *David* and frescoes for the Palazzo Vecchio. Called to Rome in 1505 by Pope Julius II to work on the Pope's tomb and to decorate the Sistine Chapel ceiling (1509-1512); work on the tomb was resumed later, but it was left unfinished the completed section is in San Pietro in Vincoli. Back in Florence from 1520-1534: tombs of the Medici in new sacristy of San Lorenzo. Settled in Rome after 1534: frescoes of *Last Judgement, Conversion of St Peter, Conversion of St Paul*; work on architecture and town planning; St Peter's, the Capitol. *pp.* 4, 18, 267, 270, 271, 292 296; *ills* 253, 256, 280.

MICHELE DI GIOVANNI DA MILANO, mentioned at end of 15th century, sculptor and architect who worked at Ancona. Peristyle of the Palazzo degli Anziani (1493).

MICHELOZZO DI BARTOLOMMEO, Florence 1396-1472. Florentine architect, sculptor and ornamentist, pupil of Ghiberti and Donatello. Active at Florence: Monasteries of San Francesco in Bigallo (Bosco ai Frati), San Marco (1437-1452). Master builder at the Cathedral, 1446-1451; built Palazzo Medici (1444-1459). In Milan he built the Palazzo del Banco and the Chapel of Sant' Eustorgio (1462). *pp.* 79, 86, 300; *ill.* 70.

MIDDELBURG (Paul of), A Dutch theologian and astronomer who was doctor to Guidobaldo of Montefeltro at the court of Urbino. Author of *Pronostica ad viginti annos duratura* (Antwerp, 1484). *p.* 46.

MILAN, principal city of Lombardy, ruled by the Sforzas from 1450-1535; Francesco (1450), Galeazzo Maria (1466), Gian Galeazzo Maria (1476), Lodovico Il Moro (1494-1499). *pp.* 2, 28, 31, 44, 46 68, 86, 87, 88, 90, 91, 126; *ill.* 78.
Patron saints: Ambrogio, Barnabas, Carlo Borromeo, Eustorgio of Milan, Celso, Gervasius, Protasius, Peter, Satiro, Theodelinda of Marza.
Secular buildings: Castello Sforzesco by Filarete and Bramante. *p.* 281; *ill.* 267. Cenacolo Vinciano in former Dominican monastery, containing *Last Supper* (1499) by Leonardo da Vinci. Ospedale, begun by Filarete (1456-1465) and C. Solari in charge of decoration. *p.* 87.
Casa della Fontana (façade, 1475).
Churches: Cathedral (founded 1386). *pp.* 86; *ill.* 79. Sant' Eustorgio (12th and 13th centuries): Portinari Chapel (1462) by Michelozzo, frescoes (1468) by V. Foppa. *pp.* 86, 180.
Santa Maria delle Grazie (1465-1490) by G. Solari, enlarged by Bramante (1492-1498). *p.* 89; *ill.* 82.
Santa Maria presso San Celso (1491) by Dolcebuono, Solari and C. Lombardo.
Santa Maria della Passione (1485-1530, enlarged 1591): octagonal dome by C. Solari.
Santa Maria presso San Satiro (1476) by Bramante with Baptistry by Bramante. *pp.* 89, 180.
Church at 'La Conca del Naviglio' (1469).
Santa Maria della Pace (1466-1497) by G. Solari.
Lazzaretto (1488).
Pinacoteca Ambrosiana.
Pinacoteca di Brera.
Castello Sforzesco.

MINIATURE: the illumination of books still, in the 15th century, kept many specialized studios busy, at Ferrara, Florence, Venice and elsewhere; some of the masterpieces of the period are to be found in choir-books (e.g. at Siena) and illustrated manuscripts of the works of poets (especially Dante). *pp.* 157, 241; *see bibliog.* 254.

MINO DA FIESOLE, Poppi 1429-Florence 1484. Florentine sculptor, who produced many busts and tombs. Panels for Prato Cathedral; tomb of Paul II in Rome. *pp.* 68, 103, 231, 239; *ill.* 190.

MIRANDOLA, city in Emilia, ruled by the Mirandola family from 1311 to 1707, its most famous prince being Giovanni II (1463-1494). *see map* 310.

MIRANDOLA (Giovanni II), *see* PICO.

MISTRA, Byzantine city in Sparta. *p.* 17.

MODENA, city of Emilia, raised to a duchy by the princes of the house of Este in 1452. *pp.* 173, 190, 246, 247.
Patron saints: Gimignano of Modena, Pellegrino.
Churches: Cathedral (11th-13th centuries); marquetry in the choir (1461-1465) by the Lendinara brothers. *ill.* 236.
San Pietro (rebuilt in 1476).
Galleria e Museo Estense.

MONTAGNA (Bartolomeo), Orzinuovi (near Brescia) 1450-Vicenza 1523. Painter founder of the school of Vicenza, pupil of Domenico Morone. Produced altarpieces. *pp.* 197, 248; *ill.* 186.

MONTAGNANA (Jacopo da), Montagnana *c.* 1443-Padua *c.* 1499. Paduan painter also active in Belluno, pupil of Mantegna and the Bellinis. *p.* 136; *ill.* 128.

MONTE DI GIOVANNI DEL FORA, 1449-1529. Florentine painter, mosaicist and miniaturist, son of the sculptor Giovanni di Miniato and brother of Gherardo del Fora. *ill.* 73.

MONTEFALCO, Umbrian city, taken over in 1400 by Ugolino Trinci, but soon afterwards by the Papal States. *see map* 310.

MONTEFELTRO (Federico and Guidobaldo da), *see* URBINO.

MORONE, Veronese painters. DOMENICO, Verona 1442-1517. Painter formed by Mantegna, mentioned in the Verona archives as one of the best artists of that city (1491-1493): religious pictures. FRANCESCO, Verona 1471-c. 1529: son, pupil and collaborator of Domenico; one of his earliest works was a *Descent from the Cross* (1498) in the Chapel of San Bernardino. *p.* 146; *ill.* 138.

MOSAIC (in Italian *Opera mosaica*): the technique of making pictures (mostly mural) out of small cubes of vitreous and coloured matter *(tesserae).* The technique was revived in Florence for the Baptistry and in Venice for St Marks. In the second half of the Quattrocento it was sufficiently popular to be extended to portable panels and to the decoration of the reredos as well as to that of doors and archivolts: it was much practised by the studio of D. Ghirlandaio. *pp.* 81, 114; *see bibliog.* 70.

MOSCOW, capital of Russia, *see* KREMLIN.

NAPLES, in 1435 the Kingdom of Naples passed to the Princes of Aragon (for names and dates see ARAGON). *pp.* 2, 6, 8, 11, 14, 57, 91, 92, 94, 96, 98, 277, 309, 310.
Patron saints: Asprenas, Athanasius, Biagio, Eligio, Francesco di Paolo, Gennaro, Louis of Anjou, Lucia, Restituta, Rosalia of Palermo.
Secular buildings: Porta Capuana (1485) by G. da Maiano. *p.* 94.
Castelnuovo (1283): triumphal arch (1452-1466) by Lorenzo and P. da Milano. *pp.* 57, 91, 92; *ills* 85-87, 189.
Palazzo Carafa (1466).
Palazzo Colobrano (1466).
Palazzo Cuomo (1464-1490).
Palazzo dell'Ospedale (c. 1500).
Palazzo Orsini (1471).
Palazzo Sanseverino.
Palazzo Santangelo (1467).
Villa of Poggio Reale (1487) by G. da Maiano. *pp.* 94, 284, 285.
Churches: Sant' Anna dei Lombardi (1414), tomb of Maria of Aragon, by A. Rossellino (1470), *Pietà* (1490), by Guido Mazzoni. *p.* 94.
With Marquetry (1505), by Fra Giovanni da Verona.
San Gennaro (1294-1323) rebuilt in 15th century.
SS. Severino and Sosio (1494-1537).
Capella Pontano (1492) by a pupil of Brunelleschi.
San Lorenzo Maggiore (exterior, 1487-1507).
San Giuseppe Maggiore (founded in 1500).
San Pietro a Mariella (1403-1508).

NEGROPONT, *see* EUBOEA.

NERI DI BICCI, 1415-1591. Florentine painter who ran a large-scale artisanal studio; produced *cassoni* and altarpieces. Left a journal. *p.* 72; *ill.* 76.

NICCOLO DELL'ARCA *see* ARCA.

NICHE (Italian *nicchia*): a recess in which statues were often framed. The transformation of the Gothic niche into an aedicule with pediment took place in Florence from 1420 onwards, but did not spread to the rest of Italy until after 1450-1500.

NICHOLAS V, *see* POPES.

NICOLETTO DA MODENA. Italian engraver 15th-16th centuries. Active in Modena from 1490 to 1525. *ill.* 132.

NON FINITO, term applied to works left in a state of *abbozzo*. The concept was at first a negative one, but shortly after 1500 began to be associated with inspiration *(furor)* and to be given a positive value, largely as a result of the work of Leonardo and Michelangelo. Already in 1450 an academic dispute on the 'unfinished' in art began; it was summed up by Vasari in his *Life of Luca della Robbia* (edition of 1568).

NOTKE (Bernt), Holstein c. 1435 - Lübeck 1509. German sculptor and painter. *p. 285.*

NOVARA, city in Lombardy, under the protection of Milan from 12th century onwards. *see map 310.*

OCULUS: Latin word used in term for round window. *p. 89.*

ORDER: term for a type of column complete with base and capital and all the characteristics appropriate to each type. The concept was propagated by Vitruvius, but applied only spasmodically before the 16th century.

ORVIETO, Umbrian city, became a possession of the Church in 1450.
Patron saints: Dominic, Daniel, the Blessed Giovanna of Orvieto.
Secular building: Palazzo Simoncelli (15th century).
Churches: Cathedral (1290-1319), holy-water stoop (1455) by A. Federighi; Capella San Brizio; frescoes (1499-1504) by Signorelli. *p. 186; ill. 176.*

OSTIA, small town belonging to the Papal states. *see map 310.*

OTRANTO, seaport in the south-east of Italy, where the Turks massacred thousands of Christians in 1481. *p. 14.*

OVID (Publius Ovidius Naso), Sulmona 43 B.C.- Tomi A.D. 17-18. Roman poet. *p. 51.*

PABLO DA SAN LEOCADIO or PABLO DE AREGIO. Italian 15th century painter, active in Valencia. *p. 310; ill. 304.*

PACHER (Michael), Bruneck c. 1435 - Salzburg 1498. Austrian sculptor and painter *p. 313.*

PACIOLI (Luca) Borgo San Sepolcro 1445-Rome 1510. A Franciscan monk and mathematician, friend of Piero della Francesca and of Leonardo da Vinci, close to the court of Urbino, teacher of the young duke Guidobaldo. Author of *Summa de arithmetica* (1494) and *De divina proportione* (1508). *pp. 46, 47, 49, 50, 91, 164, 248, 263; ills 43, 45.*

PADUA, city in the Veneto, from 1405 a possession of Venice. *pp. 27, 41, 42, 44, 54, 57, 67, 68, 89, 92, 114, 130, 132 to 136, 146, 147, 156, 157, 246, 248; ills 124, 125.*
Patron saints: Antony, Giustina.
Secular buildings: Loggia del Consiglio (1498-1523). Villa Olziguani (1467) by P. Lombardo.
Palazzo del Capitano (15th century).
Università (12th century), façade 15th century.
Churches: Cathedral, *ill. 237.* Sant' Antonio, known as il Santo (1232-1307): altar of the Santo (1447-1450), by Donatello (restored in 1895). *pp. 57, 247.*
SS. Filippo e Jacopo (Eremitani): Ovetari Chapel with frescoes (1449-1454), by Mantegna (destroyed and in part restored); tomb of Roselli (1467) by Bellano. *pp. 57, 132, 135; ills 38, 51, 52.*
Scuola del Santo: frescoes of the *Life of St Antony* by B. Montagna. Monastery of Preglia (near Padua): church of the Assunta (1490-1548) by T. Lombardo.

Santa Giustina: Chapel of St Luke with St Luke polyptych (1454) by Mantegna. *pp. 188, 189; ill. 178.*
Museo civico.

PALA: Italian for an altar painting (usually as distinct from a polyptych).

PALERMO, important city of Sicily, subject to the Princes of Aragon from 1282 onwards. *pp. 91, 96, 310.*
Patron saints: Agatha, Ninfa of Palermo, Rosalia, Oliva, Sylvia.
Secular buildings: Palazzo Abbatelli (1495) by M. Carnelivari.
Palazzo Aiutamicristo (1490) by M. Carnelivari.
Palazzo del Municipio (1463).
Palazzo Petragliata (15th century) by M. Carnelivari.
Palazzo Sclafani (1330) turned into a Hospital in the 15th century.
Churches: Santa Maria della Catena (15th century) by M. Carnelivari.
Cathedral (1185), Alterations made in 15th century: stalls (15th century), statues by Gagini, the *Virgin and Child* (1469) by F. Laurana.
Sant'Agostino (14th century): doorway (1463) by G. Gagini.
Pinacoteca.

PALIO: a race, held yearly in various Italian cities, always at a religious festival; the prize was a valuable length of cloth or picture (of the same name). The Siena *palio* took place twice a year, on July 2nd and August 16th.

PANOFSKY (Erwin). American art historian, of German origin; born in 1892. *pp. 129, 192, 296, 303, 309.*

PAOLO DA VERONA. ? - Florence 1516. Italian embroiderer. *p. 304.*

PARENTINO or PARENZANO (Bernardo) known as FRA LORENZO, Parenzo 1434 - Vicenza 1531. Painter from the Romagna. Painted picture of *Christ carrying the cross, St Jerome before a crucifix, and a bishop.* Also unfinished fresco (*Life of St Benedict*) in Santa Giustina Convent, Padua. *pp. 157, 290, 291, 292; ills 126, 146.*

PARMA, city of Emilia, subject to the Sforzas, rulers of Milan, from 1449-1500. *pp. 246, 300; ill. 261.*
Patron saints: Bernardo degli Uberti, Ilario, Thomas.
Churches: Cathedral, *ill.* 235 San Giovanni Evangelista (rebuilt 1498-1510). San Francesco del Prato (1260), finished in 1445-1462. Baptistry (12th and 13th centuries) *ill. 261. Galleria nazionale.*

PASTEL, a coloured paste or chalk, used already in the 15th century for the heightening of drawings, especially on *carta tinta.*

PAUL II, *see* POPES.

PAUL OF MIDDELBURG, *see* MIDDELBURG.

PAVIA, city of Lombardy, subject to the Viscontis and Sforzas from 1364 onwards. *pp. 180, 239, 273; ill. 227.*
Patron saints: Augustine, Siro.

Churches: Cathedral (1488), by C. Rocchi, Bramante and Amadeo. *p.* 180 Santa Maria del Carmine (1494-1513). *Certosa* (1396): the monastery was finished in 1450, cloister (1465 onwards), by R. de Stauris, Mantegazza, Amadeo; façade by C. Solari, Mantegazza, Amadeo and Briosco (1473-1499). Interior: frescoes and paintings by Borgognone, funerary monuments of Lodovico il Moro and Beatrice d'Este by C. Solari; tomb of Gian Galeazzo Visconti (1493-1497) by G.C. Romano. *pp.* 88, 239, 241, 273.

PAZZI, powerful Florentine family, at emnity with the Medicis: conspired against them (the Pazzi Conspiracy, 1478). *p.* 14.

PENSIERO: Italian Term for the initial idea of a composition, for its rough sketch.

PERRÉAL (Jean) Paris *c.* 1455-? *c.* 1530. French painter, active at end of 15th century, in the service of Charles VIII, Louis XII and François I. *p.* 277.

PERSPECTIVE (in Italian, *prospettiva*): term for any major ordering of spacial depth, especially in accordance with the system of projection of Alberti and Brunelleschi. Marquetry became a favoured interpreter of perspective, owing to its sharply defined network of lines ; hence the close association between *intarsia* and the art of the perspectivists, especially at Florence. *pp.* 49, 129, 134, 245, 246; *ill.* 40.

PERUGIA, Umbrian city, subject in 1392 to Boniface IX: captured in 1416 by the condottiere Braccio Fortebracci: became subject, in 15th century, to Pope Eugenius IV, but still was disputed by the Oddi and Baglione families until 1520, when Leo X made it a Papal city. *pp.* 46, 158, 162, 209.
Patron saints: Constantine, Herculanus of Perugia, Colomba of Rieti.
Secular buildings: Porta San Pietro (1475-1477) by A. di Duccio and Polidoro di Stefano.
Collegio del Cambio (1452-1457); audience chamber (1500) by Perugino and Raphael. *p.* 186.
Palazzo della Vecchia Università (1483-1515).
Palazzo del Capitano del Popolo (1472-1481).
Churches: San Domenico (1305, rebuilt in 1632) altar (1459) by A. di Duccio, stalls (1489).
Santa Maria di Monte Luce (13th-15th centuries) façade by A. di Duccio.
San Pietro (10th century) campanile (1468).
Oratory of San Bernardino (1457-1461) façade by A. di Duccio (1462). *pp.* 158, 208. *ills.* 148, 149.

PERUGINO (Pietro VANUCCI, called Il Perugino) Città della Pieve *c.* 1450-Fontignano 1523. Umbrian painter, pupil of Verrochio: worked mainly at Perugia. Decorated Collegio del Cambio, Perugia, with the young Raphael. At Rome contributed to the Sistine Chapel frescoes. Worked also at Mantua in the service of Isabella d'Este. *pp.* 50, 66, 162, 167, 169, 184, 197, 199, 270, 292; *ills* 153, 159, 185, 279.

PESARO, city of the Marches, subject to the Malatestas, then to the Sforzas and to the Della Rovere family. *ill.* 181.
Patron saints: Terentius, Ubaldo.
Secular buildings: Ducal Palace (15th century).
La Rocca Costanza (1474-1483) by Luciano Laurana.

PESELLINO (Francesco di STEFANO, called Il Pesellino) Florence *c.* 1422-1457. Painter. *p.* 76; *ill.* 65.

PETER (St): martyred in A.D. 57. The First Apostle. Founder of the Church. The first Pope. *ills.* 159, 185, 186, 303. *Emblem:* keys.

PETRARCH (Francesco), 1304-1374. Italian poet and humanist, one of the paramount influences during the Quattrocento: author of works in Latin as well as famous Italian sonnets and *canzone*. *pp.* 8, 241.

PIAGNONE: Italian term for mourner. In Florence the name was applied to supporters of Savonarola. *p.* 270.

PICO DELLA MIRANDOLA (Giovanni), 1463-1494. Lord of Mirandola and a distinguished humanist. Settled in 1484 in Florence, in the circle of Lorenzo de' Medici. His premature death came just before the revolution against the Medicis. *pp.* 36, 51.

PIUS II PICCOLOMINI, *see* POPES.

PIENZA, city formerly called Corsignano: it belonged to the Piccolominis and its transformation by Pope Pius II began in 1459. *p.* 126; *ills* 118, 119.
Patron saints: Pius, Vito, Crescenzio.
Secular buildings: Palazzo Piccolomini (1459-63) by B. Rossellino. *p.* 126.
Churches: Cathedral (1459-62) by B. Rossellino, stalls (1462); triptych (1461) by Vecchietta. Bishop's Palace by B. Rossellino. *pp.* 126, 127, 180.

PIERO DELLA FRANCESCA, *see* FRANCESCA.

PIERO DA VENEZIA. Italian embroiderer, 15th century. *p.* 304.

PIETÀ: Italian term for a representation of the Virgin lamenting the dead Christ. *p.* 124; *ill.* 141.

PIETRA SERENA: grey stone of Florence, often used, from Brunelleschi onwards to pick out the structural features of a building. *p.* 181.

PIETRO SPAGNOLO, *see* BERRUGUETE.

PINTURICCHIO (Bernardino di BETTO, known as Pinturicchio), Perugia 1454-Siena 1513. Umbrian painter, pupil of Perugino. Worked at Rome: Borgia apartments (1492-1494), at Spello (1500-1501) and at Siena (1503-1508). *pp.* 105, 106, 108, 111, 186, 304; *ills* 98, 105, 106, 171, 175.

PIOMBINO, Tuscan city from 1400 to 1634 a possession of the house of Appiano.

PIRI REIS, Turkish admiral and cartographer of the 16th century. *p.* 11; *ills* 10, 11, 12 a and b.

PISA, Tuscan city, subject to the Viscontis until 1405, then ceded to Florence. *p.* 246.
Patron saints: Bona of Pisa, Efeso of Cagliari, Rainier of Pisa, Torpeo.
Secular buildings: Archibishop's palace (court, end of 15th century). Fortress and new citadel (1468) rebuilt in 1512.

Churches: Camp Santo (1278) finished in 15th century; frescoes by Benozzo Gozzoli (1408-84). *p.* 184 *ills.* 172, 173.

PISANELLO (Antonio PISANO, known as Il Pisanello), 1395-after 1450. Italian painter and medallist. *pp.* 135, 177, 300; *ills.* 18, 189.

PISTOIA, Tuscan city, a free commune from 1329 onwards. *see map* 310.
Patron saints: Atho, James the Greater, Zeno.
Churches: Cathedral (12th century):
Forteguerri monument (1476) by Verrocchio; Altarpiece (1485) by Leonardo and Verrocchio.
Bust of Donato de' Medici (1475) by A. Rossellino.
Santa Maria delle Grazie (1452-1469) by Michelozzo.
San Giovanni Battista (1487-1516).
Santa Maria dell'Umiltà (1495).

PIZZOLO (Niccolo), Vicenza 1421-Padua 1453. Paduan painter and sculptor, pupil and assistant of Squarcione. *p.* 133.

PLATINA (Bartolomeo SACCHI, known as Il Platina) Piadena 1421-Rome 1481: humanist, owes his nickname to his native town, which is Platina in Latin. *ill.* 97.

PLATO, c. 428-347 B.C. Greek philosopher whose theories were taken up and developed by the humanists of the Renaissance. *pp.* 18, 45, 46, 49.

PLETHO (Giorgio Gemisto PLETONE, known as Pletho) Constantinople c. 1355-Peloponnese c. 1450; Byzantine philosopher and humanist. *p.* 17.

POGGIO A CAIANO, *see* FLORENCE.

POGGIO IMPERIALE, *see* FLORENCE.

POGGIO REALE, *see* NAPLES.

POLIZIANO (Angelo) Montepulciano 1454-Florence 1494. Humanist and poet, a protégé of the Medicis from 1473 onwards; appointed teacher in the 'Studio'. Author of *Stanze per la Giostra, Favola di Ofeo. Ballades, Epigrammi, 'Elegies', 'Odes'* the *Silvae* (*praelectiones* in verse given at the 'Studio') and famous for the erudition of his *Miscellanea* (1489). *pp.* 27, 51.

POLLAIUOLI, family of Florentine artists. JACOPO D'ANTONIO DEL POLLAIUOLO 1399-1480. Goldsmith, father of Antonio and Piero. ANTONIO BENCI, Florence 1432-Rome 1498. Painter, sculptor and medallist, collaborated with Ghiberti, and follower of Donatello and Uccello (collaborated on *Labours of Hercules* series c. 1465-1470): called to Rome in 1490 for tombs of Pope Sixtus IV and Innocent VIII (1493-1497); also an outstanding engraver. PIERO, Florence 1443-Rome 1496. Painter and sculptor, brother and collaborator of Antonio; painted the *Virtues* (Uffizi) and the *Coronation of the Virgin* (Sant' Agostino at S. Gimignano, 1483). *pp.* 68, 76, 103, 129, 237, 304; *ills* 16, 63, 95, 96, 122, 123, 208, 225.

PONTELLI (Baccio), Florence c. 1450-Urbino 1492. Florentine architect and sculptor. Pupil of Francesco di Giorgio. Worked at Urbino, and at Rome for Sixtus IV (Ospedale di Santo Spirito, façades of churches of San Pietro in Vincoli and Santi Apostoli). Also built the Rocca at Ostia and made choir stalls for Pisa Cathedral. *pp.* 106, 246, 251, 307; *ills.* 238, 239, 240, 241, 242, 246. *see bibliog.* 173.

POPES, during the Quattrocento, as follows:
NICOLAS V (Pope 1447-1455), promotor of the Peace of the Church and of the 1450 Jubilee. *pp.* 3, 57, 101, 103, 105, 184.
CALIXTUS III (Pope 1455-1458).
PIUS II (Aeneas Sylvius Piccolomini) (Pope 1458-1464): famous humanist before he was Pope, steered the Church in the direction of modern culture, transformed the town of Pienza to suit his own taste. *pp.* 1, 3, 17, 24, 38, 103, 126, 157, 180, 300.
PAUL II (Pope 1464-1471).
SIXTUS IV (Pope 1471-84), a member of the Della Rovere family, uncle of Cardinal Giuliano, took major initiative in the replanning of Rome. *pp.* 3, 28, 101, 103, 106, 304; *ills.* 95-97, 122, 288,
INNOCENT VIII (Pope 1484-92); showed greater reserve with regard to modern culture. *p.* 108.
ALEXANDER VI BORGIA (Pope 1492-1503): chiefly concerned for the political expansion of the Roman State. *pp.* 1, 3, 108, 111; *ill.* 289.
JULIUS II (Cardinal Giuliano Della Rovere, Pope 1503-13); gathered up and brought to fruition the ambitions of previous Popes, in politics, town planning and culture. *pp.* 100, 101, 284.

PORTINARI, family of Florentine bankers; in about 1480 Tommasso presented the *Nativity* triptych of Hugo van der Goes (now in the Uffizi) to the church of Sant' Egidio, Florence; and Pigello presented a chapel to the church of San Eustorgio, Milan. *pp.* 5, 180, 309; *ill.* 5.

PRAGUE, capital of Bohemia; capital also of the Empire from 1346 to 1547. *p.* 3. *see map* 312.

PRATO, Tuscan city, subject to Florence from 1351 onwards.
Patron saints: Caterina dei Ricci of Florence, Stephen.
Churches: Cathedral (13th century), façade 1365-1457; throne (1473) by Mino da Fiesole; frescoes (1456-1466) by Filippo Lippi. *pp.* 57, 184; *ills.* 55, 56, 74.
San Francesco (13th century) Renaissance façade; Inghiarini tomb (1460) by B. Rossellino.
Santa Maria delle Carceri (1485-1492) by G. da Sangallo. *p.* 180.

PREDELLA: lower part of an altarpiece, divided into several compartments (either painted or sculptured). A *predella* usually shows scenes related to the lives of the saints, of Christ or of the Virgin, according to the altar's dedication.

PREPARATION: treatment of the panel or canvas of a picture, before the colours are laid on.

PREVEDARI (Bernardo). Engraver, specializing in the use of the burin and mentioned at Milan in 1481. *pp.* 88, 89.

PRISCIANO (Pellegrino). Ferrarese writer and astrologer, adviser to Isabella d'Este. *p. 36.*

PTOLEMY (Claudius), 2nd century A.D. Greek astronomer and mathematician, whose works and theories were current all through the Middle Ages and the Renaissance. *pp. 9, 11.*

PULCI (Luigi), Florence 1432-Padua 1484. Humanist and poet, protégé of Lorenzo de' Medici, who sent him on political missions to Camerino and Naples, Author of the mock-heroic poem *Morgante Maggiore*. *p. 12.*

PUTTO (Italian for small child): the motif of the child angel without wings) became, during the Renaissance, a frequent decorative motif, especially in sculpture; Donatello, Desiderio and others made of it a kind of lyrical accompaniment to their scenes with figures. *p. 135; ills 84, 215.*

QUARTARARO (Riccardo). Sicilian painter, mentioned in 1484 in Trapani; active in Palermo (1484-1489 and 1494-1501), also in Naples (1491-92) where he collaborated with Costanzo de Moysis. Painted altarpieces. *p. 310; ill. 303.*

RAFFAELLINO DEL GARBO, Florence *c.* 1466-*c.* 1525. Florentine painter, pupil of Filippino Lippi, a specialist in embroidery designs for church vestments. *pp. 211, 304; see bibliog. 258.*

RAIMONDI (Marcantonio), Bologna *c.* 1480-between 1527 and 1534. Bolognese engraver, pupil of Raphael, reproductions of whose large-scale compositions he spread throughout Europe; also many copies of Dürer. *p. 231.*

RAPHAEL (Raffaello SANZIO, known as Raphael) Urbino 1483-Rome 1520. Painter and architect, pupil of Perugino, worked at Perugia and Florence, and at Rome in the service of Popes Julius II and Leo X. *pp. 157, 162, 270, 292.*

RAPPRESENTAZIONE (sacra): Italian term for a 'mystery play' commenting in the form of *tableaux vivants* on the liturgy, the Bible or the lives of saints *p. 55.*

RATDOLT (Erhard), Augsburg *c.* 1443-*c.* 1528. German typographer, active in Venice 1476-1485. *p. 241.*

RAVENNA, city of the Romagna; subject to Venice from 1449 to 1509 then part of the Papal States. *p. 28. see map. 310.*
Patron saints: Andrew, Apollinare, Barbatianus, Damiano, Severus, Vitale of Ravenna, Adelbert.
Secular buildings: Piazza del Popolo (1483).
Palazzetto Veneto (1461-1462).
Churches: Tomb of Braccioforte (1480).
Tomb of Dante (portrait of Dante, 1483, by P. Lombardo).

RECANATI, city of the Marches, possession of the Papal States from 13th century. *see map 310.*

REEUWICH (Erhard). Flemish painter and engraver. active at Utrecht in about 1484 and in Germany, *ill.* 107.

REGGIO NELL' EMILIA, city in Emilia, one of the Lombard republics, it then came under the house of Este in 1409. *see map* 310.

RENÉ I D'ANJOU, Angers 1409-Aix-en-Provence 1480. King of Provence, who made an expedition into Italy in 1458. *pp. 8, 96, 278.*

RIARIO, ruling family of Imola; RAPHAEL cardinal, nephew of Sixtus IV. *p.* 107.

RICCIO (Andrea BRIOSCO, known as Il Riccio), Padua 1470-1532. Paduan sculptor in bronze. Tomb of Torres in San Fermo, Verona (a fragment is in the the Della Louvre) Many statuettes. A specialist in small decorative bronzes. *pp.* 136, 157; *ills* 3, 133.

RIEMENSCHNEIDER (Tilman), *c.* 1460-1531. German late gothic sculptor, active in Würzburg and famed for his work in wood. *p.* 313; *ills* 305, 307.

RIMINI, capital of the Pentapola and domain of the Malatestas, the most remarkable of whom was Sigismondo Pandolfo (1417-1468). Included in the Papal States from 1509 onwards. *pp.* 17, 29, 57, 300. *Patron saints:* Cordulus of Cologne, Gaudenzio of Rimini.
Churches: San Francesco (13th century) rebuilt from plans by Alberti, it became the 'Tempio Malatestiano'; reliefs by A. di Duccio, tomb of Sigismondo Malatesta attributed to F. Ferruci, tomb of Isotta degli Atti (third wife of Sigismondo) by A. di Duccio, frescoes by Piero della Francesca.

RIPANDA (Jacopo), Bologna *c.* 1480-1534. Bolognese painter and engraver, formed by Francia and Mantegna. Active in Rome from 1507. *pp.* 231; *ill.* 222.

RIZZO (Antonio), mentioned 1465-1498. Veronese sculptor and architect. Worked at the Certosa of Pavia (1465), and later at Venice (the Tron monument, 1473). *pp.* 118, 119.

ROBBIA (Della), family of Florentine sculptors and ceramic artists. LUCA, Florence 1399-1482, originated the art of sculpture in terracotta with polychrome glazes; *cantoria* in stone for Florence Cathedral (1431-1437); medallions for Campanile (1437-1439); bronze door for Cathedral (1446). ANDREA, Florence 1435-1525: nephew and pupil of Luca; continued the making of glazed faïence, assisted by his sons, Girolamo and Giovanni. *pp.* 68, 86; *ill.* 58.

ROBERTI (Ercole de'), Ferrara 1456-1496. Ferrarese painter, pupil of Cosimo Tura with whom he collaborated in the Palazzo Schifanoia. Official painter (1477). At Bologna worked with Cossa on the *Griffoni* Altarpiece (1480-1486) San Lazaro Altarpiece (Berlin, destroyed). Accompanied Alfonso d'Este to Rome in 1492. *p.* 197; *ills* 31, 32, 33, 162; *see bibliog.* 183.

ROBETTA (Cristoforo di Michele) Florence 1462-*c.* 1522. Engraver and goldsmith. Engraved repro-

ductions of works by Lippi, Pollaiuolo and various German engravers, including Schongauer and Dürer. *p.* 231; *ill.* 218.

ROMANO (Gian Cristoforo) Rome *c.* 1465-Loreto 1512. Architect, sculptor and medallist, active in Mantua, Urbino and Naples. Portraits of Beatrice d'Este and of Isabella d'Este (1490); collaborated on tomb of Galeazzo Visconti (1493-1497). *p.* 300.

ROME, enjoyed a great political and cultural revival from 1450 onwards. *pp.* 2, 14, 24, 28, 31, 42, 43, 44, 46, 68, 91, 92, 100, 101, 103, 105-108, 157, 180, 184, 186, 300; *ills* 44, 93.
Emblem: broken column barred by initials S.P.Q.R. in gold preceded by a cross in gold.
Patron saints: Bibiana, Francesca Romana, Paul, Peter, Prassede, Pudentiana, Sabina of Rome, Sebastian, Susanna of Rome.
Secular buildings: Palazzo Capranica (1457).
Palazzo della Cancelleria (1483-1511) by A. Bregno and Bramante. *p.* 107, *ills.* 96, 100.
Palazzo Corsini (15th century) rebuilt in 1732.
Palazzo dei Penitenti (1480).
Palazzo Venezia (*c.* 1455), attributed to Alberti. *p.* 100.
House of the Knights of Rhodes (restored in 1467-1470).
Ospedale del Spirito Santo (*c.* 1471) by Baccio Pontelli, doorway by A. Bregno.
Churches: Sant' Agostino (1479-1483) by G. da Pietrasanta.
San Cosimato: 15th century cloister, church rebuilt in 1475.
San Giovanni Battista dei Genovesi (1481) cloister by Baccio Pontelli.
Santa Maria della Consolazione.
Santa Maria di Monserrato (*c.* 1495) by A. da Sangallo.
San Marco (1468). *p.* 100.
Santa Maria del Popolo (rebuilt 1472-1477) by Baccio *p.* 186; *ill.* 103.
Pontelli and A. Bregno.
San Pietro in Vincoli (1475). *p.* 106.
San Pietro in Montorio (1505), by Baccio Pontelli. *p.* 106.
Capella dell' Aracoeli (1409). *pp.* 111, 186, *ill.* 171.
Santa Maria sopra Minerva (1280, façade 1453); the Carafa Chapel with frescoes by Filippino Lippi (1489-1490). Tomb of Francesco Tornabuoni by Mino da Fiesole, *p.* 201; *ill.* 90.
Santa Saba (restored in 1458).
San Vitale (1475).
The Vatican: First Basilica of St Peter (324-344); in 1452 Nicholas V decided on rebuilding which was begun by B. Rossellino; this was later entrusted by Julius II to G. da Sangallo, and then to Bramante.
Grotte Vaticane; tomb of Paul II (1475) by Mino da Fiesole; tomb of Sixtus IV (1483-94), by A. Pollaiuolo.
Vatican Palace; first building 1272-80 constantly enlarged. *pp.* 100, 106, 111; *ill.* 24.
Chapel of Nicholas V (1447-1449).
Sistine Chapel (1473-1484). *pp.* 106, 180, 184.
Borgia Apartments for Alexander VI (1492-1495), by Pinturicchio.
Stanze by Raphael and his pupils (1510-1520).

Belvedere (1489-1492). *p.* 108; *ill.* 101.
Vatican Museums.
Quirinal Museum.

ROSSELLI (Cosimo), Florence 1439-1507. Florentine painter, pupil of Neri di Bicci and of Benozzo Gozzoli. Active in Florence (1476, fresco in the Annunziata), in Rome (to which he was called by Sixtus IV to work with Signorelli, Ghirlandaio and Perugino on the Sistine Chapel. He also worked in Lucca. *p.* 231.

ROSSELLI (Francesco di Lorenzo), Florence 1455-*c.* 1513. Painter, miniaturist and cosmographer. *ills* 9, 59.

ROSSELLINI, family of Tuscan architects and sculptors. BERNARDO ROSSELLINO, Settignano 1409-Florence 1464. Architect and sculptor formed by Alberti. Rossellino worked on the Palazzo Venezia, Rome (1455); Palazzo Rucellai (1446-1450) town plan and Bishop's Palace, Pienza; tomb of Leonardo Bruni (1444-1451 Santa Croce, Florence); ANTONIO, Settignano 1427-Florence 1479. Brother of Bernardo, worked at Empoli, Faenza, Pistoia, Ferrara, Naples and relief carvings of Madonnas. *pp.* 86, 94, 126, 180; *ill.* 72.

ROSETTI (Biagio) Ferrara *c.* 1447-1516. Bolognese architect; made town plan of Ferrara for Ercole I; build Palazzo dei Diamanti (begun 1492); Palazzo Constabilio, church of San Francesco (1494). *p.* 91.

ROVERE (Cardinal Della), *see* POPES.

ROVERELLA, Ferrarese family, art patrons. LORENZO, a bishop of the 15th century presented an altarpiece to the church of San Giorgio, Ferrara. *p.* 173.

RUCELLAI, notable Florentine family; outstanding member, GIOVANNI (Florence 1475-Rome 1525), a humanist. *p.* 43.

RUSTICATION: term used when parts of the walls of a building, most often at the base, are built of stone blocks deliberately left in a rough state.

SACELLUM: Latin term for small temple after the antique or chapel. *p.* 86.

SAGRERAS (Guillermo) Majorca ?-† Naples 1456. Architect, active at Naples; worked on the Castelnuovo for Alfonso V. *p.* 92.

SANGALLO, family of architects - Florence, then Rome. GIULIANO GIAMBERTI known as Giuliano da SANGALLO. Florence *c.* 1445-1516. Sculptor and architect, oldest of a line of architects; began as woodcarver (stalls of Medici Chapel), then as architect responsible for Santa Maria delle Carceri, Prato (1485-1491), Villa of Poggio a Caiano (1480-1485) and sacristy of Santo Spirito (in collaboration with Cronaca (1489-1492) worked also at Loretto, Naples, Savona, and at Rome in the service of Julius II; author of a collection of studies and designs. ANTONIO GIAMBERTI DA SANGALLO (known as the ELDER) Florence *c.* 1455-1534; architect, pupil of his brother, Giuliano; built the Annunziata at Arezzo, and San

Biagio, Montepulciano (1519-1526). *pp.* 51, 67, 94, 107, 108, 199, 227, 284; *ills* 23, 71; *see bibliog.* 152.

SAN GIMIGNANO, Tuscan city, a free commune which came under Florence from 1353. *see map* 310.

SANGUINE: drawing done with red or brown stone. In 15th century was used mostly together with charcoal and chalk, but sometimes alone.

SAN MARINO, ancient republic, an enclave of the Papal States. *see map* 310.

SANO DI PIETRO, Siena 1406-1481. Sienese painter, master of a very active studio which produced a large number of Madonnas and village altarpieces. In about 1445-1450 he painted scenes from the life of St Bernardino for the Osservanza, Siena; also an *Assumption.* *p.* 127.

SANSOVINO (Andrea CONTUCCI, known as Il Sansovino), Monte San Sovino *c.* 1460-1529. Florentine sculptor and architect, pupil of Bramante. Worked at Rome and Loretto, in Tuscany (Siena), in Central Italy and in Portugal. *Baptism of Christ* (1500-1502) in Florence Baptistry; tombs in Santa Maria del Popolo, Rome. *pp.* 281, 284.

SASSETTI (Francesco), Florence ?-1488. Humanist and agent of the Medicis; with his wife, Nera CORSI he founded a chapel in Santa Trinità, Florence. *p.* 179.

SAVONA, city in Liguria, centre of the Marquisate of the Alerami, free commune subjected to Genoa in 1528. *see map* 310.

SAVONAROLA (Girolamo), Ferrara 1452-Florence 1498. Florentine Dominican monk, who distinguished himself by his piety, his preaching and his writings; raised a party against the Medici, preached reform of the Church and declaimed against the clergy. Excommunicated by Alexander VI, he was hanged and burned as a heretic. *pp.* 24, 36, 243, 270.

SCACCO (Cristoforo), mentioned at the end of 15th century. Painter who came from Verona and worked chiefly in Naples; pupil of Melozzo, influenced also by Antoniazzo Romano and Girolamo da Cremona. The Penta triptych (1493) in the Capodimonte Museum, Naples; Sessa Aurunca polyptych (1500) in the Campona Museum, Capua; frescoes of Tolosa Chapel (1500) at Monte Oliveto, Naples. Worked also at Palermo, Nola and Fondi. *p.* 310; *ill.* 302.

SCARDEONE (Bernardino), Paduan historian, 16th century. Published in 1516 *De Antiquitate urbis Patavii.* *p.* 133.

SCHEDEL (Hartmann), Nuremberg 1440-1514. German physician and humanist. *ill.* 93.

SCHIAVONE (Fra Sebastiano), Rovigno (Istria) *c.* 1420-Venice 1505. Wood engraver and marquetrist; active in Padua (1461), in Mantua (1462-1464), in Verona (1464-1466 and 1468-1470), in Monte Oliveto (1470-1473), in Florence, in Ferrara (1477-1479) and in Bologna (stalls in the cloister of Sant'-Elena, 1479-1505). *p.* 246.

SCHIAVONE (Giorgio di Tomaso CHIULINOVITCH, known as Il Schiavone) Scurdone (Dalmatia) 1436-Sebenico 1504. Painter specializing in Madonnas. *pp.* 135, 136; *ills* 129, 130.

SCHONGAUER (Martin), Colmar *c.* 1445-Alt-Brisach 1491. Alsatian painter and engraver. *p.* 231.

SCUTARI, town in N.W. Albania, at month of Lake Scutari (Shkodër); a Venetian possession from 1396 to 1479. *p.* 14.

SEBASTIAN (St), martyred in 288 (according to his legendary *Acts*); a centurion, he was used as a target by archers; hence patron saint of the Confraternity of Archers: much invoked against the plague. *p.* 313; *ills* 26, 222, 307, 309. *Emblem:* arrows.

SECCO: Italian term for mural painting or fresco in which paint is applied after the surface has dried; used particularly of retouching with distemper.

SELLAIO (Jacopo del), *see* JACOPO.

SERLIO (Sebastiano) Bologna 1475-Fontainebleau 1554. Architect and theoretician of architecture, pupil of B. Peruzzi; his *Irattato di architettura* had a great influence. *p.* 285.

SEVILLE, city in Spain, important in the 15th century as one of the cardinal points of Genoese and Florentine commerce, and above all for having been the first base for relations with America. *p.* 1.

SFORZA, Ducal family, Milan. Reigning dukes in 15th century; FRANCESCO, 1401-1466; he became master of Milan in 1450, brought many artists there and so began to make the court of Milan a rival to Florence. *p.* 90, *ill.* 83. GALEAZZO MARIA, 1466-1476. GIAN GALEAZZO, 1476-1494; dethroned by his uncle, Lodovico Il Moro. *pp.* 6, 87, 90, 115, 300, 309. LODOVICO Il MORO (who reigned 1494-1508) brought the French into Italy and died at Loches; like Francesco he imported great brilliance to the court of Milan, to which he brought Leonardo da Vinci. *p.* 90.

SFUMATO: Italian term for the veiled, smoky, atmospheric tone introduced into painting by Leonardo and, simultaneously, by Giorgione.

SIBYLS: name given to certain prophetesses in the ancient world—in the Renaissance the term was particularly applied to those supposed to have announced the coming of the Messiah: in the 15th century the *Institutiones divines* of Lactantius and the *Discordantiae non multae inter Sanctum Hieronymum Augustinum* by Filippo Barbieri (1481) popularized the theme of the Sibyls, which was then taken up frequently by artists.

SIENA, Tuscan city, a powerful republic at emnity with Florence; subjected to Gian Galeazzo Visconti

in 1399, but recovered its liberty in 1487. *pp.* 68, 98, 126, 157, 158, 260, 300.
Patron saints: Bernardino of Siena, Catherine of Siena, Cresenzio, Galgano, Vittorio, Alberto.
Secular buildings: Palazzo Pubblico (1325-1340); stalls of chapel (1423-1433) by D. dei Cori.
Palazzo del Magnifico (1453-1505) by G. Cozzarelli.
Piccolomini Library (1495).
Palazzo Spannocchi (1473).
Churches: Cathedral *p.* 251, San Domenico (1226) enlarged *c.* 1465. Chapel of St Catherine. *p.* 197.
Church of Fontegiusta; façade (1484), doorway (1489) by Urbano da Cortona (1326-1475).
Osservanza (15th century) by F. di Giorgio and Cozzarelli.
Sant' Agostino (1258) San Sacramento Chapel (*Massacre of the Innocents* by M. di Giovanni, 1482; *ill.* 15).
Loggia del Papa (1462) by A. Federighi.
Pinacoteca.

SIGISMOND OF HUNGARY (or of LUXEMBURG), Nuremberg 1368. Znoimo 1437; Emperor of Germany and King of Hungary. *p.* 13.

SIGNORELLI (Luca) Cortona *c.* 1445-1523. Umbrian painter, pupil and collaborator of Piero della Francesca. Worked in the Marches, in Rome (1481, in the Sistine Chapel), in Monte Oliveto, in Florence (*c.* 1490, *Pan p.* 55; *ill.* 46, painted for Lorenzo de' Medici, destroyed, Berlin), at Orvieto (1499-1503, in the San Brizio Chapel in the Cathedral). Painted many altarpieces, which include *Madonna* (1484) at Perugia; San Medardo polyptych (1508) at Arcevia; and the Bichi polyptych (1498) now dispersed. *pp.* 50, 55, 169, 186; *ills* 158, 168, 176.

SILVER POINT: drawing technique, in use during 15th century. Used on prepared tablets or on sheets of paper. *p.* 211.

SINOPIA: preparatory drawing for a fresco, full-size sketch on the wall outlined in red ochre on the 'arriccio'. The term is derived from the city of Sinope in Asia Minor, which was famous for its red pigments.

SIXTUS IV, *see* POPES.

SLUTER (Claus), Haarlem *c.* 1340-1350 - Dijon 1406. Flemish sculptor, leading figure of the Burgundian School. *p.* 123.

SOLARI (Pietro Antonio da), Milan *c.* 1450 - Moscow 1493. Lombard architect and sculptor, son and pupil of Guiniforte Solari: worked in Milan (1476, Cathedral. 1481, Ospedale Maggiore). From 1490 he worked at the Kremlin. *p.* 281; *ill.* 268. *see bibliog.* 34.

SPAGNOLO (Ferrando), Painter identified with Yañez de la Almedina, who assisted Leonardo da Vinci on the *Battle of Anghiari* in 1505. *pp.* 277, 281.

SPANZOTTI, Piedmontese painters. FRANCESCO, ? - Casale 1531. Active at Casale from 1483 onwards, father of Pietro. GIAN MARTINO, Casale *c.* 1456 - Chivasso 1528. Worked at Casale, Vercellio and Ivrae (cycle of frescoes of the *Life of Christ* at San

Bernardino); painted altarpieces including triptych (1480-1490) in the Turin Gallery; in 1507 became painter to the court of Savoy. *p.* 90.

SPELLO, small town near Assisi; part of the Papal States from 1449. *see map* 310.

SPINELLI (Niccolo, known as FIORENTINO) Florence 1430-1514. Medallist and sealmaker, trained in the studio of Nicolas of Florence and identified with one Nicola Spinelli recorded as working at the court of Charles the Bold. Engraved many medals with the effigies of leading people of his time. *p.* 300; *ill.* 285.

SPOLETO, Umbrian city, included in the Papal States from 1354 onwards. *see map* 310.

SPRETI (Desiderio), Ravenna 1414-*c.* less 1474. Historian and humanist, writer of *De amplitudine, eversione et restauratione urbis Ravennae* (1489, Venice, 1588). *p.* 42.

SQUARCIONE (Francesco), Padua 1397-1468. Paduan collector and painter, teacher of Mantegna. *pp.* 132, 133, 134, 135; *ill.* 125.

STERLING (Charles), French professor, art critic, formerly Curator of Painting at the Louvre. Born in 1901. *pp.* 307, 310.

STILL LIFE: the concept of an independent *genre* dealing with 'things' apart from a religious or historical context was still foreign to the 15th century; but under pressure from Flemish naturalism, compositions were becoming more and more enriched with details such as flowers, objects lying on a table, fruit, etc., and these were taking on a noticeable importance; at the same time marquetry was developing the theme of the cupboard or shelf filled with objects, and this entailed a considerable vocabulary of still lifes. *pp.* 252, 255, 306, 307; *ill.* 117, 249; *see bibliog.* 283.

STROZZI, wealthy Florentine family. FILIPPO STROZZI began the building of the imposing palace in Florence, whose architects were Cronaca and B. da Maiano. *pp.* 78, 79.

STUDIO: Italian for workroom or study; this was often decorated with allegorical paintings and woodcarvings, as at Urbino. *p.* 103.

SYLVIUS (Aeneas), *see* POPES.

SYRACUSE, Sicilian city, under Spanish rule after 1282. *p.* 98.
Patron saints: Lucia, Sebastian.
Secular building: Palazzo Bellomo (15th century).

TARSIA, *see* INTARSIA.

TEMPERA: Italian term for paints mixed with white of egg and glue, used in particular for certain frescoes.

TEMPIETTO (Italian for 'small temple'): term applied to models or miniatures of buildings, or sometimes actually to a small building such as Bramante's San Pietro in Montorio. *pp.* 180, 190, 201; *ill.* 196.

TIBURIO: Italian term for outside shape of a dome covered with a (Byzantine or palaeo-Christian) roof, most often octagonal. *p. 28.*

TODI, Umbrian city, became part of the Papal States at the end of the 15th century. *see map 310.*

TOLFA, (La) commune near Rome, well-known for its mines of iron and alum, lead and zinc. *p. 4; see map 310.*

TOMMASO DI MALVITO, painter from Como, mentioned at the end of the 15th century. *p. 278.*

TONDO: a type of round picture, much in fashion in the years round about 1470-1490.

TORDESILLAS, Spanish town near Valladolid where a treaty was signed in 1494 between Spain and Portugal for the division of all overseas American possessions. *p. 1.*

TORNABUONI (Francesco di Simone), distinguished Florentine noble of the 15th century. *ill. 190.*

TORNABUONI (Giovanni) 15th century Florentine noble; founded a chapel in Santa Maria Novella, Florence. *p. 179.*

TOURS, capital of Touraine, one of the royal cities in the 15th century. *p. 279. see map 312.*

TRAÙ (Giovanni da), Dalmatian sculptor mentioned at end of 15th century. *p. 103.*

TRAVERTINE: a kind of calcareous stone from the neighbourhood of Tivoli, of which many buildings in Rome, both secular and religious, are built. *p. 108.*

TREVI, Umbrian city, subject to the Trinci family from 1392, became part of the Papal States after undergoing many vicissitudes in the 15th century. *see map 310.*

TREVIGLIO, small town in Lombardy; came under Venetian rule in the 15th century. *see map 310.*

TREVISO, city of the Veneto; came under Venetian rule in 1339. *see map 310.*

TURA (Cosimo) Ferrara 1430-1495. Ferrarese painter, trained under Squarcione at Padua. Met Piero della Francesca at Ferrara in 1450. One of the three masters of the Palazzo Schifanoia paintings (1470); Organ doors for Ferrara Cathedral. Altarpiece (Roverella polyptych, 1470-1475, dispersed): many portraits. *p. 173, ill. 165.*

TURIN, Piedmontese city, a possession of the Counts of Savoy from 1295, became capital of the Duchy in 16th century. *see maps 310, 311.*

UBERTI (Lucantonio degli). Italian engraver of the 15th and 16th centuries. *ill. 221.*

UCCELLO (Paolo di Dono, known as Uccello) Pratovecchio 1397-Florence 1475. Florentine painter, decorator and mosaicist, pupil of Ghiberti. Mosaics for St Mark's, Venice (1425). Designs for stained glass windows for Florence Cathedral (1445). Hawk-

wood monument, a mural painting of an equestrian statue. (1436), in Florence Cathedral. Battle pictures (1456-1460) in Louvre, Uffizi and London, National Gallery. Old Testament frescoes in cloister of Santa Maria Novella (*c.* 1445). His works were distinguished by their pioneering of perspective. *pp.* 134, 171.

UDINE, capital of the Friuli; came under Venice in 1420. *see map 310.*

URBINO, city of the Marches, centre of the domain of the Montefeltro family from the 13th century. Raised to extraordinary brilliancy under Federico; *ills* 160, 161, 286, (1410-1482) and Guidobaldo (1472-1508). *pp.* 2, 6, 29, 41, 46, 50, 91, 107, 130, 156, 162, 164, 170, 171, 246, 251, 255, 260, 281, 303, 306, 307, 309, 310; *ills* 44, 152, 286, 298.
Patron saints: Michelina of Pesaro, Thomas.
Secular buildings: Palazzo ducale (begun in 1444) continued in 1465 by Laurana and in 1475 by F. di Giorgio. *pp.* 107, 251; *ills* 238-240.
Churches: San Domenico; doorway (1449-1451) by T. di Bartolomeo known as Maraccio.
San Bernardino dei Zoccolanti (1472-1491).
National Gallery of the Marches.

UTILI, painters from the Romagna. ANDREA, mentioned as working at Faenza in 1482; painted the *Virgin and Child flanked by St John and St Antony* (Faenza, Pinacoteca). GIOVANNI BATTISTA, active at Faenza between 1450 and 1500, identified with G.B. Bertucci the Elder. *p. 303; ill. 290.*

UZUN (Hasan), *see* HASAN.

VAN DER GOES (Hugo) Ghent ? *c.* 1440-Anderghem 1482. Flemish painter. *p.* 5, 309; *ill.* 5.

VAN EYCK (Jan), Maastricht ? *c.* 1390-Bruges 1441. Flemish painter. *pp.* 5, 98, 197, 265, 266, 309.

VARESE: Lombard city, ruled by the Torriani family and then by the Viscontis; famous for the sanctury of Santa Maria del Monte, to the north of the city. *p. 304.*

VASARI (Giorgio) Arezzo 1512-Florence 1574. Painter, architect and historian; famous for his *Vite* (1542-1550). *pp.* 46, 66, 68, 94, 106, 108, 133, 134, 211, 231, 245, 270, 292, 304.

VAVASSORE (Zoan Andrea) mentioned from 1475 to 1505. Mantuan painter and engraver, pupil and imitator of Montagna. Biblical and mythological scenes (British Museum). *ill. 228.*

VECCHIETTA (Lorenzo di PIETRO, known as Il Vecchietta), Catiglione d'Orca *c.* 1412-Siena 1480. Sienese painter and sculptor. Frescoes in the Siena Baptistry (1450); triptych of the *Assumption* for Pienza Cathedral (1461-62). His sculptures include both bronzes (*Resurrection*, 1472, New York, Frick Collection); the *Risen Christ* (1476, Ospedale, Siena) and wood carvings (*St Antony, Abbot*, Narni; *St Bernardino*, Bargello, Florence). *p. 127.*

VENEZIANO (Domenico), Venice *c.* 1400-Florence 1461; Venetian painter, active in Florence where

he worked on the choir frescoes (destroyed) of Sant' Egidio (1439-1445). Collaborated with Piero and Baldovinetti. *p.* 158.

VENICE: powerful republic, governed by a Doge and Council. *pp.* 1, 2, 13, 14, 17, 27, 28, 31, 42, 44, 46, 67, 68, 91, 92, 114, 115, 118 to 121, 124, 125, 126, 134, 147, 171, 197, 243, 246, 248, 270, 274, 300; *ill.* 107.
Patron saints: Mark, Bassus, of Venice, Christina, Justina of Padua, Liberale of Treviso, Magnus, Rocco, George, Trifone (Tryphonius) of Dalmatia, Jerome.
Secular buildings: Palazzo Ducale (8th century) partly rebuilt in 14th century, east wing end of 15th century. Courtyard by A. Rizzo, then P. Lombardo; Foscari arch (1457) by the Boni, Scala dei Giganti (1484-1501). *p.* 119.
Fondaco de' Turchi, built *c.* 1250 by Palmieri.
Palazzo Corner-Spinelli by M. Coducci.
Palazzo Dario (1487) by P. Lombardo. *p.* 118.
Palazzo Vendramin-Calergi (1481), begun by Coducci. *p.* 118; *ill.* 111.
Vecchie Procurati (1480-1514) attributed to Coducci.
Clock-tower (1496) attributed to Coducci.
Campo di SS. Giovanni e Paolo; with equestrian statue (1481-1486) of B. Colleoni by Verrocchio.
Churches: San Giovanni Crisostomo (after 1497) by Coducci. *p.* 118.
SS. Giovanni e Paolo (or Zanipolo), 13th century; Tombs of the Doges P. Mocenigo (*c.* 1485), *ill.* 191, and P. Malipiero (1462), by P. Lombardo. In one of the chapels, altarpiece by Giovanni Bellini. *p.* 201.
San Giovanni in Bragora (1475): paintings by Cima da Conegliano and B. and A. Vivarini.
Santa Maria del Carmelo (14th century); paintings by Cima da Conegliano, *Deposition* (low-relief) by Francesco di Giorgio.
Santa Maria Formosa, by Coducci.
Santa Maria Gloriosa dei Frari (1340-1443); many tombs; including those of the Doge Fr. Foscari by A. Bregno, of N. Tron (1473) by A. Rizzo; in sacristy, *Madonna* (1488) by Giovanni Bellini. *pp.* 124, 125; *ills* 115, 116.
Santa Maria de' Miracoli (*c.* 1489) by P. Lombardo.
Santa Maria dell'Orto (15th century).
San Michele in Isola (1469-1479) by Coducci.
San Rocco (1495) by Bartolomeo Bon.
San Trovaso, rebuilt after 1583; *S. Chrysogonus* fresco (1462) by M. Giambono. (or Jacobello del Fiore).
San Zaccaria (9th century), rebuilt from 1458 to 1515. *p.* 134.
Scuola di San Giorgio degli Schiavoni: paintings by V. Carpaccio (1502-1511).
St Mark's (1485-1495) by the Lombardis (Zen Chapel).
Mascoli Chapel (mosaic *c.* 1450).
Accademia.
Ca d'Oro.
Museo Correr.

VENTURI (Adolfo), Modena 1856-Santa Margherita Ligure 1941. Italian art historian. *p.* 304.

VERONA, North Italian city, an ancient commune, the city of the Scaliger family; a Venetian possession from 1405 onwards. *pp.* 42, 89, 146, 157, 300.
Patron saints: Celso, Nazaro, Peter martyr of Verona, Zeno of Verona.
Secular buildings: North-east door of Piazza delle Erbe (1480), rebuilt in 1532-1537.
Loggia del Consiglio (1476).
Casa Camozzini (15th century).
Churches: S. Anastasia (beginning of 14th century), completed from 1423-1481: in the Grini Chapel, *St George* (1463), by Pisanello.
San Bernardino (1451-1466).
San Fermo Maggiore (11th-12th centuries); *Annunciation* (fresco) by Pisanello.
Santa Maria in Organo (15th century).
SS. Nazaro e Celso (rebuilt from 1464-1483).
San Tomaso Cantuariense (rebuilt in 15th century).
San Giorgio in Braida (1477-1536).
San Zeno (1120-1138); triptych (1457-1459) by Mantegna. *pp.* 180, 189; *ill.* 179.

VERROCCHIO (Andrea di CIONE, known as Verrocchio), Florence 1435-Venice 1488. Sculptor, goldsmith and painter. In his studio in Florence, one of the most important in the city (1465-1480) many works were executed, including busts, breast-plates; the tomb of Giovanni and Piero de' Medici (San Lorenzo, 1472); bronze group of *Christ and St Thomas* for Or San Michele (*c.* 1460-1482). In 1482 Verrocchio left for Venice, where he made the Colleoni statue. Verrocchio's paintings include the *Baptism of Christ* (*c.* 1470-1475), on which Leonardo da Vinci collaborated, and the Pistoia altarpiece (1478-1482), on which Lorenzo di Credi collaborated. His pupils included Leonardo, L. di Credi and Perugino. *pp.* 76, 162, 212, 270.

VESPASIANO DA BISTICCI, *see* BISTICCI.

VESPUCCI (Amerigo), Florence 1454-Seville 1512. Florentine navigator who went several times to the New World shortly after its discovery and has given his name to America. *p.* 11.

VIBOLDONE, Abbey in Lombardy, near Melegnano; built in 1201. *p.* 273.

VICENZA, city in the Veneto, subjected to Venice in 1404. *see map* 310.

VIGEVANO, Lombard city. *see map* 310.

VILLA: the word meant, in the Quattrocento, a country house, usually the centre of a country estate; Alberti wrote a treatise on its proper design and function. At the end of the 15th century the villa developed into either a country retreat or stately mansion. *pp.* 108, 284; *ill.* 101.

VINCENT FERRIER (St), Valencia *c.* 1355-Vannes 1419. Spanish monk. *ills* 89, 90.

VINDELINO DA SPIRA, 15th century German typographer, active at Venice in 1470, brother of Giovanni da Spira. *p.* 241.

VIRGIL (Publius Virgilius Maro), Mantua 70-Brindiso 19 BC; great Latin poet. *pp.* 27, 51; *ill.* 27.

VISCONTI, Lombard family who ruled Milan from 1277 to 1447. *pp.* 30, 86, 304.

VITRUVIUS (Marcus Vitruvius Pollio), 1st century BC. Roman architect, author of the *De architectura*. *p.* 46.

VIVARINI, family of Venetian painters. ANTONIO, Murano *c.* 1415-Venice *c.* 1476 or 1484; Venetian painter, brother of Bartolommeo and father of Alvise; collaborated with Giovanni d'Alemagna until 1450; many altarpieces and polyptychs. BARTOLOMMEO, Murano *c.* 1432-1499; brother and collaborator (1450-1462) of Antonio; worked with his brother on many altarpieces; *Madonna and Child* (1478), etc. ALVISE, Venice *c.* 1445-1503-5; son of Antonio and nephew of Bartolommeo; *Virgin and Child with Saints* (Franciscan Monastery of Monte Fiorentino); *Virgin and Child* (1483) at church of Sant' Andrea, Barletta; *Virgin and Child* (1485) in Vienna Gallery. *pp.* 125, 134, 147; *ill.* 134.

VOLTERRA, Tuscan city, a self-governing community which came under Florentine rule in 1361. *see map* 310.

WEISS (Roberto), British philologist and epigraphist of Italian origin, born in 1906. *p.* 300.

WEYDEN (Rogier Van der, known as ROGER DE LA PATURE), Tournai 1399-Brussels 1464. Flemish painter. *pp.* 98, 177, 309.

WÖLFFLIN (Heinrich), Winterthur 1864-Zürich 1945. Swiss art historian. *p.* 313.

YAÑEZ DE LA ALMEDINA, *see* SPAGNOLO.

ZENALE (Bernardino), Treviglio 1436-Milan 1526. Lombard painter, trained in same studio as Butinone, with whom he collaborated on the frescoes in the church of San Pietro in Gessate, Milan, and on the Treviglio polyptych (1485). Painted other altarpieces.

ZENOBIUS (St) 344-417. Bishop of Florence, exorcizer of devils. *ill.* 73.
Emblems: mitre, Florence lily, dead tree (on the day of his death a dried up tree is said to have flowered again).

ZENO (St), Bishop of Verona from 362 to 372. Patron saint of Verona and other Italian cities (including Pistoia).
Emblems: mitre, crosier (*see* Montagna's San Zeno Altarpiece. *p.* 180; *ill.* 179.

ZOAN ANDREA, *see* VAVASSORE.

ZOPPO (Marco), Cento 1433-Venice 1478. Bolognese painter, author of a collection of designs at one time attributed to Mantegna. Active in the Marches (Pesaro Altarpiece, at Bologna.) (Triptych of the Collegio di Spagna) and at Venice. *pp.* 132, 135, 190, 227; *ill.* 131.

BIBLIOGRAPHY

The following list does not in any way attempt to give a complete catalogue of the enormous volume of literature on the subject, but aims to give the essential works from among those consulted in the preparation of the present volume and which may be recommended on this account. This bibliography has most bearing firstly upon the links between Italy and neighbouring countries, secondly upon the activity of the different provinces within Italy itself, and thirdly on the links between artistic phenomena and cultural and social life. For this reason time-honoured works, invaluable for the documentary information they contain are listed in close proximity with recent publications, preferably the most recent, in which more complete references are to be found.

ABBREVIATIONS USED IN THE BIBLIOGRAPHY

A.	Arte, *Rome*.
A.B.	The Art Bulletin, *New York*.
A. in A.	Art in America, *New York*.
A.L.	Arte Lombarda, *Milan*.
A.V.	Arte Veneta, *Venice*.
B.A.	Bollettino d'Arte, *Rome*.
B.M.	The Burlington Magazine, *London*.
B.S.H.A.F.	Bulletin de la Société d'histoire de l'art français, *Paris*.
Com.	Commentari, *Rome*.
G.B.A.	Gazette des Beaux-Arts, Paris, New York (1940-1954), *Paris*.
H.R.	Bibliothèque d'Humanisme et Renaissance, *Paris* then *Geneva*.
J.B.	Jahrbuch der preussischen Kunstsammlungen, *Berlin*.
J.W.	Jahrbuch der kunsthistorichen Sammlungen in Wien, *Vienna*.
J.W.C.I.	Journal of the Warburg and Courtauld Institutes, *London*.
M.F.K.	Monatshefte für Kunstwissenschaft, *Leipzig*.
O.M.D.	Old Master Drawings, *London*.
Pa.	Paragone, *Florence*.
R.A.	Rassegna d'Arte, *Rome*.
R.F.K.	Repertorium für Kunstwissenschaft, *Munich*.
Riv. A.	Rivista d'Arte, *Florence*.
R.J.	Römisches Jahrbuch für Kunstgeschichte, *Rome*.
W.J.K.G.	Wiener Jahrbuch für Kunstgeschichte, *Vienna*.
Z.B.K.	Zeitschrift für bildende Kunst, *Leipzig*.
Z.K.G.	Zeitschrift für Kunstgeschichte, *Stuttgart*.

BIBLIOGRAPHY

1. ALATRI (P.), Federigo da Montefeltro: *Lettere di stato e d'arte*, 1470-1480, Rome, 1949.

2. ALAZARD (Jean), *L'Art italien au XVe siècle*, Paris, 1951.

3. ALBERTI (Leon Battista), *De re aedificatoria libri*, X, Florence, 1485; ed. M. Theuer, 2 vols, Leipzig, 1912; English ed. by G. LEONI, 1726, and new ed. by J. RYKWERT, London, 1955.

4. ALBERTI (Leon Battista), *Della Pittura*, ed. L. Mallé, Florence, 1950; English ed. by J.R. SPENCER, London, 1956.

5. ALLENDE-SALAZAR (J.), *Pedro Berruguete en Italia*, in 'Archivio español de Arte y Archeologia', 1927.

6. ALMAGIA (R.), *Il primato di Firenze negli studi geografici durante i secoli XV° e XVI°*, Florence, 1929.

7. ALMAGIA (R.), *Uno sconosciuto geografo umanista : Sebastiano Compagni*, in 'Miscellanea in onore di G. Mercati', IV, Rome-Vatican, 1946.

8. ALMAGIA (R.), *Osservazioni sull' opera geografica di Francesco Berlinghieri*, in 'Archivio della Società romana di storia Patria', vol. LXVIII (1946).

9. ANDERSON (W.J.), *The Architecture of the Renaissance in Italy*, 5th ed., revised by A. STRATTON, London, 1927.

10. ANTAL (F.), *Breu und Filippino*, in 'Z.B.K.', LXII (1928-29).

11. ARCANGELI (F.), *Tarsie*, 2nd ed., Rome, 1943.

12. *Arte e artisti dei laghi lombardi*, I: *Architetti e scultori del Quattrocento*, Como, 1959.

13. *Arte lombarda dai Visconti agli Sforza*, Exhibition, catalogue by G. BELLONI, R. CIPRIANI, F. MAZZINI and F. RUSSOLI, preface by R. LONGHI, Milan, 1958.

14. BABELON (Jean), *Jean Paléologue et Ponce Pilate*, in 'G.B.A.', CXXVI (1930).

15. BABINGER (Franz), *Leonardo da Vincis Bauvorschläge an Bajezid II*, Munich, 1952, re-edited 1963.

16. BABINGER (Franz), *Mehmet II der Eroberer*, Munich, 1953.

17. BABINGER (Franz), *Ein venetischer Lageplan der Feste Rümeli Hisar*, in 'La Bibliofilia', LVII (1955).

18. BABINGER (Franz), *Le vicende veneziane nella lotta contro i Turchi durante il secolo XV°*, in 'Civiltà Veneziana del Quattrocento', Florence, 1957.

19. BABINGER (Franz), *Un rittrato ignorato di Mahometto II, opera di Gentile Bellini*, in 'A.V.', XV (1961).

20. BABINGER (Franz), *Ein weiteres Sultansbild von Gentile Bellini aus russischem Besitz*, in 'Oesterreichische Akademie der Wissenschaften', Graz-Vienna, Cologne, 1962.

21. BAGROW (L.), *Geschichte der Kartographie*, Berlin, 1951.

22. BALDI (B.) and BIANCHINI (F.), *Memorie concernenti la Città d'Urbino...*, published by Cardinal Annibale di SAN CLEMENTE, Rome, 1787.

23. BALDWIN-BROWN (G.), *Vasari on Technique*, London, 1907, p. 204 ff.

24. BALOGH (J.), *Uno sconosciuto scultore italiano presso il re Mattia Corvino*, in 'Riv. A.', 1933.

25. BALOGH (J.), *Ercole de' Roberti a Buda*, in 'Acta Hist. Artium' (Budapest), VI (1959).

26. BALTRUSAITIS (Jurgis), *Réveils et prodiges, le gothique fantastique*, Paris, 1960, chap. IX.

27. BARUFFALDI (Girolamo), *Vite de' pittori e scultori ferraresi*, Ferrara, 1844.

28. BATTELLI (G.), *A Sansovino in Portogallo*, in 'Bibl. Coïmbra', V (1929).

29. BATTISTI (Eugenio), *Rinascimento e Barocco*, Turin, 1960.

30. BATTISTI (Eugenio), *Il significato simbolico della capella Sistina*, in 'Com.', VIII (1957); taken up again in: *Rinascimento e Barocco*, chap. IV, no. 29.

31. BAUM (Fritz), *Baukunst und dekorative Plastik der Frührenaissance in Italien*, Stuttgart, 1920.

32. BECHERUCCI (L.) and GNUDI (G.), *Mostra di Melozzo e del Quattrocento romagnolo*, Bologna, 1938.

33. BELOTTI (Bertoldo), *Storia di Bergamo e dei Bergamaschi*, III, Bergamo, 1959, book VII: *Il Rinascimento a Bergamo*.

34. BELTRAMI (L.), *Artisti italiani a Mosca al servizio di Ivan III*, in 'Atti della società piemontese di archeologia e belle arti', 1925.

35. BENESCH (O.), *The Orient as a Source of Inspiration of the Graphic Arts of the Renaissance*, in 'Festschrift für Fr. Winckler', Munich, 1959.

36. BERCKEN (E. von) and Mayer (A.L.), *Die Malerei des 15. und 16. Jh. in Oberitalien*, Berlin, 1947.

37. BERENSON (Bernard), *The Drawings of the Florentine Painters*, 3 vols, Chicago, 1938.

38. BERTAUX (E.), *Botticelli costumier*, in 'Etudes d'art', Paris, 1912.

39. BERTAUX (E.), *Rome*, 3 vols, Paris, 1931.

40. BETTINI (S.), *Un grande artista veneto in Russia: Alvise Lamberti da Montagnana*, in 'Le Tre Venezie' (1944), nos. 7-12.

41. BIALOSTOCKI (Jan), *The Power of Beauty: A Utopian Idea of Leone Battista Alberti*, in 'Studien zur toskanischen Kunst'. See no. 142.

42. BLUNT (Anthony), *Artistic Theory in Italy 1450-1550*, London, 1940, re-edited Oxford, 1956.

43. BLUNT (Anthony), *Mantegna's Triumph of Caesar*, in 'B.M.', 1962.

44. BODE (Wilhelm von), *Florentiner Bildhauer der Renaissance*, Berlin, 1910.

45. BODE (Wilhelm von), *Die Kunst der Frührenaissance in Italien*, Berlin, 1923.

46. BODE (Wilhelm von), *Bertoldo und Lorenzo dei Medici*, Fribourg, 1926.

47. BOLL (F.) and BEZOLD (C.), *Sternglaube und Sterndeutung*, 3rd ed. Leipzig, 1926.

48. BOLOGNA (Ferdinando), *Una Madonna lombarda del Quattrocento*, in 'Pa.', no. 93 (1957).

49. BOMBACI (A.), *Venezia e l'impresa turca di Otranto*, in 'Rivista storica italiana' (1954).

50. BOMBE (W.), *Florentiner Entdeckungen und Restaurierungen*, in 'Der Cicerone', 1913.

51. BORSOOK (E.), *Decor in Florence for the Entry of Charles VIII of France*, in 'Mitteilungen des kunsthistorichen Instituts in Florenz' (XII), Berlin, 1961.

52. BOTTARI (Stefano), *Contributi allo studio dell' ambiente artistico siciliano nel 400 e alla formazione di Antonello da Messina*, in 'La Critica d'Arte', 1935.

53. BOVI (A.), *Il periodo milanesi di Leonardo e la nuova prospettiva di luce e di ombra*, in 'A.L.', VII (1962).

54. BRIZIO (A.M.), *La pittura in Piemonte dall'età romanica al Cinquecento*, Turin, 1942.

55. BRIZIO (A.M.), *Le Vetrate della Cattedrale e della Collegiata di S. Orso ad Aosta*, in 'Relazioni ... al XXXIº Congresso Subalpino, Aosta' (Sept. 1956), pp. 366-379.

56. BRUNETTI (M.) and LORENZETTI (G.), *Venezia nella storia e nell'arte*, Venice, 1950.

57. BUCHOWIECKI (W.), *Die städtebauliche Entwicklung Roms vom 15. Jh. bis zur Gegenwart*, in 'Jahrbuch des Vereins für Geschichte der Stadt Wien', XVII-XVIII (1961-1962).

58. BUDEL (O.), *Leonardo da Vinci, Medieval Inheritance and the Creative Imagination*, in 'The Romantic Review', LXXIII (1961).

59. BURCKHARDT (Jacob), *Die Kultur der Renaissance in Italien*, 1st ed. Stuttgart, 1860; English ed. by S.C.G. Middlemore, London, 1944, and many other eds.

See: Jacob Burckhardt and the Renaissance, 100 years after, The University of Kansas, Lawrence, 1960.

60. BURCKHARDT (Jacob), *Die Sammler*, in 'Beiträge zur Kunstgeschichte von Italien' (Gesamtausgabe, XII), Berlin, 1930.

61. CAMPANA (A.), *Civiltà umanistica faentina*, in *Il Liceo 'Torricelli' nel primo centenario della sua fondazione* (1961), Faenza, 1963 (with bibliography).

62. CAMPANA (Giov. Pietro), *Roma di Sisto, le 'Lucubraciunculae Tiburtinae' di Robert Flemmyng*, in 'Strenna dei Romanisti' (Rome), 1948.

63. CASELLA (M.) and POZZI (G.), *Francesco Colonna, biografia e opere*, 2 vols, Padua, 1959.

64. CASTELNOVI (G.V.), *Il polittico di Gerard David nell'abbazia della Cervara*, in 'Com.', III (1952).

65. CASTIGLIONE (T.R.), *Luca Pacioli e Leonardo da Vinci*, in 'Miscellanea Francescana', vol. LIV, fasc. III-IV (Rome), 1954.

66. CAUSA (R.), *Pittura napoletana dal XVº al XIXº*, Bergamo, 1957.

67. CHABOD (Federico), *Machiavelli and the Renaissance*, English trans., London, 1958, re-edited, 1960.

68. CHASTEL (André), *Léonard de Vinci et la culture*, in 'Léonard de Vinci et l'expérience scientifique' (Congress, 1952), Paris, 1953.

69. CHASTEL (André), *Marqueterie et perspective au XVe siècle*, in 'Revue des Arts', III (1953).

70. CHASTEL (André), *La Mosaïque à Venise et à Florence au XVe siècle*, in 'A.V.', VIII (1954).

71. CHASTEL (André), *L'Art italien*, 2 vols, Paris, 1956; English ed. London, 1963 (with bibliography).

72. CHASTEL (André), *Marsile Ficin et l'Art*, Geneva, 1957.

73. CHASTEL (André), *Art et Humanisme à Florence au temps de Laurent le Magnifique*, Paris, 1959.

74. CHASTEL (André), *Intarsia*, in *Enciclopedia universale dell'Arte* (Rome), vol. VII (1962), cols. 574-578.

75. CHASTEL (André) and KLEIN (Robert), ed.: *Léonard de Vinci, Traité de la peinture*, Paris, 1960.

76. CHASTEL (André) and KLEIN (Robert), *L'Age de l'humanisme*, Paris, 1963, English, German and Italian editions.

77. CHIARINI (M.), *Una citazione della 'Sagra' di Masaccio nel Ghirlandajo*, in 'Pa.', no. 139 (1962).

78. *Civiltà veneziana del Quattrocento*, Venice, 1957. Studies by PIOVENE (G.), VALERI (N.), BABINGER (F.), GRIERSON (P.) and PALLUCHINI (R.).

79. COLONNA (Francesco), *Hypnerotomachia Poliphili*, critical edition with commentaries by G. POZZI and L.A. CIAPPONI, including reproductions of the engravings, Padua, 1964.

80. COLVIN (Sidney), *A Florentine Picture-Chronicle by Maso Finiguerra*, London, 1894 (Picture-Chronicle, British Museum).

81. COVI, *Lettering in 15th-century Florentine Painting*, in 'A.B.', XLV (1963).

82. DACOS (V.), *Ghirlandajo et l'antique*, in 'Bull. de l'Inst. hist. belge de Rome', no. 34 (1962).

83. DATI (Goro), *La Sfera*, adaptation into Italian of the treatise *Spherae mundi* by John Hollywood (or Giovanni Sacrobosco), of 1255, ed. 1472, Ferrara.

84. *Decorative Arts of the Italian Renaissance 1400-1600*, Detroit, 1958. Exhibition, introduction by Paul L. GRIGAUT.

85. DONATI (L.), *Il Botticelli, le prime illustrazioni della Divina Commedia*, Florence, 1962.

86. DORINI (V.), *La casa di Mino e i disegni in essa recentemente scoperti*, in 'Riv. A.', IV (1906).

87. DUSSLER (L.), *Italienische Meisterzeichnungen*, Frankfurt-on-Main, 1938.

88. DVORAK (Max), *Geschichte der italienischen Kunst im Zeitalter der Renaissance*, 2 vols, Munich, 1927-1929.

89. EIMER (G.), *Abstrakte Figuren in der Kunst abendländischen Renaissance*, in 'Kunsthistorisk Tidskrift', XXV (1956).

90. EINEM (H. von), *Das Abendmahl des Leonardo da Vinci*, Cologne, 1961.

91. ELWERT (W.), *L'importanza letteraria di Venezia*, in 'Studi di letteratura veneziana', Venice, 1948.

92. ERRERA (I.), *Les Tissus reproduits sur les tableaux italiens du XIV^e au XVII^e siècle*, in 'G.B.A.' (1921).

93. ESCHER (E.), *Die Malerei des 14. bis 16. Jh. in Mittel- und Unteritalien*, Berlin, 1922.

94. ESSLING (Prince d'), *Les Livres à figures vénitiens de la fin du XV^e siècle et du commencement du XVI^e siècle*, 2 vols, Florence-Paris, 1907-1914.

95. ETTLINGER (L.), *Observations critiques sur l'ouvrage de H. Siebenhüner, Das Kapitol in Rom*, no. 274, in 'B.M.', May 1956.

96. FABRICZY (C. von), *Künstler im Dienste der Aragonesen*, in 'R.F.K.', X (1887).

97. FABRICZY (C. von), *Toskanische und oberitalische Künstler im Dienste der Aragonesen zu Neapel*, in 'R.F.K.', XX (1897).

98. FALDI (Italo), *Una scultura francese del XV^o sec. nell'abbazia di Grottaferrata*, in 'B.A.', July 1958.

99. FALKE (O.), *Chinesische Seidenstoffe des XIV. Jahrhunderts und ihre Bedeutung für die Seidenkunst Italiens*, in 'J.B.', XXXIII (1912).

100. FELDHAUS (F.M.), *Leonardo da Vinci als Techniker und Erfinder*, Jena, 1922.

101. *Fiamminghi e l'Italia*, Bruges-Venice-Rome, 1951. Exhibition, preface by P. FIERENS.

102. FILANGIERI (Gaetano), *Documenti per la Storia, le arti e le industrie delle Provincie napoletane*, Naples, 1883-1892.

103. FILARETE (A.), *Trattato d'Architettura*, ed. W. von Oettinger, Vienna, 1846.

104. FILIPPINI (F.), *Le opere architettoniche di A. Fioravanti in Bologna e in Russia*, in 'Cronache', 1925.

105. FIOCCO (Giuseppe), *Lorenzo e Cristoforo da Lendinara e la loro scuola*, in 'A.', XVI (1913).

106. FIOCCO (Giuseppe), *Felice Feliciano amico degli artisti*, in 'Archivio veneto tridentino', IX (1926).

107. FIOCCO (Giuseppe), *L'ingresso del Rinascimento nel Veneto*, in 'Venezia e l'Europa' (Congress, 1955), Venice, 1956.

108. FIOCCO (Giuseppe), *Le tarsie di Pietro Antonio degli Abati*, in 'Scritti di Storia dell'arte in onore di Lionello Venturi', Rome, 1956.

109. FIOCCO (Giuseppe), *Il museo imaginario di Francesco Squarcione*, in Atti dell'Accademia patavina' (1959).

110. FIOCCO (G.) and SARTORI (A.), *I cori antichi della Chiesa del Santo, i Canozzi e Pietro Antonio dell' Abate*, in 'Il Santo' (Padua), I, II (1961).

111. FIRPO (L.), *La città ideale del Filarete*, in 'Studi in memoria di Gioele Solari', Turin, 1954.

112. FRANCASTEL (Pierre), *La Fête mythologique au Quattrocento*, in 'Revue d'Esthétique', IV (1951), taken up again in: *la Réalité figurative*, éléments structurels de sociologie de l'art, Paris, 1965.

113. FRANCASTEL (Pierre), *Imagination et réalité dans l'architecture civile du Quattrocento*, in 'Hommage à Lucien Febvre', Paris, 1954.

114. FRANCESCA (Piero della...), *De Prospectiva pingendi*, ed. G. Nicco Fasola, Florence, 1942.

115. FRANCESCO DI GIORGIO MARTINI, *Trattato d'architettura civile e militare*, C. Promis and C. Saluzzo, Turin, 1841.

116. FRIEDLAENDER (M. J.), *Drei niederländische Maler in Genua*, in 'Z.B.K.', LXI (1927-1928).

117. GAMBA (Carlo), *Pietro Berruguete*, in 'Dedalo', VII (1926-1927).

118. GARIN (Eugenio), *Medioevo e Rinascimento*, Bari, 1954. Collection of articles including *Magia ed astrologia nella cultura del Quattrocento* (1950).

119. GARIN (Eugenio), *La cultura filosofica del Rinascimento italiano*, Florence, 1961. Collection of articles including *Note sull'ermitismo* (1955).

120. GARIN (Eugenio), *La cultura filosofica del Rinascimento italiano*, Florence, 1961. Collection of articles including *Il 'nuovo secolo' e i suoi annunciatori; i desideri di riforma nell'oratoria del Quattrocento* (1948).

121. GAURICUS (Pomponius), *De Sculptura*, Florence, 1504; ed. H. Brockhaus, Leipzig, 1886.

122. GENGARO (M.L.), *L.B. Alberti teorico ed architetto del Rinascimento*, Milan, 1939.

123. GEREVICH (L.), *Johannes Florentinus und die pannonische Renaissance*, Budapest, 1959, in 'Mélanges Pigler, Acta historiæ artium', VI, 3-4.

124. GILLE (B.), *Les Ingénieurs de la Renaissance*, Paris, 1964.

125. GNOLI (Umberto), *La Cancelleria e altri palazzi attribuiti a Bramante*, in 'Archivio Storico dell'Arte', V (1892).

126. GOLDSMITH-PHILIPPS (J.), *Early Florentine Designers and Engravers*, Cambridge (Mass.), 1955.

127. GOULD (Cecil), *An Introduction to Italian Renaissance Painting*, London, 1957.

128. GRASSI (L.), *I Disegni italiani del Trecento e Quattrocento*, Venice n.d.

129. GROTE (Ludwig), *'Hier bin ich ein Herr', Dürer in Venedig*, Munich, 1956.

130. HAENDEKE (Berthold), *Der niederländische Einfluss auf die Malerei Toskana-Umbriens im Quattrocento um c. 1450-1500*, in 'M.F.K.', V (1912).

131. HAFTMANN (W.), *Ein Mosaïk der Ghirlandajo-Werkstatt aus dem Besitz des Lorenzo Magnifico*, in 'Mitteilungen des kunsthistorischen Instituts in Florenz', VI (1940).

132. HARTT (H.), CORTI (G.), and KENNEDY (C.), *The Chapel of the Cardinal of Portugal*, Philadelphia, 1964.

133. HAUPT (Albrecht), *Die Baukunst der Renaissance in Portugal*, 2 vols, Frankfurt-on-Main, 1890-1895.

134. HAUPT (Albrecht), *Architettura dei Palazzi dell'Italia settentrionale e della Toscana dal sec. XIII° al sec. XVII°*, 3 vols, Milan-Rome, n.d. [1930 et seq.].

135. HAUSER (Henri) and RENAUDET (Auguste), *Les Débuts de l'âge moderne; la Renaissance et la Réforme*, 2nd ed., Paris, 1938; 3rd ed., 1946.

136. HAY (D.), *Italy and Barbarian Europe*, in *Italian Renaissance Studies*, ed. J.A. Jacob, London, 1959.

137. HECKSCHER (W.S.), *Sixtus IV... aeneas insignes statuas Romano populo restituendas censuit*, The Hague, 1955.

138. HEINEMANN (F.), *Das Bildnis des Johannes Corvinus in der Alter Pinakotek und die Jugendentwicklung des Jacopo de' Barbari*, in 'A.V.', XV (1961).

139. HEVESY (A. de), *La Bibliothèque du roi Mathias Corvin*, Paris, 1923.

140. HEYDENREICH (L.H.), *Les dessins scientifiques de Léonard de Vinci*, in 'Les Arts plastiques', I, Brussels, 1953.

141. HEYDENREICH (L.H.), *Leonardo da Vinci*, 2 vols, Basle, 1953.

142. HEYDENREICH (L.H.), (Festschrift für), *Studien zur toskanischen Kunst*, Munich, 1964.

143. HILL (G.F.), *A Corpus of Italian Medals of the Renaissance before Cellini*, 2 vols, Oxford, 1930.

144. HILL (G.F.), *The Gustave Dreyfus Collection. Renaissance Medals*, Oxford, 1931.

145. HIND (A.M.), *An Introduction to the History of the Woodcut*, London, 1938-1948.

146. HIND (A.M.), *Early Italian Engraving, a Critical Catalogue*, 7 vols, London, 1938-1948.

147. HOLTZINGER (H.), *Federigo da Montefeltro cronaca di Giovanni Santi*, Stuttgart, 1893.

148. HOOGEWERF (G.I.), *Vlaamische Kunst en italiaanische Renaissance*, Antwerp, n.d. [1934].

149. HORODYSKY (B.), *Birago, miniaturiste des Sforza*, in 'Scriptorium', X.

150. HUARD (P.) and GRMEK (M.D.), *Léonard de Vinci, dessins scientifiques et techniques*, Paris, 1962.

151. HULIN DE LOO (G.), *Pedro Berruguete et les portraits d'Urbin*, Brussels, 1942.

152. HÜLSEN (G.), *Il libro di Giovanni da Sangallo (Cod. Barberini 4424)*, Leipzig, 1910.

153. ISERMEYER (C.A.), *Die Arbeiten Leonardos und Michelangelos für den grossen Ratssaal in Florenz...*, in 'Studien zur toskanischen Kunst'. see no. 142.

154. JACOBS (Eduard), *Die Mohammed-Medaille des Bertoldo*, in 'J.B.', 1927.

155. JACQUOT (J.), *Les Fêtes de la Renaissance*, studies assembled by J. Jacquot, editions of C.N.R.S., Paris, 1956.

156. JAERNS (Max), *Handbuch der Geschichte des Kriegswesens*, Leipzig, 1880.

157. JAERNS (Max), *Geschichte des Kriegswissenschaft*, 3 vols, Munich, 1889-1891.

158. JANITSCHEK (H.), *Kunstgeschichtliche Notizen aus dem Diarium des Landucci*, in 'R.F.K.', III (1880).

159. *Juste de Gand-Berruguete et la cour d'Urbin*, Exhibition catalogue, Ghent, 1957, by P. EECKHOUT.

160. KAFTAL (G.), *Iconography of the Saints in Tuscan Painting*, Florence, 1952.

161. KAHLE (P.), *Die verschollene Columbuskarte von 1498 in einer türkischen Weltkarte von 1513*, Leipzig, 1933.

162. KARABACEK (Josef von), *Abendländische Künstler zu Konstantinopel im XV. und XVI. Jh.* (Denks. der Akad. der Wiss. in Wien, Phil. Hist. Kl., vol 62,1), Vienna, 1918.

163. KELLER (Harald), *Die Kunstlandschaften Italiens*, Munich, 1960.

164. KERNODLE (George), *From Art to Theatre, Form and Convention in the Renaissance*, Chicago, 1943.

165. KLEIN (Robert), *L'Urbanisme utopique de Filarete à Valentin Andreae*, in 'Les Utopies à la Renaissance, (Address 1961), Brussels-Paris, 1963.

166. KNABENSHUE (Paul de), *Ancient and Medieval Elements in Mantegna's Trial of St. James*, in 'A.B.', XLI (1959).

167. KRISTELLER (Paul), *Studies in Renaissance Thought and Letters*, Rome, 1956.

168. KRÖNIG (Wolfgang), *Der italienische Einfluss in der flämischen Malerei im ersten Drittel der XVI. Jh.*, Würzburg, 1936.

169. KÖRTE (Werner), *Deutsche Vesperbilder in Italien*, in 'Kunstgeschichtl. Jahrb. der Bibl. Hertziana', Leipzig, I (1937), Regesten VIII.

170. LANDUCCI (Luca), *Diario*, ed. J. del Badia, Florence, 1887.

171. LA TOUR (H. de), *Jean de Candida*, in 'Revue de Numismatique', XII (1894) and XIII (1895).

172. LAVAGNINO (Emilio), *Il palazzo della Cancelleria*, Rome, 1924, re-edited by P. TOMEI.

173. LAVAGNINO (E.), *L'architetto di Sisto IV*, in 'A.', Jan.-Feb. 1924.

174. LAVALLÉE (A.), *Techniques du dessin*, Paris, 1943.

175. LAVALLEYE (J.), *Les Primitifs flamands. Corpus de la peinture des anciens Pays-Bas méridionaux au XVe siècle. Le Palais Ducal d'Urbin*, Brussels, 1964.

176. LAVIN (M.A.), *Giovannino Battista...in 'A.B.''* XXXVII (1955).

177. LEE (R.W.), *Ut pictura poesis*, in 'A.B.', XXX (1940).

178. LESUEUR (Pierre), *Fra Giacondo en France*, in 'B.S.H.A.F.', 1931.

179. LEVI D'ANCONA (Mirella), *Miniatura e miniatori a Firenze dal XIVº al XVIº secolo*, Florence, 1962.

180. *Le Lieu théâtral à la Renaissance* (Colloque de Royaumont, 96), Paris, 1964. Collection of studies including: CHASTEL (A.), *Cortile et théâtre;* KLEIN (R.) and ZERNER (H.), *Vitruve et le théâtre de la Renaissance italienne;* POVOLIDO (E.), *Le théâtre de tournoi en Italie pendant la Renaissance*.

181. LOGA (V. von), *Spanische Maler des 15. Jh. in Neapel*, in 'M.F.K.', XI (1918).

182. LO GATTO (E.), *Gli artisti italiani in Russia*, vol. I, Rome, 1934.

183. LONGHI (Roberto), *Officina ferrarese*, Rome, 1934; re-edited with additions, Florence, 1958.

184. LONGHI (Roberto), *Arte italiana e arte tedesca*, Florence, 1941.

185. LONGHI (Roberto), *Viatico per cinque secoli di pittura veneziana*, Florence, 1946.

186. *Le Lucubraciunculae tiburtinae*, ad. V. Pacifici, (coll. Publ. Tiburtina di storia e d'arte), Rome, 1923.

187. LUGANO (P.), *Fra Giovanni da Verona e i suoi lavori alla Camera delle Segnature nel palazzo vaticano*, Rome, 1908.

188. MAGNUSON (Torgil), *Studies in Roman Quattrocento Architecture*, Stockholm, 1958.

189. MALAGUZZI-VALERI (Francesco), *La corte di Lodovico il Moro*, 3 vols, Milan, 1913-1937.

190. MARANGONI (G.), *La cappella di Galeazzo Maria al Castello sforzesco*, in 'B.A.', Nov. 1921.

191. MARANGONI (M.), *Firenze*, Novara, 1935.

192. MARLE (R. Van), *The Development of the Italian School of Painting*, 19 vols, The Hague, 1923 et seq.

193. MARTINDALE (A.), *L. Signorelli and the Drawings Connected with the Orvieto Frescoes*, in 'B.M.', 103 (1961).

194. MAZZARIOL (G.) and PIGNATTI (T.), *La pianta prospettiva di Venezia del 1500 disegnata da Jacopo de' Barbari*, Venice, 1962.

195. MEDER (J.), *Die Handzeichnung*, Vienna, 1919.

196. MEISS (Millard), *A Documented Altarpiece by Piero della Francesca*, in 'A.B.', XXIII (1941).

197. MEISS (Millard), *Jan Van Eyck and the Italian Renaissance*, in 'Venezia e l'Europa' (Congress 1955), Venice, 1956.

198. MEISS (Millard), *Towards a more Comprehensive Renaissance Paleography*, in 'A.B.', XLII (June 1960). See no. 209.

199. MELLER (P.), *Nachhall eines Mantegna-Stiches bei Leonardo*, in 'Mitteilungen des kunsthistorischen Instituts in Florenz', 1959-1960.

200. MENDES (Manuel), *A Capela do Cardeal de Portugal em Florenza a luz de novos documentos*, I, in 'Studi in onore di Amintore Fanfani', Milan, 1961.

201. MESNIL (Jacques), *L'Art au Nord et au Sud des Alpes à l'époque de la Renaissance*, Paris, 1911.

202. MEYER (Alfred Gotthold), *Oberitalienische Frührenaissance, Bauten und Bildwerk der Lombardei*, 2 vols, Berlin, 1897-1900.

203. MEZZANOTTE (P.) and BASCAFÉ (G.L.), *Milano nell'arte e nella storia*, Milan, 1948.

204. MICHEL (Paul-Henri), *La Pensée de L.B. Alberti*, Paris, 1930.

205. MOLINARI (C.), *Spettacoli fiorentini del Quattrocento contributi allo studio delle sacre Rappresentazione*, in 'Raccolta Pisana di saggi e studi', V, Venice, 1961.

206. MÖLLER (E.), *Maso Finiguerra*, in 'H.R.', XIX (1959).

207. MONTAND (R.), *L'antiumanesimo di Leonardo o della pittura pura*, in 'Convivium', N.S., 30 (1962).

208. MORISON (Samuel), *Fra Luca di Pacioli del Borgo*, New York, 1933.

209. MOSCHETTI (Andrea), *Le iscrizioni lapidarie romane negli affreschi del Mantegna agli Eremitani*, in 'Atti dell'Istituto veneto di scienze, lettere ed arti', LXXXIX (1929-1930). See no. 198.

210. MUNTZ (Eugène), *Les Arts à la cour des papes*, 3 vols, Paris, 1888.

211. MUNTZ (Eugène), *Les Collections des Médicis au XVe siècle*, Paris, 1888.

212. MUNTZ (Eugène), *Histoire de l'art en Italie pendant la Renaissance*, 3 vols, 1888-1894.

213. MUNTZ (Eugène), *Gli artisti fiamminghi e tedeschi in Italia nel XVº sec.*, in 'Archivio Storico dell'Arte', III (1890).

214. MURARO (M.), *Venezia*, Florence, 1953.

215. NERI DI BICCI, *Le Ricordanze (1453-1475)*, ed. G. Poggi, ,Il Vasari', 1927, 1929, 1930.

216. NEUMANN-TYSZIEWIEZ (M.) and KENNEDY (C.), *The Tomb of the Cardinal of Portugal*, Northampton (Mass.), 1934.

217. *New Cambridge Modern History*, vol. I. *The Renaissance*, 1957. Articles by WITTKOWER, WEIS, LAFFAN, etc.

218. NICCOLINI (F.), *L'arte napoletana del Rinascimento*, Naples, 1925.

219. OLSCHKI (Leonardo), *Geschichte der neusprachlichen wissenschaftlichen Literatur*, I, Leipzig, 1919.

220. OLSCHKI (Leonardo), *Storia letteraria delle scoperte geografiche*, Florence, 1937.

221. OLSCHKI (Leonardo), *I cantari dell'India di G. Dati*, in 'La Bibliofilia', XL (1938).

222. PAATZ (W. and E.), *Die Kirchen von Florenz*, 5 vols, Frankfurt-on-Main, 1942-1954.

223. PAATZ (Walter), *Die Kunst der Renaissance in Italien*, Stuttgart, 1953, 2nd ed., 1954; English ed.

224. PACCAGNINI (G.), MARIANI (E.) and PERINA (C.), *Mantova, le Arti dall'inizio del secolo XVº alla metà del XVIº*, Mantua, 1961.

225. PACIOLI (L.), *De divina proportione*, Venice, 1509, ed. C. Winterberg, Vienna, 1889. See no. 208.

226. PANOFSKY (Erwin), *Albert Dürer*, 2 vols, Princeton, 1943.

227. PANOFSKY (Erwin), *Dürers Stellung zur Antike*, in 'Jahrbuch für Kunstgeschichte', I (1921-1922). English trans. in *Meaning in the Visual Arts*, New York, 1955.

228. PANOFSKY (Erwin), *Das erste Blatt aus dem 'Libro' Giorgio Vasaris; eine Studie über die Beurteilung der Gotik in der italienischen Renaissance*, in 'Städel Jahrbuch', VI (1930). English trans. in *Meaning in the Visual Arts*, New York, 1955.

229. PANOFSKY (Erwin), *The First Page of Giorgio Vasari's Libro*, in *Meaning in the Visual Arts*, New York, 1955.

230. PANOFSKY (Erwin), *Artist, Scientist, Genius, Notes on the Renaissance*, 'The Renaissance, a Symposium', New York, 1953, re-edited, 1963.

231. PANOFSKY (Erwin), *Renaissance and Renascences in Western Art*, 2 vols, Stockholm, 1960.

232. PANOFSKY (Erwin), *La Construction de l'Argo en tant qu'allégorie platonicienne. L'iconographie d'un dessin mantegnesque vers 1500*, in 'Bulletin du Musée hongrois des Beaux-Arts', XX (1962).

233. PANOFSKY (E.), *Studies in Iconology, Humanistic Themes in the Art of the Renaissance*, New York, 1939.

234. PARKER (K.T.), *North Italian Drawings of the Quattrocento*, London, 1927.

235. PARRONCHI (A.), *The Language of Humanism and the Language of Sculpture: Bertoldo as Illustrator of the Apologi of Bartolomeo Scala*, in 'J.W.C.I.', XXVII (1964).

236. PINTO (E.G.), *Intarsia*, in 'Apollo', IX (1954).

237. PISANI (M.), *Un avventuriere del Quattrocento. La vita e le opere di Benedetto Dei*, Genoa-Florence, 1923.

238. POPHAM (A.E.) and POUNCEY (P.), *Italian Drawings of the XIVth and XVth Centuries*, British Museum, London, 3rd ed., 1949.

239. POPHAM (A.E.), *The Drawings of Leonardo da Vinci*, London, 3rd ed., 1949.

240. POUZYNA (I.V.), *La Chine, l'Italie et les débuts de la Renaissance*, Paris, 1935.

241. POZZI (G.) and CIAPPONI (L.A.), *La cultura figurativa di Francesco Colonna*, in 'A.V.', 1962.

242. *Les Primitifs flamands*, vol. V, le Musée National du Louvre, tome I, Brussels, 1960; vol. VII, la Galerie d'Urbin, Brussels, 1964.

243. QUINTAVALLE (A.C.), *Cristoforo da Lendinara*, Parma, 1959.

244. RAVA (C.E.), *L'arte dell'illustrazione nel libro italiano del Rinascimento*, Milan, 1945.

245. RICCI (C.) and ZUCCHINI (G.), *Guida di Bologna*, Bologna, 1930.

246. RIGONI (E.), *Pietro Antonio degli Abati da Modena e Lorenzo da Bologna, ingegneri architetti del XVº secolo*, in 'Atti dell'Accademia di Padova', 1932 and 1934.

247. ROQUES (Marguerite), *Les Architectes et les sculpteurs lombards dans le Sud-Est de la France entre 1450 et 1550*, in 'Arte e artisti dei laghi lombardi', Como, 1959.

248. ROTONDI (Pasquale), *Il Palazzo ducale d'Urbino*, 2 vols, Urbino, 1950.

249. RUHMER (E.), *Bernado Parentino*, in 'A.V.', XII (1958).

250. RUHMER (E.), *Ergänzendes zur Zeichenkunst des Ercole de' Roberti*, in 'Pantheon', XX (1963).

251. SACHSON (F.H.), *Intarsia and Marquetry*, London, 1903.

252. SALIS (A. von), *Antike und Renaissance, über Nachleben und Weiterwirken der alten in der neueren Kunst*, Zürich, 1947.

253. SALMI (Mario), *Aspetti della cultura figurativa di Padova e di Ferrara nella miniatura del primo Rinascimento*, in 'A.V.', VIII (1954).

254. SALMI (Mario), *La miniatura italiana*, Milan, 1954.

255. SALMI (Mario), *Riflessioni sulla civiltà figurativa di Ferrara nel suoi rapporti con Padova durante il primo Rinascimento*, in 'Riv. A', XXXIV (1959).

256. SALMI (Mario), *Schifanoia e le miniature ferraresi*, in 'Com.', XII (1961).

257. SANDER (Max), *Le Livre à figures italien depuis 1467 jusqu'à 1530*, 7 vols, Milan, n.d.

258. SANGIORGI (G.), *Tessuti istoriati fiorentini*, in 'Dedalo', fasc. III (1921).

259. SANTANGELO (A.), *I tessuti d'arte in Italia dal XIII° al XIX° secolo*, Milan, 1959.

260. SANTINELLI, *Leon Battista Alberti, una visione estetica del mondo e della vita*, Florence, 1962.

261. SANUDO (M.), *La spedizione di Carlo VIII in Italia*, in 'Archivio Veneto', I, XXIV, 2, no. 28.

262. SARTORI (A.), *I cori antichi della chiesa del Santo e i Canozzi dell' Abbate*, in 'Il Santo', I, II, May-August, 1961.

263. SAXL (Fritz), *Rinascimento dell' Antichità*, in 'R.F.K.', XLIII (1921-1922).

264. SAXL (Fritz), *The Classical Inscription in Renaissance Art and Politics*, in 'J.W.C.I.', IV (1940-1941).

265. SAXL (Fritz), *Lectures*, 2 vols, London, 1957.

266. SAXL (Fritz), *The Capitol during the Renaissance, a Symbol of the Imperial Idea*, in Lectures, London, 1957.

267. SCHLOSSER-MAGINO (J.), *La letteratura artistica*, re-edited (with additions by O. KURTZ), Florence, 1956.

268. SCHOTTMULLER (F.), *I mobili e l'ambitazione del Rinascimento in Italia*, Stuttgart, 2nd ed., 1928.

269. SCHUBRING (P.), *Das Blutbad von Otranto in der Malerei des Quattrocento*, in 'M.F.K.', I (1908).

270. SCHUBRING (P.), *Cassoni, Truhen und Truhenbilder der italienischen Frührenaissance*, 2 vols, Leipzig, 1925, Suppl., 1923.

271. SCHUDT (L.), *Le Guide di Roma*, Vienna, 1930.

272. SCHULZ (J.), *Pinturicchio and the Revival of Antiquity*, in 'J.W.C.I.', XXV (1962). (Concerning the grotesques.)

273. SEZNEC (Jean), *La Survivance des dieux antiques*, London, 1939; English ed., New York, 1953.

274. SIEBENHÜNER (Herbert), *Das Kapitol in Rom. Idee und Gestalt*, Munich, 1954. See no. 95.

275. SIGNINOLFI (L.), *I Mappamondi di Taddeo Crivelli e la Stampa bolognese della Cosmografia di Tolomeo*, in 'Bibliofilia' (1908).

276. SIMONSFELD (H.), *Der Fondaco dei Tedeschi in Venedig und die deutschvenezianischen Handelsbeziehungen*, 2 vols, Stuttgart, 1887.

277. SIVIERO (C.), *Questa era Napoli*, Naples, 1954.

278. SOLERTI (Angelo), *Ferrara e la Corte estense, nella seconda metà del secolo decimosesto*, Città di Castello, 1900.

279. SOULIER (Gustave), *Les Influences orientales dans la peinture toscane*, Paris, 1924.

280. STEINGRÄBER (E.), *Studien zur venezianische Goldschmiedekunst des XV. Jh.*, in 'Mitteilungen des kunsthistorischen Instituts in Florenz' (X), Berlin, 1961-63.

281. STEINGRÄBER (E.), *Zwei 'Libri d'ore' des Lorenzo il Magnifico de' Medici*. See no. 142.

282. STEINITZ (Kate), *The Voyage of Isabelle d'Aragon in 1489 from Naples to Milan*, in 'H.R.', 23 (1961).

283. STERLING (Charles), *La Nature morte*, Paris, 2nd ed., 1959.

284. STOKES (Adrian), *The Quattrocento*, London, 1932.

285. *Storia di Milano*, vol. VII, *L'Età sforzesca*, Milan, 1956.

286. STUBBE (W.), *Die Anfänge der italienischen Graphik und ihre Entwicklung in der Renaissance.* (Exhibition) Hamburg, 1955.

287. TERRASSE (C.), *L'Architecture lombarde de la Renaissance 1450-1525*, Paris, 1926.

288. THORNDIKE (L.), *A History of Magic and Experimental Science*, vol. IV, New York, 1925.

289. THUASNE (L.), *Gentile Bellini et le Sultan Mahomet II*, Paris, 1888.

290. TIETZE (H.) and TIETZE-CONRAT (E.), *The Artist of the 1486 View of Venice*, in 'G.B.A.', 1943.

291. TIETZE (H.) and TIETZE-CONRAT (E.), *The Drawings of the Venetian Painters in the XVth and XVIth Centuries*, New York, 1944.

292. TOLNAY (C. de), *History and Technique of Old Master Drawings, a Handbook*, New York, 1943.

293. TOMMASSIA (A.), *Visioni di Antichità nell'opera del Mantegna* in 'R.C. della Pontificia Accademia romana di Archeologia', XXVIII (1955-1956).

294. TOMMASSIA (A.), *Jacopo Bellini e Francesco Squarcione, due cultori dell'antichità classica*, in 'Il mondo antico nel Rinascimento' (Vº Convegno di Studi sul Rinascimento, 1956), Florence, 1958.

295. URBAN (G.), *Die Kirchenbaukunst des Quattrocento in Rom*, in 'J.F.K.', IX-X (1961-1962).

296. VASARI (Giorgio), *Le Vite...* 1st ed., 1550, 2nd ed., 1568; MILANESI, 9 vols, Florence, 1878-1885. Other editions: A.M. CIARANFI, Florence, 1927-1932; Cl. RAGGHIANTI, 4 vols, Milan, 1942-1950; under the direction of P. DELLA PERGOLA, L. GRASSI and G. PREVITALI, 6 vols appeared, Milan, 1962-1965.

297. *Venezia e l'Europa* (Acts of the XVIIth Congress of the History of Art, 1955), Venice, 1956.

298. VENTURI (Adolfo), *L'Arte a Ferrara nel periodo di Borso d'Este*, in 'Rivista Storica Italiana', 1885.

299. VENTURI (A.), *Storia dell'arte italiana*, 23 vols, Milan, 1901-1941: vol. VI, *La scultura del Quattrocento*, Milan, 1908; vols VII-1, VII-1, VII-3, *La Pittura del Quattrocento*, Milan, 1911-1914; vol. VIII-1, VIII-2, *L'Architettura del Quattrocento*, Milan, 1923.

300. VENTURI (Adolfo), *L'Ambiente artistico urbinato*, in 'A.', XX, 1917.

301. VOIGT (G.), *Weiderbelebung des classischen Altertums*, 1843, 3rd ed., 2 vols, Berlin, 1893.

302. WACKERNAGEL (Martin), *Der Lebensraum des Künstlers in der florentinischen Renaissance*, Leipzig n.d. 1938.

303. WALSER (E.), *Gesammelte Studien zur Geistesgeschichte der Renaissance*, introd. by W. KÄEGI, Basle, 1932.

304. WARBURG (Aby), *Gesammelte Schriften*, 2 vols, Leipzig, 1932, collection of studies including *Flandrische und florentinische Kunst im Kreise des Lorenzo Medici im 1480* (1901) and *Italienische Kunst und internationale Astrologie im Palazzo Schifanoja zu Ferrara* (1912).

305. WATERHOUSE (E.K.), COLLINS-BAKER (Ch.) and MACINTYRE (J.), *Mantegna's Cartoons at Hampton Court*, in 'B.M.', March 1934.

306. WEISBACH (Werner), *Trionfi*, Berlin, 1919.

307. WEISE (Georg), *Der doppelte Begriff der Renaissance*, in 'Deutsche Vierteljahrsschr. für Literaturwiss. u. Geistesgesch.', XI (1933).

308. WEISE (Georg), *Der spätgotische Stilströmung in der Kunst der italienischen Renaissance*, in 'H.R.', XIV (1952).

309. WEISE (Georg), *Der Humanismus und das Prinzip der klassischen Geisteshaltung*, in 'H.R.', XVI (1954).

310. WEISE (Georg), *L'ideale eroico del Rinascimento e le sue premesse umanistiche*, Naples, 1961.

311. WEISS (Raymond), *Jan van Eyck and the Italians*, in 'Italian Studies', XI (1956), p. 9 ff.

312. WEISS (Roberto), *Il primo secolo dell'umanesimo. Studi e testi*, Rome, 1949.

313. WEISS (Roberto), *Un umanista veneziano, Papa Paolo II (1464-1471)*, Venice, 1958.

314. WESCHER (P.), *Zanetto Bugatti and Rogier Van der Weyden*, in 'The Art Quarterly', XXV (1962).

315. WINTERWITZ (E.), *Quattrocento Science in the Gubbio Study*, in 'The Bulletin of the Metropolitan Museum of Art', October 1932.

316. WINTERWITZ (E.), *Instruments de musique étranges chez Filippino Lippi, Piero di Cosimo et Lorenzo Costa*, in *Les Fêtes de la Renaissance*, I, Paris, 1956.

317. WÖLFFLIN (Heinrich), Introd. to *Die Kunst der Renaissance in Italien*, in *Gesammelte Werke*, VI, Berlin and Leipzig, 1932.

318. WÖLFFLIN (Heinrich), *Die klassische Kunst*, Munich, 1899; English ed., *Classic Art*, London, 1952.

319. ZANZONI (F.), *I corali del Duomo di Cremona*, in 'Annali della Biblioteca di Cremona', no. 2, 1956.

INDEX TO THE BIBLIOGRAPHY

LIST OF ILLUSTRATIONS

Unless otherwise stated, photographs have been obtained from the source indicated in the note.

LIST OF ILLUSTRATIONS

21 *Turkish art. Portrait of the victorious Sultan Mohamet II. 15th century.* Istanbul, Topkapi Museum. Watercolour: 0.39×0.27 m.

22 *Venetian art.* GENTILE BELLINI. *Portrait of Mahomet II with a young man (detail). c. 1450-1460.* Basle, private collection. (*Photo: Dietrich Widmer.*)

23 GIULIANO DA SANGALLO. *Elevation of Santa Sophia. c. 1514-1516.* Vatican Library. Pen and wash on vellum (F°30 r° - ex 28 r°); 0.44×0.74 m. Part of a collection known as the *Codex Barberini 4424.*

24 AMBROGIO FOPPA CARADOSSO. *St Peter's, Rome after the drawing by Bramante. c. 1505.* London, British Museum (Dreyfus Collection). Bronze medal; diameter; 0.057 m. Other copies exist in Berlin, London, and Milan.

25 *Venetian art.* Venice, Scuola di Sant' Orsola. VITTORE CARPACCIO. *Legend of St Ursula. Meeting of the betrothed and their departure (detail). 1485.* Venice, Accademia. Canvas; overall dimensions : 2.80×6.11 m. (*Photo: U.D.F. - La Photothèque.*)

26 *Paduan art.* ANDREA MANTEGNA. *St Sebastian (detail). 1459.* Vienna, Kunsthistorisches Museum. Painted on panel; 0.68×0.31 m.

27 *Mantuan art.* SCHOOL OF MANTEGNA. *Monument to Virgil. c. 1499.* Paris, Louvre. Pen drawing ; 0.340× 0.214 m. This was probably drawn for Isabella d'Este. (*Photo: U.D.F. - La Photothèque.*)

28 *Florentine art.* DESIDERIO DA SETTIGNANO. *Julius Caesar.* Paris, Louvre. Marble, bas-relief; 0.42 ×0.29 m. This attribution is generally accepted; the work demonstrates all the characteristics which distinguish the work of this sculptor from that of Donatello. (*Photo: U.D.F. - La Photothèque.*)

29 *Art of Ferrara.* Ferrara, Schifanoia Palace, Sala dei Mesi. FRANCESCO DEL COSSA. *The Month of April (detail): The Palio 1458-1478. In situ.* Fresco; dimensions of the room: length: 24 m.; width: 11 m.; height: 7.50 m. Part of the series of subjects decorating the lower section of the east wall. This shows a scene in the life of Borso d'Este. (*Photo: U.D.F. - La Photothèque.*)

30 *Napolitan art.* REGINALDUS PIROMUS DE MONOPOLI. *Nicomachean Ethics: Frontispiece (detail). c. 1500.* Vienna, National Library. Miniature representing the allegory of the human soul, with the four cardinal virtues, surrounded by scenes from mythology.

31 *Art of Ferrara.* Ferrara, Schifanoia Palace Sala dei Mesi. ERCOLE DEI ROBERTI and FRANCESCO DEL COSSA. *The Month of August (first decade). 1458-1478. In situ.* Fresco; dimensions of the room: length: 24 m. ; width: 11 m.; height: 7.50 m. Part of the series of the signs of the Zodiac which decorate the centre section of the North wall. (*Photo: Scala.*)

32 *Art of Ferrara.* Ferrara, Schifanoia Palace, Sala dei Mesi. ERCOLE DEI ROBERTI and FRANCESCO DEL COSSA. *The Month of August (second decade) : Sign of Virgo. 1458-1478. In situ.* Fresco. *cf.* Ill. 31. (*Photo : Scala.*)

33 *Art of Ferrara.* Ferrara, Schifanoia Palace, Sala dei Mesi. ERCOLE DEI ROBERTI and FRANCESCO DEL COSSA. *The month of August (third decade) : Virgo. 1458-1478. In situ.* Fresco. *cf.* Ill. 31. (*Photo: Scala.*)

34 *Art of the Marches.* Rimini, Tempio Malatestiano AGOSTINO DI DUCCIO (attr.). *The God Mars. 1454-1457. In situ.* Marble, bas-relief. Part of the series of bas-reliefs in the chapel of the Planets. (*Photo: Alinari.*)

35 *Sienese art.* APOLLONIO DI GIOVANNI. *Cassone panel. Scenes from the Odyssey (detail) Mid-15th century* Chicago. The Art Institute (Martin A. Ryerson collection). Tempera on panel; 0.419×1.666 m.

36 *Venetian art.* VITTORE CARPACCIO. *The Embassy of the Amazons to Theseus. Late 15th century.* Paris, Musée Jacquemart-André. Painted on panel; 1.02×1.45 m. The subject is taken from the first canto of Boccacio's *Teseida* and depicts the principal event of the epic. (*Photo: U.D.F. - La Photothèque.*)

37 *Mantuan art.* Mantua. ANDREA MANTEGNA. *The Triumph of Caesar (IV), The Vase Bearers (detail) 1484-1492.* Hampton Court (Royal Collection). Distemper on paper mounted on canvas; 2.74×2.74 m. Part of a series of 'Triumphs' commissioned by Gian Francesco Gonzaga III, to decorate a room in the Castello Vecchio in which theatrical performances were held. This group is comprised of nine triumphs forming a frieze 27 meters long. (*Photo: A.C. Cooper.*)

38 *Paduan art.* Padua, Eremitani, Ovetari chapel. ANDREA MANTEGNA. *The Judgement of St James (detail). 1449.* Fresco, part of the Eremitani cycle destroyed on 11th March 1944. Mantegna painted the left side, Pizzolo the right. (*Photo: Alinari-Giraudon.*)

39 *Venetian art.* JACOPO BELLINI. *Roman Epigraph. Mid-15th century.* Paris, Louvre. Pen drawing on parchment; 0.295×0.425 m. From the collection of drawings by Jacopo Bellini. (*Photo: U.D.F. - La Photothèque.*)

40 *Venetian art.* JACOPO BELLINI. *Study in perspective and architecture. c. 1450.* Paris, Louvre. Pen drawing on parchment; 0.29×0.427 m. (*Photo: Giraudon.*)

41 *Venetian art.* ANON. *Hypnerotomachia : Triumph. 1499.* Paris, Bibliothèque Nationale. Woodcut (F°K7, v°); page height: 0.285 m. Illustration for Francesco Colonna's *Dream of Polyphilus* or *Hypnerotomachia*, edited by Aldus Manutius in Venice.

42 *Venetian art. Hypnerotomachia : Triumph. 1499.* Paris, Bibliothèque Nationale. Woodcut (F°K8, r°). *cf.* Ill. 41.

43 LEONARDO DA VINCI. *Semiregular polyhedron. 1509.* Milan, Biblioteca Ambrosiana. Engraving on parchment; 0.29×0.20 m. The illustrations for the Treatise *De Divina proportione* by the mathematician Luca Pacioli were drawn by Leonardo da Vinci.

44 *Central Italian art.* Urbino. FRANCESCO DI GIORGIO (attr.). *Ideal City. c. 1500.* Urbino, National

Gallery of the Marches. Painted on panel; 0.60×2 m. The attribution is difficult: after having been given to Piero della Francesca, then to Luciano Laurana, this panel is sometimes still considered to be the work of Francesco di Giorgio. (*Photo: U.D.F. - La Photothèque.*)

45 *Central Italian art.* JACO BAR. *Portrait of LUCA PACIOLI. 1495.* Naples, Museo e Gallerie Nazionali di Capodimonte. Painted on panel; 0.99×1.20 m. Signed and dated 'Jac.Barb. Vigonnis' 1495. An unknown artist who should not be identified with Jacopo de' Barbari. (*Photo: U.D.F. - La Photothèque.*)

46 *Umbian art.* LUCA SIGNORELLI. *The Triumph of Pan (destroyed). c. 1490* Formerly in the Kaiser Friedrich Museum, Berlin. Canvas. 1.94× 2.57 m. Painted for Lorenzo de' Medici, while Signorelli was working in Florence; discovered in 1865 at the Palazzo Corsi near San Gaetano in Florence; destroyed in 1944. (*Photo: Berlin-Dahlem, Staatliche Museum.*)

47 *Venetian art.* VITTORE CARPACCIO. *Meditation on the Dead Christ. Late 15th or early 16th century.* New-York. The Metropolitan Museum of Art (Kennedy Bequest). Tempera on panel; 0.70×0.86 m.

48 *Paduan art.* SCHOOL OF MANTEGNA. *Calumny of Apelles. Mid-15th century.* London, British Museum. Pen drawing, bistre on white paper; 0.205×0.38 m. Engraved by Mocetto. *Document reversed.*

49 *Florentine art.* Medici collection. SANDRO BOTTICELLI. *Calumny of Apelles. 1485-1490.* Florence. Uffizi. Painted on panel; 0.62× 0.92 m. (*Photo: U.D.F. - La Photothèque.*)

50 BRAMANTE. *Interior of a Ruined Church. 1481.* London, British Museum. Drawing: 0.705×0.513 m.

51 *Paduan art.* Padua, Eremitani, Ovetari Chapel ANDREA MANTEGNA with the collaboration of NICOLO PIZZOLO. *A view of the Frescoes. 1448-1454. In situ.* The side walls of the Ovetari chapel are decorated with the legend of St James and scenes from the life of St Christopher. The *Assumption* on the East wall was

badly damaged by bombing in 1944. (*From Giuseppe Fiocco, Mantegna, the Ovetari Chapel in the Church of the Eremitani, Milan, n.d., Ill. 18.*)

52 *Paduan art.* Padua, Eremitani, Ovetari chapel. ANDREA MANTEGNA with the collaboration of NICOLO PIZZOLO. *The Assumption (detail). 1448-1454. In situ. cf.* Ill. 51. (*Photo: U.D.F. - La Photothèque.*)

53 *Tuscan art.* Arezzo, San Francesco. PIERO DELLA FRANCESCA. *A view of the Choir 1452-1459. In situ.* Fresco. The decoration depicts scenes from the Story of the True Cross. The chapel arch was painted before the arrival of Piero in 1452 by Bicci di Lorenzo. (*Photo: Alinari.*)

54 *Tuscan art.* Arezzo, San Francesco. PIERO DELLA FRANCESCA. The Story of the True Cross (detail). *The proving of the True Cross (detail): A Man is restored to Life. 1452-1459. In situ.* Fresco. (*Photo: Scala.*)

55 *Tuscan art.* Prato, Cathedral. FILIPPO LIPPI, with the collaboration of FRA DIAMANTE. *A view of the Frescoes. 1452-1465. In situ.* Height: 1.62 m., width: 0.77 m. Lives of St Stephen and St John the Baptist. (*Photo: U.D.F. - La Photothèque.*)

56 *Tuscan art.* Prato, Cathedral, choir. FILIPPO LIPPI. *Dance of Salome. 1452-1465. In situ.* Fresco. From the scene of Herod's Banquet in the life of St John the Baptist. (*Photo: Scala.*)

57 *Florentine art.* Florence, the Baptistry of San Giovanni. LORENZO GHIBERTI. *The Doors of Paradise (detail). 1425-1452. In situ.* Bronze, bas-relief. (*Photo: Scala.*)

58 *Florentine art.* Florence. Or San Michele. LUCA DELLA ROBBIA. *Virgin and Child (in a medallion) c. 1455-1460. In situ.* Terracotta with polychrome glaze; diameter: 1.80 m. (*Photo: U.D.F. - La Photothèque.*)

59 *Florentine art.* FRANCESCO ROSSELLI. *View of Florence. c. 1482-1492.* Berlin Dahlem, Staatliche Museen, woodcut. 0.29×0.44 m.

60 *Florentine art.* Florence, San Lo-

renzo. DESIDERIO DA SETTIGNANO. *Tabernacle. 1492. In situ.* Marble. (*Photo: Alinari.*)

61 *Florentine art.* Florence, San Lorenzo. Pulpit (detail). *The Three Marys at the Sepulchre. Begun 1460. In situ.* Bronze; overall dimensions: 1.37×2.80 m. The pulpits were not finished at Donatello's death. (*Photo: Brogi.*)

62 *Florentine art.* MASO FINIGUERRA. (attr.). *The Planet Mercury. c. 1460.* London, British Museum. Line-engraving (first state); 0.324× 0.220 m. Engraved by B. Baldini. Colvin re-attributes this engraving to Maso Finiguerra.

63 *Tuscan art.* ANTONIO POLLAIUOLO (attr.) *Female profile. 15th century,* Berlin-Dahlem, Staatliche Museen. Coloured line-engraving 0.220×0.142 m. (*Photo: Karl H. Paulmann.*)

64 *Tuscan art.* FRANCESCO DI ANTONIO. *Cassone. Late 15th century.* Copenhagen, Statens Museum for Kunst. (*Photo: Musée Royal des Beaux-Arts.*)

65 *Tuscan art.* FRANCESCO PESELLINO Cassone panel. *The story of Griselda (detail). c. 1455-1457.* Bergamo, Accademia Carrara. Painted on panel; overall dimensions: 0.43× 1.10 m. (*Photo: U.D.F. - La Photothèque.*)

66 *Florentine art.* JACOPO DEL SELLAIO. *St John the Baptist c. 1460.* Washington, National Gallery of Art (Samuel H. Kress collection). Painted on panel; 0.52×0.33 m. Painting of the young St John, the companion of Jesus. St *Giovannino,* to whom the Baptistry was dedicated, was an extremely popular patron saint in Florence.

67 *Florentine art.* FILIPPINO LIPPI. Cassone panel. *Esther arriving at Susa (detail). Late 15th century.* Ottawa, National Gallery of Canada, Tempera on panel; 0.49×0.43 m.

68 *Florentine art.* SCHOOL OF BOTTICELLI. *The Miracle of St John the Evangelist. c. 1491.* Paris, Louvre. Drawing for an embroidery. Pen on silk; 0.295×0.23 m. (*Photo: U.D.F. - La Photothèque.*)

69 *Florentine art.* Florence, Palazzo Vecchio, door to the Sala dei Giglii. GIULIANO and BENEDETTO DA MAIANO. *Portrait of Dante. 1475-1480. In situ.* Marquetry. *(Photo: Alinari.)*

70 *Florentine art.* Florence, Palazzo Strozzi façade. MICHELOZZO. *1457-1469. In situ.* According to Fabriczy, G. da Maiano continued Michelozzo's work after 1462. *(Photo: Alinari.)*

71 *Florentine art.* Florence, Palazzo Gondi, façade. GIULIANO DA SANGALLO. *1490-1494. In situ. (Photo: Alinari.)*

72 *Florentine art.* Florence, San Miniato al Monte. ANTONIO ROSSELLINO. *Tomb of the Cardinal of Portugal. 1461-1466. In situ.* Marble. *(Photo: U.D.F. - La Photothèque.)*

73 *Florentine art.* Florence. Santa Maria del Fiore, chapel of St Zenobius. MONTE DI GIOVANNI. *St Zenobius. c. 1490.* Florence, Opera del Duomo. Mosaic, an example of a type of mosaic icon for which the fashion spread to Florence after 1450-1460. Gherardo di Giovanni, his brother, was commissioned to renovate the Cathedral. *(Photo: U.D.F. - La Photothèque.)*

74 *Tuscan art.* Prato Cathedral, FILIPPO LIPPI. *The Feast of Herod (detail) Herodiad. 1460-1464. In situ.* Fresco. Part of the cycle of the life of St John the Baptitst which decorates the choir of Prato Cathedral. *(Photo: U.D.F. - La Photothèque.)*

75 *Florentine art.* Florence, Palazzo Pandolfini. DOMENICO GHIRLANDAIO. *Presumed portrait of Giovanna degli Albizzi, wife of Lorenzo Tornabuoni. 1488.* Lugano, private collection. Painted on panel; 0.75 × 0.50 m. Only Lipmann contests this attribution, and gives the work to the School of Ghirlandaio.

76 *Florentine art.* NERI DI BICCI. *Coronation of the Virgin. 1419-1451.* Baltimore, Walters Art Gallery. Painted on panel; 2.057 × 2.006 m.

77 *Florentine art.* Florence, Santa Maria Maddalena dei Pazzi. FRANCESCO BOTTICINI. *Virgin and Child with St Mary the Egyptian and St Bernard. c. 1490.* Paris, Louvre. Painted on panel; 1.89 × 1.77 m. *(Photo: U.D.F. - La Photothèque.)*

78 LEONARDO DA VINCI. *Drawing of the town of Milan (detail). c. 1490.* Milan, Biblioteca Ambroisiana. Pen drawing on parchment (F°73v°b); dimensions of the complete folio: 0.67 × 0.45 m. Part of the *Codex Atlanticus.*

79 LEONARDO DA VINCI. *Study for the Dome of Milan Cathedral (detail). c. 1488.* Milan, Biblioteca Ambrosiana. Pen drawing on parchment (F°266r°); dimensions of the folio: 0.67 × 0.45 m. Part of the *Codex Atlanticus.*

80 *Florentine art.* ANTONIO FILARETE. *Plan for Bergamo Cathedral. 1460-1464.* Florence, Biblioteca Nazionale. Pen drawing, figures slightly heightened with water-colour; dimensions of the codex: 0.29 × 0.40 m. Illustration from the *Trattato d'architettura Codex Magliabechiano,* libro XVI (F° 192). *(Photo: U.D.F. - La Photothèque.)*

81 *Art of Lombardy.* Bergamo, *Colleoni Chapel and the Basilica of Santa Maria Maggiore, façade.* GIOVANNI ANTONIO AMADEO. *12th, 14th and 15th centuries. In situ.* Stone with inlaid marble. The Colleoni chapel was built between 1470 and 1475 by G.A. Amadeo. The basilica of Santa Maria Maggiore was begun in 1137. In 1353 and 1375 G. da Compione carved the main doors of the transepts and the campanile was built in 1436. *(Photo: U.D.F. - La Photothèque.)*

82 *Art of Lombardy.* Milan, Santa Maria delle Grazie. GIOVANNI SOLARI and DONATO BRAMANTE. *1465-1498. In situ.* Begun in 1465 by Solari and enlarged by Bramante who also built the choir between 1492 and 1498. *(Photo: Alinari.)*

83 *Tuscan art.* LEONARDO DA VINCI. *Study for the equestrian Monument to Francesco Sforza. c. 1483-1484.* Windsor Castle, Royal library. Silverpoint on blue prepared paper (F° 12.358 r°); 0.148 × 0.185 m. Like Pollaiuolo in the equestrian monument he planned for the same patron, Leonardo introduced the theme of the 'fallen adversary'; a subject probably inspired by antique coins.

84 *Art of Lombardy.* GIOVANNI ANTONIO AMADEO. *Group of putti. After 1498.* London, Victoria and Albert Museum. Marble; high relief; 0.568 × 0.273 m.

85 *Neapolitan art.* Naples. The *Castelnuovo. 13th to 15th centuries. In situ.* Built in 1283, and enlarged in the second half of the 15th century under Alfonso I of Aragon. The entrance arch was carved in 1452-1466 by F. Laurana and Pietro di Martino da Milano. *(Photo: U.D.F. - La Photothèque.)*

86 *Neapolitan art.* Naples, Castelnuovo. FRANCESCO LAURANA and PIETRO DI MARTINO DA MILANO. *Triumphal arch of Alfonso I of Aragon. 1452-1466. In situ.* Commissioned by Alfonso I of Aragon from the Catalan studio of Sagrera in 1452 and finished, by the architects mentioned above, in 1466. *(Photo: U.D.F. - La Photothèque.)*

87 *Neapolitan art.* Naples, Castelnuovo. FRANCESCO LAURANA (attr.). *Triumphal arch of Alfonso I of Aragon (detail): griffin. 1452-1466. In situ.* cf. Ill. 86. *(Photo: U.D.F. - La Photothèque.)*

88 *Tuscan art.* Naples, Monte Oliveto (Santa Anna dei Lombardi) BENEDETTO DA MAIANO. *The Annunciation 1489. In situ.* Marble, bas-relief. Central section of a sculptured triptych. The scene of the Annunciation is surrounded by St Jerome on the right and St John the Baptist on the left. Above the saints are two sibyls in medallions. The predella consists of seven panels showing the life of Jesus. This triptych is of the same type as the one by A. Rossellino in the Piccolomini chapel in the same church. *(Photo: U.D.F. - La Photothèque.)*

89 *Neapolitan art.* Naples, San Pietro Martire. ANTONIO COLANTONIO. Polyptych (detail). *St Vincent Ferrer appears to a wrecked ship. c. 1450-1460. In situ.* Painted on panel. Part of a series of small pictures surrounding St Vincent Ferrer. The view is probably one of Naples. *(Photo: U.D.F. - La Photothèque.)*

90 *Neapolitan art.* Naples, San Pietro Martire. ANTONIO COLANTONIO. Polyptych of St Vincent Ferrer (detail) *St Vincent Ferrer kneeling before Christ. c. 1465. In situ.* Painted on panel. Composed of a central panel of St Vincent Ferrer, framed by small pictures showing miracles and events in the life of the Saint. *(Photo: U.D.F. - La Photothèque.)*

374

91 *Sicilian art.* Syracuse, San Girolamo fuori le mura. M. COSTANZO. *St Jerome (detail) 1468.* Syracuse. Cathedral, sacristy. Painted on panel; 2.05 × 0.95 m. Central subject of an altarpiece surrounded by scenes from the life of St Jerome. (Destroyed and dispersed after 1903.) A *cartellino* in the lower half of the large panel of St Jerome is signed, and dated 1468. (*Photo: Angelo Maltese.*)

92 *Southern Italian art.* ANTONELLA DA MESSINA. *The Condottiere. 1475.* (Signed and dated.) Paris, Louvre. Painted on panel; 0.35 × 0.38 m. (*Photo:U.D.F. - La Phototheque.*)

93 Nuremberg. HARTMANN SCHEDEL. *Liber Chronicorum: Panorama of Rome. 1493.* Vatican Library. Wood-engraving by M. Wholgemut; 0.23 × 0.536 m.

94 *Roman art.* Rome. ANON. *Mirabilia Urbis Romae. 1500.* Vatican Library. Woodcut; 0.103 × 0.066 m. Title-page of a guide-book containing lists of the Holy Places and indulgences interspersed with references to Antiquity.

95 *Roman art.* ANTONIO POLLAIUOLO. *Tomb of Pope Sixtus IV. 1484-1493.* Grotte Vaticane. Bronze high-relief; the base of the statue being decorated with bas-reliefs. (*Photo: Alinari-Giraudon.*)

96 *Roman art.* ANTONIO POLLAIUOLO. Tomb of Pope Sixtus IV (detail). *Face of the effigy. 1484-1493.* Grotte Vaticane. Bronze high-relief. (*Photo: Alinari.*)

97 *Roman art.* Vatican. MELOZZO DA FORLÍ. *Pope Sixtus IV appointing Platina Vatican Librarian. c. 1490* Vatican, Pinacoteca. Fresco transferred to canvas; 3.70 × 3.15 m. (*Photo: Pasquale de Antonis.*)

98 *Roman art.* Vatican. Borgia Appartments, Sala dei Sainti. BERNARDINO PINTURICCHIO. *St Antony Abbot, and St Paul the Hermit (detail); The Temptresses. 1493-1494. In situ.* Fresco. Part of a fresco in a small lunette. (*Photo: de Antonio.*)

99 *Roman art.* Rome, *Palazzo Riario or Palazzo della Cancelleria, façade.*

A. BREGNO and D. BRAMANTE *1483-1511. In situ. (Photo: Alinari.)*

100 *Roman art.* Rome, *Palazzo Riario or Palazzo della Cancelleria, the courtyard.* ANDREA BREGNO and BRAMANTE *1483-1511. In situ.* (*Photo: Alinari.*)

101 Rome. *Reconstruction of the Belvedere as it must have been at the death of Innocent VIII (1492).* Water-colour. This reconstruction is taken from Redig de Campos' work on the Belvedere, and is painted by Aurelio Barbagallo. *cf.* D. Redig de Campos, *II Belvedere di Innocenzo VIII in Vaticano, in Omaggio a Pio XII,* Vatican, 1958, tome II. (*Photo: Bibliothèque Nationale, Paris.*)

102 *Florentine art.* Vatican, Sistine Chapel. SANDRO BOTTICELLI. *The Temptation of Christ and the Leper's Sacrifice (detail). 1481-1482. In situ.* Fresco; overall dimensions: 3.45 × 5.55 m. In the background may be seen the façade of the Ospedale di Santo Spirito. (*Photo: Bruno del Priore.*)

103 *Roman art.* Rome, *Santa Maria del Popolo, façade.* BACCIO PONTELLI and ANDREA BREGNO. *1477. In situ.* Reconstruction started by Pontelli in 1472, and continued by Bregno. The date 1477 is carved on the architrave of the two lateral doors of the façade. (*Photo: Brogi.*)

104 *Tuscan art.* Vatican, St Peter's, Orsini chapel, known as San Biagio. ISAIA DA PISA. *Virgin and Child with SS. Peter and Paul and two Donors. c. 1447-1450.* Grotte Vaticane. Marble bas-relief. The two donors are Eugene IV and Cardinal Orsini. The head and arms of the Infant Jesus were broken, but have been restored.

105 *Roman art.* Vatican, Borgia Apartments, Sala dei Santi. BERNARDINO PINTURICCHIO. *The dispute of St Catherine of Alexandria (detail). 1493-1494. In situ.* Fresco. Part of 'The Dispute of St Catherine of Alexandria' in one of the two large lunettes. This detail shows the Emperor Maximian and the portraits of Andrea Paleologus and of Djem, the brother of Bajazet. (*Photo: De Antonis.*)

106 *Roman art.* Vatican, Borgia Apartments, Sala dei Santi. BERNARDO PINTURICCHIO. *Susanna at the Fountain (detail). 1493-1494. In situ.* Part of the Sala dei Santi frescoes. (*Photo: De Antonis.*)

107 Mainz. E. REEUWICH. *Panoramic View of Venice (detail). 1486.* Paris, Bibliothèque Nationale. Woodcut; overall dimensions: 0.293 × 1.655 m. View taken from Bernard von Breydenbach's 'Opusculum sanctarum peregrinationum in Terram Sanctam'.

108 *Venetian art.* LAZZARO BASTIANI. *The Funeral Rites of St Jerome. c. 1450.* Venice, Accademia. Painted on poplar wood. 1.52 × 0.25 m. Detail from a group of three episodes in the life of St Jerome: the Saint removing a thorn from the lion's paw, the Saint in the desert and the Saint's death. (*Photo: U.D.F. - La Phototheque.*)

109 *Venetian art.* Venice, Scuola di San Giovanni Evangelista. GENTILE BELLINI. Miracle of the True Cross (detail): *Women mourners. 1500.* Venice, Accademia. Canvas; overall dimensions : 0.325 × 0.430 m. This picture refers to the Miracle of the Cross which took place on the bridge of San Lorenzo. (*Photo: U.D.F. - La Phototheque.*)

110 *Venetian art.* Venice, Scuola di San Marco GENTILE and GIOVANNI BELLINI. *St. Mark preaching at Alexandria (detail). Late 15th - early 16th century.* Milan, Brera. Canvas. *cf.* Ill. 13. (*Photo: U.D.F. - La Phototheque.*)

111 *Venetian art.* Venice, *Palazzo Vendramin-Calergi, façade.* MAURO CODUCCI and the LOMBARDI. *c. 1501-1509. In situ.* Begun by M. Coducci in 1481, finished by the Lombardi in 1509. (*Photo Osvaldo Böhm.*)

112 *Venetian art.* Venice, *Santa Maria dei Miracoli, façade.* PIETRO LOMBARDO and his sons. *c. 1481-1489. In situ.* Façade decorated with marble inlay, and porphyry crosses. (*Photo: Osvaldo Böhm.*)

113 *Venetian art. ANON. Hero leaping from the tower of Sestos. 1495.* Paris, Bibliothèque Nationale. Wood-engraving; page height : 0.189 m. Illustration for the poem *Hero and Leader* by Musaeus edited in Venice by Aldus Manutius.

114 *Venetian art.* ANON. *Hypnero-tomachia. Group in a garden. 1499.* Paris, Bibliothèque Nationale. Wood-engraving (F° Z9, v°). *cf.* Ill. 41.

115 *Venetian art.* Venice, Santa Maria Gloriosa dei Frari. MARCO CA-NOZZI, LORENZO LENDINARA and an unknown STRASBOURG MASTER. *Stalls (detail) 1468. In situ.* Wood-carving, bas-relief and marquetry. The Frari Stalls consist of marquetry panels and moulding by M. Canozzi and L. Lendinara and back-rests carved by an unknown master from Strasbourg. *(Photo: U.D.F. - La Photothèque.)*

116 *Venetian art.* Venice, Santa Maria Gloriosa dei Frari. ANON. STRAS-BOURG MASTER. *Stalls (detail) 1468. In situ.* Wood bas-relief. *cf.* Ill. 115. *(Photo: Osvaldo Böhm.)*

117 *Tuscan art.* GUIDO DA SARA-VALLINO. *Still Life. End of the 15th century.* Pisa, Cathedral Sacristy. Marquetry. *(Photo: U.D.F. - La Photothèque.)*

118 Pienza. *Aerial view.* From *L'Arte nel Rinascimento.* T.C.I., 1962, pl. 10, fig. 16.

119 After MAYREDER. *A plan of Pienza.* This is reconstruction of the plan of Pienza drawn up by A. Rossellino in 1462 at the time of the transformation of the town by Pope Pius II Piccolomini. *(Photo: Bibliothèque Nationale, Paris.)*

120 *Florentine art.* Florence Cathedral. East façade of the Campanile DONA-TELLO. *A Prophet. 1415-1420.* Florence, Opera del Duomo. Marble. 1.90 m. (full height). *(Photo: Alinari.)*

121 *Florentine art.* Padua, Sant' Antonio. DONATELLO. *High Altar (detail) 1446-1450. In situ.* Bronze bas-relief; 0.57×1.23 m. The High Altar, which had been broken up and dispersed was reconstructed in 1895, and decorated with Donatello's bronzes from the original altar *(Photo: Anderson-Giraudon.)*

122 *Roman art.* ANTONIO POL-LAIUOLO. *Tomb of Pope Sixtus IV (detail): Arithmetic. 1483-1493.* Grotte Vaticane. Bronze, bas-relief. One of the eight allegories of the liberal arts which decorate the sar-cophagus of Sixtus IV. *(Photo: Alinari-Giraudon.)*

123 *Tuscan art.* ANTONIO and PIERO POLLAIUOLO. *Tobias and the Archangel Raphael. c. 1465.* Turin, Pinacoteca. Painted on panel; 1.87× 1.18 m. *(Photo: Chonon Perino.)*

124 *Paduan art.* ANON. *Plan of Padua (detail). c. 1450-1460.* Padua, Museo Civico. Drawing on parchment; 1.17×1.01 m.

125 *Paduan art.* Padua, Chapel of Leon de Lazzara, altarpiece. FRAN-CESCO SQUARCIONE. *Polyptych of St Lazarus. c. 1449-1452.* Padua, Museo Civico. Painted on panel with carved frame. 1.75×2.20 m. *(Photo: U.D.F. - La Photothèque.)*

126 *Paduan art.* BERNARDO PAREN-TINO (Known as FRA LORENZO) *Franciscan mystical scene (detail). Second half of the 15th century.* Venice, private collection. Painted on panel. *(Photo: U.D.F. - La Photothèque.)*

127 *Paduan art.* ANDREA MANTE-GNA. *Triptych. Right panel: the Circumcision. 1450.* Florence, Uffizi. Painted on panel; 0.86×0.425 m. According to some authorities it formed part of a triptych now in the Uffizi which was reconstructed in 1827 in a modern frame with the Ascension in the centre and the Ado-ration of the Magi on the left. Accord-ing to others, the work in question never belonged to this group and was in fact painted earlier than the two panels mentioned. *(Photo: U.D.F. - La Photothèque.)*

128 *Paduan art.* JACOPO DA MON-TAGNANA. *Triptych (detail): The Archangel Michael. 1496.* Padua, chapel of the Archbishop's palace. Painted on panel. Triptych com-posed of the Archangel Michael on the left, the Annunciation in the centre and the Archangel Raphael on the right. *(Photo: U.D.F. - La Photothèque.)*

129 *Paduan art.* GIORGIO SCHIA-VONE. *Virgin and Child. Late 15th century.* Baltimore, Walters Art Gallery. Painted on panel.

130 *Paduan art.* GIORGIO SCHIA-VONE. *Virgin and Child. c. 1460.* Turin, Pinacoteca. Painted on panel; 0.72×0.62 m. Signed on a *cartellino* before the Virgin: 'Opus Sclavoni Dalmatis Squarcioni'. Zam-petti compares this *Virgin and Child* with that by Crivelli in the Verona Museum, and dates it around 1460. *(Photo: Chonon Perino.)*

131 *Art of Bologna.* Bologna, Collegio di Spagna. MARCO ZOPPO. Trip-tych (detail): *The Virgin and Child c. 1461-1463. In situ.* Painted on panel, carved wooden frame; 2.08× 2.35 m. Altarpiece. Signed: 'Opera del Zoppo da Bologna' Cen-tral panel of a triptych composed of St Andrew and St Augustine on the left; the Virgin and Child in the centre, and St Jerome on the right. On the predella are the calling of the Apostles, the Nativity, and St Jerome in prayer. *(Photo: U.D.F. - La Photothèque.)*

132 *Art of Ferrara.* NICOLETTO DA MODENA (attr.). *Fortuna. Early 16th century.* London, British Mu-seum, line-engraving; 0.261×0.182 m.

133 *Paduan art.* ANDREA RICCIO. *Warrior on horseback. Early 16th century.* London, Victoria and Albert Museum. Bronze; height: 0.41 m.

134 *Venetian art.* Venice, Sant' Andrea della Certosa, Morosini chapel. BAR-TOLOMMEO VIVARINI. Polyp-tych (detail); *St Andrew. 1464.* Venice, Accademia. Painted on panel; 1.08×0.36 m. Part of the Casa Morosini polyptych with St John the Baptist and St Andrew on the left, the Virgin and Child in the centre and St Dominic and St Peter on the right. *(Photo: U.D.F. - La Photo-thèque.)*

135 *Art of Lombardy.* Milan, San Pietro in Gessate, Grifi chapel. BER-NARDO BUTINONE, and B. ZE-NALE. *The Hanged Man. c. 1490-1493. In situ.* Fresco. Part of the cycle depicting the story of St Am-brose. *(Photo: Scala.)*

136 *Florentine art.* ANTONIO FILA-RETE. *Virgin and Child surrounded by angels. Second half of the 15th century.* Paris, Louvre. Bronze pla-que; 0.29×0.205 m. *(Photo: U.D.F. - La Photothèque.)*

137 *Art of Lombardy.* Parma, San Pietro Martire. GIOVANNI ANTONIO AMADEO. *The Flight into Egypt. 1484-1485.* Parma, Museo Nazionale d'Antichità. Marble, bas-relief; 1.23 ×0.73 m.

138 *Art of Verona.* DOMENICO MO-
RONE (attr.) Cassone panel. *Scene
at a Tournament. c. 1490.* London,
National Gallery. Painted on panel;
0.455×0.49 m. *(Photo: U.D.F. -
La Photothèque.)*

139 *Art of Verona.* LIBERALE DA
VERONA. *Adoration of the Magi.
c. 1500.* Verona, Cathedral Museum.
Painted on panel. *(Photo: U.D.F. -
La Photothèque.)*

140 *Venetian art.* Montefiore dell' Aso
San Francesco. CARLO CRIVEL-
LI. Triptych (detail): *St Mary
Magdalen. Late 15th century.* Mon-
tefiore Dell' Aso, Santa Lucia. Pain-
ted on panel; dimensions: 1.74×
0.54 m. According to Zampetti,
this panel was part of a large polyp-
tych (now dispersed) in the church
of San Francesco. *cf.* Exhibition
Catalogue *Crivelli e i Crivelleschi,*
Venice, 1961. *(Photo: Fabri.)*

141 *Venetian art.* Ascoli Piceno, Cathe-
dral, Chapel of the Holy Sacrament.
CARLO CRIVELLI. Polyptych
(detail) *Pietà. 1473. In situ.* Painted
on wood; 0.61×0.64 m. Central
panel of the upper register of the
polyptych. Signed and dated: 'Cri-
velli Veneti, 1473'. *(Photo: U.D.F.
- La Photothèque.)*

142 *Art of Ferrara.* Ferrara, Palazzo
Schifanoia. Sala dei Mesi FRAN-
CESCO DELL COSSA. *The Month
of March (1st decade) 1458-1478. In
situ.* Fresco. Dimensions of the
room: length: 24 m., width: 11 m.,
height: 7.50 m. Allegorical figure,
part of a series of subjects in the
central zone of the East wall.
(Photo: U.D.F. - La Photothèque.)

143 *Art of Ferrara. Virgin and Child.
Late 15th century.* Edinburgh, Nat-
ional Gallery of Scotland. Painted
on Panel; 0.60×0.46 m. Attributed
by Venturi to E. de' Roberti, and by
Berenson to F. del Cossa. *(Photo:
Tom Scott.)*

144 *Paduan art.* Master signing himself
'P.P.'. *The Triumph of the Moon.
Late 15th century.* London, British
Museum line-engraving; overall di-
mensions: 0.180×0.225 m. The
device 'P.P.' does not refer to the
engraver but to the artist himself.
The artist has been identified with

B. Parentino who originally came
from Romagna, but worked in
Padua.

145 *Paduan art.* Master signing himself
'P.P.'. *The Triumph of the Moon
(detail). Late 15th century.* London,
British Museum. *cf.* Ill. 144.

146 *Paduan art.* BERNARDINO PA-
RENTINO. *Temptation of St An-
tony. Second half of the 15th century.*
Rome, Doria Gallery. Painted in
oils on panel; 0.45×0.58 m. *(Photo:
U.D.F. - La Photothèque.)*

147 *Art of Verona.* LIBERALE DA
VERONA. *Gradual. Calling of
St Matthew. c. 1470.* Siena, Libre-
ria Piccolomini. Illuminated ma-
nuscript illustrating a Gradual entitled
the *Graduale della domenica di Settua-
gesima alla domenica terza di Quaresima.*
(Photo: U.D.F. - La Photothèque.)

148 *Umbrian art.* Perugia, Oratory of
San Bernardino. AGOSTINO DI
DUCCIO. *West façade (detail).
Tympanum. 1457-1461. In situ.*
(Photo: Alinari.)

149 *Umbrian art.* Perugia. Oratory of
San Bernardino. AGOSTINO DI
DUCCIO. *West façade. 1457-1461.
In situ. (Photo: U.D.F. - La Photo-
thèque.)*

150 *Tuscan art.* AGOSTINO DI DUC-
CIO. *Virgin and Child surrounded by
Angels. Late 15th century.* Paris,
Louvre. Marble bas-relief; 0.81×
0.77 m. *(Photo: U.D.F. - La
Photothèque.)*

151 *Art of the Marches.* GIOVANNI DI
BOCCATI. *Virgin and Child sur-
rounded by Angels. Late 15th century.*
Settignano, Berenson collection.
Painted on panel. 0.84×0.55 m.
According to B. Berenson this work
is typical of Boccati's second stay
in the Marches (between 1458 and
1470). *(Photo: Arte Grafiche Ri-
cordi.)*

152 Urbino. *Aerial view. (Photo: Foto-
mero.)*

153 *Umbrian art.* Perugia, Oratory of
San Bernardino. PERUGINO. *The
Life of St Bernardino: Healing of a
man injured by a bull. 1473.* Perugia,
National Gallery of Umbria. Tem-

pera on panel; 0.775×0,57 m. Part
of the series of eight pictures extend-
ing over two panels, and showing
scenes from the life of St Bernardino.
The scenes represented are: the healing
of the man with paralysis; the freeing
of the prisoner; the miracle of the
eagle; the healing of a child; the
healing of a man injured by a blow
from a spade; two miracles of Saint
Bernardino; the resurrection of the
still-born child, and the healing of
a man injured by a bull. *(Photo:
U.D.F. - La Photothèque.)*

154 *Art of Urbino.* Senigallia, Santa
Maria delle Grazie fuori le mura.
PIERO DELLA FRANCESCO.
Senigallia Madonna. c. 1472. Urbino,
National Gallery of the Marches.
Painted on walnut; 0.61×0.533 m.
(Photo: U.D.F. - La Photothèque.)

155 *Tuscan art.* Viterbo, Santa Maria
della Verità. LORENZO DA VI-
TERBO. *Marriage of the Virgin
(detail). 1469. In situ.* Fresco. The
central part of the fresco has been
destroyed, and the figures between
the Virgin and St Joseph have been
silhouetted by a bistre coloured line.
(Photo: U.D.F. - La Photothèque.)

156 *Art of the Marches.* Rome, Santi
Apostoli, Apse. MELOZZO DA'
FORLI. *Angel Musician. c. 1478-
1480.* Vatican, Pinacoteca. Fresco
Part of the frescoes showing Christ
giving his blessing surrounded by
the Apostles and by angels playing
musical instruments. The frescoes
were in the apse of the Santi Aposoli
in Rome. *(Photo: Pasquale de Antonis.)*

157 *Art of Urbino.* Urbino, Sacristy of
the old Cathedral. PIERO DELLA
FRANCESCA. *The Flagellation (de-
tail). c. 1460-1469.* Urbino, Nation-
al Gallery of the Marches. Painted
on poplar wood. 0.59×0.815 m.
It is probably one of the small pic-
tures mentioned by Vasari. *(Photo:
U.D.F. - La Photothèque.)*

158 *Umbrian art,* Fabriano, Santa Maria
del Mercato LUCA SIGNORELLI.
The Flagellation. 1475. Milan,
Brera. Painted on poplar wood.
0.84×0.60 m. Signed on the frieze
background wall 'Opus Luce Cor-
tonensis'. A similar panel representing
the Virgin and Child was jointed to
this, and together they were origin-
ally used as processional standards.
(Photo: U.D.F. - La Photothèque.)

159 *Umbrian art.* Vatican, Sistine chapel. PERUGINO. *The Remission of the Keys to St Peter. 1481-1482. In situ.* Fresco; about 3.35 × 5.50 m. Part of the series of frescoes commissioned between 1481 and 1482 by Sixtus IV from D. Ghirlandaio, S. Botticelli, C. Rosselli and Perugino and which were destined for the decoration of the Sistine chapel. *(Photo: Pasquale de Antonis.)*

160 *Art of Urbino.* Urbino, Ducal Palace. PIERO DELLA FRANCESCA. *Diptych of the dukes of Urbino, right wing (detail); Federico da Montefeltro c. 1465.* Florence, Uffizi. Painted on panel; dimensions of each panel: 0.47×0.33 m. This portrait forms part of a diptych of which the left panel is the portrait of Battista Sforza. It was executed during Piero della Francesca's stay at Urbino. On the reverse sides of the panels are two allegorical triumphs. *(Photo: U.D.F. - La Photothèque.)*

161 *Art of Urbino.* Ducal Palace PEDRO BERRUGUETE (attr.) *Federico da Montefeltro and his son Guidobaldo (detail). 1476-1477. In situ.* Painted on poplar wood. Overall dimensions: 1.36×0.82 m. For a long time this was attributed to Justus of Ghent but today the majority of critics consider it to be the work of Berruguete. *(Photo: U.D.F. - La Photothèque.)*

162 *Art of Ferrara.* Ferrara, Schifanoia Palace, Sala dei Mesi. ERCOLE DE' ROBERTI. *The Month of September (detail): Vulcan's Forge 1458-1478. In situ.* Fresco; dimensions of the room: length: 24 m.; width: 11 m.; height: 7.50 m. Part of the series of allegorical subjects decorating the upper section of the North wall. *(Photo: Scala.)*

163 *Art of Bologna.* Bologna, Santa Maria della Vita. NICCOLO DELL' ARCA. *Deposition from the Cross (detail): St John. c. 1485. In situ.* Terracotta. *(Photo: U.D.F. - La Photothèque.)*

164 *Tuscan art.* Arezzo. San Francesco. PIERO DELLA FRANCESCA. *Victory of Constantine over Maxentius (detail): Constantine's trumpeter. 1452-1459. In situ.* Fresco; overall dimensions: 3.29×7.64 m. One of the principal scenes from 'The Story of the True Cross'. *(Photo: Alinari.)*

165 *Art of Ferrara.* Ferrara, Cathedral COSIMO TURA. *St George and the Princess (detail). 1469.* Ferrara, Opera del Duomo. Canvas; overall dimensions: 4.13×3.38 m. The two panels of St George and the Princess and those of the Annunciation originally decorated the Cathedral organ. They were removed in the 18th century. *(Photo: U.D.F.- La Photothèque.)*

166 *Art of Ferrara.* Ferrara, Schifanoia Palace, Sala dei Mesi. FRANCESCO DEL COSSA. *The Month of April (detail): The Three Graces and the Group of Lovers. 1458-1478. In situ.* Fresco; dimensions of the room: length: 24 m.; width: 11 m.; height: 7.50 m. Part of the series of allegorical subjects decorating the upper section of the East Wall. *(Photo: U.D.F. - La Photothèque.)*

167 *Art of Ferrara.* Ferrara, Schifanoia Palace, Sala dei Mesi. FRANCESCO DEL COSSA. *The Month of April (detail): The Garden of Love, 1458-1478. In situ.* Fresco. *Cf.* Ill. 166. *(Photo: U.D.F. - La Photothèque.)*

168 Orvieto Cathedral. LUCA SIGNORELLI. *Study for the Resurrection of the Dead (detail). c. 1498-1499. In situ.* Drawing on intonaco. *(Photo: Scala.)*

169 *Florentine art.* Florence, Santa Maria Novella. FILIPPINO LIPPI. *Strozzi Chapel. 1487-1502. In situ.* Frescoes; height: 12 m.; width: 6.14 m., (side walls). The frescoes show the lives of St Philip and St John the Evangelist. *(Photo: Alinari.)*

170 *Art of Lombardy.* Lodi, *Santa Maria Incoronata, Interior.* GIOVANNI DI DOMENICO BATTAGIO. *c. 1488-1494. In situ.* A type of centrally planned church begun by G. Domenico Battagio (1488-1494), continued by G. Dolcebuono; the cupola was finished by G.A. Amadeo in 1513. *(Photo: U.D.F. - La Photothèque.)*

171 *Central Italian art.* Rome, Santa Maria in Aracoeli. BERNARDINO PINTURICCHIO. *Bufalini Chapel. 1485. In situ.* Frescoes. This chapel is decorated with scenes from the life of St Bernardino. *(Photo: U.D.F. - La Photothèque.)*

172 *Tuscan art.* Pisa, Campo Santo. BENOZZO GOZZOLI. *Cursing of Ham (detail) 1467-1484. In situ.* Fresco. Part of the Old Testament cycle which was badly damaged in 1944, and is now being restored. *(Photo: Anderson.)*

173 *Tuscan art.* Pisa, Camp Santo. BENOZZO GOZZOLI. *Building of the Tower of Babel (detail): 1467-1484. In situ.* Fresco. *(Photo: U.D.F. - La Photothèque.)*

174 *Tuscan art.* Arezzo. San Francesco. PIERO DELLA FRANCESCA. *The Story of the True Cross. The Discovery of the Cross (detail): A View of Jerusalem. 1452-1459. In situ.* Fresco; overall dimensions: 3.56× 7.47 m. *(Photo: Scala.)*

175 *Umbrian art.* Rome, Santa Maria in Aracoeli, Bufalini chapel. BERNARDINO PINTURICCHIO. *Funeral Rites of St Bernardino (detail). 1490. In situ.* Fresco: Part of the cycle of the life of St Bernardino in the Bufalini chapel. *Shaded to demonstrate the architectural setting and scenic development. (Photo: Scala.)*

176 *Umbrian art.* Orvieto Cathedral, Capella della Madonna di Brizio. LUCA SIGNORELLI. *The Antichrist (detail): 1499-1504. In situ.* Fresco. Detail of a cycle in which Signorelli shows the Antichrist (whose coming is probably identified with the recent career of Savonarola) and the end of the world. *Shaded to demonstrate the architectural setting and scenic development. (Photo: Scala.)*

177 *Mantuan art.* Mantua, Ducal Palace. ANDREA MANTEGNA. *Sala degli Sposi. 1468-1474. In situ.* Fresco; square room with walls 8.05 m. long. Also known as the *Camera picta.* The fresco was finished in 1474 as is indicated by the inscription above the door. Cycle of frescoes of the life of the Gonzaga family. *(Photo: U.D.F. - La Photothèque.)*

178 *Paduan art.* Padua, Santa Giustina. Chapel of St Luke. ANDREA MANTEGNA. *St Luke Polyptych. 1453.* Milan, Brera. Painted on panel; 2.30×1.77 m. Polyptych of ten panels in two tiers, in a modern frame. Commissioned by the monks of Santa Giustina of Padua on 10 August 1453. *Shaded to demonstrate the building up of a polyptych by means of separate panels beneath pointed arches. (Photo: U.D.F. - La Photothèque.)*

179 *Paduan art.* Verona. San Zeno. ANDREA MANTEGNA. *San Zeno Altarpiece. 1459-1460.* Verona, Paris, Tours. 4.80×4.50 m. Altarpiece commissioned by the protonotary Gregorio Correr for the high altar of the Church of San Zeno in Verona. It was taken to France in 1797, and was returned to the church in 1815, with the exception of the predella, of which the three panels are divided between the Louvre and the Museum at Tours. Copies of these three panels have been substituted in the Altarpiece itself. *Shaded to demonstrate the architectonic framing and the enormous pediment 'all' antica'. (Photo: Anderson-Giraudon.)*

180 *Venetian art.* Ascoli Piceno. Cathedral, chapel of the Holy Sacrament. CARLO CRIVELLI. *Polyptych. 1473. In situ.* Carved frame. Overall dimensions (including pinnacles); 3.64×2.80 m., signed and dated on the base of the Virgin's throne in the central panel: *Opus Karoli Crivelli Veneti 1473. Shaded to demonstrate the floret motif in the framing which is reminiscent of frames in the 'flamboyant' style. (Photo: U.D.F. - La Photothèque.)*

181 *Venetian art.* Pesaro, San Francesco. GIOVANNI BELLINI. Altarpiece: *Coronation of the Virgin. c. 1475.* Pesaro, Museo Civico. Painted on panel; 2.62×2.40 m. This altarpiece, signed 'Joannes Bellinus' on the Virgin's throne, was dispersed in 1797. The pediment which depicted a *Pietà* is now in the Vatican picture gallery and has been replaced on the altarpiece by a modern St Jerome. The whole altarpiece has been restored several times; the most recent of these restorations was in 1948. *Shaded to demonstrate a classical framing. (Photo: U.D.F. - La Photothèque.)*

182 *Art of the Marches.* GIOVANNI DI BOCCATI. *Marriage of the Virgin. Second half of the 15th century.* Settignano, Berenson collection. Painted on panel; 0.205×0.60 m. This attribution was contested for a long time, but is now acknowledged to be correct. According to F. Zeri, this panel was part of the predella of an altarpiece the components of which have been dispersed, and the central subject of which was an Annunciation. *(Photo: U.D.F. - La Photothèque.)*

183 *Sienese art.* MATTEO DI GIOVANNI. *Appearance of SS. Jerome and John to St Augustine. 1482.* Chicago, *The Art Institute* (Martin A. Ryerson collection) Tempera on panel; 0.374×0.660 m.

184 *Sienese art.* Sienna, San Domenico. FRANCESCO DI GIORGIO. *Nativity. c. 1480-1490. In situ.* Painted on panel. *Shaded to demonstrate the architectonic setting. (Photo: U.D.F. - La Photothèque.)*

185 *Umbrian art.* Vatican, Sistine chapel. PERUGINO. *The Remission of the Keys to St Peter (detail). 1481-1482. In situ.* Fresco: overall dimensions: c. 3.35×5.50 m. *Shaded to demonstrate the architectural background. (Photo: Pasquale de Antonis.)*

186 *Paduan art.* BARTOLOMMEO MONTAGNA. *St Peter. 1476.* Padua, private collection. Oil on panel. *The lighter areas indicate attempts at restoration. (Photo: Scala.)*

187 *Art of Ferrara.* GALASSI-GALASSO (?) Muse. *Late 15th century.* Budapest, Museum of Fine Arts. Dimensions: 1.05×0.387 m.

188 *Florentine art.* Medici collection. SANDRO BOTTICELLI. *Calumny of Appeles (detail) 1485-1490.* Florence, Uffizi. Painted on panel. *Cf. Ill. 49. (Photo: U.D.F. - La Photothèque.)*

189 ANTONIO PISANELLO. *Project for the gate of the Castelnuovo, Naples. c. 1450.* Rotterdam, Boymans-van Beuningen Museum. Pen and brown wash over black crayon; 0.311×0,162 m. *(Photo: Frequin.)*

190 *Florentine art.* Rome, Santa Maria sopra Minerva MINO DA FIESOLE.

Tomb of Francesco Tornabuoni. c. 1480. In situ. Marble. *(Photo: Alinari.)*

191 *Venetian art.* Venice, SS. Giovanni e Paolo. PIETRO LOMBARDO. *Tomb of Pietro Mocenigo. c. 1476-1481. In situ.* Marble sculpture and bas-relief decorations. Type of wall tomb constructed in the manner of the great sculptured retables with columns and in tiers. Under the arch the statue of the Doge Pietro Mocenigo dominates the sarcophagus. *(Photo: Ferruzzi.)*

192 *Sienese art.* Cortona, *Santa Maria delle Grazie del Calcinaio, interior.* FRANCESCO DI GIORGIO. *1485. In situ.* Decorative facing in *pietra serena. (Photo: Alinari.)*

193 *Art of Lombardy.* Brescia, *Santa Maria dei Miracoli, façade.* GIOVANNI DA VERONA *1488-1508. In situ.* Marble facing. *(Photo: Scala.)*

194 *Art of Lombardy.* Brescia, *Santa Maria dei Miracoli, façade (detail).* GIOVANNI DA VERONA. *1488-1508. In situ.* Marble facing. *(Photo: Alinari.)*

195 *Art of Lombardy.* Como, *Cathedral, façade (detail).* TOMASO RODARI *1463-1486. In situ.* Marble decorations; Height of the central part: 38.70 m. T. Rodari only took part in the work on the cathedral from 1484 onwards. In 1487 he was appointed permanent engineer to the cathedral, and he worked there till 1526. *(Photo: Anderson.)*

196 *Tuscan art.* Lucca Cathedral. MATTEO CIVITALI. *'Tempetto' del Volto Santo. 1481-1484. In situ.* Marble. *(Photo: Alinari.)*

197 *Art of Lombardy.* Bergamo, *Colleoni Chapel, interior.* GIOVANNI ANTONIO AMADEO *1470-1475. In situ.* The Colleoni Chapel contains the tombs of B. Colleoni and his daughter M. Colleoni, both of which were constructed by Amadeo. *(Photo: Alinari.)*

198 *Florentine art.* MASO FINIGUERRA (attr.). *A Florentine Picture-Chronicle: Linus and Musaeus. c. 1460.* London, British Museum. Pen and wash. *Cf. Ill. 6.*

199. *Tuscan art.* FILIPPINO LIPPI. *Drawing of a young girl. 1489-1493.* Florence, Uffizi. Pen drawing: lead carbonate on grey paper. 0,251 × 0.203 m. *(Photo: U.D.F. - La Photothèque.)*

200. *Florentine art.* BENOZZO GOZZOLI. *Portrait of a little girl. c. 1460.* Florence, Uffizi. Drawing on pink paper; 0.14×0.09 m. *(Photo: U.D.F. - La Photothèque.)*

201. *Tuscan art.* LEONARDO DA VINCI. *Drapery study for a seated figure. 1470-1472.* Paris, Louvre. Brush drawing on linen, white highlights; 0.266×0.234 m. One of a well-known series of studies of which one is in the British Museum, three are in the Louvre, five in the collection of the Comtesse de Behage, three in the Uffizi, and one in the Museum at Rennes. *(Photo: U.D.F. - La Photothèque.)*

202. *Florentine art.* LORENZO DI CREDI. *Angel. 15th century.* London, British Museum. Silverpoint and ink, heightened with brown and white water colour, on a mauve-pink background; 0.243×0.182 m.

203. *Florentine art.* FILIPPO LIPPI. *Virgin and Child with St John the Baptist. c. 1460.* Florence, Uffizi. Silverpoint heightened with white on prepared brown paper; 0.327×0.237 m. Probably the preparatory drawing for the painting in the Uffizi. *(Photo: U.D.F. - La Photothèque.)*

204. *Florentine art.* LORENZO DI CREDI. *Head of an Old Man. Second half of the 15th century.* Paris, Louvre, Cabinet des dessins (inv. 1779). Black chalk on pink tinted paper with white highlights (some of which were added at a later date); height: 0.295× width 0.211 m. (without the margin). *(Photo: U.D.F. - La Photothèque.)*

205. *Florentine art.* DOMENICO GHIRLANDAIO. *Head of an Old Man. c. 1488.* Stockholm, Royal Library. Drawing; 0.34×0.295 m. Study for the painting in the Louvre: *Portrait of an old man and his grandson.* This drawing was part of the *Libro de Vasari. (Photo: National museum.)*

206. *Tuscan art.* LEONARDO DA VINCI. *Head of a Woman. c. 1484-*

1486. Paris, Louvre. Silverpoint on a prepared green paper; 0.18× 0.168 m. Study for the Madonna Litta according to Berenson. This is one of Leonardo da Vinci's earliest drawings. Dumonts and Bodmer place it around 1490-1494. *(Photo: U.D.F. - La Photothèque.)*

207. *Art of Verona.* LIBERALE DA VERONA. *Angels playing musical instruments. 14th to 15th centuries.* London, British Museum. Pen drawing on pale blue paper; 0.28 ×0.284 m.

208. *Florentine art.* ANTONIO POLLAIUOLO. *Hercules and the Hydra. c. 1494.* London, British Museum. Pen and brown ink; 0.235×0.165 m. Sketch for a painting in which Pollaiuolo represented the labours of Hercules and in particular Hercules and the Hydra—which he mentions in a letter in 1494.

209. *Venetian art.* GIOVANNI BELLINI (attr.). *Portrait of a Man. Late 15th century.* Oxford, Christ Church Library. Black crayon drawing with pale grey watercolour; 0.392×0.28 m. There have been many opinions as to the authorship of this portrait. Bel attributed it to Alvise Vivarini, Colvin and Popham attributed it to Francesco Bonsignori, Tietze and Parker regarded it as the work of either Mantegna or Giambellino and finally, Shaw attributed it to Giovanni Bellini—the only attribution that is currently accepted. *(Photo: Walker Art Gallery.)*

210. *Florentine art.* LEONARDO DA VINCI. *Study for the Virgin of the Louvre Annunciation (?). c. 1480.* Florence, Uffizi. Silverpoint, pen and bistre. 0.282×0.199 m. *(Photo U.D.F. - Draeger.)*

211. *Venetian art.* JACOPO DE' BARBARI. *Apollo and Diana. c. 1502.* Paris, Bibliothèque Nationale. Copper-engraving; 0.160×0.100 m. This subject was repeated by Dürer in 1502 and by the German sculptor Hans Vischer who in 1532 reproduced in bronze the statue of Apollo which formed part of the Nuremberg fountain.

212. *Florentine art.* RAFFAELLINO DEL GARBO. *Angel holding the Infant Jesus. Second half of the 15th century.*

Florence, Uffizi. Silverpoint heightened with white on prepared pink paper (F° 207); 0.215×0.205 m. Berenson attributes it to Raffaellino del Garbo, and this is the only one retained inspite of the signature which appears to be entirely unauthentic. *(Photo: U.D.F. - La Photothèque.)*

213. *Venetian art.* JACOPO BELLINI. *St George and the Dragon. c. 1445.* London, British Museum. Silverpoint; 0.415×0.335 m.

214. *Florentine art.* LEONARDO DA VINCI. *Study of an Angel, Riders and other figures. c. 1505.* Windsor Castle, Royal Library. Pen and black chalk (12328 r°); 0.21×0.283 m. Reverse: pen sketches of a head and horses galloping.

215. *Tuscan art.* FRANCESCO DI SIMONE (attr.). *Studies of Saints and Putti. c. 1487.* London, British Museum. Pen and brown ink with touches of chalk on pink paper (57 a, r°); 0.272×0.19 m. Other sheets exist at the Musée de Chantilly dated 1487 and at the Ecole des Beaux-Arts in Paris which bear the date 1488, and as they are of the same format, they might be part of the same series or from the same notebook.

216. *Florentine art.* FRANCESCO DI GIORGIO (attr.). *Studies of Nudes. c. 1495.* Florence, Uffizi Drawing (F° 269E, v°); 0.203×0.276 m. *(Photo: Alinari.)*

217. *Florentine art.* MASO FINIGUERRA. *Florentine Picture-Chronicle.* The Death of Hercules. *c. 1460.* London, British Museum. Pen and wash drawing. *Cf. Ill. 6.*

218. *Florentine art.* CRISTOFORO ROBETTA (signed R.T.B.A.). *Faith and Charity (detail). Late 15th - Early 16th century.* Paris, Bibliothèque Nationale, Cabinet des Estampes. Line-engraving; 0.195 × 0.169 m.

219. *Florentine art.* ANON. The Vienna Passion: *The Flagellation. c. 1460-1470.* Vienna, Albertina. Line-engraving painted in grey-black ink on brown paper; 0.218×0.129 m. (including surround). Part of the 'Vienna Passion' series and, according to Hind, it is the work of the same artist who engraved the 'Triumphs of Petrarch' in Vienna.

220 *Florentine art.* ANON. *Aristotle and Phyllis. c. 1480-1500.* Hamburg, Kunsthalle. Line-engraving; 0.207 × 0.137 m. *(Photo: Musée Kleinhempel.)*

221 LUCANTONIO DEGLI UBERTI (signed L.A.F.) *Seated Woman with two children playing in a landscape. Early 16th century.* London, British Museum. Line-engraving; 0.216 × 0.171 m.

222 THE MASTER OF THE BIRD. *St Sebastian. Early 16th century.* London, British Museum. Line-engraving; 0.207 × 0.146 m.

223 *Mantuan art.* ANDREA MANTEGNA. *Battle of the Sea Gods. c. 1481-1490.* London, British Museum. Line-engraving; 0.307 × 0.417 m. Original of the fresco painted for the Gonzagas in the castle of Marmirolo. *(Archives photographiques. Monuments historiques.)*

224 *Paduan art.* ANDREA MANTEGNA. *Seated Madonna (second state). c. 1466-1470.* Vienna, Albertina. Line-engraving; 0.210 × 0.221 m.

225 *Florentine art.* ANTONIO POLLAIUOLO. *Battle of the Nudes. 1470.* Paris, Petit Palais. Line-engraving; 0.387 × 0.565 m. Signed and dated. *(Photo: U. D. F. - La Photothèque.)*

226 *Florentine art.* ANON. *Beheading of a Prisoner. c. 1460-1470.* Hamburg, Kunsthalle. Line-engraving; 0.256 × 0.182 m. *(Photo: Musée Kleinhempel.)*

227 *Art of Lombardy. Certosa di Pavia (detail): window.* School of GIOVANNI ANTONIO AMADEO. *c. 1490. In situ.* Stone. Part of the lower section of the façade of the monastery where windows and small columns give the effect of candelabra. *(Photo: U.D.F. - La Photothèque.)*

228 *Mantuan art.* ZOAN ANDREA. *Two Lovers. c. 1500.* Milan, Biblioteca Ambrosiana. Line-engraving (first state); 0.205 × 0.155 m.

229 *Florentine art.* ANON. *Death flying over four figures lying on the ground. c. 1500.* Paris, Bibliothèque Nationale. Woodcut. Page height: 0.190 m. Title page of Savonarola's *Predica dell'arte del Ben Morire.*

230 *Venetian art.* ANON. *Hypnerotomachia. Poliphilus in the dark forest. 1499.* Paris, Bibliothèque Nationale. Woodcut (F° a.3, v°). Page height: 0.285 m. *Cf.* Ill. 41.

231 *Venetian art.* ANON. *Herodotus crowned by Apollo.* Paris, Bibliothèque Nationale. Woodcut. Title page of *Historiarum libri IX* edited in Venice by Giovanni and Gregorio de Gregoriis.

232 *Florentine art.* Florence Cathedral. New Sacristy. GIULIANO DA MAIANO from a cartoon by Baldovinetti. *The prophet Isaiah. 1463-1465. In situ.* Marquetry. The attribution is disputed. Ortolani attributes the cartoon to the young Pollaiuolo. The coats of arms are said to have been begun by Angelo di Lazzaro d'Arezzo, Bernardo di Tommaso di Ghigo and Giovanni di ser Giovanni. They were finished by Giuliano da Maiano between 1463 and 1465. *(Photo: U.D.F. - La Photothèque.)*

233 *Venetian art.* Venice, Santa Maria Gloriosa dei Frari. M. CANOZZI-LORENZO LENDINARA. *Stalls (detail): Perspective of a town. 1468. In situ.* Marquetry. *Cf.* Ill. 115. *(Photo: Osvaldo Böhm.)*

234 *Venetian art.* Venice, Santa Maria Gloriosa dei Frari. M. CANOZZI (LORENZO LENDINARA). *Stalls (detail). 1468. In situ.* Marquetry. *Cf.* Ill. 115. *(Photo: U.D.F. - La Photothèque.)*

235 *Emilian art.* Parma Cathedral. CRISTOFORO LENDINARA. *Chair back with a view of square and an ogival portico. 1473. In situ.* Marquetry. *(Photo: U.D.F. - La Photothèque.)*

236 *Venetian art.* Modena, Cathedral Sacristy. CRISTOFORO LENDINARA from a cartoon by Piero Della Francesca. *St Matthew. c. 1460-1465. In situ.* Marquetry 1.13 × 0.86 m. *(Photo: U.D.F. - La Photothèque.)*

237 *Emilian art.* Padua, Cathedral Sacristy. PIERANTONIO DA MODENA. *Ideal City. c. 1489. In situ.* Marquetry. *(Photo: U.D.F. - La Photothèque.)*

238 Urbino, Ducal Palace, Studiolo of Federico da Montefeltro. SANDRO BOTTICELLI and BACCIO PONTELLI. *Landscape (detail). 1476. In situ.* Marquetry. *Cf.* Ill. 239. *(Photo: U.D.F. - La Photothèque.)*

239 *Florentine art.* Urbino, Ducal palace. BACCIO PONTELLI from a drawing by Botticelli and Piero della Francesca. *Interior of the studiolo of Federico da Montefeltro 1476. In situ.* Marquetry. *(Photo: Alinari-Giraudon.)*

240 *Art of Urbino.* Urbino, Ducal Palace, Studiolo of Federico Montefeltro. SANDRO BOTTICELLI and BACCIO PONTELLI. *Charity. 1476. In situ.* Marquetry. The attribution of the cartoons to Botticelli was contested for a long time, but is now accepted. *(Photo: U.D.F. - La Photothèque.)*

241 Gubbio Ducal Palace. FRANCESCO DI GIORGIO and BACCIO PONTELLI. *Studiolo of Federico da Montefeltro (detail). c. 1480-1482.* New York, The Metropolitan Museum of Art. *Cf.* Ill. 242.

242 Gubbio, Ducal Palace. FRANCESCO DI GIORGIO and BACCIO PONTELLI. *Studiolo of Federico da Montefeltro. Reconstruction of the ensemble. c. 1480-1482.* New York, The Metropolitan Museum of Art. Marquetry. The studiolo was probably not completed until after 1482, according to the inscription 'G. BALDO DX' which refers to Federico's son.

243 *Art of Urbino.* Urbino, Ducal Palace, Sala degli Angeli. FRANCESCO DI GIORGIO. *The Liberal Arts (detail). c. 1476. In situ.* Marquetry. Part of the lower register of the left-hand panel on the exterior of the door. *(Photo: U.D.F. - La Photothèque.)*

244 *Art of Urbino.* Urbino, Ducal Palace, Sala degli Angeli. SANDRO BOTTICELLI and FRANCESCO DI GIORGIO. *Door (detail): Minerva. 1476. In situ.* Marquetry; 1.58 × 0.69 m. *(Photo: U.D.F. - La Photothèque.)*

245 *Sienese art.* Siena Cathedral. AN-
DREA BARILI. *St Catherine of
Alexandria. 1483-1502.* Now at San
Quirico d'Orcia. Marquetry. Part
of the ensemble executed by A. Barili
for the choir of the chapel of San
Giovanni in Siena. It was moved
from there in the 18th century.
(Photo: Grassi.)

246 Gubbio, Ducal Palace, studiolo of
Federico da Montefeltro. FRAN-
CESCO DI GIORGIO and BACCIO
PONTELLI. *A trompe-l'œil panel
of an open cupboard. c. 1480-1482.*
New York, The Metropolitan Mu-
seum of Art. *Cf.* Ill. 242.

247 *Genoese art.* San Lorenzo, choir.
ANON. *Stalls (detail): mandolin
1514-1530. In situ.* Marquetry.
0.37×0.54 m. *(Photo: Cresta.)*

248 Cassone panel. City view. *Late
15th century.* Florence, private col-
lection. Marquetry. *(Photo: Ali-
nari.)*

249 *Tuscan art.* Monte Oliveto Mag-
giore. FRA GIOVANNI DA VE-
RONA. *Stalls (detail): Still life.
Late 15th century. In situ.* Mar-
quetry. *(Photo: U.D.F. - La Pho-
tothèque.)*

250 *Genoese art.* Genoa. San Lorenzo,
choir. ANON. *Stalls (detail): spinet
1514-1530. In situ.* Marquetry.
0.37×0.54 m. *(Photo: Cresta.)*

251 *Florentine art.* SANDRO BOTTI-
CELLI. *Portrait of a young man with
a medal. Second half of the 15th century.*
London, Royal Academy. *(Photo:
U.D.F. - La Photothèque.)*

252 *Florentine art.* SANDRO BOTTI-
CELLI. *Paradiso, canto XXI. c.
1479-1510.* Berlin-Dahlem, Depart-
ment of Prints. Silverpoint and
leadpoint 0.47×0.32 m. Illustration
for Dante's *Divina Commedia.*

253 *Tuscan art.* MICHELANGELO.
After Giotto. *Ascension of St John
the Evangelist. 1489.* Paris, Louvre.
Drawing; 0.317×0.204 m. Copy of
the frescoes in the Peruzzi chapel of
Santa Croce In Florence, painted by
Giotto in the first half ot the 14th
century. *(Photo: U.D.F. - La Photo-
thèque.)*

254 Florence. Santa Croce, Peruzzi cha-
pel. GIOTTO. *Ascension of St John
the Evangelist (detail). First half of
the 14th century. In situ.* Fresco.
(Photo: Brogi.)

255 *Mantuan art.* ANDREA MANTE-
GNA. *Judith. 1491.* Florence. Uffizi.
Brush drawing; 0.36 × 0.24 m.
This drawing has been identified with
those described by Vasari. *(Photo:
U.D.F. - La Photothèque.)*

256 *Tuscan art.* MICHELANGELO.
After Masaccio. *Figures from the
Consecration. 1491.* Vienna, Alber-
tina. Pen and ink; 0.294×0.201 m.
Taken from the scene of the Conse-
cration in the church of the Carmine,
in Florence, painted by Masaccio in
the Brancacci chapel in 1427.

257 *Art of Romagna.* ANTONIAZZO
ROMANO. *Copy of the 'Navicella'
by Giotto. 1468.* Campana collec-
tion. Tempera on canvas; 1.87×
1.77 m. Giotto's 'Navicella' executed
in 1295 for St Peter's, Rome, is now
destroyed. 'The copy by Anto-
niazzo Romano therefore assumes
real value as a historical document'.
(M. Laclotte). At the time of going
to press, the picture is being restored.
(Photo: Sylvestre.)

258 *Florentine art.* Florence, *Santa Maria
Novella, façade.* LEON BATTISTA
ALBERTI. *1456-1470. In situ.*
Marble decorations. The church of
Santa Maria Novella was begun in
1278 and completed in 1360 by
J. Talenti. Alberti completed the
façade between 1456 and 1470.
(Photo: Anderson.)

259 *Florentine art.* Florence. *San Mi-
niato al Monte, façade. 12th century.
In situ.* Marble facing. Begun in
1018, the façade was completed in
the 12th century. *(Photo: U.D.F. -
La Photothèque.)*

260 *Art of Lombardy.* Lodi, Santa Maria
Incoronata GIOVANNI BATTAG-
GIO. *Cupola and Campanile. c.
1487-1494. In situ. (Photo: Alinari-
Giraudon.)*

261 *Emilian art.* Parma, *Baptistry.*
BENEDETTO ANTELAMI. *12th
and 13th centuries. In situ. (Photo:
U.D.F. - La Photothèque.)*

262 *German art.* ALBRECHT DÜRER.
*Young Women of Nuremberg and of
Venice. 1495.* Frankfurt-am-Main,
Städelsches Kunstinstitut. Pen draw-
ing; 0.247×0.160 m. Drawn in
Venice during Dürer's visit to Italy.

263 *French art.* Château de Gaillon,
chapel. MICHEL COLOMBE.
St George and the Dragon. 1508.
Paris, Louvre. Marble bas-relief;
1.75×2.72 m. *(Photo: U.D.F. -
La Photothèque.)*

264 *French art.* Château de Gaillon.
PIERRE FAIN (architect), MICHEL
COLOMBE and the GIUSTI (deco-
rators). *Entrance. 1502-1508. In situ.*
Built by Cardinal Georges d'Amboise,
Archbishop of Rouen and Minister
to Louis XII. *(Photo: U.D.F. - La
Photothèque.)*

265 *Spanish art.* PEDRO BERRU-
GUETE (attr.) Diptych: *Adoration
of the Magi.* Right wing: *two Magi.
c. 1500.* Madrid, Prado. Distem-
per on canvas; dimensions of each
wing: 3.50×2.06 m. First attri-
buted to Berruguette by Lafora in
1926, and today the attribution is
universally accepted. The panel is
part of a diptych depicting pictures
of St Peter and St Paul on the reverse
sides of the panel. The diptych is
now in the museum at Valladolid.
(Photo: U.D.F. - La Photothèque.)

266 *Florentine art.* DEL FORA BRO-
THERS. *Bible of Matthias Corvinus.
King Matthias Corvinus (detail). c.
1490.* Florence, Biblioteca Lauren-
ziana. Miniature, overall dimensions
of the illuminated page: 0.533×
0.367 m. Illustration to the *Psalms.*
Matthias Corvinus is portrayed as
David playing the harp.

267 *Art of Lombardy.* Milan, Castello
Sforzesco. *Clock tower. 1451-1455.
In situ.* The Castello Sforzesco was
begun by Filarete and completed by
Bramante. *(Photo: U.D.F. - La
Photothèque.)*

268 Moscow. PIETRO ANTONIO
SOLARI. *Diamond Palace. c. 1490.
In situ. (Photo: 'Novosti' Press
Agency.)*

269 LEONARDO DA VINCI. *Sketch
for the Château de Romorantin. 1518.*
Windsor Castle, Royal Library.
Drawing (12292 v°).

270 *French art.* Coimbra, monastery of Santa Cruz. N. CHANTERENE. *Pulpit.* c. *1521-1522.* In situ. Carved wood. *(Photo:Bruma.)*

271 *Venetian art.* Venice, Santa Maria dei Servi. TULLIO LOMBARDO. *Vendramin tomb (detail): Bust of a Warrior.* *1493.* Venice SS. Giovanni e Paolo. Marble. Sculpture. *(Photo: Osvaldo Böhm.)*

272 *German art.* Marburg, St Elizabeth. HERMANN and HEINZ. *Effigy of Louis I (detail).* *1471.* In situ. *(Bildarchiv Foto Marburg.)*

273 *French art.* Moulins, Cathedral. *Head of a young man.* *Early 16th century.* Moulins, Musée départemental. Stone; height; 0.31 m. *(Photo: U.D.F. - La Photothèque.)*

274 *French art.* Château d'Olivet. Studio of MICHEL COLOMBE (attr.) *Virgin and Child.* *Early 16th century.* Paris, Louvre. Marble; 1.83 × 0.60 m. *(Archives photographiques. Monuments historiques.)*

275 *Mantuan art.* ANDREA MANTEGNA. *Battle of the Sea Gods.* *Late 15th century.* London, British Museum. Line-engraving; 0.328 × 0.440 m. Several dates have been put forward for this work. Delaborde and Rubbiani give it as. c. 1500; Zani gives 1481, and Petrucci 1461. Dürer's copy was made in 1494.

276 *German art.* ALBRECHT DÜRER. *The Rape of the Sabine Women.* *1495.* Bayonne, Musée Bonnat. Drawing; 0.283 × 0.423 m.

277 *German art.* HANS LEINBERGER. *Instruments of the Passion carried by Angels.* *1511.* Paris, Bibliothèque Nationale. Line-engraving; 0.07 × 0.09 m.

278 *Flemish art.* HANS MEMLING. *Portrait of a young Italian.* c. *1471.* Antwerp, Koninklijk Museum voor Schone Kunsten. Paint; 0.26 × 0.20 m. Portrait of Giovanni Candida, a medallist active in the Low Countries and in France, where he became secretary to Charles VIII. *(Photo Giraudon.)*

279 *Umbrian art.* Perugia, Collegio del Cambio. PERUGINO. *Virtues and Heroes (detail).* *1496-1507.* In situ. Fresco; 2.91 × 4.00 m. (left wall). Part of the group of frescoes in the Collegio del Cambio. Detail from the left wall: Strength and Temperance with six heroes from Antiquity. *(Photo: U.D.F. - La Photothèque.)*

280 *Roman art.* MICHELANGELO. *Madonna 'della Scala'.* c. *1491.* Florence, Casa Buonarroti. Marble, bas-relief. 0.55 × 0.40 m. One of Michelangelo's earliest works. *(Photo: Alinari.)*

281 F. CARADOSSO (attr.). *Lodovico Sforza, called 'the Moor'.* c. *1488.* London, British Museum. Bronze medal; diameter: 0.041. Reverse: scene of a parade before the Doge of Genoa. (From G.F. Hill, *A Corpus of Italian Medals of the Renaissance before Cellini*, II, Oxford, 1930, pl. 115, fig. 654.)

282 *Mantuan art.* LODOVICO CORADINO. *Ercole d'Este.* *1472.* Formerly in the Dreyfus collection. Bronze medal; diameter: 0.057 m. Reverse: Hercules carrying a shield bearing the arms of the d'Este family (From G.F. Hill, *The Gustave Dreyfus Collection. Renaissance Medals*, Oxford, 1931, pl. XIII, n° 38.)

283 *Venetian art.* Studio of GIAMBELLO. *Agostino Barbarigo 1486-1501.* Formely in the Dreyfus collection. Bronze medal; diameter: 0.032 m. Reverse: allegory of Venice (From G.F. Hill, *The Gustave Dreyfus Collection. Renaissance Medals* Oxford, 1931, pl. XL, n° 155.)

284 *Mantuan art.* SPERANDIO. *Giovanni II Bentivoglio.* c. *1485.* Formerly in the Dreyfus collection. Bronze medal; diameter: 0.098 m. Reverse: G. Bentivoglio in armour, on horseback. (From G.F. Hill, *The Gustave Dreyfus Collection. Renaissance medals*, Oxford, 1931, pl. XXXIV, n° 128.)

285 *Florentine art.* NICCOLO SPINELLI FIORENTINO. *Lorenzo the Magnificent.* c. *1490.* Florence, Bargello. Bronze medal; diameter: 0.086 m. Reverse: allegory of Florence. (From G.F. Hill, *A Corpus of Italian Medals of the Renaissance before Cellini*, II, Oxford, 1930, pl. 150, fig. 926.)

286 *Art ot the Marches.* CLEMENTE DA URBINO. *Federico da Montefeltro.* *1468.* Formerly in the Dreyfus collection. Bronze medal; diameter: 0.094 m. Reverse: arms and emblems of Federico da Montefeltro and the stars of Jupiter, Mars and Venus. (From G.F. Hill, *A Corpus of Italian Medals of the Renaissance before Cellini*, II, Oxford, 1930, pl. 48, fig. 304.)

287 *Tuscan art.* FRANCESCO DI GIORGIO. *Alfonso of Aragon, 1479.* Oxford, Ashmolean. Bronze medal; diameter: 0.062 m. Reverse: Alfonso of Aragon holding a sword, accompanied by the God Mars. (From G.F. Hill, *A Corpus of Italian medals of the Renaissance before Cellini*, II, Oxford, 1930, pl. 49, fig. 311.)

288 *Florentine art.* ANDREA GUAZZALOTTI. *Sixtus IV.* c. *1481.* Formerly in the Dreyfus collection. Bronze medal; diameter: 0.060 m. Reverse: allegory of Constancy rising above an army of Turkish captives. (From G.F. Hill, *The Gustave Dreyfus Collection. Renaissance Medals*, Oxford, 1931, pl. LIII, n° 209.)

289 *Roman art.* ANON. *Alexander VI.* c. *1496.* Florence, Biblioteca Nazionale. Medal in lead and bronze; diameter: 0.056 m. Reverse: View of the Castel Sant'Angelo with the bridge over the Tiber. (From G.F. Hill, *A Corpus of Italian Medals of the Renaissance before Cellini* II, Oxford, 1930, pl. 138, n° 854.)

290 *Art of the Marches.* G.B. UTILI DA FAENZA (identified with the painter BIAGGIO DI ANTONIO) *Ecce Homo.* *Late 15th century.* Settignano, Berenson collection. Painted on panel; 0.46 × 0.34 m. The work bore the attribution to Andrea del Castagno, which was accepted by Berenson in 1936; Longhi however attributes it to the school of Botticelli, and dates it after 1470. Finally Berenson suggested the name of Utili da Faenza.

291 *Art of the Marches.* GENTILE DA FABRIANO. *Ecce Homo.* *Late 15th century.* Baltimore, Walters Art Gallery. Painted on panel.

292 MASTER OF THE SFORZA ALTARPIECE. *Altarpiece (detail).* *Ecce Homo.* *Late 15th century.* Cambridge, Fitzwilliam Museum. Painted on panel; 0.437 × 0.312 m. *(Photo: Royal Academy of Arts, London.)*

293 *Art of the Marches.* MELOZZO DA FORLI (attr.). *Salvator Mundi. c. 1466.* Urbino, National Gallery of the Marches. Canvas; 0.62×0.55 m. *(Photo: Fotomero.)*

294 *Florentine art.* ANTONIO POL-LAIUOLO. Design for an embroidery. *St John the Baptist being led into prison. (Detail). 1466-1480.* Florence, Opera del Dumo. Part of the embroidery-work for the baptistry showing scenes from the life of St John the Baptist. *(Photo: Alinari.)*

295 *Venetian art.* CARLO CRIVELLI. *Triptych. Central panel. (Detail of the Madonna's robe.) 1482.* Milan, Brera. Painted on panel; 0.78× 1.90 m. The triptych is signed and dated, and consists of St Peter and St Dominic on the left; Virgin and Child in the centre and St Venanzio and St Peter the Martyr on the right. *(Photo: Anderson-Giraudon.)*

296 *Cut velvet (detail). Late 15th century.* Paris, Musée des Arts décoratifs. Dimensions of the whole: 1.70×0.70 m. Made from three separate lengths of cloth coloured in red with a yellow background, embroidered in gold and decorated with lobate medals each bearing the device of a stylized fruit.

297 *Venetian art.* Venice. *Cut velvet (detail): stylized fruit.* Late 15th century. Paris, Musée des Arts décoratifs. Dimensions of the whole: 0.85×0.61 m. Red cut velvet on a background of yellow silk decorated with palm-leaves with a pomegranate in silver thread in the centre.

298 Urbino. Ducal Palace, *Studiolo of Federico da Montefeltro.* Marquetry design, after M.P. Rotondi.

299 *Flemish art.* The abbey church of La Cervara GERARD DAVID (attr.). *God the Father giving his blessing. c. 1506.* (Date suggested by G.V. Castelnuovo.) Paris, Louvre. Painted on panel; 0.457×0.88 m. Lunette from a dispersed polyptych of which Castelnuovo gives the following possible reconstruction: In the lower zone: three panels. St Jerome on the left, the Virgin and Child in the centre and St Benedict on the right (Genoa, Palazzo Bianco). Middle zone: two panels. The Annunciation (New York, The Metropolitan Museum).

300 *Art of Lombardy.* ZANETTO BUGATTI. *St Jerome. c. 1460-1464.* Bergamo, Accademia Carrara. Painted on panel; 0.53×0.36 m. (From Angela Ottino della Chiesa, *Accademia Carrara*, Bergamo, 1955, p. 15.)

301 *Neapolitan art.* NEAPOLITAN SCHOOL. *Flight into Egypt.* Naples, Museo e Gallerie Nazionali di Capodimonte. Painted on panel. *(Photo: Soprintendenza alle Gallerie.)*

302 *Sicilian art.* Church of Piedimonte d'Alife. CRISTOFORO SCACCO. Triptych. *Virgin and Saints. Late 15th century.* Venice, Private collection. Painted on panel. *(Photo: Fiorentini.)*

303 *Sicilian art.* Palermo, Confraternita di San Pietro la Baguera. RICCARDO QUARTARARO. *St Peter and St Paul. 1494,* signed and dated. Palermo, National Gallery of Sicily. Painted on panel; 2.15×1.55 m.

304 *Spanish art.* PABLO DA SAN LEOCADIO. *Madonna. Early 16th century.* London, National Gallery.

Painted on panel. *(Photo: Mas, Barcelone.)*

305 *German art.* Rotherburg ob der Tauber, church of St James. TILMAN RIEMENSCHNEIDER. Retable. *Christ (detail). 1501-1504. In situ.* Carved wood; overall dimensions: 8×4.16 m. (From Kurt Gerstenberg, *Tilman Riemenschneider*, Vienna, 1941, pl. 37.)

306 Bolzano, San Martino. NARCISIO DA BOLZANO. *The Trinity (detail): Christ. Late 15th century. In situ.* Carved wood. (From Enzo Carlis, *Bois sculptés polychromes du XIIe au XVIe siècle en Italie*, Paris, 1963, pl. CXXV, p. 111.)

307 *German art.* Würzburg. Chapel of St Mary. TILMAN RIEMENSCHNEIDER. *St Sebastian (detail) 1500-1505. In situ.* Carved wood; height; 1.15 m. (From Kurt Gerstenberg, *Tilman Riemenschneider* Vienna, 1941, pl. 59.)

308 *Austrian art.* Cloister of Neustift. MICHEL PACHER. *The Prayer of St Wolfgang. 1467-1483.* Munich, Pinakothek. Painted on pine wood; 1.03×0.91 m. (From Eberhard Hampel, *Michel Pacher*, Vienna, 1931, pl. LXI.)

309 *Umbrian art.* ANON. *St Sebastian. Second half of the 15th century.* Perugia, National Gallery of Umbia. Polychrome wood carving. (From Enzo Carli. *Bois sculptés polychromes du XIIe au XVIe siècle en Italie*, Paris, 1963, pl. 63.)

310 Artistic centres.

311 Italy in 1490: the States.

312 The Growth of Italian Influence.

384

MAPS

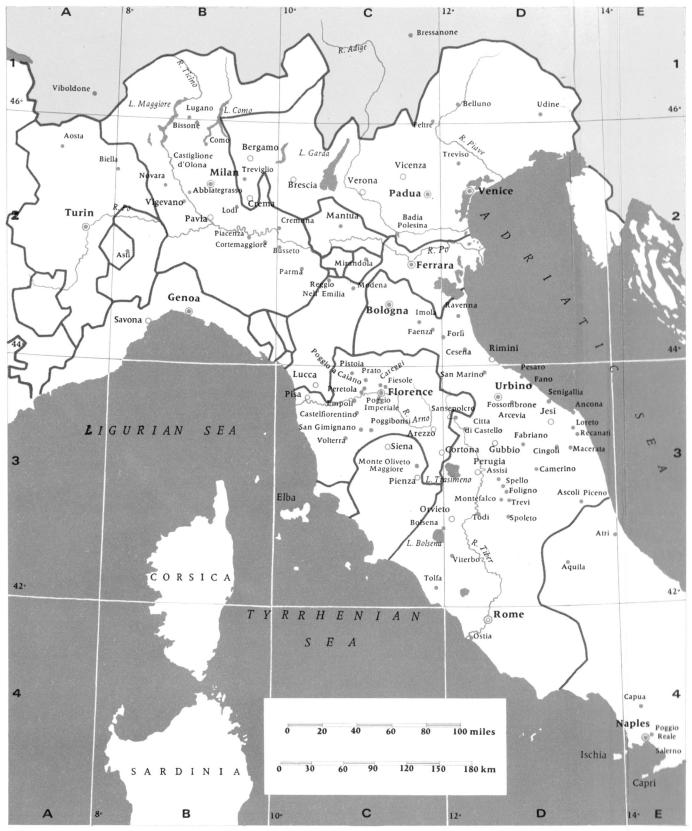

A 8° B 10° C 12° D 14° E

1

Bressanone

R. Adige

Viboldone

46°

L. Maggiore Lugano L. Como Belluno Udine

Bissone

Aosta Como Feltre

Biella Castiglione Bergamo R. Piave

d'Olona Milan Treviglio Vicenza Treviso

Novara Brescia Verona Padua Venice

2 Vigevano Abbiategrasso

Turin Lodi Crema Mantua A

R. Po Pavia Cremona Badia D

Asti Piacenza Polesina R

Cortemaggiore Busseto Mirandola Ferrara I

Parma Modena A

Reggio Imola Ravenna T

Genoa Nell'Emilia Bologna I

Savona Faenza Forli C

Cesena Rimini

44° Poggio a Caiano Pistoia San Marino Pesaro 44°

Lucca Prato Careggi Fano

Peretola Fiesole Urbino Senigallia

Pisa Empoli Florence San Marino Fossombrone Ancona S

LIGURIAN SEA Poggio Sansepolcro Arcevia Jesi E

Castelfiorentino Imperiale R. Arno Citta Fabriano Loreto A

San Gimignano Poggibonsi di Castello Recanati

3 Volterra Arezzo Cortona Gubbio Cingoli Macerata 3

Siena Perugia

Monte Oliveto Assisi Camerino

Maggiore Pienza L. Trasimeno Spello

Elba Montefalco Foligno Ascoli Piceno

Orvieto Trevi

Bolsena Todi Spoleto Atri

L. Bolsena Aquila

Viterbo R. Tiber

CORSICA Tolfa

42° 42°

TYRRHENIAN Rome

SEA Ostia

4 Capua 4

Naples Poggio

0 20 40 60 80 100 miles Reale

Ischia Salerno

0 30 60 90 120 150 180 km

SARDINIA Capri

A 8° B 10° C 12° D 14° E

310 - ARTISTIC CENTRES

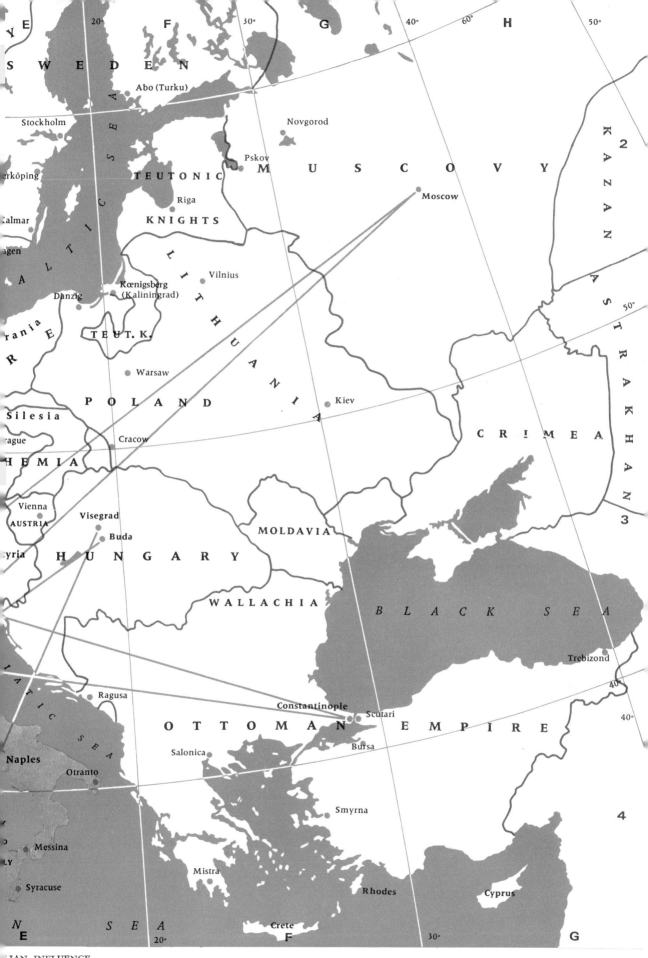

SWEDEN

Abo (Turku)

Stockholm

Novgorod

erköping

Pskov

MUSCOVY

TEUTONIC

Riga

Moscow

Kalmar

KNIGHTS

agen

LITHUANIA

Vilnius

Kœnigsberg
(Kaliningrad)

Danzig

rania

TEUT. K.

KAZAN

Warsaw

POLAND

Kiev

CRIMEA

ASTRAKHAN

Silesia

ague

Cracow

HEMIA

Vienna

AUSTRIA

Visegrad

MOLDAVIA

yria

HUNGARY

Buda

BLACK SEA

WALLACHIA

Trebizond

IATIC

Ragusa

40°

Constantinople

Scutari

40°

OTTOMAN EMPIRE

SEA

Naples

Salonica

Bursa

Otranto

Smyrna

4

Messina

LY

Mistra

Syracuse

Rhodes

Cyprus

N

SEA

Crete

20°

30°

E

F

G

ARTISTIC CENTRES

ITALY IN 1490

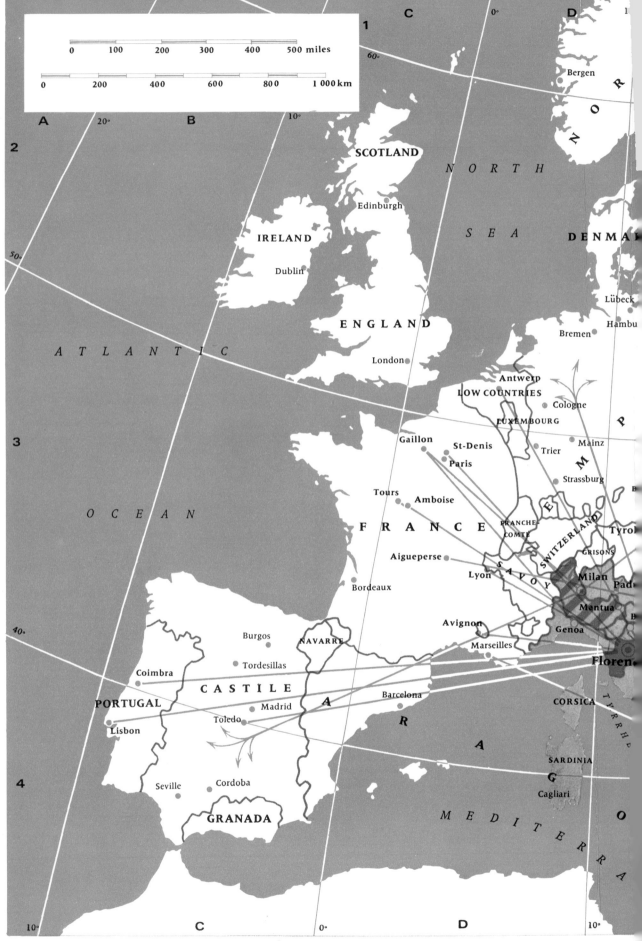

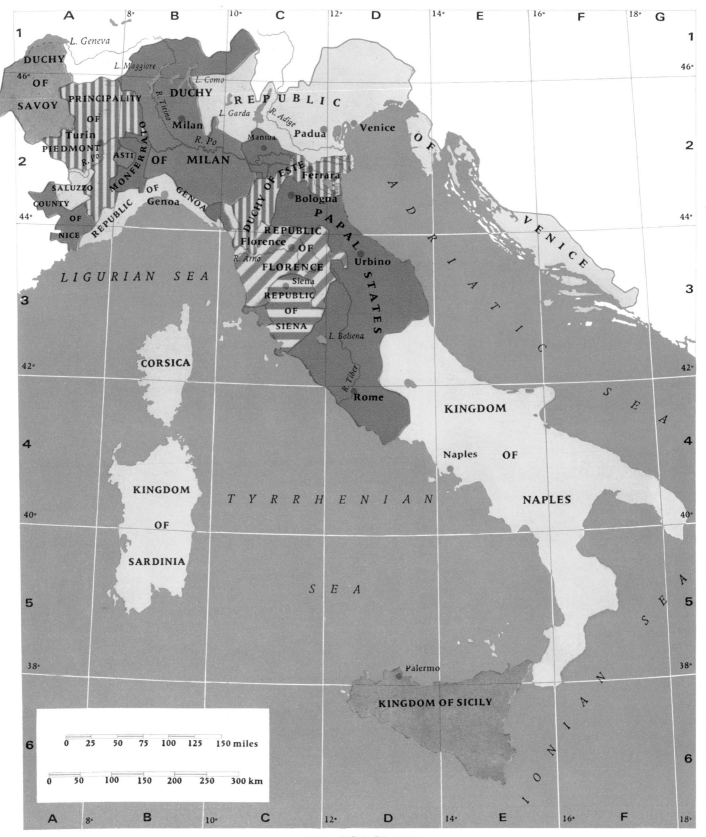

A1 **DUCHY OF SAVOY**

L. Geneva

46° **OF SAVOY**

8° *L. Maggiore*

PRINCIPALITY OF

Turin

PIEDMONT

2 *R. Po*

ASTI

SALUZZO

COUNTY OF

44° **NICE**

MONFERRATO

R. Ticino

DUCHY OF MILAN

Milan

R. Po

OF

REPUBLIC OF GENOA

Genoa

B **DUCHY**

L. Como

L. Garda

Mantua

R. Adige

C **R E P U B L I C**

Padua

DUCHY OF ESTE

Ferrara

Bologna

REPUBLIC OF FLORENCE

Florence

R. Arno

Siena

REPUBLIC OF SIENA

L. Bolsena

R. Tiber

PAPAL STATES

Urbino

Rome

D **Venice**

O F

E **V E N I C E**

44°

L I G U R I A N S E A

3 **CORSICA**

42° 42°

4 **KINGDOM OF SARDINIA**

40° 40°

T Y R R H E N I A N S E A

KINGDOM OF NAPLES

Naples

A D R I A T I C S E A

5

38° 38°

Palermo

6 **KINGDOM OF SICILY**

I O N I A N S E A

| 0 | 25 | 50 | 75 | 100 | 125 | 150 miles |

| 0 | 50 | 100 | 150 | 200 | 250 | 300 km |

A 8° B 10° C 12° D 14° E 16° F 18°

311 - ITALY IN 1490

THIS, THE SEVENTH VOLUME OF 'THE ARTS OF MANKIND'
SERIES, EDITED BY ANDRÉ MALRAUX AND GEORGES SALLES,
HAS BEEN PRODUCED UNDER THE SUPERVISION OF ALBERT
BEURET, EDITOR-IN-CHARGE OF THE SERIES. THE BOOK WAS
DESIGNED BY ROGER PARRY ASSISTED BY JEAN-LUC HERMAN.
THE TEXT, THE PLATES IN BLACK AND WHITE AND IN SEPIA
WERE PRINTED BY L'IMPRIMERIE GEORGES LANG, PARIS; PLATES
IN COLOUR BY L'IMPRIMERIE DRAEGER, MONTROUGE. THE
BINDING, DESIGNED BY MASSIN, WAS EXECUTED BY BABOUOT,
GENTILLY.

PRINTED IN FRANCE